The Art of American Car Design

*You never hear of any of the great
artists working in a committee. They
were all single guys. All the great
architects were single guys. And all
the great automobile designers were
single persons. Sometimes people
forget it. You know the old story
that a camel was designed by a
committee. You design a car with a
committee, and you get what you get.
You get a camel. I am not kidding you.*

Frank Hershey, Designer of the original 1955 Ford Thunderbird

*In a design organization as big and active as GM
Styling, with the number of talented
designers, ideas bounce around and feed off
each other. Nobody has a monopoly on
originality. Some ideas float in the air like
pollen, some go underground only to emerge
years later. . . .*

Bill Porter, Buick Chief Designer, 1987

*I said, "Don't be simple like in Simon." Give
them something to look at. . . . You throw a
billiard ball to a guy, and he puts it down. But a
baseball! He'll keep playing with it [because of]
the stitches.*

Bill Mitchell, GM Vice-President of Design, 1958–77

*I'm from the Clean and Simple School. But not
simple like Simon. You know there has to be
some entertainment, but you can do it with
form. . . .*

Irv Rybicki, GM Vice-President of Design, 1978–86

The Art of
American Car Design

The Profession and Personalities

"Not Simple Like Simon"

C. Edson Armi

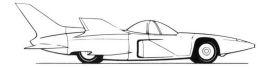

THE PENNSYLVANIA STATE UNIVERSITY PRESS
University Park and London

To Florian and Penelope

Library of Congress Cataloging-in-Publication Data

Armi, C. Edson.
The art of American car design.

Includes index.
1. Automobiles—United States—Bodies—Design and
construction—History. I. Title.
TL255.A76 1988 629.2'3 86-43251
ISBN 0-271-00479-7

Contents

Acknowledgments

C AN one acknowledge the climate of a city? Berliner Luft *culturally uplifted that city;* L.A. car smog *evidently stimulated a heightened automotive awareness. While fifties' East Coast children learned visual refinement the traditional way, on sidewalks and in museums, we West Coast beachtown kids honed our eyes on the streets. There was no Getty or Norton Simon Museum—the only thing I remember in a museum is a mummy. There were, however, streets, longer and wider than anywhere else, and the cars cruising them riveted our attention. My brother and I would play a game to pass time on the freeway en route to "neighbors" one hundred miles away: The winner first identified a complete ten-year run of any make of car. Well before the age of ten, we learned to discriminate at a distance of a quarter of a mile minute trim alterations from major sheet-metal changes. Imagine the anticipation with which we greeted an annual rite in those years—the fall model change—and the letdown we experienced from thinly disguised last-year's models.*

I owe a profound debt to my car culture and to my family. As Weimar Republic Germans, my parents tempered the sunny hedonism of L.A. with their brand of "Bauhaus functionalism" (meaning that we sat on Knoll furniture, gave away all tarnishable family silver, and bought only Buicks). They had in mind a very special Buick—the Century or Invicta—"with the light body and big engine," as my mother put it, "for fast pick-up" (i.e., stoplight dragging). Today, at 4'10" and almost eighty,

she drives (sign of the times!) a Toyota Supra, and, just in case she may need low-geared high acceleration, always keeps the "extra power" button depressed.

Many others contributed to this book along the way. Twenty years ago, Edgar Kaufmann, Jr., not only opened my eyes to car design as a legitimate art-historical subject but challenged me to publish on cars in respected scholarly journals. I would have never ventured in this direction without his initial encouragement. Since then, Richard Martin's support has made the difference for many of us in design history, and Michael Lamm's groundbreaking articles in Special-Interest Autos *have set the standard in the automotive field. More recently, Penelope Hunter-Stiebel has given invaluable advice; I would not have written this book without her help. Florian Stuber's friendship and counsel have been indispensable for many years, and his brilliant editorial skills immeasurably benefited this work. Chris Kentera's insight, intelligence, and judgment have infused the text. My special thanks to Marvin Saltzman and Claude McKinney for their open-minded defense of this project. Mary Spear, Russell Flinchum, and other students have contributed input, feedback, and enthusiasm. I express my appreciation to Dave Holls, William Knight, and Joe La Porte of the General Motors Corporation, Steve Hamp and Cynthia Read-Miller of the Edison Institute, and Rachel Frew of the Sloane Art Library. Finally, I am most grateful to the car designers for sharing the fire and joy of their creation and showing incredible patience with me.*

Introduction

[Henry Ford] didn't believe in art, like most engineers didn't.
—George Walker

As Americans, we have come to take the car for granted. For most of us, buying, driving, and keeping up our cars are simple facts of modern life, as necessary and natural as shopping at the neighborhood supermarket. Those of us who don't own cars can hardly escape seeing them since the car is perhaps the most ubiquitous and arguably the most dominant visual form of our century. We see cars all the time, but how often do we look at them as works of art? Although among the least analyzed and understood of the commercial arts, the American car continues to be one of our most significant and creative contributions in the history of design.

Cars have shaped America like no other visual form—except, perhaps, the movies, with which a telling comparison may be drawn. The founder of the General Motors styling department, Harley Earl (Figs. 1, 2), earned his early reputation designing custom cars for movie stars, and his taste for "Hollywood styling"—as General Motors President Alfred P. Sloan, Jr., called it—reflected his roots in the entertainment community. Both cars and movies rank among the most significant new visual forms of the twentieth century. As their production grew during the thirties, they altered our lives in similar ways. The movie and automobile expanded the horizons of our young nation while they joined us together and reinforced our values and goals. Successes in both businesses depended on the efforts of individual artists, but in both, individual creativity took

second place to profit.[1] Seldom before World War II was filmmaking or car designing considered artistic work.

Today, however, movies are acknowledged as a legitimate art form to the extent that the Museum of Modern Art reruns old films and devotes festivals to "cinema" masterpieces of the thirties and forties. Journalists daily interview actors and directors for their inside perspectives on the creative process. In contrast, no major American art museum permanently exhibits an American car.[2] Indeed, art historians are unaware of the names of the leading American car designers, and good critical writing on the subject of automobile aesthetics is almost nonexistent.

Surely it is time that we take cars, like the movies, more seriously. And yet, how can we? Basic questions remain unanswered, are for the most part even unasked. How is a car created? How is the idea for a car conceived, how does it develop into a design, and how does the design become a finished product? Does the design process affect the ultimate appearance of the car, and if so, how? Answering these questions would help us begin to see cars as works of art. The questions throw a spotlight on the role played by creativity within the automotive industry; the answers will reveal the unique form this creativity takes.

Such is one purpose of my book—to begin to view American car design as an art, with its own history and heroes, culture and lore. And yet, I am not writing a philosophical tract or an apologia for car design. Car designers need no spokesman and probably would disown one if he appeared. It is not my intention to argue the nature of art or even to apply a definition to car design. The last thing on my mind is to engage in the tired old debate that distinguishes art from design by separating the substantive from the decorative and the gratuitous from the functional. I simply hope to show that vehicles repay careful study and appreciation, just like paintings or sculpture.

To treat cars like one of the traditional arts, however, is difficult because the documentary material is hard to come by. Car-design studios have been kept secret for a long time. In the 1930s, the doors were deliberately closed to the outside world for sound business reasons; since cars had to be designed two or three years before production, no company wanted to tip its hand to its competition. Not that art historians were beating down the doors to get in: Given their background in the fine arts, they distrusted the effect economic considerations would have on car design. Their distrust was perhaps surpassed by the designers' suspicion of the art world. In the isolated, guildlike atmosphere of the design studio, it was felt that only an experienced car designer could understand and appreciate the complexities and subtleties of this particular commercial art.

There is a great deal of truth in the designers' position. Every medium generates its own language and thought and requires years of training and practice to master. There is danger in imposing preconceived notions from other disciplines upon the activity of these designers. In a sense, an apprenticeship with the great American car designers is needed if one is to understand their complicated aesthetic and technical decisions. Fortunately, many of the principal designers from

the thirties and forties are still living, and I have been able to interview quite a few of them. It is a critical time to do so because many of our greatest designers are now quite old; most are retired and therefore feel free to discuss their former companies' secrets. In the interviews, they willingly and eagerly offered insights into the history and appearance of cars.[3] Questions about cars as artworks, then, can now be answered with inside information from actual conversations with designers rather than from an outsider's point of view.

BACKGROUND AND FOCUS

The prominent car designers talk primarily about their work at General Motors, and, mirroring their interest, this book highlights GM design. This focus reflects the larger picture of American car styling because GM consistently attracted the best talent and consequently produced the finest designs. The other domestic manufacturers constantly raided the GM studios, while General Motors, after the mid-thirties, almost never hired from another company. More important, General Motors was the first to institutionalize the actual process by which mass-produced cars are designed, a fact acknowledged by both GM stylists and their competitors. Noting that GM was first to stress style, Bill Mitchell (Fig. 3), who was vice-president of design at General Motors from 1958 to 1977 and who started working there in 1935, even argues that the way the cars looked ultimately determined the pecking order of the Big Three American car companies: "See, nobody had a design studio but Earl. And then Edsel [Ford] was interested. He saw that and started one at Ford. Prior to that, Chrysler was ahead of Ford in the industry, but their chief engineers had contempt for styling. They used to say that you could piss over the top of our cars, we were so low. And, by God, their spite hurt them." A recent vice-president of design at Ford acknowledges that even Ford management recognized General Motors' position as the style-setter: "They all recognized that. They didn't want to, but they all did. GM was the leader."[4]

Before GM dominated styling, wealthy car buyers looked to custom designers for high style. They bought the engine and chassis from a large manufacturer and then commissioned a carrozzeria to fabricate an individual design to specifications. Typically in the early thirties, coachbuilders like LeBaron and Walter M. Murphy designed and built most of the bodies for prestigious chassis like the Chrysler Imperial (Fig. 4) and Peerless (Figs. 5, 6). Even through the mid- and late thirties, large companies like Ford, Dodge, and Studebaker often farmed out mass-produced car designs to the studios of body manufacturers like Briggs and Budd.[5] It was an unusual step in 1927 when General Motors hired Harley Earl both to supervise design and create a separate department, the Art and Colour Section. It was the first time any large American corporation seriously considered styling an integral part of its program.[6]

A number of events led to the creation of a separate Art and Colour Section within General Motors Corporation in 1927. This original design department came as a sort of fallout in the explosion of late-twenties' tastes. As the economy boomed, the public could afford to be taste-conscious, demanding style, color, and form from commercial products as diverse as flapper dresses and designer trains. Earl's attempt to organize car designing paralleled a nationwide interest in decorative arts and the formation of the American industrial-design profession by Raymond Loewy, Walter Teague, and Norman Bel Geddes.

Specifically, Earl's creation of the new Art and Colour Section at General Motors was the climactic result of President Sloan's varied-market strategy. When Sloan instituted his policies in the early twenties, his first goal was to dislodge Ford from its position of prominence in the industry. Sloan varied the styles of his cars, replacing the "naively developed and haphazardly assembled group of divisions" of his predecessor, William Durant, with a calculated and systematic series of offerings.[7] He instituted the annual model change not only to attract the affluent and style-conscious consumer of the twenties but also to make change a routine part of his corporate procedures. To encourage an appetite for his new styles, he initiated the installment plan and used-car trade-in, and he took advantage of the resulting fast turnover by flooding the used-car market with cheap, reliable, and diverse alternatives to the perpetual Model T. In the new consumer society of the mid-to-late twenties, Henry Ford tried to compete with GM by offering low prices. To do so, he clung to essentially the same Model-T design from 1908 to 1927, refusing to offer a variety of colors and accessories and appealing to an ever-shrinking market segment in the face of an expanding economy.

Central to his strategy, Sloan offered a systematic variety of products based on price, model, and style. He explained his marketing policy in the now-famous dictum "a car for every price and purpose," and his effort to replace the haphazard GM offerings of his predecessor with a stylistically diversified program led (through a specific order of events) to the current General Motors design system. After 1937 Earl changed the name of his organization to the Styling Section to reflect a new general focus on design, including all aspects of creating and modeling. But during its formative first decade of the twenties, the narrow appellation Art and Colour Section reflected Sloan's preoccupation with color. In 1927 Sloan suggested to the other members of the Executive Committee that a special department be established within GM "to study the question of art and color combinations in General Motors products."[8] Although eventually rigged with a top-heavy enclosure, the Model-T Ford originally came only as a black, open-top model, and Sloan wanted to contrast the sleek closed-body surfaces of his inexpensive Chevrolet and Oakland models by painting them in color. During the early twenties, black enamel was the only quick-drying paint. Colored pigments and varnish combinations could not be used in low-cost production because they required multiple applications and took up to fourteen days to dry.

To meet his objective of a fast-drying color paint, Sloan assigned the brilliant engineer Charles Kettering to the problem, and in 1923 Kettering's Advisory Staff, guided by members of a special Paint and Enamel Committee, perfected a fast-drying lacquer, called Duco.[9] The increased popularity of technically advanced and colored, closed-body Chevrolets forced Henry Ford in 1927 to replace his Model T with the Model A.

While low-priced competition spawned the Paint and Enamel Committee, price competition on the high end brought the Art and Colour Section into being. Chevrolet's sales had proved the success of color as a styling edge against Ford and set the stage for the creation of a separate design department. When Packard began eroding Cadillac's market share in the mid-twenties, the Executive Committee appointed its own member, Larry Fisher, as divisional manager of Cadillac and charged him with upgrading Cadillac's appearance. He was specifically assigned to create an entirely new image for a smaller Cadillac, the La Salle, and he chose Harley Earl for the job.

Fisher encountered Earl while visiting Cadillac's West Coast distributor, Don Lee, who had bought the Earl Automobile Works in the early twenties and retained the design services of Harley, the owner's son. After fleeing academics at Stanford, Earl learned the skills of designing at his father's custom-car studio, whose clients included the greatest movie stars of the twenties (Fig. 7). In the decade before his thirtieth birthday, the strikingly debonair Earl easily mingled with celebrities who demanded his flashy, eye-catching cars. According to Sloan, the La Salle Harley Earl introduced in March 1927 (Fig. 8) marked a turning point in "American automotive history" as "the first stylist's car to achieve success in mass production."[10] Pleased with the La Salle, Sloan contracted Earl to form the Art and Colour Section in the same year.

Unlike the creative goals of the Styling Section, the Art and Colour Section, as its name implied, initially concentrated on recognized style (i.e., art) and decorated surface (i.e., color). The objective at that time was to bring established style tendencies to mass-produced cars and to create surface diversification through color. In his La Salle design Earl directly copied the world's most prestigious and expensive body, the Hispano-Suiza, and he transferred that imitated theme to most GM cars by 1930. Frank Hershey, creator of the original Thunderbird, who began his career at GM in 1928, explains that Earl aspired to bring the outward signs of custom design to mass-produced styling: "You take Harley Earl's La Salle, the first La Salle that came out. It was nothing but an Hispano-Suiza, which he loved. [It] was one of the best-looking cars in the world, even to the big louvers on the hood. If you ever put the two together, you couldn't tell the difference. Now, that is a European design, and his first Cadillac was an Hispano-Suiza, too." A Ford vice-president corroborates those first objectives of the Art and Colour Section as he tells "about Harley Earl and how he got in at GM" after designing the Cadillac La Salle: "Larry Fisher told the story to me. We got to know the Fishers very well. . . . Harley Earl was then at Don Lee Studios,

which made very expensive cars styled for the movie industry. Larry Fisher was with him at this big party in Los Angeles, with all these movie girls. They were talking about cars, and Harley Earl said to him, 'I can make a car for you, like your Chevrolet, to look like a Cadillac.' And Fisher said, 'If you can, you've got yourself a job.' So, he came out to Detroit. That is how Harley got out there."

If the earliest phase of styling at GM can be described as derivative in nature and oriented toward the surface, the process for creating these designs can only be called unstructured. Fifty Art and Colour employees conducted almost all the business of styling in one central room where full-sized drawing boards casually separated the working areas of each car division. Designers from one division were frequently assigned to work on another division's models. Frank Hershey recollects a vignette from early 1936 typical of the unstructured Art and Colour approach: "Chevrolet studio wasn't getting anywhere . . . and Harley said, 'Look, Frank, you've done your job [as chief designer] on the Pontiac. Why don't you take your crew up there and make a front end for the Chevrolet?' So we made a hell of a nice front end."

No advanced studios prepared future designs, and no design-development studios eased new designers into the process. In 1928, beginning designers like Hershey started drawing details like radiator caps and worked their way up: "We made name plates, hubcaps, and stuff like that, because they didn't have any formalized studios in those days. They didn't have Buick, Cadillac, and Pontiac studios." Exterior, interior, and even portions of engineering design took place in the same unstructured environment. "In the thirties," Hershey recalls, "[as chief designer] I worked very closely with Roy Milner, chief body engineer at Pontiac. We became good personal friends. We picked wood grains and things without Harley Earl's overseeing. . . . We didn't have the big staff then . . . and so I did an awful lot on my own with this man at Pontiac."

After the mid-thirties, however, Earl began to structure a formal process for designing. The costly die presses required to stamp new steel tops in 1935 and all-steel bodies in 1937 forced Sloan to institute a massive program of interchangeability among the divisional makes. In turn, to maintain divisional identity, Earl was compelled by the necessity of these shared body sections to distinguish the remaining noninterchangeable parts. He actually institutionalized this separation when he transformed the haphazard central-space partitions into locked divisional-studio rooms. Each car-division studio boasted its own modeling platforms, lay-out tables, and built-in clay ovens in the rechristened Styling Section, opened officially April 1, 1938, on the top five floors of the new Research Annex Building "B." With few modifications, the system of studios and the sequence of design practice Earl formalized at that time have continued as the standard for the industry. The activity of the years preceding the Styling Section, as opposed to the beginning experiments in Art and Colour, formed the basis of the American car-design profession.

The sequence Earl established for the design of American cars divided into two phases. The first was two-dimensional; the second, three-dimensional. Car design began with rough sketches, which were turned into two-dimensional line drawings (Fig. 9). Some of these were then molded into three-dimensional clay models of various sizes (Figs. 10, 11), and finally presented to management as realistic mock-ups (Fig. 12). Nothing like this systematic sequence for designing cars had existed before, and it offered a marked improvement over the methods in other fields of commercial art. Architects in the construction industry, for example, solved their commercial-design problems through small-scale models and reduced graphics. The expense of change orders all but excluded major, on-the-spot building alterations. By contrast, Earl's sequence allowed for hands-on, full-sized development in both two and three dimensions. Like early medieval masons, car designers could explore aesthetic nuances in the context of actual scale, shape, and texture, and make "organic" changes while they worked on a facsimile of the production car. The lasting success of this system is proved by contemporary car designers, who create almost exclusively with it, aided by the computer only to document their results.[11]

ORGANIZATION

The General Motors approach became standard for the industry not only because of the size and importance of the GM Styling Section but also because of the personality of the section's legendary creator, Harley Earl. Describing the creative system Earl engineered is, therefore, the focus of the first part of the book, while introducing the designers as individuals is the subject of Part 2.

Chapter 1 begins with a discussion of the car designer as artist within the profession. This is a logical beginning, because the designer's artistic attitudes reflect not only the design system in which he works but also the personality of its inventor, Harley Earl, with all his strengths and weaknesses. Chapter 2 follows the changing role of the individual designer in creating mass-produced objects from 1930 to the present. It shows that four vice-presidents in charge of styling at GM and Ford personally effected radical changes in the aesthetics, organization, and structure of car design. Despite the significant changes they made, it also shows that the rules and attitudes Earl established continue to govern the car-design profession.

How we look at the past, especially its aesthetic values, is conditioned by our present assumptions, and this is especially true for an industry where design is money, and where financial advantage is perceived as vesting in certain shapes valued at a particular moment. Cars were not created in a vacuum, and their designers were affected by what was happening in the world around them and

even by the art theories of the time. In Chapter 3, I look for the connections between car design and other arts and for the meanings we have given to automotive shapes.

With the information from the last chapters, I present a new history of American car design in Chapter 4. For easy reference, I arrange photographs to follow the chronology of this chapter. I begin by concentrating on the crucial decades of the thirties and forties, when the major American companies institutionalized the design process. By the end of that period, Detroit cars had become distinctly American in their look. I see the nonfunctional forms, developed in pseudo-aerodynamic cars during these two decades, as significant American innovations and not as devaluations from the classical designs of the twenties. And I see the postwar era in America as a time of creative synthesis—a blending of European and American designs. This was the moment when Earl's greatest artistic rival, Bob Gregorie, head designer at Ford, conceived subtle, complex, and daring automobiles. The late fifties at GM under Earl was a powerful, new, and sophisticated period, quite unlike the current perception of it as an aberrant and superficial interlude. The historical account shows the sixties as the last great unrestrained epoch of American car design before emission and safety standards were imposed by the federal government. During those years, Mitchell supported originality from his designers while encouraging a blend of his own classicizing style and the latest hard-edged Italian taste. Reacting to internal federal regulation and external competition, American car design underwent a period of retrenchment in the seventies, from which it only began to emerge in the late eighties.

Chapter 4, then, serves as a kind of reference for the reader as he plunges through the specifics of the interviews in Part 2 of the book. In this final section, nine major designers speak at length about important aesthetic issues. The designers range in experience from Gordon Buehrig, who was hired at GM by Harley Earl in 1928 and eventually created the famous Cord 810, to Irv Rybicki, vice-president of design at General Motors since 1978. My conversations with these designers present a variety of personalities, from the complex and sensitive Bill Porter, chief designer of Buick since 1980, who consciously creates with a most sophisticated awareness, to an equally great artist like Frank Hershey, former divisional styling director at Ford, who resists self-conscious theorizing about his creative process and "feels" his way through a design. I tried to be sensitive to differences like these, and I changed my interview technique depending on the designer's personality, his willingness to address the issues, and the topics I wished to discuss.

The interview format, despite its many advantages, has a number of pitfalls. Interviews may be used for historical self-aggrandizing—for taking sole responsibility for a design created by a team, for venting polemics, for rationalizing professional disappointment, or for unleashing the animosity of personal conflict and jealousy. The designers often disagree about important historical facts, such

as who was responsible for the design of the postwar Ford and Cadillac, but also about decisions of value and judgment made by Ford after the war and by General Motors recently. As a whole, the second part presents "raw" history, uncleaned-up by scholarly reflection, which is why this primary evidence is placed at the end of the book. Its position does not imply that the material is of secondary importance or that the first part of the book would be possible without it. In fact, unless otherwise noted, all quotations in the text are from these interviews. What emerges from the interviews is a clear picture of the creators themselves and the effect of their individual personalities and imaginations on the process of design and the shape of commercial art. This is the first in-depth analysis of the most important American cars by the designers themselves. Not only have they been asked to look at cars historically; in turn they have provided the public with an insider's use of language and revealed to us a working understanding of a creative process previously unexplored in automotive literature.

To transform the standard car chronicle into an art-historical interpretation would be a delicate operation for the professional automobile journalist, even if he should choose to undertake it. He depends for his livelihood on constant contact with industry representatives and on repeated access to their archives, just as a local institution like the Detroit Institute of Arts depends on the automobile companies for future financial support. In their presentations of past and current cars, neither the individual nor the institution can afford to jeopardize the industry's immediate interests; therefore, what they present is frequently the industry's own image of its history, interesting no doubt, but hardly objective or complete.[12] As an academic, I may be in a better position to deliver a disinterested assessment. Expecting no future benefits from the industry, I hope to be both fair to the past and fairly critical of the present.

Part One:

The Art of
American Car Design

1

The Designer

I can see but I can't hear.
—Dave Holls

 arley Earl faced a tall order when he came to Detroit in 1927 to head GM's new Art and Colour Section. Practically from scratch he began to assemble an organization capable of designing the exterior of almost every product of the world's largest corporation. Battling entrenched interests, he took nearly ten years to formalize and lay down the rules that continue to guide American car design. In the process, he created a new profession, establishing, as in other professions, standard practices. While the designer in this new métier was artistically rooted in the early custom-car studios, his character quickly came to reflect the unique surroundings and the peculiar demands Earl made on all his employees. Earl's personality also affected design leadership, setting a pattern for a different sort of person at the top from that at the bottom of the profession. To discover the special temperament and makeup of the car designer, we should ask: What does he do? Does he think of himself as an artist? And is he creative in the ways other artists are?

The demands of his job partly explain the character of the American car designer. Activities in any major American business are organized on personnel levels and around organizational tasks, and within the automotive business, the activity of designing cars is structured the same way. Traditionally, design decisions are referred to the top, where the vice-president of design and two chief lieutenants resolve almost all aesthetic questions. Depending on the vice-

president, these lieutenants coordinate different groups of designers working in advanced or production studios. The vice-president's power is almost absolute and his control wide-sweeping. At "executive showings," the Executive Committee and divisional general managers accept or reject the cars he ultimately proposes, but they seldom interfere with the decisions he makes at the Tech Center, where the designs originate and develop. There, the organizational structure, personnel decisions, and aesthetic direction are left in his charge.

Advancement within the organization occurs in distinct stages. Most designers major in transportation and graduate with a commercial-arts degree from a few highly competitive art institutions financially supported by the car companies. Since 1960, about 50 percent of Detroit designers have graduated from the Art Center College in Pasadena, but recently, under the creative standards of Homer La Gassey, Jr., the Detroit Center for Creative Studies moved to a competitive level. As director of the Transportation Department, La Gassey accepts one of five applicants and then weeds out three-fourths of his students. After graduation, life becomes even more difficult for the fledgling car stylist because scarcely a dozen are hired worldwide in a boom year. The constricted market for American cars partially explains why in the mid-seventies almost all Art Center transportation graduates went to Detroit, but in 1987 they can be found scattered throughout the world.[1]

Let's say one of these lucky twelve is hired to be a designer at GM. What is the likely progress of his career at the Tech Center? He may follow a variety of twists and turns along the way, but the typical path would be this. He and a few others start in an experimental or design-development studio. Under a studio chief, the beginning designer works on hypothetical projects—show cars, dragsters (Fig. 106), and future and experimental designs—that scarcely ever will be produced. Rather, the design-development studio is a playpen where, without risk to the company, the talent of these beginning designers can be showcased, their ability and personality can be tested, and they can be eased gradually into the cold world of commercial design. If he is found lacking in skill, he is usually fired. If his problem is a lack of creativity, he is transferred and trained as a technical stylist (layout technician). But if he shows promise, in about a year he will be promoted to an advanced-design studio.

In the advanced-design studio, the designer creates thematic prototypes for cars (Fig. 68) that, if he is lucky, will actually be produced. It is at this point that the work of a car designer comes closest to our idea of that of the fine artist. Here, the designer is encouraged to generate idealistic, even futuristic, concepts for a Cadillac, Buick, or Oldsmobile, depending on which studio he's attached to. The concept he develops may be as specific as a grille or as broad as the silhouette of a car, but it is referred to as a "theme."

Some of the advanced studios might even be free-floating, but unlike the fanciful musings of the pure artist, the themes the studios develop have a very specific commercial purpose: to generate possible models for actual production

three to five years in the future. Oddly, the men who create these themes practice in isolation from those engaged in production-design activity. With as few as two or as many as ten others, they work in a separate advanced studio adjoining a production studio or down the hall from it. If a studio chief selects a designer's theme for production, the theme moves on, but he stays behind. He remains a year or two generating themes in an advanced studio before he is promoted to a production studio, where he learns the ropes of on-line production.

It's in the production studios that a designer designs cars that are actually produced. This is the top of the line—this is what we mean when we talk of a "car designer"—it is what he aspires to be. With four or five others in a production studio, he creates the cars GM puts its money on the line to produce. If he shows signs of administrative skill, he may be promoted to assistant studio chief in an advanced or production studio, and if he passes that managerial test, he may move on to head one himself. Depending on politics and personalities, he may also be demoted or sidelined along the way to studios where esoteric research or future-concept studies are undertaken in fields like aerodynamics and impact collision. But such an assignment usually means he has failed as a production designer.

What does it mean to reach the top of the profession as a production designer? It means the designer becomes part of a team that creates the car a human being actually drives. If he is lucky, the designer in an advanced studio abandons his theme to the collective system of creation. In the belief that two heads are better than one, the American car designer, except in extremely unusual instances, must share his concept with other team members. As a project or a collection of themes works its way from an advanced studio into a production studio, individual creative control and the spark associated with authorship almost always are lost as different designers massage the original concept into shape. The designers who work on the blue-sky "theme" alter, sometimes radically, the original artist's idea to satisfy practical demands like function, safety, economy, quality, and construction. Federal safety and consumption standards, foreign quality and labor competition, and even the price at the gas pump impose restrictions of size, shape, and finish on these designers.

While these practical and economic considerations reshape the creator's original idea, GM's design philosophy in the eighties compromises his creativity from the very start. Car design in America is part of a threatened industry whose leaders consciously avoid sudden visual change. The turn-on-a-dime philosophy that sometimes colors our notion of "artistic" originality in the fine arts, and that was encouraged in the car-design profession in the rapidly changing fifties, is largely a thing of the past—and not regretted by the men at the top of General Motors. In an industry where every new car risks billions of dollars and where Asian and European competition is more intense than ever, shapes are increasingly based on consumer polls, and artistic change is conceived as slow and careful evolution. The man at the very top, GM Design Vice-President Irv

Rybicki, explains his conservative outlook: "Back in Earl's time . . . if you made a mistake, you could easily correct it with [a] face-lift. Today we put a car out there and we hardly touch it for a six-year period. You may change grilles and a few things like that . . . [but] you are living with the basic theme for five to six years." With a slow turnover, the company is afraid to risk radical mutations. The number-three man at GM, Executive Designer Dave Holls, for many years director of advanced design, details this step-by-step approach: "I know what is going to happen in the next five years, and I call it not a mild evolution but a major evolution—but not a revolution."

These considerable constraints, magnified today, attract and hold artists of a certain disposition. Only men who manage to merge their ideals with the perceived realities necessary to sell cars survive. While the top car designers insist that creativity and talent are the keys to longevity in the profession, they almost inevitably couple these words with others: resilience and adaptability. Hardiness and flexibility are not just mental or artistic requirements but physical demands as well. It is in the nature of a car designer's art for him to work hard—with little time for creative fantasy. Even in the thirties, when GM production was a fraction of what it is today, back-breaking labor was the norm. One of Earl's first chief designers, Frank Hershey (Fig. 23), describes how "we worked hard. For years, I worked up to nine o'clock many a night and sometimes on Saturdays and Sundays." After the war, when the Tech Center opened and the range of models increased, GM designers were asked to put in continual overtime; the normal day extended from 8:30 A.M. to 10 P.M., and frequently to midnight. Today the load is similarly brutal, as Rybicki explains: "We worked overtime hours—and we were working ten to twelve hours a day, and we still do a lot of that today."

Although all designers must toil, only those disposed to compromise endure. Strother MacMinn, a designer with GM throughout the thirties and forties, and today one of the most respected analysts of automobile styling, lists "resilience and creativity" as "the essential elements of survival": "If you are really creative, there is no end to it . . . the way that many designers—I would say, almost every one of them—can come back the next morning, bounce back into work, tear off another sketch, direct another model, or make a new change." Another top professional, one who worked right beside Harley Earl and Bill Mitchell, puts it this way: "Designing is not a very scheduled process. You think you got something, and all of a sudden you got shit. You have to have a very adaptable personality to be able to roll with the punches. You have to have shoulders of leather. . . . I've had people ask me, well, how do you plan your day? I plan my day every morning by getting up and coming to work. I never know what the day is going to bring. How the hell can I plan it if I don't know what is going to happen?"

The reflective artist who prefers a long-term strategy traditionally has found little success as a car designer. A designer like Buick Studio Chief Bill Porter (Fig. 105) wallowed in a GM doghouse for ten years after colliding with the mercurial

Bill Mitchell. Looking back, he makes the point that success is survival: "Well, I think gradually you find that if you can manage to hang around long enough, and if you survive, the situation that you went in with alters through time and circumstance, and then you become one of the people who are doing the very designs that were being done differently from the way you wanted earlier. And, ultimately, if you happen to land in the right place at the right time, you can influence events in a way that is consistent with your own underlying ideas."

Adaptability and a thick skin are necessary for a designer to remain in the artistic flow, but he needs extra talent to attain a managerial position. He must have the ability to control the design process, as a system. If a designer becomes a studio chief, he increasingly takes on the responsibility of administering the anonymous creative system. The two GM vice-presidents after Earl had to prove themselves as organizers of talent or "team players"—the phrase GM executives most often like to use. First they served as chief designers—Mitchell at Cadillac and Rybicki at Chevrolet and Oldsmobile—and then as assistants to the vice-president.

Another characteristic of the executive designer is salesmanship, the ability to communicate with the world outside the Tech Center. Ironically, the *lack* of this kind of verbal skill is a characteristic of the everyday car designer and is actually fostered by the design system. An architect or other commercial designer who produces as part of a team constantly needs to deal with a demanding client, but the everyday car designer is not required to "sell" his work to an outside buyer. Only those at the very top need to convince divisional management of the merits of a design, and therefore philosophy, theory, and even explanation traditionally have been disdained in the profession. The conceptual orientation of architects like Wright, Corbusier, and Venturi or the salesmanship associated with industrial designers like Loewy, Dreyfuss, and Teague is missing from the standard repertoire of the studio designer.

Industry insiders often distinguish the men at the top from those beneath who are not asked to pitch their ideas. GM Design Director Chuck Jordan slapped down a chief designer who tried to explain a particularly subtle design passage with the comment, "Why don't you put it in the owner's manual." Dave Holls, executive director of design at GM, also frowns upon his employees' speaking too soon, and he suggests that the truly avant-garde artist shows before telling: "That is maybe not that unusual if you are a pretty progressive designer," he says. For Holls, car designers are not like some architects and industrial designers who must encourage clients to accept projects with their linguistic and social skills; he reserves the role of salesman for the man at the top, the vice-president. "You couldn't last around here thirty days doing that. Boy! . . . No. Never. Wrong! We have a few people around here who used to say, 'I can see but I can't hear. Don't give me any of that bullshit.' Any of the designers start talking like that, before he's got it down and can show you, and—[suddenly he slams his fist on the table]. . . . Fortunately, only the man who heads this building has to be convinced."

Historically, this distinction between the personality of upper and lower designers at General Motors reflects the chain of command established by Harley Earl. As we shall see in the next chapter, Earl could not draw, and he rarely communicated with any but his top designers; therefore, complicated explanations about visual matters became a useless, even detrimental skill for staff artists. More broadly speaking, the nonverbal aspect of design coincided with the history of the profession. Earl, like most early designers, trained in a custom-car studio (Don Lee Studios) and not in an art institution. In the custom-car environment, automobile design was considered something apart, really a separate craft from the fine arts and industrial design. Time and again, automobile designers emotionally describe themselves as car lovers, who must have a "feel" for a car to design one. Earl's takeoff on Gertrude Stein's saying summarizes it best: "A car is a car is a car." When referring to a competitor's automobile, he would often say, "That looked like a baby buggy. It didn't look like a car." To Earl, "emasculated design" was a vehicle that wasn't "automotive." He would say, "A car has got four wheels and they belong on the road, not on the roof."

Most car designers have related their preoccupation with cars to a "manly expression"—what it really "takes" to design them. "Womanly sensibilities" were not considered part of the process. In the mid-thirties, not one woman designer worked for GM's Art and Colour Section. As a GM designer describes it, "In those days, women were nothing, absolutely nothing. I don't think there are many women there now, and there never were any women at Ford [in the early fifties]. Never! Never! This is a man's world." "Macho" men like Bill Mitchell, who succeeded Earl and ran GM design for twenty years, speak of the need for having "gasoline in your veins" in order to design cars. Like Earl, he believes that the overriding requirement for a car designer is love of cars—anything less raises unwelcome questions about a designer's masculinity. Anything more jeopardizes his standing, because Mitchell renounces the need or desirability for a true car designer to practice or even be aware of another artistic craft:

> BM Well, you see, car designers—there is a great percentage of imposters here. Cars, you have to love them. You have to feel them, and you have to drive them. Like they'd say, "You have to put the cam into the wheels." You have got to know them all—the histories. And if you are an icebox designer— fine. I know, because I hire a lot of guys here [at his private industrial-design business]. They can do rockets, but an automobile? Humph! Damn few people know how to do a car! You have to get the heritage of an old Duesenberg, an old Mercedes, not just a modern car. It's like an old shoe.
>
> CEA What is the opposite side of that? What do car designers know about icebox design?
>
> BM They don't want to know anything about it. They don't give a damn about it. They are different people entirely. That is why Raymond Loewy was not a car designer. He wanted to be.

Designing cars not only requires loving them but frequently implies exclusivity: If you are interested in other arts, if you *can* design refrigerators as Mitchell puts it, then you are not a real designer of cars. Men like Raymond Loewy, George Walker, Ned Nickles (Fig. 2), and Art Ross, who came to design automobiles from a fine-arts background rather than from the custom-car studios, are regularly dismissed by car designers as superficial dilettantes. Typical are Frank Hershey's comments about Ross, who conceived Cadillac's famous egg-crate "architectural" grille (Fig. 32), and the comparison he makes to his own love of cars and his education in the custom studios: "I think Ross was an artist. He wasn't really an automotive man. His whole background was different. See, my background was automobiles. I have always been interested in cars—late cars, early cars, any cars. One of the reasons I came back from Mexico after I retired was that I just had to be around the new cars when they came out. It sounds silly to some people, but I just had to be with them. I love them. Now, Ross, he was not an automobile lover. Mitchell was an automobile lover. So were all the other people who came from custom-body shops. And that is where you got your designers, because there was no formal education for designers anywhere."

The historical pattern of a split between monomaniacal designers with "gasoline in their veins," who toil away from prying corporate chiefs, and sales-oriented, smooth-talking executive designers who negotiate with divisional leaders, occurred through necessity. When Harley Earl came to GM, he had to convince managers and especially engineers of the need for his aesthetic services. This opportunity challenged him considerably, and the last thing he wanted was further interference from his own designers. To ensure their loyalty, he isolated them through a hierarchical, even dictatorial, chain of command through which all professional contacts passed. Simultaneously, Earl worked hard to solidify his exterior contacts with directors of Chevrolet, Pontiac, and the other car divisions by consciously developing the image of an indispensable arbiter of taste.

Earl manipulated and intimidated these divisional managers by flaunting his close friendship with GM President Sloan and by parading his flamboyant lifestyle. Mitchell describes the sales method as raw power: "Earl was in with the Fisher brothers to begin with. He was powerful. He had the power. Nobody dared cross him. . . . See, Sloan hired [the divisional managers], don't forget, and if things didn't go right—in his office Earl had a button, which I inherited. He could push it and talk directly to Sloan. And he'd have a meeting coming up, and he'd press that son of a bitch." Although he learned to threaten by invoking his friendship with Sloan, it was touch and go at first as to whether Earl would control the design process by his sales abilities. According to the early recollections of Frank Hershey, "In the beginning Harley had to sell himself to management and win the divisional managers over. And in that he did a great job, but it took some doing. It was only after he'd been there a couple of years that he got control to the point where Fisher Body could not make a change to a design unless they asked us to do it. From then on, very few changes were made, and

when they were, we made them. But it took Harley some time to get there. He had a hard row to hoe, which nobody really understood."

Trying to control the design situation outside the Styling Section, Earl developed and projected a sense of aesthetic rightness that silenced his corporate rivals. Hershey explains how Earl consciously used his image to support his sales objective: "Harley was always so image-conscious. Detroit was macho in those days. Everything was macho—the Fisher brothers, the Dodge brothers, all these people. And they used to make fun of Harley Earl's neckties and suits and shirts. All the time. The big shots at GM couldn't understand these either, but that was part of Harley Earl's image. He was showing them that he was a designer by wearing all this stuff. He paid twenty-five dollars for a shirt. He was a big man; he should have dressed very conservatively, but he didn't. He had an image. He had to sell himself."

Henceforth, the executive designer at GM was not necessarily the creative designer, but someone who recognized the style that sells and who convinced management that his judgment was right. The pattern Earl set of a leader different from others—almost touched by a divine knowledge—was communicated by his clothes and bearing and by his faith in the salability of his product. A Ford vice-president of styling understood these qualities in his chief rival. "That is the only thing Earl said, 'Did they sell?' . . . If you are in the business, your sense tells you how a product is. They hire you to tell them what to do. They take your word for it. That is what Harley Earl was known for. As Larry Fisher used to say, 'Whatever Harley Earl said, our board would OK it.' " The secret to sales success was knowing and projecting the correct taste. "He was a guy who had a good sense of style. Let's put it that way. Harley was a better salesman than he was a stylist—knowing a good style. And that was very important, for he had to get up through all the General Motors group—the directors—and present his cars like I did at Ford. And if you sold a new car, you had to have a lot of faith in what you were doing."

Infallible taste, or at least the impression of it, was the premium commodity. Gene Garfinkle, who worked on numerous custom cars for Earl during his final year as vice-president, observed this exceptional trait in him: "I think if you saw two naked men in the shower, you would know who was a commanding general and who was a noncom. I think people just carry that authority with them, and that is something I don't think you can learn, either. You just have it. Earl had it, he really did. He exuded it. I am not sure it was confidence, but rather just a rightness about him. He was convincing when he did something. It was right."

The qualities Earl projected to secure his own position also served to establish car design as an activity equal to engineering and other professions in the automobile industry. Rival GM executives began to face an uncomfortable reality: Interpreting future buyers' tastes had become a visual question left largely in the hands of one person. The hierarchy and split Earl had orchestrated left him as the

only trained professional with the verbal skills necessary to deal with both visual problems and management. The divisional manager, the man the car companies empowered along with the Executive Committee to make the final design decisions, had no design training and therefore little choice: Either he accepted the design guru's advice (for which the company had paid fully, indeed), or he rejected his professional opinion and entered the design game himself, a very risky business for someone with no artistic background, who would then have to assume responsibility in case of failure.

By establishing the top designer as someone special, in effect a unique authority above the level of other vice-presidents, Earl left a lasting heritage. He positioned himself, and consequently the car-design profession, as simultaneously inviolate and indispensable. Walker not only witnessed the transformation in the role of the design director, but later, from 1956 to 1962, he shouldered the mantle himself at Ford: "During that time, just before Harley Earl got there, things were done by hacks. Engineering hack-designers. The engineer would do it, and then turn the idea over to the illustrator, whom he told to 'Do this and that.' Then the illustrator would get credit for it, and that made the engineer angry. After that the designer became the czar. . . . If management came in, and the designer was there, the management would talk to him because management thought he designed it. And he was advertised and publicized. The artist was something different. He was a different breed of cat." An extreme point was reached when company president Henry Ford II urged Walker to take styling off his hands: " 'George, I want you to run this styling like your own business. And don't you let anybody ever tell you what to do, even me!' And I did that. I didn't do it to be smart-alecky. I didn't have to, even though I was dealing with the boss." The top designer became so much the king of the jungle that the executive director of Ford, Ernest Breech, could only throw up his hands as he summarized the state of affairs with his designers during the late fifties: "That is why we hired these bastards, so we *can't* tell them what to do!"

While the personality of the vice-president of design has changed over the years, he must still be able to convince unknowledgeable and inexpert executives and directors about the merits of his artistic products. Hershey explains that at first even Earl's personality may have been recycled, as Mitchell's flamboyant behavior and dress and his absolute and determined way of speaking resembled his predecessor's approach: "Mitchell, you see, got in . . . because he was like Harley. Same kind of guy as Harley." Perhaps, as some designers suggest, these blatant aspects of Mitchell's style made him the obvious successor to Earl in the eyes of GM brass. As he nears eighty, Mitchell wears a gold-lamé suit as he rides his pin-striped motorcycle, and he portrays himself foremost as a fighter. He sees himself as the prototypical car-loving designer, who survived under Earl by never crossing him and then waged war with management after he made it to the top: "Well, I don't know how I survived myself. You have a lot of battles, by God. . . .

The problems were . . . taste, design, judgment, and politics. . . . I had to fight like hell, because they were all waiting to gang up on me. 'Hell, we'll knock this guy off.' But they didn't."

The men at the top of GM design today describe themselves as different from Earl in their disposition and approach. Yet they admit that Earl's willful character made theirs a respected design organization and that management on the whole continues to accept their word on the appearance of cars. A designer almost at the top of GM today analyzes this shift in personality type: "I'll tell you what I think, and it may not agree with everyone else. We talk about that. Harley Earl would not have made it today. He was a man for his time. He did an excellent job developing a design group from nothing. From nothing. Engineers, who were designing the cars, were bitterly against him. He carved out and made this Art and Colour Section into a respected design organization. But his way of working—today the government would sue you." Earl established the role of the top designer as the exclusive arbiter of taste, the pitchman extraordinaire, whom Dave Holls describes as a virtually infallible demigod, even today. "Fortunately, the man who heads this building [Irv Rybicki] has to be convinced. And we have had such a damn good batting average that our corporate management at GM has pretty much gone along with what we have been recommending." With Rybicki's retiring in the fall of 1986 and GM's sales percentage reaching a historic low, the old pattern may be due for a shake-up. The design vice-president's judgment may become just another team-player's opinion as Chairman Roger Smith diversifies but streamlines GM's operations.

2

The System of Creation

Car Design at GM and Ford under Harley Earl, Bob Gregorie, Bill Mitchell, and Irv Rybicki

*Earl would go, "Now, look at this here—
the-the-the hhhhheeeeadlight treatment
here." He'd walk over to the headlight, and
his half of the big circle, with all the black
suits, would wander along behind him and
nod, "Oh yeah, wow, I sure like that
direction myself."*
—Gene Garfinkle describing a GM "Executive Showing"

To understand how the car designer functioned within the creative process of mass production, we must first examine the limits of individual artistic action. Was the creative act of design a communal or an individual effort? To what degree was the individual given license or restricted, and how did the strength of other designers affect his creativity? Did the creative process change as the industry developed, and were there important countercurrents to prevailing methods?

After looking at the important period from 1930 to 1950, we will see that a largely anonymous creative system was developed at General Motors. As well-trained refugees from GM gained control of styling sections at other automotive companies, they spread this system. Once accepted, it was assumed to be practically the only way to deal effectively with the quantity and complexity of detail involved in designing mass-produced cars. It is a peculiar irony, however, that this same anonymous and communal system was the creation of an individual, Harley Earl, whose skills as a synthesizer, administrator, and critic overshadowed his visual and creative abilities. Our notion of car design as properly an anonymous group effort—an accepted norm of car design by 1950—actually is a creation, and a largely original contribution, of Harley Earl, who dominated the American car-design scene during the thirties and forties.

Although the system Earl created eventually became the industry's standard, it

wasn't the only way cars were being designed during this time. Bob Gregorie developed another and opposite creative system at Ford, and his role will be reviewed after the introduction to Earl. The discussion of Earl will cover three areas: his personality and aesthetic interests; the process he evolved for generating creative ideas from his employees; and the system and structure of the design section at General Motors. While these areas seem distinct, they are fundamentally related: The studio system of anonymous stylists evolved from, and in many ways expressed, the strengths and weaknesses of Earl's personality.

The importance given to Earl's personality directly reflects the decentralized management philosophy of President Sloan, who by 1931 had established three independent entities inside the corporation: the Engineering Staff, the Research Laboratories, and Harley Earl's Art and Colour Section. Within his concept of "coordinated decentralization," Sloan made special allowances for the personality of a strong individual: "The role of personalities can be so important that sometimes it is necessary to build an organization, or rather perhaps a section of it, around one or more individuals rather than to fit individuals into the organization. . . . In order to tap the potentialities of a genius, it is necessary to build around him and tailor the organization to his temperament."[1] Through his gifted personality, Earl so thoroughly established the position of vice-president within the anonymous system of design that his successors, Bill Mitchell and Irv Rybicki, could institute their own priorities and aesthetics within the preexisting structure. The changes each of these men made within Earl's system will be examined at the end of the chapter.

HARLEY EARL

Although Harley Earl was known throughout the industry as a perceptive critic, his design contribution was limited to verbal themes. Those who knew him best remember his communicating ideas about visual form but almost never originating a visual form himself. We will see that the process he developed for extracting original shapes from others and the system he invented to structure that process stem from a lack of original visual ability on the one hand and a critical, synthetic, and administrative genius on the other.

One of Earl's closest aides attributes his way of dealing with employees to his frustration at not being able to express his ideas visually. In a frantic effort to communicate—and frequently in anger at not being understood—Earl relied upon expletives and sexual metaphors: "It was from his difficulty in communicating that he would try to get down to basics. In communicating with a person, how more basic could he get to try to get his thoughts across?" He invented words to represent the visual forms in his head, and, because of the communication barrier, once understood they became a permanent part of everyone's vo-

cabulary. "It was so hard to communicate with Earl, because he couldn't draw, that when he would call something a 'Blitz' line, all right, that became a Blitz line. If you said a Blitz line he knew what you were talking about." According to this well-informed insider, Earl issued typical instructions in a language unto itself: "I want that line to have a duflunky, to come across, have a little hook in it, and then do a little Rashoom or a Zong."

Bill Mitchell, who from his position as director of styling at GM replaced Earl in 1958 as vice-president, worked closely with him for more than twenty years, beginning in 1935. Mitchell emphasizes how Earl's inability to communicate visually explains his synthetic, or "director's," concept of design: "When he wanted something, it would be very difficult to work with him because he knew what he wanted and he couldn't draw it for you. And he would be so impatient with you if you didn't get it. . . . He had a chair like a director in a studio in Hollywood. He came from Hollywood. He would sit in that chair, and the way he would do it, he would sit and have all the people around him: . . . 'Now, move this back. Now do this!' And he would sit there and everyone would run around like a bunch of monkeys. That was the way cars were done when he was here."

Kenneth Coppock, chief designer for Chevrolet in the thirties, also links Earl's verbal orientation, critical abilities, and lack of original visual ideas to the operational methods and studio system Earl created at General Motors: "Earl wasn't a designer himself, but he was one of the finest critics of design that ever came along. He was a good one to figure out just what constituted a good design. . . . There aren't many of those. And, of course, he coordinated all the design studios. . . . Harley also liked to pick up an idea from one studio and take it into another studio and say, 'Why don't we try it this way?' . . . And, of course, it was something he'd just seen next door."[2] A former vice-president of styling at a major independent car company describes Earl's abilities in very much the same way—coupling his outstanding critical talents with his lack of creative visual skills: "He knew when it was right! That's the important thing. If you showed him ten drawings on the wall, he'd pick the best one, every time. He really would. He knew what he wanted. *He might not see it* [that is, he might not have been able to visualize it himself], *but when he saw it, he knew it.* And he had a tremendous feel for line." Along with his critical, but noncreative, ability was a sense of "direction." This former close employee points to him as "a classic example of a eunuch. A eunuch can tell you how to do it, but he can't do it himself. So, that was Harley." But, significantly, the "direction" was not precise. It was vague in its visual particulars: "He wasn't very articulate, really. He would try to express himself on the kind of things he wanted. He wanted a high or a low fender. He wanted a rubber-band type front end rather than a vertical front end. Those sort of things. He could get the *direction* across to you, what kind of direction he wanted to go in. But he wouldn't give it to you precisely because he couldn't. He just couldn't. I never saw Harley Earl sketch. I don't think anybody ever did."[3]

Earl, then, verbally presented visually generic ideas. As Strother MacMinn, a GM designer in these decades, puts it, "He would give an ambience of a theme, but he would not define the theme as far as hardware or proportion."

Earl did, however, have a preference for a certain type of visual design. He preferred large, softly rounded three-dimensional forms. Gene Garfinkle, who worked at GM in the fifties, offers some of the most perceptive insights into the visual side of Earl's personality: "Earl was like using a big hammer when you only needed a little tapping lever to knock something in place. He was a very strong, big man, and his sense of form had that—everything was like an over-stuffed couch. Mitchell tried to refine things more; he was after a slimmer look." This difference is a view Mitchell himself holds: "The difference between him and me, of course, was that he was a big man, 6′4″, and he thought big. In fact, when I took over his office, I had to lower all his seats because he *felt* big. So he liked rounded hoods [Figs. 7, 17, 88]. I never did. I liked sharper things [Figs. 94–96]."

Coupled with the very strong verbal themes he directorially laid down, Harley Earl's Hollywood background perhaps also expressed itself in his insistence on originality from others. He explained that as a nontraditional artist the car de-signer has to experiment: "In this he differs from those who are sometimes content with the traditional forms of beauty. He's a pioneer in aesthetics. . . . The Stylist is never content with what *is* or what *has been*—why he lives always in the future—dealing with what *will* be."[4] Harley Earl's famous cry was "Give us something new," and his desire for the "new," the novel design, accorded with the economic policy of GM's President Sloan. In the GM annual report of 1937, an entire section was devoted to "product evolution" and a frank discussion of the need for new forms: "it superimposes on the normal rate of depreciation the influence of a more rapid obsolescence. There is stimulated the desire to possess the new and more advanced products."[5] Unlike the understanding of evolution-ary change at General Motors in the eighties, the policy of the company in the thirties, forties, and fifties was always to be the leader in design. When Earl caught a staff member with pirated photos of a competitor's car, he furiously threw them out, as Mitchell recalls: "I don't give a damn what they are doing. *We* are leading the industry. *They* copy us!"

Evolution then, for Earl, implied continual change but constant leadership and originality.[6] Writing in 1941, Sloan observed not only that "today the appearance of a motor car is a most important factor in the selling end of the business—perhaps the most important single factor," but also that his Styling Section under the leadership of Earl made it the world leader: "We were able to develop such superior talent right here at home that . . . American cars advanced in styling prestige to the point that even in France, the style creator of the world, American cars became the smart thing to own."[7] Encouraged by management, Earl's desire to lead, to strike out in new directions, became a staple of his design philosophy. Dave Holls, a colleague of Earl's in the fifties, describes Earl's originality like

this: "I think because everyone else was tending to another way, Harley had a tendency to do what he called the 'cross up.' If everyone was doing higher accents, he would do a low accent. If everyone was wearing black tuxedos, he'd wear a white one. He just loved to do something entirely different from what everyone else was doing." Mitchell adds: "He was a master of making 180-degree turns, changes that would sort of shock you. Most of us didn't realize how serious he was—we couldn't do that jump at first."

There was a disadvantage to Earl's insistence on novelty, however. It produced a certain lack of continuity in the design process, which in turn led to what can only be called creative chaos. As we shall see, Earl's unpredictability undermined serious designers but reinforced his own position at the top.

There is a direct connection between Earl's personality and the way he designed, the "process" of his creativity. In order to generate forms, Earl depended on other people's ideas presented as flat scale outlines to make up for his lack of visual originality and drawing skills. Knowing Earl's inability to sketch, automobile historians often suggest that he created three-dimensionally in clay.[8] This common misunderstanding stems from Earl's early practice as a custom designer, when he used clay mock-ups *after* he had worked out his designs in two-dimensional elevations of the front, side, and rear. Indeed, this orthographic drafting technique became the basis for the way production cars were designed: The process was highly schematic and totally flat in its formative and creative stages (Fig. 9).

Bill Mitchell specifically links Earl's inability to draw with this orthographic design process: "Earl couldn't draw. He didn't want to draw. He came from the coachman days when you had side elevations" (Fig. 5). Mitchell confirms that Earl rejected clay as a source for creating form: "Modeling wasn't in its prime then. You'd make sections [cross-section drawings] every ten inches. And then the templates [Fig. 11] would fit them, and *then* you modeled. If he came in a studio and saw you modeling, and went over and didn't see it on the board, you'd get hell: 'Where is your drawing? How are you doing this without any reference?' . . . He wasn't interested in modeling. He wanted the drawing: side [Fig. 80], front [Fig. 81], and rear." Vincent Kaptur, Jr., head of the Body Development Studio and eventually executive in charge of engineering and development, worked closely with both Earl and Mitchell, and he corroborates the difference between their priorities and sequence of design: "With Earl, before you ever got into clay, you had to draw up the entire car: front view, side view, rear view. Only then would he say: 'That's it, let's go into clay.' If he saw in clay something he didn't like, he would not change the clay. He would go to the drawing and change it there first. He had to see it in the drawing—it had to look right on the drawing—before he changed it."[9]

Time and again, Earl's colleagues testify that he concentrated his efforts where he felt most comfortable, on two-dimensional design. Garfinkle says that Earl

"was more comfortable with reading in two dimensions, with reading drafting or lofting-type drawings, than three-dimensional or perspective sketches. . . . The sketches he didn't usually pay much attention to. It was what was up on the board that he looked at." As a result of this interest, he developed an unusual sensitivity to line variation and subtlety. Garfinkle describes a typical situation where "there would be guys drafting lines the width of a 2H pencil—tenths of a millimeter wide on a full-size drawing. . . . [Earl] might have been in a studio three nights before and asked if that fender line could be lowered a little bit. As soon as he had that [studio] door open, I mean you could hear his voice. . . . 'I thought I told you to lower that line!' He could see it from forty feet away—he knew exactly where that line was supposed to be. That was the sort of sensitivity he had."[10] The line-drawing board was where it all began and where the form took shape, as one of the most sensitive twentieth-century car designers, Frank Hershey, recalls: "It was all laid out on the blackboard first . . . that was what we started from. That is what we took the lines off and everything."[11]

Since he conceived car design two-dimensionally, it was only natural that Earl thought that the most important aspects of design were the front elevation and the outline on the side, perceived through highlight lines.[12] Thomas Hibbard, one of the prominent custom designers of the twenties and a principal designer at GM and Ford, "found that Harley Earl, our boss, attached great importance to the frontal aspect of a car . . . spending many hours looking over the work put into designing the 'FACE' of any new model."[13] Gordon Buehrig, designer of the famous 1936 Cord (Fig. 20) and before that an important figure at GM, describes a meeting with Earl on this subject: "He called the designers up [to his office] one day in 1933, and he said, 'The most important part of the design of an automobile is the grille, the face of it. That is the whole design, right there.' "

Similarly, Earl concentrated on linear aspects of the sides of the car, as expressed in highlight lines. Mitchell recalls Earl's preference for geometrically based lines on the sides: "They were to have nice soft lines, and we carried those highlights right straight through [Fig. 76]. There wasn't any dropping hood. He was very much for checking a highlight straight through—a long, straight through-line." Earl was obsessed with the angular precision of the highlight lines. "Highlights would have to be checked. He would have a bubble meter, and he checked them. Everything was geometric."

Thus, the process of designing, which became an industry-wide standard in the thirties and forties, was based on Earl's personal strengths and weaknesses. Before a car was visualized in three-dimensional models, it was completely developed graphically and blown up to full size in orthographic drawings. Similarly, the priorities Earl gave to front and side elevations stemmed from his interest in the two-dimensional presentation as opposed to the modeled form.

Like the two-dimensional design approach and the resulting visual priorities, the procedures, the actual design process at GM, were related to Earl's personal strengths and weaknesses. His skills as a critic and synthesizer dictated the type of

system that developed at GM. As we have seen, outside of setting general themes, Earl did not originate visual ideas, so he had to come up with a selection process that presented him options from which he could then synthesize. He seldom dealt directly with designers, but rather filtered his instructions through studio chiefs. This system played to his administrative strengths while eliminating the need for direct visual input on his part. Garfinkle recounts that, "Just like a Beaux-Arts class—everything went up against the wall. Normally, Earl did not come in during the day to select; he would come in during the evening. If the studio head wasn't there, Earl would leave instructions for which of the things he saw on the wall he'd like to see pursued. He would not talk to the designers directly, except in general terms; specifics always went through studio heads." Hershey reinforces this link between Earl's lack of design skills and originality and the system that evolved at GM: "Harley had a flair, but he depended on other people to give him ideas." A GM chief designer concurs: "I think he picked the direction out of what people were doing. I am sure of that. . . . He wasn't the designer, he didn't originate."[14]

As may well be imagined, this process was demoralizing for the more creative designers and for those who wished to see a complete concept through to the end. Visual ideas were generated from below, refined through intermediaries, and synthesized from above. Hibbard observes that "those who had the roughest time and were most liable not to 'make it' were, of course, the creative designers. . . . The designers were under Earl's scrutiny constantly and came and went through what amounted to a revolving door."[15] "Earl would change his mind from day to day, and that made it difficult for someone with a professional viewpoint to try to pursue a course of improvement and refinement," MacMinn explains.

Earl's intimidating personality made all the more pronounced the hierarchy in personnel and the distance between the creation of an idea and its eventual implementation. At times, his abusive manner paralyzed and demoralized the more sensitive and creative types. Irv Rybicki recalls that "people in GM design called him 'The Shadow' because he was so huge he cast a shadow over everything."[16] "All of us designers were afraid of him; at least I was," Buehrig confesses. "He just scared the hell out of you," a successful colleague explains, "because he was a very tall, very imposing sort of guy. He really reflected almost a godlike image. He carried himself very well, and he was a fastidious dresser. He used to wear a Panama hat when he came back from his month's vacation in Florida, and he would come through the studios and everybody would know— almost like a magnetic presence—that he was around, somewhere. There was a hotline: 'God, Harley's on the first floor, he's on the second floor, he's on the fourth floor, he's in the Buick studio, HE'S IN THE PONTIAC STUDIO!' He really kind of terrified people. He struck the fear of God into people, he really did. They respected him—with all that." A highly placed designer at GM also recollects that Earl "was very, very domineering. He was very quick-tempered

and sharp with his tongue. . . . He was a tyrant when he wasn't getting what he wanted."

This high-voltage approach took its toll on the artist and his expression, as Mitchell explains: "I would never go in to talk to him much. He was aloof. I was second in command, but I was second! So I said, 'You know, you don't realize it, but your size and your voice—you are powerful.' And I said, 'You just scare the hell out of these guys. They are no good to me. They are scared to do anything.' " This was a problem or, rather, a situation that Earl was aware of. He probably wished to preserve his total control, and yet he depended upon the creativity of others to make up for his own weaknesses. Hershey describes a scene in the thirties during which the conflicts in Earl's position were exposed: "One day Harley called us all up into his big office and said, 'Now, fellows, I know that I intimidate you. I know that I keep you from doing what you want to do. But we have to plan for the next big step in design. Now, we are going to have a whole new deal. I'm going to listen to you and consider your ideas. Now, Frank, you start.' I got up and said, 'Harley, I think we should do this and that and so on.' Suddenly Harley stiffened; then he said, 'That is exactly what I don't want to hear! Meeting's over!' And that was that. He got no further than me." By 1951, as demoralized artists revolved in and out of the GM studios at an alarming rate, GM hired the director of the Pratt Institute, Alexander Kostellow, to advise them "about the turnovers and the problems of exploiting their creative talent properly."[17]

Just as the strengths and weaknesses of Harley Earl shaped the design process, the system of creation he established at GM, so such links extended further to the very structure of the Styling Section. Until the fall of 1936, conditions in the Art and Colour Studio had been informal, with designs for all makes freely displayed in a central studio. Anticipating the move a year and a half later to the locked Styling Section studios, Earl broke up the space into a series of divisional studios separated by temporary walls, with absolute security between each. Central to the locked-studio system was a "body room," closed to all but the closest Earl advisors. According to Strother MacMinn, "In order to reinforce his directorial ability . . . he set up a committee, a hierarchy of people [called the Design Committee]. . . . Earl would send them around in his absence to review the design process, to give him their inputs on how problems could be solved. And the committee became a very formidable political power . . . they were made up of old-guard people, who had been around the business for a while, and that is perhaps why he trusted their judgment." From their position at the center, these men created the interchangeable parts shared by the divisional cars. Clay "base" models showing these parts were reproduced in every divisional studio, where a chief stylist added sheet metal and details that gave a distinctive identity to each car.

The door to every production studio was kept locked, and the only people with

keys were Earl, his secretaries, the Design Committee, and each studio chief. Two important and complementary objectives were achieved by the creation of these "key studios." With the introduction of partial steel bodies and widespread interchangeability in the 1935 models, Earl realized that, to maintain make identity among the separate car divisions, design secrecy would be important. Perhaps more to the point, by this restructuring he reinforced his synthetic power and control, reducing further the knowledge and impact of individual designers on the final product. Only Earl completely knew what was going on outside the individual studios, and therefore only he knew who contributed what to the end product. As Hibbard writes about his experiences at GM during the thirties, "No one was to get publicity in his department but Harley J. Earl. . . . With few exceptions, pains were taken to see that no individual except Earl received publicity outside the company or got credit for anything they contributed."[18]

If this design process alienated designers, the structure he imposed forced them to create in the way he wanted. Contacts were made through a chain of command that filtered down through each studio chief, or "key man." "The chief designer," MacMinn explains, ". . . is *the* designer in the studio at this point. And all the other people working in the studio . . . were merely extensions of the master's hand." As time went on, Earl further isolated himself, increasingly speaking with studio chiefs through a male secretary and permitting almost no direct contact with actual designers. A step was "never, never" skipped in this hierarchy, according to Hershey, and a top designer describes it "very much as a caste system. With Harley, all the designers would be standing around, and he would say, 'Ask him why he did that.' And the guy would be standing there! It was always the third party. . . . It was as if you did not exist. 'Ask why he put this line on the side of the car.' And I was standing there right next to him."

In this way—and in spite of his lack of creative visual skills—Earl achieved a design process and structured a system over which he had absolute control and sole knowledge. His position became virtually invincible because of his relationship with the management of GM, a relationship that ensured the successful production of his cars. Just as Earl intimidated designers by his presence, he controlled and swayed the Executive Committee. Power, charisma, and social contacts counted much more in selling his ideas than theory or even logic. Underlying all his relations with that committee were his bond with President Sloan and the agreements worked out with him in advance. Before the fall presentation, Earl would spend a month with Sloan on his yacht, going over designs to be proposed to the committee. Mitchell reports that, "in the summer, he'd go on a cruise with Sloan on his yacht down in the Atlantic. We'd make up books on the new ideas he'd sell him." Coppock tells a similar story: "I know that every year Harley Earl would go to Florida to meet with Sloan. But before he'd go down there, he'd collect a lot of sketches and drawings. . . . That's where a lot of the real product planning and development would take place." His close ties with Sloan almost assured acceptance for his proposals. A chief designer recalls

the presentation of the 1941 Cadillac Sixty Special, and this example is typical: "They had it out in the auditorium . . . and they had all the executives up there. They were hemming and hawing, and they didn't know whether they were going to take it or not. Now, this was the dirty work. Harley, I remember him standing around like this—a huge man—and he looked down on everybody. All these other guys were short. The Fisher brothers and all were short. He looked down on them, and finally he couldn't stand it any longer. He got red in the face and said, 'Gentlemen, what am I going to tell Mr. Sloan when he asks me?' They approved the car in ten minutes. . . . They knew he had Sloan's ear. He could talk Sloan into doing anything he wanted. How many guys spent a month or so on Sloan's yacht every year?"

The combination of intimidation and a sure power base guaranteed the acceptance of his designs.[19] A man at the very top of GM styling corroborates Earl's control and describes how it worked: "In styling, Earl was so powerful that nobody could touch him. And he had [Chairman Albert P.] Bradley and [President Harlow] Curtis in the palm of his hand. . . . I'd be in his office, and he had a switch. . . . And there'd be somebody, say it was ———, chief of ———, that was crossing him up. He'd push the button right to Sloan's office: 'Alfred, how are you today? Fine. Yes, yes. You know that fucking s.o.b., that cocksucker? He doesn't know shit! Would you fix his ass for me? Thanks, Alfred.' And then he would go into the meeting." Intimidation, rather than communication, was the norm, since Earl expressed his power straightforwardly; as a GM insider quips, "Harley did not speak English, he spoke swearwords."

Besides the backing he had from Sloan, Earl's own intimidating presence—his size, his polish, and, in a peculiar contradiction, his unbridled vulgarity—ensured his success with management. The theory of design, the visual concept, indeed any communicated idea, were unimportant compared with these qualities. Garfinkle recalls that "theory was frowned upon there. That wasn't a man's way of doing things. You didn't theorize about it. You just did it!"

Thus, by the design process he developed, Earl synthesized the creations of others; and by the administrative structure he invented, Earl discouraged dialogue and communication, garnering all power and knowledge for himself. In designing cars, moreover, Earl did not need the range of skills of other great American industrial designers of this period. While they shared with Earl his salesmanship and sense of taste, they acted as free-lance communicators and writers, promoting jobs by explaining their ideas in public. Earl was an in-house salesman who had only to convince his board of directors. These "patrons of the arts" were more convinced by contacts and intimidation, it seems, than by the virtues of design and theory or the power of reasoning.

Insiders' humor referred to Earl as "our father who art in Styling, Harley be thy name," and sure enough, Earl created the first large corporate styling department, and it multiplied.[20] The future leaders of automotive styling passed through the Earl studios, and they patterned their creative programs on the GM

system. Even President Sloan proudly recognized that "the sequence of sketches, full-scale drawings . . . which Mr. Earl and the Styling Section had pioneered, now became standard throughout the industry."[21] By the early fifties, the system at GM became one of the largest organizations of creative people working together in industry, totaling about 850, with more than 150 designers and creative technicians.

It is a peculiar irony that, although the Styling Section was the personal creation of one man, its aim was the anonymous, systematic creation of mass-produced products. Earl's intention, one may note, was contrary to that of the Bauhaus system, where the aim was to serve mass production while preserving the creative control of each individual artist. As we shall see when discussing the related arts, this other system, with a philosophy basically opposite to that which became standard in the automobile industry, was largely supported by other American industrial designers who achieved prominence during the same period of the thirties and forties.

When evaluating the important issue of the impact of Harley Earl and the system he created in the thirties and forties, practicing designers constantly question the quality of the designs, especially in comparison with cars from the "classic" period before the early thirties. I will try to show in Chapter 4 that this system, with Earl in charge, produced some of the finest objects of commercial art, ever. The quality of the product, however, has little to do with the intrinsic value of this system because the contemporary Ford system, as we shall see, produced cars of equal quality with opposite means. The real question is, could the system have produced at the same level without Earl?

Even for a subtle and individualistic designer like Hershey, the answer is clear: "Nobody could have put General Motors into the design business like Harley did because Harley had the guts, he had the size, he had the vision, he had the eyes, he had everything to do it with." An absolute system required an absolutely magnificent figure at the top. With this hierarchical structure and system of design in place, it required a man with vision, taste, and respect to avoid turning out bland corporate cars with an innocuous flavor on the one extreme, or serendipitous, trendy, and unsophisticated "follies" on the other. Earl left the industry with the notion of anonymous collective decision-making as a system, indeed as a necessity, if you talk to most industry leaders.

But he could not ensure that his tyrannical direction from above would survive forever. To work as it did under Earl, the system required a leader whose power within the institution was so great that his artistic license practically knew no limits. With complete artistic freedom, Earl could insist on design originality and industry leadership, demand turn-on-a-dime breakthroughs when the spirit moved him, and single-handedly control development up and down the line. After he left GM, the chaos Earl had generated in his design team diminished as each designer gained more responsibility to follow through on his projects. The fact is, however, that the very demoralization and

creative frustration Earl caused allowed him to fill in and compensate for his own weaknesses and to remain the ultimate artist, with only one person, in the end, controlling all the pieces. A director of design perceptively compares Earl's approach in the past with the way cars are designed at GM in the eighties. He gives full credit to Earl for creating the anonymous collective system and yet sees less of a need for a strong individual designer in a period when cars reflect a corporate design personality: "Harley Earl was suited to that era" of cars, he says. For today's cars, however, things are different: "You might sit back and say, 'Yes, but they don't look like one guy did them.' Well, who cares, if they are good. . . . We are putting our personality into them. *Our* personality means this collective place." The difference between "our" and "my" may seem, perhaps, small, but for Earl it implied a great deal more: "When I refer to myself," he said, "I am merely using a shortcut to talk about my team."[22] The difference is between a creative group responding to a collective will of the corporation and buying public instead of to an individual's personality. Earl's team—and the playing field, one might add—was an extension of himself, an anonymous reflection of one man, with all his strengths and weaknesses. In this new collective medium, he was the artist, and everyone else an apprentice.

"BOB" GREGORIE

After being hired by Edsel Ford in 1932, E. T. "Bob" Gregorie (Fig. 36) created a design studio different in almost every respect from the Styling Section at General Motors. Practically everything was different: the talents and personality of the top designer, his relation to the patron, the patron's knowledge of and interest in design, the process of design, and the administrative structure of the department. For almost fifteen years, ending in 1946, an opposite form of creativity prevailed at Ford.

In one sense, however, Gregorie and Earl were similar: Their will as individuals dominated, and they had almost unlimited control over the visual product. Although the structure of the departments and the system of designing were almost completely opposite at Ford and GM, the artistic setup at both manufacturers reflected the abilities and personality of the individual in charge. Gregorie was not trained as a car designer but came from naval architecture, a related field of commercial design. There he learned to express his ideas through drawing, and because of the normal relationship with clients in that field, he developed the skill to talk precisely about visual form. Indeed, because of his visual abilities, he delegated little authority and required a minimal support staff. As a consequence of his special abilities to combine artistic, mechanical, and verbal expertise, he developed an intimate and almost a one-on-one relationship with his sensitive

patron. It was not a question of selling or intimidating a policy committee but of working together with Edsel Ford toward a common goal.

Gregorie recognizes that his situation was unusual in Detroit, and he describes himself as a maverick among the "four or five of us who were directors of design for these various companies. . . . Outside the [Ford] company, I was a mystery. Most of them never heard of me. . . . I never associated with them particularly. I lived distantly from them. I lived on an island down the Detroit River. I purposely stayed away from them. I didn't belong to the golf clubs they belonged to, and that type of thing." As sensitive and gentle in his demeanor as he is subtle in his designs, Gregorie sees himself simply as a meat-and-potatoes man: "I am a private person. I just didn't care for that sort of thing. I am a boatman. I am a yachtsman. I didn't care for golf, and I didn't care to get mixed up with them particularly."

He attributes many of his abilities—and his attractiveness to Edsel—to his boating background. "He always liked the way I referred to the aft end of a car—like a boat" (Fig. 51), and like Edsel, Gregorie considered his interests in the two machines to run parallel: "Designing boats gives you a great feeling of proportion and a sense for a beautiful line. . . . I can look at a line and tell whether it is fair or should be tucked in here or tucked in there. That is one thing that appealed to Mr. Ford. I could dissect conversationally the design of a car while he stood there and looked at it. That appealed to Mr. Ford greatly. He was a great art connoisseur . . . and he liked the way I conversationally could design a car or criticize what was wrong with it."

This set of abilities, so opposite to Earl's, fostered a completely different creative system, with a different structure and a different relationship between designer and patron. "We just had a small setup compared to General Motors. We had, most of the time, fifty or sixty. They had hundreds. They had departments—'studios,' they called them—a Pontiac studio and a Cadillac studio, and so on. Then they had a head boss man there, and he had his underlings. . . . I was in charge of all of Ford design: buses, trucks, tractors, everything. Ours was set up in one big room. We didn't have any straw bosses or secondary designers or such. I would do a lot of the pencil work myself."

Convincing management was almost as simple and direct as designing itself. Since Edsel had such confidence in Gregorie's visual skills, Gregorie's task was less to sell a design than to come to a mutual understanding: "We worked like a country store. You'd be surprised at the decisions that were made just sitting at the end of a drafting board. Mr. Ford and I would decide on this hood ornament or that hood ornament. There were no committees, nothing of that nature at all." There was no interference from above because "the elder Mr. Ford took virtually no interest in designing or styling, leaving this phase of operations to Mr. Edsel Ford and myself."[23]

Gregorie's approach to his department suited the unique company philosophy of Henry Ford. Ford proclaimed that his business had no formal organization, and he ridiculed Alfred Sloan for emphasizing administrative structures and organizational charts at GM. Internal boundaries remained nebulous as Henry encouraged a kind of creative fluidity: "To my mind there is no bent of mind more dangerous than . . . the 'genius for organization.' This usually results in the birth of a great big chart showing, after the fashion of a family tree, how authority ramifies. The tree is heavy with nice round berries, each of which bears the name of a man or an office. Every man has a title and certain duties which are strictly limited by the circumference of his berry. . . . And so the Ford factories and enterprises have no organization, no specific duties attaching to any position, no line of succession or of authority, very few titles, and no conferences."[24]

Indeed, the bureaucracy at Ford was so slimmed down that creating and selling the design product became at times indistinguishable: "[Edsel and I] had a very good appreciation for each other's thoughts, as far as automobile design was concerned. He had always handled the design for the company. He was not a designer, but he had a sense of what looked right. . . . He was an excellent critic, and he had an immediate sense of when something looked right. . . . We managed to arrive at some very, very workable decisions with a minimum of meetings and conferences and a lot of lost motion."

The personality of the designer, the process of designing, and the relationship with the client created an artistic environment almost like that of an enlightened Renaissance court. The aim was a direct and mutual striving for artistic excellence, and it was attained with an organizational structure opposite to the industry norm. It used to irk the higher-ups in the company that Gregorie had a direct pipeline to Mr. Ford and that the designer could talk to the president in a different way than they could: "I was involved in a subject matter which he personally loved." Gregorie is convinced that the one-on-one relationship he had with Edsel Ford "probably accounts for some of the cleaner, simpler, straightforward styling we were able to accomplish" (Fig. 43).[25] More important, Gregorie was allowed to express himself as an artist. A collector of Titian and Perugino paintings and a patron of Rivera, Edsel believed that the car should be a work of art representing the best efforts of the individual designer: "I had every chance to express myself. . . . Mr. Ford respected imagination and talent, and such respect was rare, I can tell you, in the old automobile companies."[26]

From 1932 until 1946, with a lapse of six months in 1943, Gregorie's influence and his approach to styling were as pervasive at Ford as Earl's were at GM. It was Earl's system, however, that prevailed as the industry standard, and the unique generation at Ford that nurtured a powerful creative artist and a sympathetic patron came to an end. With Edsel's death in 1943, Henry II assumed control, and in 1946, the Styling Department was modified by Ernie Breech, a former GM executive and president of Bendix Corporation, who convinced Henry II to pattern the Ford Company along the organizational lines of General Motors.[27]

Rather than conform to the General Motors system, Gregorie chose retirement and returned to designing boats.

BILL MITCHELL

Throughout his twenty-year vice-presidency, Bill Mitchell (Fig. 3) dedicated himself to improving the profession Earl had founded. "[Earl] built a team that I took over and [I] built better," Mitchell says, and a close associate of both vice-presidents confirms his commitment: "I've heard Mitchell say many, many times that he had a very deep, profound feeling that Earl had established a profession—that he had created the professional automobile designer. Because Mitchell did not have much trust and faith in his competition at Ford and Chrysler and elsewhere, he felt it was his job, it was solely on his back, to carry forth what Earl had started in creating this professional automobile designer. And he used to say it many times, 'Earl has given me a challenge and I can't go back on it.'"

Mitchell interpreted his professional obligation as a mandate to create original, tasteful designs in the GM tradition. "I always kept Harley Earl's painting in back of me and thought, 'I'll never let you down.' It was Earl's home and he fought for good design."[28] To this day, General Motors employees point to their company's products as distinctive in this regard, as one top designer explains: "There were times when Mitchell might have problems with one of the general managers, even a president. They didn't like something. They might say, 'Why don't you do something more like what Ford is doing?' Oh, that would curl the hair on his neck. He felt that was an insult to the automobile designer to be copying." Like Earl, Mitchell understood that the professional designer's job was to promote novelty, governed by what he took to be refinement. Indeed, Mitchell had a common expression, "No matter what you do new and different, it always has to be in good taste." Someone once responded, "Well, what the hell is good taste?" And he reportedly said, "Picture two guys dressed up in a tuxedo, who are going to a nice, formal party—a very elegant affair. They both are in black tie. One fellow, he has got a dash of red in the kerchief in his pocket, and maybe a little dash of red showing out from under his sleeves. The other is standing there with his fly open and his cock hanging out! One is crude and the other is elegant." The professional automobile designer as original, tasteful, and macho car lover survived in the person of Bill Mitchell.

Mitchell applied many of Earl's organizational principles to the design of cars. Among these a certain artistic detachment was necessary: "[Earl] taught me to come in alone," he explains, and like his predecessor, Mitchell wandered the studios by himself on weekends and evenings. In response, designers continued another tradition—propping up designs they particularly wanted the boss to see. Flamboyant and domineering like Earl, Mitchell also emphasized the chain of

command and maintained the anonymous design system that isolated groups of workers. He believed in hierarchy, and he consciously distanced himself from employees, as Gene Garfinkle recalls: "He was a very gregarious kind of guy. But in the studio, for some reason, he kept himself very insulated."

Mitchell also preserved the sequence of design that Earl had established. Although, as we shall see, Mitchell deemphasized orthographics and stressed modeling, he started designs with the traditional two-dimensional sequence: Clay modeling only came after theme sketching and orthographics.

For all the similarities between the two men, Mitchell's distinctive personality inspired important changes in the method and the organization of design at General Motors. Mitchell was a skilled draftsman and painter (Figs. 26, 28), who loved to design himself. Even today, he paints in his own studio, and his feeling for creativity distinguishes Mitchell from Earl, as Garfinkle explains: "[Mitchell] was of the more flamboyant, gee-whiz school of design, but I think he had a genuine appreciation of the forms and the kinds of feelings and shapes that were being generated by some of the people he had under him. And he gave them much more of a chance to exercise that [freedom] than Earl did." A well-known designer similarly recalls Mitchell's respect for creativity: "There were times, if there was something he wasn't really with, but if somebody was pushing him in a certain direction, he might stay out of that room for a while and wait to be invited in, to give the guy a chance. He gave the guys a chance to show their stuff and do their thing."

Earl knew in his mind what he wanted, but he had difficulty expressing it. As one top designer remembers, Earl had "communications difficulties" that forced designers "to dig out ideas from his head." By contrast, Mitchell gave freer rein. As a practicing designer, he appreciated independence, and in his central administrative role, he recognized that artistic freedom for designers produced more options for him. One insider explains: "Mitchell's philosophy of operation was different from Earl's—just like day and night. To put it as simply as I know how: In the Earl philosophy, people were just pencils in his hands. 'Do what I tell you,' with all the communications problems: 'Don't you understand what I want? Use this sweep!' Whereas with Mitchell it was: 'I want to see what you can do.' And he never criticized anyone for doing something. If it ended up god-awful, he might be critical about wasting time, and how you let a dumb-assed thing like that get this far. But he generally unreined the horses and let people do their thing." Stanley Parker, chief designer of Buick, Cadillac, and Oldsmobile under Mitchell, agrees that "Mitchell was kind of inspiring because he wanted you to go all out." Mitchell generated creativity with "all kinds of phrases. Oh, he'd kick and scream and holler." But designers did not feel put down or "live in terror," as under Earl, because "there was a little bit of humor in the thing. He was giving a frank opinion." Parker explains that Mitchell encouraged "flair and more excitement. You could not get enough for him. Not that Earl was conservative at all. Even in the period when [Mitchell] wanted to have a renaissance of design,

going back and trying to get the Rolls-Royce look of the twenties and thirties into a contemporary way of thinking, he was always trying to generate newness."

Mitchell's understanding of the creative process also led to easier communication and less confrontation. "Decisions were almost an automatic process," Vincent Kaptur, Jr., recalls: "As things developed and everyone was doing their job, he had his finger on every aspect. And he was constantly in conferences with me from an engineering standpoint, as he was with the designers. And things sort of floated out. I think Mitchell, in contrast to Earl, tried to avoid that direct, mad confrontation. When Earl walked in the door, everyone would say, 'Oh, Jesus Christ,' and they were ready for all hell and brimstone to come down on you. But, with Mitchell, it wasn't that way. I am sure there were outbursts under Mitchell, but I can't recall any."

Mitchell's inclination to give designers freedom and then to pick their best work coincided with the changing production requirements at General Motors. In the late fifties and early sixties, models proliferated: Only five years after Mitchell took over, the Chevrolet studio alone designed as many cars in a year as the entire GM Tech Center created annually under Earl. Mitchell relieved the logjam by delegating as much work as possible to the various studios. Relying on his artists to come up with ideas, rather than forcing them to work on designated concepts, he satisfied, if only vicariously, his own artistic temperament while solving the new needs of the company.

Mitchell's creative personality and the new corporate work load led to new and faster design methods, which he instituted right away. Wanting to see more alternatives, Mitchell arranged a speedier turnover at the initial sketch stage by deemphasizing blackboard drawings and renderings—traditionally done with colored pencils, tempera, and washes—and by promoting "tape drawings," as they came to be known, which were taped silhouettes of proposed automobiles. In this system of rapidly projected ideas, after a technical designer put up the "control points" of a car package on a large sheet of paper, the stylist would block out the basic car with one-half-inch black tape. As tape drawing increasingly dominated the traditional "theme" stage of GM design, artists became very clever with the new technique. They created shadows and even a little highlighting with the tape, and Mitchell organized their efforts into what he called "tape shows." Lining the perimeter of the auditorium with twenty-five to thirty tape drawings, Mitchell would judge them with his chief designers. One of these men recalls the gist of Mitchell's pronouncements: "Yeah, that one looks pretty good, and that one ain't worth a damn."

Besides aiding the rapid turnover of alternative ideas, the taped silhouette served a number of new purposes in keeping with Mitchell's artistic personality. It allowed him to enter the design process immediately and directly, as one designer recounts: "Well, [with the tape] Mitchell could come in, and he'd zip-zip the tape off and try it another way." Although Mitchell continued the three-step Earl design sequence—from sketch to orthographic to clay—he changed the

priorities to suit himself. He quickly went from tape drawings to the three-dimensional medium, with little thought given to orthographics. As a practicing artist, Mitchell could directly attack a clay model in a way that he could not do with a technical orthographic drawing, and that is why many designers remark that Mitchell just had to see it in clay: "He would work right with the clay. He'd be right there, Johnny-on-the-spot," one top designer recalls. Mitchell himself recognizes that his aesthetic outlook required new priorities and new procedures: "A lot of my show cars you couldn't draw—you had to model them. . . . I believed in modeling and he [Earl] didn't."

Under the previous system, any change in the clay model had to be initiated through orthographic section drawings, and these Earl approved before they could be sent to the wood shop to make clay templates. Mitchell's hands-on approach to clay, with little emphasis on orthographics, reversed Earl's priorities. Because Mitchell looked for different qualities in his designs, he was drawn to tapes and clay models rather than technical outlines. "He would never look at the hard line drawing. It didn't require his approval, as it did with Earl," a knowledgeable body-room expert recalls. "Even with the two-dimensional [orthographic] drawing, I don't think he could really read the drawings. He could see a few basic lines that he would like. He'd like the roof profile. He'd like the deck profile and the body side sweep profile and the hood line—those are what he was generally after." Mitchell spoke so often of cars that were "simple but not simple like Simon" that his successor, Irv Rybicki, adopted the expression as his own. One chief designer refers to his "cartoon-artist sensibility," suggesting that beyond the silhouette Mitchell had little interest in fine surface modeling. In Bill Porter's opinion, Mitchell's attraction to powerful but simple shapes (Fig. 95) was related to the visceral mood he was after in design: "He just came in and either liked it or didn't like it. The car has a mood that he either liked or didn't. . . . He was more concerned with whether or not he liked the overall style impact of a design and tended to focus on certain immediately recognizable features." Stanley Parker gives a specific example of how Mitchell based his gut reactions on large, definite shapes: "One time, when I was chief designer of Cadillac, we had a scale model, and he looked at it and said, 'Parker, that looks like a fucking bull dog: all head and no ass.' So, you kind of got a whole lot of what he thought of your design. If he liked it, he really liked it." An immediate and definite judgment is what everyone came to expect, as Gene Garfinkle explains: "If you showed him something, he'd look at it and say, 'That's great,' or 'That's crap,' or whatever. You know, it was always very direct."

Mitchell's changed priorities in design paralleled and may have affected a different appearance in his cars. Excited by the silhouetted shape in a tape drawing and by the outline of a roof, deck, or hood in an orthographic drawing, Mitchell preferred the definite profile of a "razor-sharp" car, to use his own words. Indeed, he argues that he promoted the "sheer look" throughout his career. By comparing an automobile he drew in 1935 (Fig. 26) to a Cadillac

designed when he was vice-president, he outlines this point: "Now, here is a car, one of the last ones I did: a 1967 Eldorado chassis [Fig. 98]. This is a vee'd [V-shaped] windshield, flush glass, and those lines are very similar to the earlier lines. [I prefer] flowing lines, with a narrow nose. I don't like dumpy, boxy things. Long hoods. And this, the last Cadillac I did, has got the same look. And it showed that I hadn't changed my thinking the whole time I was there."

While Mitchell's personality permeated GM aesthetics and design practice, his artistic outlook colored the very structure of operations. Seeking varied and rapidly changing ideas, Mitchell *reversed* the direction of the creative process at General Motors. Specifically, he reversed the position of the body room in relation to the production studios. Before, under Earl, the vice-president spent most of his time in the body room overseeing designers who assembled the basic interchangeable package. Conceived in orthographic drawings and sculpted in what were called "master models," these interchangeable parts frequently included the roof, doors, deck lid, and even the quarter-panels. These interchangeable clay bodies would then be re-created in each divisional studio, where a chief designer contributed distinctive front-end sheet metal, bumpers, wheel openings, moldings, and so on.

In the body room, Earl assembled an experienced group of designers (the "Design Committee"), whom he informally called his "firemen." Veteran designers like Julio Andrade and Tom Hibbard, together with expert engineers and interior specialists, put together the master models. Running interference for them would be thick-skinned communications experts like Vincent Kaptur, Sr., Bill Block, and Carl Pebbles, who could understand and interpret Earl's language. The body room created the "anatomy" of the car (to use an Earl metaphor), leaving the production-studio designers to attach the finishing touches. "You designers are nothing but a bunch of dressmakers," Earl was fond of saying.

When Mitchell inherited the vice-presidency, he retained the responsibility and function of the body room to assemble interchangeable master models, but, as in the case of design methods, he significantly changed the priorities and sequence of the operation. Emphasizing diversity, he removed all designers from the centralized body room and relied solely on the studios as his source for design. Mitchell no longer needed the body room to initiate designs; instead he used it as an assembling center, to receive and coordinate the separate designs from the production studios.

Reversing the previous direction of activity, the body-room staff spread throughout the studios to monitor the various designs and then returned to the central room to establish interchangeability. In the process the body room functioned as a political boiler room where its staff suggested compromises the divisional studios could live with. While the studio chiefs haggled over details like hinging, glass drops, door locks, and door construction, as well as major exterior sheet-metal design, the body-room staff refereed, proposing that one

studio "wiggle" a surface line one thirty-second of an inch to correspond to a similar line on another division's car. A highly knowledgeable body-room expert suggests a typical conversation: "Hey, Chevy, if you do this, Pontiac you do this, and Olds you do this, we get a common line." In the meeting of the minds in the body room, Mitchell was still the ultimate judge. "All of the comparison drawings would be up for each division's cars, and frequently the question would be, 'What should we do, Bill?' "

With the role of the body room reversed, Mitchell "became adamant about where he wanted design to emanate." According to an insider, he sought to get his "money's worth" out of his designers: "You are not dressmakers," he muttered many times, contradicting the famous Earl adage. Under Mitchell the image of car designers improved to reflect their increased impact. For the first time, staff designers sensed that they were directly involved in the important goals of designing, and independent artists like Gene Garfinkle felt especially the effects of the reorganization: "Before [under Earl] . . . they would just come in with a body package—without any front, back end, doors, fenders, or anything. And then they would say, 'Stan, why don't you take the front end?' and 'Hank, why don't you do some sketches, maybe tying them all together?' " When Mitchell took over, things changed: "They were just starting to get together, talking over objectives and trying to get a sense of direction in the studio before anyone actually committed something to paper—so that we knew what kind of areas we should be working towards, what kind of shape goals we were after, and what kind of character we wanted to see in a car."

Over a short period of time, Mitchell "promoted" to nonproduction studios most of the chief designers who were used to the previous system, and he replaced them with younger people. The directorate of GM design in the eighties, Irv Rybicki, Chuck Jordan, and Dave Holls, were among the new set of chief designers who appreciated the looser structure of design and shared Mitchell's philosophy of cooperation and nonconfrontation. While Earl tended to play one designer against the other, Mitchell emphasized dependence and cooperation to get the task done.

With this new orientation came a new organizational structure. Once again, Mitchell preserved the outline of the Earl system—especially the underlying locked-door, separate studio philosophy—but he added parts to allow for greater continuity of design and cooperation. Mitchell created a new chain of command to churn up ideas and to encourage their unbroken development from bottom to top. Thus, while the studios remained separate, a new authority was erected above them: Chevrolet and Pontiac were organized into one studio group and Olds-Buick-Cadillac into another, each with its own supervisor. In turn, these two men reported to the single senior executive designer, who was responsible only to Mitchell. If themes were not established and carried out, the man at each stage of the chain was accountable, as one top designer explains: "That was his

job. If they got off the track, he got his ass kicked. It wasn't the individual studio [who was punished]."

To foster the continuity of design from theme sketch to production car, Mitchell introduced advanced studios as a normal part of operations: "When I became in charge, I made sure we had studios that worked years ahead so that you could look at something a while and if it wasn't any good not build it." Earl normally generated advanced designs through the centralized, production-oriented body room or through confrontational games (known as studio "competitions"), with no specific goal in mind. Thinking about the future, Mitchell reversed the focus: Typically, he promoted diversity on the one hand and continuity on the other. Each production studio was assigned a smaller adjacent studio, where the advanced designers created the next generation of cars while the production-studio staff finished the current model under development. According to a top professional, the advanced designer looked over the shoulder of his production colleague and could say, "Hey, you are losing the whole general theme that we established." Although the advanced designer was not directly involved with commercial products, through this new system of unbroken design he could see his creation develop into a production release.

As a practicing artist, Mitchell fundamentally transformed the design profession he inherited from Earl. He encouraged independence in his designers and continuity in their ideas, reserving for himself, however, the choicest plums. It should never be forgotten that the artistic force that provoked major changes in the work of others drove the man himself. Mitchell had his own secret advanced-design studio, his "basement," where he invited few visitors. In this sanctum he did his own work, trying to style favorite cars and establish design themes. Dave Holls tells a story that gets to the creative core of the man: "One time, I said, 'I got something new on the Corvette to show you.' And he said, 'Aw, kid, don't fool around. One thing I got to tell you. Don't flatter yourself. I am the one who does the Corvettes around here.' " Mitchell left the outlines of the anonymous structure and sequence Earl established, but he had a feeling for the action of design and understood the role of the individual designer. His new spirit blew through the old Harley Earl system and changed the aesthetics, methods, and organization of General Motors design forever.

IRV RYBICKI

GM Vice-President Irv Rybicki preserves Earl's system of design as it had been handed down by Mitchell, but he exerts less artistic presence and control. Rybicki maintains the traditional studio system and the design sequence Earl originated. He insists that three-dimensional projects originate as sketches and

be transferred to orthographics before being considered as models, and, like Earl, Rybicki leads by word pictures, never by visual suggestions.

Despite these similarities with the previous approach, Rybicki refocuses the system to downplay his own role and that of his designers. Before, Earl maintained a personal design interest and a strong visual philosophy, and while he deprived designers of much contact with their own creations he subjected them to his own erratic and imperious desires. Mitchell decentralized the design process and reversed the origin of design ideas, but he continued to exert his own aesthetic viewpoint and encouraged novel and very personal expression on the part of his designers.

Rybicki takes a hands-off attitude because he believes that the emotional statement of a car should reflect the consumers' wishes as determined by polls and media clinics. Variety is a goal, but only insofar as it reflects the unique personality of GM products, the individual character of each car division, and the specific desires of the buying public. Rybicki maintains Earl's system of locked studios and word pictures, then, not to foster individual artistic expression or even to impose his own design philosophy but to achieve internal diversity for the corporation.

For Rybicki, the good of the company excludes individual expression. He disdains individual creation as a romantic idea, seeking to make each artist feel part of a team. "Rather than isolating a designer at his desk, with his own thoughts trying to find the solution, [I found that] if you could get the creative team to communicate with each other we got down the road a hell of a lot faster." Earl used the individual in the anonymous GM system to compensate for his own lack of design skills, but Rybicki has added a new wrinkle to the system by extending anonymity to himself. When he was asked to point out the car of which he is most proud, Rybicki replied, "The one *we* are going to do next." Pressed about "the one that *you* did," the vice-president of design insisted on his anonymity: "The one that I did? I don't think I ever did a car in total for General Motors. It is very rare that we have had a designer put up a sketch, and then that we have used that total sketch. . . . I can't pinpoint an automobile for you that I'd say Irv had a lot of influence on."

Instead of projecting his own artistic personality through Earl's anonymous system, Rybicki stakes out a receptive—which is not quite to say, passive—design position. Rather than inject his artistic persona into the system or unleash talented artists to pursue holistic concepts on their own, he hopes to reap the benefits of variety by isolating teams of designers and controlling them centrally. Asked if he leads with his own design ideas, Rybicki replies, "I am not about to do that [because] in the end, they [GM cars] are all going to start looking alike. They will start looking like Irv cars" (Fig. 115). Instead, he locks the studio doors to ensure that groups of designers work by themselves: "All I'll take to them is a word picture. . . . You'd be surprised how effective that is, because it is *not mine*. They listen to my words. Each designer interprets those words differently." Although this may sound as if he were offering a chance for individuals to roam

freely or settle in on their own, individual creativity—in the sense of the pursuit of an artist's vision—is less of a goal than it was before. Instead, by isolating teams and fostering their independence, Rybicki hopes to develop separate characters for his cars: "If I let the chiefs and their teams run, we have a better chance for diversification, for creating divisional personalities."

Revealing his strengths as a designer, Rybicki has no trouble detailing organizational changes he has made or mechanical and technical innovations he has implemented. When he took over, Rybicki introduced a new centralized structure that was hardly encouraging to free-lancing individuals in pursuit of their own ideals: "One of the first things I did was to reorganize the design team. I put all the design under Charlie [Chuck Jordan, design director]. Then we took the divisional studios and put them under one man. Then we took all of advanced design and put it under one fella. So we had complete control of the entire team." He created an integrated vertical hierarchy, accessible at the top only through Chuck Jordan, a believer in the virtues of anonymous corporate design personality.

When asked to talk about his own visual contributions, Rybicki avoids speaking about his originality and aesthetic accomplishments. He enumerates some isolated technical "firsts," like the complicated S-shaped glass on the 1982 Camaro, but charts his design position in the past, between the rounded forms of Earl and the creased London-tailoring of Mitchell: "I think the path we are trying to travel takes us somewhere between those two men." He hesitates putting into words what he is doing artistically. Evaluating his own creations, he moves beyond vague adjectives like "slippery," "exciting," and "fluid" to suggestive metaphors of beautiful women and racehorses. When pressed to describe a design, for example, he depicts the Firebird this way: "It isn't round or fat. It is a slippery-looking car. It is more of a racehorse than a hippopotamus." CEA: "Can I get you to talk a bit more about what you mean by 'slippery'?" RYBICKI: "Slippery? Yeah. A racehorse is slippery looking, but a hippopotamus isn't. A racehorse can run pretty fast, but a hippopotamus can't. That is what I mean by slippery." When he was asked about the specific qualities of originality and distinction in the Fiero, he pointed generally to "the form. It is an entirely different form." Realizing that he was making little headway with his characterization, Rybicki answered the question differently, although even more broadly: "It is an emotional experience, so it is very difficult to verbalize."

Of one thing, however, Rybicki is sure: The sought-for emotional experience must not convey an artist's feelings or relate in any way to his own individuality. The only proper emotions for a car to "express" are projections of the customer's response as determined by consumer research. Typical of Rybicki's approach, even the mysterious, emotional side of artistic creation has a functional and deterministic overtone: "I can't tell you from A to Z why I like a Fiero, other than to say that its form is exciting. I couldn't say why, out of the five girls walking down here, that one appeals to me. There is some magic there that triggers some sort of chemistry, so that my eye is drawn to that particular one. I

think that it is the same thing in this business. It is an emotional experience. We are totally and completely involved with these things emotionally out there. That is what we are trying to do: reach the consumer's emotions." In Rybicki's mind, the top designer must shed himself of "ego involvement" or personal expression in order to link the personality of the corporation and its products with the will of the consumer. The consensus of the buying public, not the will of an inspired artist, should determine the appearance of a product: "What we are doing out there in those studios is slanted totally at the consumer, not at me. We are trying to understand what he is buying and what he may buy down the road, and we aim the vehicle at that market, in that direction. . . . We have a marketing group that is out there working with the consumer. We get feedback from its clinics and studies, and we use that information when we start a new program. That is how we know." Rybicki is not, then, designing for his own artistic satisfaction. If he did, "When I got through, nobody would like it but Irv. . . . If I went through those [studio] rooms and had them do exactly what I wanted . . . hell, the whole thing might come to a halt. Our market share might slip to 20 percent. I can't do that. I am looking for variety. I am looking for individual divisional personality, [at the same time] with a blanket GM kind of a look."

Thus, under Irv Rybicki, the skin and bones of the anonymous and hierarchic Harley Earl system—with locked studios, a sequence of two- and three-dimensional designs, and leadership through the spoken word—have largely survived. But the heart and soul of the system—the priority of new shapes, the insistence on strong artistic leadership, and, especially, the presence of a powerful design personality projecting himself through forms—have almost disappeared. Bill Mitchell, the only other GM vice-president of design besides Earl and Rybicki, is well aware of their loss. Mitchell sees Rybicki as a kind of sounding board of consumer research, incapable of conceiving new aesthetic ideas or pushing them through: "You know, [Walt Disney] showed me that customer research is crap. And I told that to young Ford at a dinner one night. I said, 'If you have an idea, push it through! . . .' You have to be motivated." Mitchell extends his argument to commercial artists in many other fields: "Frank Lloyd Wright never went around ringing doorbells to ask what sort of buildings people preferred. You can find out where you've been that way, but not where you should go. . . . You have to believe in yourself and go out there. Do you think the fashion designers go up and down the Champs-Elysées asking the women what kind of dress they want? Why never! You tell them what they want, they don't know what they want. A style should set a style."[29]

Old-timers echo this criticism of Rybicki as an artistic leader. For them, designing means having faith in your taste. Their assurance stems from artistic pride and from the belief that great designers create markets, not the other way around. They developed this confident outlook in the Depression by struggling to be self-made men and by working to the top from fields as diverse as fashion illustration and custom-car designing. As successful loners and outsiders, they

represent a different breed from the eighties' generation of GM leaders—Rybicki, Jordan, and Holls—who climbed the internal bureaucracy of the Tech Center during the postwar boom. Unlike these men, once the former greats became successful, their artistic backbone was reinforced by public prestige. Men like George Walker and Raymond Loewy basked in the limelight from the thirties to the fifties as they festooned the cover of *Time* magazine, led the life of jet-setters, and designed cars with the certainty and abandon of demigods. Unquestionably, their attitude reflected the confident mood of the times. Especially right after the war, the lack of foreign competition and federal regulations favored the risk-taking enjoyed by these men and made every new design less a costly gamble than an artistic ramble.

Whatever the reasons for their success, many of the legendary figures like Earl, Loewy, and Walker were known not so much for their design ability as for their sense of taste and marketing talents. The inherent salesmanship and taste of these early leaders, coupled with their worldly achievements, somehow gave them an artistic security absent in younger, corporate-trained leaders. The Old Guard stood by their artistic guns and personally controlled the direction of style, as a postwar vice-president of design at Ford tartly explains: "Whose market was it? It was *my* market!" Recently, by contrast, Gordon Buehrig sees designing bogged down by consumer surveys and artistic committees, resulting in familiar but mediocre styles. For him, as for so many distinguished older designers, real profit comes only when the individual is allowed to stake his artistic claim: "[Today] they look at it strictly from the standpoint of economics. And they can be misled in their economics. They'll have market surveys and any number of committee meetings, and committee the thing to death. You run the thing through this mill, and you eventually come out with something that's pretty mediocre because everybody has to agree to it. In the old days people used to decide things on a gut reaction, and they don't do that anymore. I'm not a great believer in teamwork; I think the designer who conceived the car should be able to carry it through pretty much by himself."[30]

The car-design profession has changed profoundly from the days of its volatile founder, Harley Earl, who could not draw, to Irv Rybicki, a diplomatic and highly skilled artist. As a transitional leader, Bill Mitchell kept the flamboyant and perhaps somewhat superficial design approach of Earl, while bringing something new: his own inventive instincts and a respect for individual creativity and continuity in design. The system under Rybicki, Jordan, and Holls preserves the old, anonymous structure attuned to the deficits in Earl's personality while compensating little for the loss of the driving force in his makeup. Great designers from the previous generation almost to a man agree that the powerful presence, assertive risk-taking, and insistent novelty exemplified by Earl's personality have disappeared—and with them the individual leadership that produces cars with identity.

3
Car Design Theory
Commercial Arts after the Second World War

*Are you one of the die hards who insist that pink
is feminine? Well then, there's something
distinctly feminine about most automobiles.*
—Motor Trend, *September 1955*

After the Second World War, most Americans approached life positively from a position of strength. They had saved, they wanted to buy, and they wished to express their individuality through cars, clothes, and other commercially available designs. During this period, also, museums began to exhibit industrial design as a legitimate form of art and, simultaneously, to reject the American car as unsuitable. Since cars were part of the resurgence of commercial arts after the war and since the automobile was an important subject of discourse among art critics at the time, car design will be discussed together with art theory and commercial design. The larger context helps to explain the eighties' generation of car designers, who trained in that postwar milieu and formulated artistic ideas in reaction to the designs and theories of the period.

In the late forties, when car designers thought about the meaning of their designs, they strived to express glamour, power, and freedom—impossible design objectives during the war, when speed was limited to thirty-five miles per hour and gas was rationed to two gallons per week. As the conflict drew to a close and designers put the finishing touches on postwar products, the press encouraged fantasies of "a period of postwar promise."[1] Ideas for postwar products ran rampant across the editorial and advertising pages of the nation, and trade journalists recognized a "phenomenon known as *pie in the sky*."[2] Men like

Bill Mitchell hoped to give visual form to such desires in their car designs: "We wanted the car to feel like that—powerful and speedy. And we wanted the instrument panel and everything to portray that. . . . You wanted to make a car look as big and as powerful and as glamorous [as possible]."[3] During the war, designers had worked up massive front-end treatments for the egg-shaped monocoque type (Figs. 34, 65), and these found their way into postwar designs like the Mercury (Fig. 50). Bob Gregorie, the designer of the Mercury, recalls his own attempt "to get into a little more bold concepts" by making the car feel "big and massive," "looking powerful." According to Mitchell, the "long hood and strong grille" specifically represented what was inside the postwar car: "Power—there was a big engine in there."

In 1948 the appearance of a new high-compression GM engine encouraged more powerful-looking designs. A real breakthrough, the overhead-valve V-8 motor developed more horsepower than any previous production engine and provided power for added size and automated frills like power brakes, power steering, power seats, and air-conditioning. Engines like this fueled the demand of the now-prosperous middle class for more ostentatious designs and a wider range of personalized options. The consumer in the fifties could choose from such an array of engines, chassis, and exterior and interior color combinations that by 1957 General Motors was offering seventy-five body styles in 450 trim combinations (Figs. 88, 90).[4]

Frank Hershey, who supervised the design of the first postwar Cadillac and its face-lifting the following year, links the introduction of the engine to a new powerful image—what designers of the period called the "gutty" look.[5] He describes the grille on the '48 Cadillac (Fig. 74) as a "very simple front end, with no guts to it." It had "very thin chrome—well, very nice—but it didn't have any punch. So then the '49 [Fig. 75] came along, and they put in the new Kettering engine, and we upgraded the grille." Lowell Kintigh, Olds engineer for thirty years and chief engineer for Buick, remembers that the Rocket 88 Oldsmobile perhaps best expressed an image of the power in the Kettering engine: "In its day, there was nothing like it. . . . Nothing could keep up. We knew this type of engine was going to be a whole new experience for the American public."[6] Advertisements called attention to the stylists' intentions by declaring the Olds' "dynamic design of the future" as "styling with a purpose." Comparing this "farthest advancement in car design" with the architecture of Frank Lloyd Wright, the ads heralded a "car whose very lines suggest action. . . . Oldsmobile gives you response to every command in a quick surge of power." Linking the power message even more closely with styling, other ads invited Americans to "ride a high tide of power . . . above that massive hood, ahead of the pack."[7] As a visual symbol of this yearning for power and speed, a flashy rocket perched on the hood, while a plaque attached to the engine with chromed bolts announced in inch-and-a-half script that *this* was the "Oldsmobile Rocket." The long hood,

short deck, and massive grille that Mitchell believes gave visual expression to glamorous power after the war were epitomized in GM cars of the early fifties.

Car designers, like everyone else, responded daily to the other major "mass-culture" visual art, fashion design. The cultural conditions after the war effected similar changes in car and fashion design: Not only were the ideas expressed in these two arts alike, so too was the very timing of the style changes. By 1947 a postbellum fashion became all the rage, and, like the postwar car, it combined a creative American style from the war years with a new European look. Like the postwar American car, the new fashion also fulfilled desires for lavishness, glamour, and a certain shapeliness.

Just as American automobile designers developed their own car type during the war, American fashion designers who were cut off from Paris established their independence through mass-produced clothes expressing a native casualness. Hollywood was a major influence on fashion in 1940, and the short dress with square shoulders and a loose midsection created by its foremost designer, Adrian, dominated showrooms across America until 1946. As the single-shell monocoque set America apart during the war (Fig. 68), the unified and continuous line of the American suit contrasted with the sculpted appearance of postwar Parisian design.[8]

When the war ended, both of these dominant commercial arts faced the same pressures for change from the buying public. Very few exciting new products were available to meet the demand of a people starved by austerity orders and fabric restrictions, so that when victory was assured in 1946 fashion designers dropped the wartime square-shouldered suit as quickly as Harley Earl renounced the monocoque car. As automobile designers put glamour and power into their cars, couturiers sought to satisfy the public's frustrated yearning for excitement by adding opulence and dash to their clothes. *Life* magazine reported a "frenzy of buying" of items of extravagant luxury in the fall of 1946: "After five lean war years the tradition of high fashion was back. . . . The ending of the war and the return of silk, French lace and metal for lamés had signaled the end of the era of mild practicality which the war had fostered on the fashion business."[9]

In satisfying the same postwar desires, designers of cars and clothes had arrived at similar solutions by January 1947, solutions that were to dominate both industries for the rest of the decade. The typical postwar car (Fig. 75) combined the fullness of form of the native monocoque (Fig. 65) with the skintight, sculpted look from Europe (Fig. 72), and the American dress came to have a similar "quality which [those in] the fashion trade called 'covered-up bareness.' " *Life* went on to describe the combination this way: "Free of OPA regulations, they have lengthened, flared and dropped their skirts, taking on such luxuries as ruffles and bustles. But whatever devices the designers have used to make this year's dresses look lush, they have made even less provision than usual for the country's millions of women with thick waists, stout arms, husky shoulders and

short legs."[10] This "subtle yielding to female shape," for which a fashion report in the fall of 1946 said fabric was "cut to fit snugly" to reveal "tighter waists" and "rounded hips," paralleled the leaner, sculpted Italian look in car design (Fig. 76) and set the stage for the full impact of French "New Look" fashion in 1947.[11]

Following in the tracks of the American bulbous monocoque car, within a season the American square-shouldered and short-skirted war style was swept aside as the fashion industry once again rejected its native designers in favor of Parisians. Naturally, American designers like Adrian were furious at being declared démodé, but overnight the battle was decided; by the end of 1948, *Vogue* spoke of a postwar international norm, a "current ideal in figures": "There is now, it seems, an almost international agreement about the figure, reiterated by designers of clothes and underclothes. The ideal: round bosom, pared waist line, rounded hips."[12] The essential if not the subtle qualities of this international type filtered down to the mass American market, which showed a preoccupation with built-up and sculpted forms typical of the new American car of the time. The advertisements described the two-piece Mabs swimming suit as "figure sculpting" because it "highlights every undulating form."[13] Indeed, unlike the present-day bikini, the "smooth stretch nylon" was expanded to include the bulge of the abdomen and tummy, stretching above and beneath the buttocks to include the full outline of its volume. Similarly, the best-selling "V-Ette" Whirlpool bra emphasized both volume ("perfect separation") and undulation ("curves you up, round, out"), while the ever-popular Formfit foundation girdle revealed the same postwar fascination with the "alluringly sculptured look," which "all in one piece . . . lifts, molds, corrects, and holds."[14]

If this seeming preoccupation with women's fashion and the perfect postwar figure appears removed from the subject of car design, Vincent Kaptur, Jr., head of Body Development at GM, reminds us how direct the connection was: "Harley Earl had a great admiration for the anatomy of a woman, and he would frequently refer to the parts of a car as resembling certain anatomical parts of the female." Like other men in postwar America who were reminded daily of the voluptuous ideal, Earl referred constantly and directly to it in his design language. In the early fifties, he spoke of such rounded shapes as the back of deck lids (Fig. 83) as being "smooth like the back of a woman's bottom"; he referred to creases in a surface (like a fender and a hood coming together) as "baby assing," or, according to Kaptur, "even more female connotations than that"; and he described pointed bumpers (Fig. 90) as "Dagmars," after the prominent breasts of the television personality. Indeed, by 1956 the female overtones in the sexual language of design had become so open that, to avoid his own embarrassment in day-to-day contact with women designers, Earl halted a two-year experiment using them as exterior stylists. According to Kaptur, he returned the women to interior design, where, Earl felt, both he and they would be more comfortable.

Artists in commercial-design fields other than fashion were also moving away from uniform and geometrically based forms. As car designers transformed the

ideal automobile from a "pure" torpedo in the thirties (Fig. 14) to a uniform bulbous egg-shape in the mid-forties (Fig. 68) and then into an irregular form after the war (Fig. 75), industrial artists who had based their thirties' designs on European pure geometric models gradually changed them in the direction of more ostentatious and "organically" sculpted postwar shapes. Like that of automobiles and clothes, the design of commercial buildings in the fifties became both more American and more European. Skyscrapers like Skidmore, Owings, and Merrill's Lever House of 1952 were intended to be a kind of glass-and-metal artwork, along the lines of European Bauhaus architecture. It had minimal ornamentation and an emphasis on horizontal stories, "less is more" partitions, and flow-through public spaces. At the same time, however, reflecting the bold and ostentatious sensibility of postwar Americans, these buildings sported a flashy finish with stainless steel and aluminum exterior stripping and plastic color coating on the curtain walls.[15]

The carefree opulence of victorious America was translated into idiosyncratic, curvaceous, bold, and asymmetrical shapes in many other areas of commercial design. For example, fashion photographers Irving Penn and Richard Avedon explored the casualness of a "new reality" after the war, showing models almost exclusively in attitudes of everyday life. By cropping the photographs into striking, almost abstract images, they broke down the formal order and emphasized the complicated visual relationships of angles and curves in the pose of the model and her clothing. Contemporary writers often used words like "unique" or "idiosyncratic" to describe the irregular curves of two- and three-dimensional commercial art objects. In 1945 the major design journal, *Interiors,* listed the three most current clichés of "1945 modernism" as the "bean pole"—described as a long, freestanding rod—along with the "cheese hole" and the "woggle," both curvaceous devices used to enliven design (and all seen in Fig. 70): "The cheese hole, or Annie Oakley, is one of a series of large holes cut in a plywood panel to give movement and decorative air to an otherwise bleak surface." Similarly, the woggle was "any one of those strange amorphous shapes which 1945 modernists use for table tops, display shadow boxes, carpets and linoleum inlays," with the intention, once more, to create lively irregularity. "Again, the praiseworthy object was to break the cold monotony of too geometric an interior."[16]

Like other commercial artists released from wartime restrictions, car designers shared in what was really an across-the-board shift to fantastic, organic shapes. Indeed, in some ways, Earl's emphasis on nonverbal communication ("I can see but I can't hear") and the industry-wide change in the late forties toward more irregularly sculpted cars have more in common with the automatism of postwar expressionistic painters and their biomorphic fantasies than with the more conservative industrial designers and architects and their insistence on conscious decision-making based on structure, function, and materials.[17] Indulging their private fantasies and imagination, car designers expressed much of the freedom and novelty of the abstract expressionists, and like these American painters, they rejected many of the styles and norms imposed by established critics.

HIGHBROW TASTE

The decision whether to exhibit cars at an art museum presented a curator after the war with an interesting contradiction. While the car, perhaps more than any other art form, expressed the American postwar belief in a new and better life, the "philosophy" of its design and the background of its designers hardly suited the views of the commercial art world at the time. Indeed, as the only museum to underwrite, publish, and exhibit industrial design, the Museum of Modern Art treated the American car like an illegitimate child. After all, the primary function of a car's appearance was sales, and the "philosophy" of its designers was likely to be a combination of power, fantasy, raw sexuality, and newness for its own sake—all basically abhorrent to the Bauhaus-oriented industrial-arts establishment.

During and shortly after the war, a group of extraordinarily talented and innovative thinkers at MOMA succeeded in carving out a place for industrial design as a legitimate art within the museum world. Indeed, as director of the Department of Industrial Design, Edgar Kaufmann, Jr., had a tremendously positive influence across the country by selling his own exquisite taste to the American mass market through the museum's seal of approval, known as the "Good Design" Award. In a peculiar inconsistency, however, the very men who valiantly fought to have industrial design recognized as a legitimate subject of museum study systematically excluded American mass-produced cars from exhibitions of modern design. In the 1951 automobile exhibition at the Museum of Modern Art, they indicted the industry by not showing a single American car designed after 1938 and rubbed salt in the wound by including a Jeep as the only model still in production. The museum rejected the contemporary American car and justified that position philosophically. According to Bauhaus principles, mass-produced American cars could not be good design because their form was superficial—that is, not meaningfully related to structure, function, and materials—and because the goal in making these cars was innovation and commercial gain rather than slow change toward a perfect type. The American car also lacked a "voice": No definite theory underpinned it, nor did institutions or magazines fight for it the way they argued the success of American painting and industrial design at the time.[18]

In the other industrial arts, leaders like Henry Dreyfuss and Walter Teague went out of their way to publicly support the European design principles. Dreyfuss showed that he understood what honesty meant when he said "an honest job of design should flow from the inside out"—and also what dishonesty meant: "it is better to be right than to be original."[19] Among major American industrial designers, only Raymond Loewy openly defied both his professional colleagues and what he called "the ivory tower modern art critic." Having worked seriously with cars at Studebaker, Loewy was the only one who could believe in novelty of form for its own sake and in economic success as a legitimate artistic aim. Countering the one-way street of mechanical and structural determinism, he

declared that "there is as much [to be gained] working backward from optical form to mechanics"; offering Betty Grable as an example, he observed that, although her "liver and kidneys are no doubt adorable, I would rather have her with skin than without." Flippant remarks like these and his open commercialism ("industrial design keeps the customer happy, the client in the black, and the designer busy") obscured an important contradiction in twentieth-century design.[20] Through its impact on GM and Ford after 1946, Loewy's studio fundamentally changed the direction of American cars from the wartime monocoque type to a synthesis that included his own European lightweight, tightly skinned, and minimally chromed Studebaker models from 1947 (Fig. 57), 1953, and 1963. The very man who had spoken out against the Establishment introduced the European visual type they had admired and sidetracked the "superficial," distinctively American form they had rejected.

To understand how industrial designers and museum spokesmen came to place American cars outside the orbit of "art," consider the developing role of Bauhaus thinking in this country. Before World War II, the Museum of Modern Art was the only major American museum with an industrial-design department, and in its first major exhibition of Machine Art in 1934, Philip Johnson stated that "styling" was a form of "advertising. Styling a commercial object gives it sure 'eye-appeal' and therefore helps sales." If machines were to achieve the level of art, as in the Old Country, designers would have to eliminate superficial styling and treat the surface as a reflection of the mechanics, function, and structure of the inside. Alfred H. Barr, Jr., the director of the museum, reinforced the Bauhaus message of that show by describing the "role of the artist in machine art": "He does not embellish or elaborate, but refines, simplifies, and perfects." He evoked Plato and St. Thomas Aquinas to support his claim, but he could have drawn on more contemporary determinists like the absolutist Mies van der Rohe ("we refuse to recognize problems of form") or the more aesthetic Le Corbusier, who believed that universal primary sensations and historical inevitability determined the pure shape of everyday objects.[21]

In planning the transition to the postwar years, the acting director of MOMA's Industrial Design Department in 1942 concluded that the deterministic principles of 1934 were still valid, but she observed that backsliding had taken place, especially among American mass-produced wares. Again, the villains were novelty and styling—specifically, the bloated streamlined shapes that had come to dominate American car and appliance designs during the war: "static objects have been streamlined into grotesque forms or their shape has been hidden under a deformed covering. To look back at the Machine Art exhibition of 1934 makes one realize that all change is not progress." To prove the point, she introduced a photograph of a swollen toaster (Fig. 69) "streamlined as if it were intended to hurtle through the air." To be certain that her readers understood that its shape was functionless and its ornament "trivial," she assured them that "this object has never been exhibited by the Museum."[22] Needless to say, MOMA never exhib-

ited, much less labeled as art, any car remotely resembling the bloated and streamlined monocoque (Fig. 68).

When a new director was put in charge of the Industrial Design Department after the war, he confirmed what had been merely suggested before. His primary purpose was to evangelize good design over bad, and to his mind the American mass-produced car embodied everything bad. "The Department has as its first duty effectively to recommend to the general public the best modern design," he explained in the fall of 1946, and then in 1950 he proceeded to lay down what he called the "twelve precepts of Modern Design."[23] Like MOMA's director, he invoked the moral imperative of St. Thomas to help him in his quest for a return to Bauhaus principles: "Good design may well be asked to live up to the three qualities which Thomas Aquinas listed as requisite for beauty: integrity, clarity, harmony." The American car fell well outside the norm of this system where "integrity is most surely expressed in the oneness of form and function," and clarity is satisfied when "all functional parts [are] visible and all visible parts function." The design of the American car irredeemably failed the test because it was novel for its own sake and superficial without a clear and harmonious relation of outside to inside. "Mere novelty is no key to good design," but worse, and more specifically, "streamlining is not good design." That "superficial kind of design known as streamlining" epitomized the native car, whose designers, like other lesser artists, indiscriminately used it "to style nearly any object from automobiles to toasters."

Encouraged by the widely publicized leaders of art, important industrial designers like Harold Van Doren felt free to deride the superfluous shape of the American car in major journals like *Design* (1949): "Let us skip the automobile: few thoughtful American designers really go along with the monstrous inflation of the current motor-car body. They agree with the rebellious chief engineer of one of the motor companies in dubbing it 'the Jello school of design.' "[24] The editors of *Interiors,* the major American industrial-design periodical of the time, felt obliged to reject the American car and the streamlined toaster by diagonally stamping in bold letters below their pictures: "These forms are style obsolete! There is not a straight or crisp line in this car, exemplifying plastic or streamlining form at its peak. It is monotonous without richness or quality."[25]

Given this outside pressure and the prevailing currents within the car industry, it is no wonder that by 1949 mainstream American car designers turned away from the bulbous native type in search of a different kind of form based on European design. The Cisitalia made a ready target for their admiration when Battista Pininfarina triumphantly unveiled it in 1946 as the vanguard of a new "Italian Taste" (Fig. 72). Declaring that the "pure, smooth, essential" lines of his car were "dictated by functionality," the designer derided American cars as "Easter eggs done up in cellophane": "In the name of aesthetic purity I declare war on superfluities and chrome fixings."[26] The worlds of art and car styling converged on the Cisitalia because its appearance seemed to satisfy both the "moral impera-

tive" of the art and industrial-design community and the automobile stylists' desire for the tighter shapes of European design. *Industrial Design,* America's premier commercial-arts magazine, used the occasion of its first issue to herald the Cisitalia as *the* example of good car design and applauded Raymond Loewy for the European sources of his Studebaker (Fig. 57). The writer, John Wheelock Freeman, alluded to the faults of the monocoque by praising "designs like the Cisitalia" for their "elimination of extraneous elements and the careful integration of what remains. In design it is generally assumed that incongruous or unrelated elements are signs of incompetence." Criticizing the American car industry, he gave Loewy credit for introducing "the European look" on our shores: "in 1947 [Loewy] lowered his lance against two all-American fetishes: conspicuous consumption (especially chrome) and the Big Package. . . . The public," he rightfully predicted, "would soon be ready for a car reflecting European design trends."[27]

These accolades from the industrial-design community reflected earlier kudos from the Museum of Modern Art, where tastemakers boosted the Cisitalia car as a return to traditional "functional" values. Unlike the independent monocoque, the shape of the Cisitalia conformed to the inside, and they used it as a rallying cry for the old Bauhaus design tenets. They admired its tightly drawn undulating body ("modeled by swellings and depressions") and gave special praise to this functional surface when they acquired a Cisitalia and cited it as an excellent work of art in 1951: "The Cisitalia's body is slipped over its chassis like a dust jacket over a book."[28]

Registering the impact from this massive public pressure after the war, the American car designer moved dramatically toward a new synthesis of styles. In doing so, he took part in the larger cultural and philosophical movement that swept commercial arts and fashion. Despite his participation in this movement, however, the car designer did not exclude voluminous wartime shapes entirely, and he did not renounce ornamental fantasy or novelty for its own sake. As a result of this persistence, museums continued to exclude American cars as art.

LASTING VALUES

Indeed, for a whole generation after the war, designers were torn between the preference of Harley Earl and the American middle class for fanciful, symbolic, and massive shapes and their own interest in clean, "functional" design as the synthesis of art and technology. Their dilemma affected the future direction of American car design in large part because they could not resolve the conflict while Earl exerted control. Only after he retired could things change. With his mammoth '58 models (Fig. 88), GM simultaneously lost money and stylistic prestige as Chrysler stunned the world with its "Flightsweep styling" of fins in

three-toned purples and pinks (Fig. 87). From that debacle emerged a new direction, geared to the interests of younger designers, and it spread throughout the American industry.

Bill Mitchell took over the vice-presidency after Earl retired in 1958, and on the surface his attitudes seemed hardly different from Earl's. Like Earl, he believed in creative novelty and showed limited patience for theory. He led a flamboyant life-style and approached design almost purely visually, spending little time on practical considerations. Far from researching simple, functional solutions, he preferred something eye-catching, something expressive of the owner's personality.

Despite these similarities with Earl, Mitchell reoriented a new generation of designers toward a more planned design approach geared to European tastes. He is very explicit about his own suppressed and frustrated desires working under Earl in the fifties: "When I worked for him, when I was under him, I never crossed him up. I waited until my time." Asked whether he wanted to change things, he unhesitatingly responds, "Oh yes. Yes, yes. I got the fins *off*. . . . Earl liked them powerful but ponderous. I liked them powerful but sleek, sharp, slick. . . . I couldn't stand them [otherwise]. I didn't say 'boo,' but those big walrus-toothed bumpers and hoods like—Oh my God!—awful-looking stuff." For Mitchell, even the best postwar car under Earl, like the '48 Cadillac (Fig. 74), was a "big, bloated sedan." "There were some dumb years with GM. It is difficult . . . for me to get excited or to pull anything out. It doesn't take any imagination to do any of those cars. They are pretty dumb, pretty dumb." Mitchell specifically points to the postwar objective of making a car look "bigger and bigger and bigger" and "as powerful and as glamorous [as possible, and] decorated to hell."

In tune with the art intelligentsia and the desires of the younger generation of designers, Mitchell applied European taste to American cars when he took over. "I wasn't for chrome either. Where we broke the ice there was when we did the first Riviera [1963; Figs. 95, 96]. That set the standard with hardly any chrome. . . . Prior to that, if you had an expensive car, it had more chrome. . . . So I remember having lunch in Stockholm with [James M.] Roche, who was GM president then, [and he asked questions about] the Riviera and the Grand Prix [Fig. 93]. He said, 'Why?' And I said, 'They don't have any chrome because Europe didn't like all that stuff we were putting on.' That was the beginning of taking the chrome off." Mitchell set the pattern for the present generation at GM by orienting design away from American middlebrow "excess" and toward the European "tasteful" lack of chrome.

To ensure that his cars went on "a diet," as he puts it, Bill Mitchell introduced a new sense of order at the Tech Center. In his opinion, foresight could have avoided chrome on the '58 cars (Fig. 90) and fins on the '59s (Fig. 92); therefore, to avoid excessive and bizarre forms in the future, he insisted on advanced planning. Mitchell links appearance with planning when he describes Earl's last

two years: "We had some cars with one headlight in the middle, some crazy things, just because we had no advanced design. When I became in charge, I made sure we had studios that worked years ahead so that you could look at something a while."

Irv Rybicki, Chuck Jordan, and Dave Holls were selected by Mitchell to be his principal successors, and like him, they "waited until their time." Indeed, the campaign waged against applied ornament by the art intelligentsia and the Museum of Modern Art in the fifties became adopted as a philosophy of design and an article of faith by GM management only in 1978, when Rybicki and Jordan assumed power as vice-president and director of design. Mitchell's acceptance of European styling and the long delay in securing the reins in their own hands had in no way decreased their frustration or diminished the intensity of their ultimate response. Rybicki and Jordan quickly installed the avant-garde position of industrial designers in Germany after World War I and in America after World War II as the entrenched and reactionary position of General Motors in the 1980s.

In the stimulating and contradictory postmodern world of ornamentalism, eclecticism, pluralism, symbolism, and historicism, GM is sure they've got it right, as the generation that boiled under Earl and then replaced him is at last having its "functional" rebellion. Rybicki even sounds like a twenties' Bauhaus designer when he describes function as his top priority: "When we take on a project, function is the first thing." He includes among the functional determinants ("the many factors that make an automobile"): "quality, government-mandated standards, packaging, aerodynamics, costs, [and] manufacturability. All of these ingredients have to be taken into account when you are creating a car." Once he has satisfied these complicated functional requirements, his next objective, as in the Bauhaus, is to make a product as clean and simple as possible, with the emphasis on form rather than on applied frills. Rybicki "never" liked big cars and thinks we are only now "getting car sizes that are correct." As for doodads, he always has been absolutely against them: "I have never been for that. Not even in the days when we were doing it. I questioned why we had to put nonfunctional chrome moldings on the side of a vehicle or to cut slots that had no function in a fender. What was the purpose in that? I'm from the Clean and Simple School."[29] Illustrating his line of thinking, he offers the 1984 Corvette (Fig. 115) as "a fresh illustration of the dictum 'form follows function.' "[30] Similarly, one of Rybicki's top aides, associated with the dry and fussy Cadillacs of the early sixties, argues that it is a question of absolute values: Heavy, obvious ornament is unacceptable, as a matter of taste. Looking back, he deprecates GM cars of the late fifties as "bad taste. No whatever. Just bad taste. Chrome all over the thing . . . big chrome bumpers, bombs that stuck out, and gull wings."

Like the Germans who searched for minimally pure forms, Rybicki hopes to find clean and simple shapes of what he calls "lasting" value: "I don't think we are in the fad business here. We are trying to do vehicles, as in the second-generation Camaro [Fig. 110] that lived for eleven years. We'd like to be able to do that with

everything from a Cadillac right down to a Fiero. We don't want to create designs that, when you look at them ten years from today, you say, 'My, why in the hell did they ever do that?' We'd rather have you say, 'Well, that damn car still looks good today.' That is the goal here."

GM Executive Designer Dave Holls repeats the position of Mitchell, Rybicki, and Jordan when he describes the fifties as a period of "airplane-inspired motifs." They were applied as a "type of cliché" that "shows up time and time again," with no objective but novelty and unplanned eccentricity for their own sake. "The era was to be as wild as you could ever think of being. That was the type of cars you were supposed to create." Earl pushed young stylists toward these outlandish airplane designs; as Holls recalls his arrival at GM, "any designer starting here, the first thing he saw when he went into the building was Harley Earl's Le Sabre [Fig. 77] sitting there at the number-one spot. . . . It was a land-bound aircraft."

Young designers such as himself found the antidote to novelty and difference for their own sake in the skintight, chromeless Italian cars so enthusiastically pushed in the highbrow world of industrial designers. "[Earl] just loved to do something entirely different from what everyone else was doing. He encouraged that . . . just to be different. He had such a good staff of designers that they could usually carry it off . . . [but] that, in my opinion, proved to be his undoing. In an era when cars were becoming recessed down between the fenders (the fenders were the high points, which was started by Pininfarina in the Cisitalia [Fig. 72], which was the first car to have the hood lower than the fenders), anyone with a brain in his head could see that that was a fresh, new style. And, talk about airplanes, another thing that affected us were these breathtaking little Ferraris and special one-off Fiats that were coming from carrozzerie in Italy at the time. I mean, there was just a slew of them, you know."

Bill Porter, chief designer at Buick, reacted similarly to Earl's applied and excessive taste. In 1957 he entered GM with what he describes as a missionary zeal to fuse art and technology. "Aircraft-shaped hood ornaments and the like . . . seemed to me to have evolved into a corny symbolism. I was interested in exploring more profound fusions of technology and design." Out of this interest and in reaction to Earl's simple highlighting principles, Porter developed his own rich and varied highlighting vocabulary, as seen in the 1970½ Firebird (Fig. 108). "We just had to expand our range of acceptable shapes to express other kinds of things." And yet, it was a creativity born of reaction and frustration to the Earl approach. "A conic section in those years was absolutely unknown in GM automobile design because Harley would just never, never put up with a conic section or a warping surface. I guess that was considered a cardinal sin. Guys would tell me you could get fired for trying a warped surface."

Even the most creative GM stylists, like Porter, continue to be caught up in the past, waging postwar design battles abandoned by other commercial artists. One of the spokesmen Porter still admires most is Edgar Kaufmann, Jr., the director of the Industrial Design Department at the Museum of Modern Art in the forties and fifties. Porter describes his objectives for the 1985 Electra (Fig. 112) in lan-

guage of that period, assailing a "straw man" at least thirty-five years old. "In the old days, the Electra exemplified all the things that many younger designers didn't care for. . . . Electras were essentially large, ostentatious cars with a lot of ornamentation." He conceives this design as a rejection of those values. "And so it was a revelation for me to find myself working on a car whose very image exactly corresponded with something that I felt it was time to change. And here was the opportunity to address that, to step right up and take a swing."

Recognized for his exceptional talent, Porter was given the chance to indulge his own very personal and creative response to the older Earl system. GM's standard response, however, substitutes clean but unoriginal design for novelty and ornament.[31] What has been achieved is a kind of Brooks Brothers car for America. The car's safe design displeases nobody but expresses little individuality or panache. The outstanding styling professionals, the old-timers, may be the most knowledgeable critics of these cars. Without theorizing about the delayed reaction to Earl's philosophy, they almost all agree that the desire for a clean, unornamented, and "tasteful" product has produced a nondescript, uniform, and uncreative style. "I think GM has fallen down terribly lately—I think they have," laments one of the great designers from the Art and Colour days. Extending his criticism to Ford, he describes the 1983–86 version of the Thunderbird as looking "like Hitler's mustache, the ugliest car I ever saw." Bob Gregorie rues the lack of expression and articulation in cars: "Today, what you have is just like a loaf of bread. It is just a big gob of stuff that is so wide, and so long, and so high. . . . On some of these newer cars, there is nothing. It is just like a balloon." George Walker, former Ford vice-president, criticizes the eighties' generation of Ford cars (Fig. 111) as undistinguished because of their lack of definition and detail.

Bill Mitchell openly criticizes Ford and GM design. He speaks not out of disloyalty but with care and concern for a creative, romantic enterprise to which he has devoted his life. Although he fostered the eighties' generation of designers at GM, he thinks that their cars are not only undistinguished but indistinguishable from other manufacturers' vehicles. When he looks at the GM lineup, he uses the metaphor of a suit: "They are all the same: boxes. No, we have to come back to some identity in the cars. . . . My God! I would not want to buy a suit like another guy. I wouldn't want a hat like somebody else. . . . The old Thunderbird, now, that is an eye-catcher! Boy, you forget how cute that was. This new Thunderbird is nothing. I say it is a bar of soap. It just looks like nothing. People want something when it goes by: 'Jesus! What was that?'" And he doesn't hesitate to blame his successor for not leading, for not creating distinctive, original designs, for not continuing the tradition that he inherited from Earl and proudly enhanced. The problem in contemporary styling is "distinction and looks. . . . In a talk in Minneapolis this fall, I showed about thirty cars on the screen, and I said, 'I don't know what the hell they are. I am a designer. I've been in the business forty years, and I don't know. . . .' They all look alike. I have to read the emblems to know what the hell they are."

4
Car Design in America

The Turning Points: 1930–1950 and Recent Car Design

*It's like a watch, you can put anything
on it. That's what's wrong with some
architecture. Just a column with
cement is no good. Have something.*
—Bill Mitchell

American car designers developed new shapes during pivotal moments in the fifty years since 1930. A preview of these important stylistic changes will be followed by a step-by-step explanation of each one.

The first major turning point occurred by 1935, when America had established its own design identity and direction. This success resulted from Harley Earl's strong leadership in the industry, new materials and processes for manufacture, and the economic pressure during the Depression to develop attractive and novel products. One radical design experiment, however, failed: The cars of the mid-thirties that attempted pure streamlining were not well received in the marketplace. Their failure did not, as is generally assumed, simply encourage reactionary design, but rather it stimulated creativity. In fact, Earl initiated a creative change during this period by developing a personal pseudo-aerodynamic style based on the streamlined envelope.

Americans initiated another important change in car design during World War II, when our country was cut off from Europe. Designers took advantage of the opportunity to develop a distinctly American car type, the monocoque. After the war, when Americans discovered the latest ideas from abroad, our designers synthesized the monocoque with European sports-car styling and created yet another important turning point of design. Bob Gregorie at Ford and Harley Earl at General Motors approached this problem of synthesis differently. Gre-

gorie's individualistic solution failed in the eyes of Ford's new management and was abandoned in favor of a design based on the postwar Studebaker. By contrast, Earl achieved great success with his postwar synthesis, and he developed the solution into a uniquely American formula that by the mid-fifties became his most powerful design statement.

After Earl retired in 1958, Bill Mitchell consolidated his position and then, in the late sixties, launched his most successful models. Beginning in the seventies, Mitchell and his successor, Irv Rybicki, supervised a new generation of smaller cars whose shapes conformed to federal mileage and safety regulations. In the final section of this chapter, the design merit and originality of these vehicles will be measured against the standard set by the past.

THE PREWAR ERA

Aerodynamics

In the early 1930s it was widely believed that the future of American car design lay in the single direction of a purely aerodynamic shape. In February 1932 the leading American car magazine, *Automotive Industries,* featured an article about the British authority on aerodynamics, Sir Dennistoun Burney, who predicted, "I believe the new conditions will evolve a new overall design which will, in time, be found superior to any other, and will become the orthodox car of the future."[1] His own experiments, as well as the well-published ones of the Germans Rumpler and Jaray, were just the most recent examples of the widespread search for an inevitable single type. In 1928, and then again in 1931, Norman Bel Geddes outlined a series of automobile designs gradually leading toward a single model, based on the pure torpedo shape.[2] In 1933 Raymond Loewy visualized this transition for the American designer in an evolutionary chart, and Henry Dreyfuss similarly proposed that the gap to "streamlines" based on scientific research be bridged smoothly by "a carefully planned design progression."[3] In January 1933 the chief automotive analyst for *Automotive Industries,* Joseph Geschelin, predicted that the future car would be a final, single streamlined form: "There is a strong feeling of change, mobility, and a general movement toward a new era of creative design. Consciously or unconsciously the movement seems to be pointing to some final streamline form which has been engaging the minds of the designers in the automobile world."[4]

By 1935, however, American designers changed direction as they gradually learned from widespread publications that no single, purely aerodynamic car type was possible. While the drawings and models of prominent American designers like Paul Browne (Fig. 14) and Bill Mitchell show that they had considered a "pure" torpedo type before 1935, with the new scientific information and the financial failure of the Chrysler Airflow (Fig. 15), they increasingly aban-

doned the torpedo as a design option. Ralph Roberts, chief designer for Briggs Manufacturing Company and thus instrumental in the design of Ford products in the early thirties, wrote as early as 1932 that "we will probably have to find other forms and shapes [than the pure torpedo] to obtain the desired increases in efficiency with safety." Published in *Automotive Industries,* this very significant statement from one of America's most influential car designers confirms that contemporary discoveries about the differences in automotive and airplane aerodynamics affected the mainstream American designer. Roberts explained his point by saying, "While the teardrop form might be an ideal shape for a body traveling through a completely fluid medium, it is not necessarily the most desirable form for an automobile, where the streamlining may be largely influenced by the fact that we are traveling over the surface of the earth [affected by] side winds. Here the work done in connection with streamlining in aeronautics means virtually nothing."[5]

Not only was the pure torpedo shown to be ineffective in relation to side winds and ground pressure, but the latest aerodynamic studies conducted in Europe by Wunibald Kamm and Jean Andreau and widely published here showed that alterations in the single pure form actually improved efficiency in head-on aerodynamics as well. The experiments conducted in Stuttgart in 1932 by Kamm and Reinhard Koenig-Fachsenfeld showed that lopping off the tail of the torpedo lost nothing in efficiency and that extending the rear in a higher and less sloping roof actually reduced drag.[6] Not only did these studies show that a less pronounced torpedo had advantages, but the ideas were reinforced by the publication of the Frenchman Jean Andreau's findings in a three-part article in *Automotive Industries* (1934). What Andreau proposed was in fact the direction the American market took. He suggested that changes in the profile of the body of the car toward a torpedo shape did not reduce the air resistance materially. By contrast, "development work on the fenders, running boards, and headlight lamps seems much more promising."[7] The chipping away on these parts is the direction the American car market took after the failure of the Chrysler Airflow shape in 1934.

The Chrysler Airflow, then, lagged behind the times aerodynamically. Its torpedo-like body was too long and unstable in crosswinds, and the details of its design were less streamlined than those of many contemporary American models. Indeed, a Chrysler design representative made this observation about the parts of the Airflow when it appeared in 1934; in his paper on the "Dynamics of Automobile Design," George L. McCain reported: "Theoretically the body should be streamlined in both the horizontal and vertical planes, but in the Airflow car no particular attempt was made to streamline the horizontal plane, aside from slightly bulging out the body, filling in the spaces between hood and fenders, and mounting the headlights flush."[8] The key statement here is that efforts to integrate and streamline the parts were limited to filling in between them, while the designers focused on the torpedo shape of the vertical plane by "rounding the nose and sloping the rear deck." Since the torpedo form was shown to be ineffective even as the Airflow was hitting the streets, the lack of

articulation in the other parts left this so-called radical car in many ways behind cars whose designers chose only to streamline the parts in an effort at styling.

An advance in the construction of the car added to the *retardataire* appearance of the Chrysler Airflow. In a peculiar irony, the Budd body builders had introduced an engineering advance to the car by producing the three major body panels entirely of steel hung on a rigid interior truss; in the process, however, they saddled the car with a late-twenties' look. At the end of that decade, the basic shape of a car was formed from a perpendicular series of flat planes rather than from a single continuous form typical of the single-die, turret-top models GM introduced for the 1935 model year (Fig. 17). The Airflow construction was an updated version of the coachwork wooden-frame system rather than an exploitation of a new aesthetic made possible through all-steel, large-die modeling. Indeed, in an early example of interchangeability, the back panel was practically a flat stamping, made that way to be identical in all three Airflow models.[9] The front section, the only part actually assembled by Chrysler, was described in a contemporary trade journal as "one of the most complex structures ventured in body building" because it "involves a great multiplicity of small pieces."[10] To join the many parts, "practically every trick in the master welder's repertory has been adapted," and the result gives the impression of a series of joined parts rather than a smoothly integrated streamlined whole. Built-up sections ("filling in," as McCain described it) separate the fenders and hood in the front, and similar sections run between the rear fenders and the side panels. Placing the Airflow even further behind the trend toward smoothed and streamlined individual parts, the fenders lack the rounded fullness of contemporary cars. Instead, their bottom edges bend concavely outward, while noodlelike ridges punctuate the surfaces around wheel covers and fender edges and between infill panels. Analogous to these ridges, dated art-deco "speed lines," in the form of parallel chrome bars, run across the bumpers, grille, and side moldings, and around the inside seats.

Earl's Pseudo-aerodynamics

In his role as industry leader and conscious innovator, Harley Earl avoided the controversy over aerodynamics, judging the public too conservative to accept a radical change in car shape. He chose instead to open a new path based on styling rather than science, and his decision led to a creative and new integration of parts. By taking this step, he left the aerodynamic controversy behind to pursue a design direction in keeping with the latest manufacturing innovations.

In the early thirties, when Earl began working toward an integrated envelope (Fig. 13), the direction had been toward the streamlining of separate parts.[11] Earl's goal became something new—the stylistic integration of the whole car into a longer and lower-looking shape, but not a pure torpedo—and he set out to realize his aim over an evolutionary period.[12] Earl said in 1954 that his "primary purpose for twenty-eight years has been to lengthen and lower . . . at times in reality and always at least in appearance," and we may see in retrospect that his

purpose was perhaps most advanced by the introduction of two essential features in 1933 and 1934.[13] In 1933 he introduced the trunk at GM as an integral part of the body of a high-volume car, the Chevrolet. Sloan himself realized that "the built-in trunk and its partner, the extended deck on which it sits, were significant . . . because they altered the overall shape of the car and helped make it longer and apparently lower."[14] Revamping the GM line for 1935, Earl had introduced in the previous year the all-steel, or "turret," top (Fig. 16), and this top complemented the built-in trunk to such an extent that it proved to be what Earl needed to integrate the design into a new and totally American whole (Fig. 17). Built entirely from one pressing, this all-steel top blended without a ripple into the extended trunk, so that the prolonged rounded line of the lid continued over the top. Commenting at the time, Joseph Geschelin perceived the link between a new unified aesthetic and the construction process involved in the turret top: "it is a single stamping extending from the windshield head, around the back, including the rear window. . . . It extends the full width of the body including the drip molding, thus giving for the first time a unit body structure not only from the viewpoint of physical strength, but also in outward appearance."[15] This car gives full expression to Earl's saying that "oblongs are more attractive than squares." Recalling Earl's taste in the mid-thirties, Bill Mitchell says, "He liked round, big rounded surfaces, and rounded roofs. You see, that was new, really." Indeed it was, and with these two features, the largest part of the body chassis became a voluminous bulk separate from the frame. It was more a single sculpture than a series of formfitting, isolated parts, a fact that separated American from European car design and led to a philosophical break with the more European-oriented commercial artists in other areas of American design.

Complementing the cohesive quality of domestic cars was the introduction in 1937 of iridescent colors, achieved by adding 5 to 10 percent of finely ground aluminum to paint. The aluminum was used in combination with gray and brown pigments to give a "metallic" surface, enhancing the softer, rounder appearance Earl sought to achieve.[16]

This conception of the car as an integrated, voluminous whole was a new American look. And it was not based on any scientific notion, as Mitchell explains: "We did as we damned pleased. There wasn't anybody saying 'that's aerodynamic' and 'that isn't'. . . . We didn't worry about it because some of the [aerodynamic] things right away showed it made the car look like hell." Rather, if one searches for a functional explanation of the new shapes, it lies in the use of a new material—all-steel construction—and in the application of a new process—die casting—but not in the functional expression either of aerodynamics or interior structure. Certainly Bill Mitchell was well aware of the new steel-die process and the curved designs it encouraged: "When they went to steel bodies, they couldn't get these sharp lines, [and thus] the big radiuses came in. . . . You had to make that to get the die out. To raise it, you couldn't have a sharp corner; you had to have the radius."[17]

The shift to new, rounded, integrated shapes occurred in America and at GM

because of the country's financial resources and Earl's taste for large, curvaceous forms. General Motors changed over to the expensive but cost-effective die-molding process, eliminating the labor-intensive practice of welding separate parts and speeding up production through large single stampings. Vincent Kaptur, Sr., chief body designer at GM during Earl's tenure, describes the pressure designers felt from the introduction of these giant presses: "If you had some complicated shapes where the curve couldn't easily be slipped off a die—anytime it was crimped over or had a flange—you couldn't possibly stamp it in one operation."[18] The direction of change thus became obvious simply from the point of view of production. The *outre-passé* curve of the pure torpedo fender had to give way to bulbous and segmental shapes or to straight-ended fender tails in order to speed manufacture.

While fenders in 1935 still looked very much like segments of pure torpedos (Fig. 17), by the 1937 model year the curvilinear changes had reached production. In the GM design studios, George Snyder's drawings show the new relaxed and organic approach to segmental forms (Fig. 19), as do the fenders of the 1936 Cord (Figs. 20, 21), a design conceived by Buehrig when he worked at GM three years earlier (Fig. 22).[19] Indeed, an insight into the nature of this change at GM can be gleaned by a comparison between the final Cord and Buehrig's 1933 design based on a Harley Earl studio competition. The fenders in the original sketch are separate, pointed, and narrow torpedo shapes, while in the final Cord the fenders are large-radius curves more fully integrated with the hood and the coupling of the front axle. Each fender appears to be a continuous but irregular voluminous shape, quite different from the rest of the parts on the production Cord. Compared with the "tumble-home" sides of the Hershey 1935 competition model (Fig. 23), the sides of the production Cord are still relatively perpendicular; even the remodeled fenders—especially in back—are pointed like torpedos, separated from the body, and articulated by two stampings—with a crease down the middle. By contrast, the fenders on the Hershey model are single bulbous stampings, hugging the side panels. Clare E. Hodgman, Hershey's assistant on the 1935 competition project, describes Hershey as a spokesman for the faction at GM that preferred an "enclosed envelope package approach," the ultimate goal Earl was pursuing through an evolutionary process.[20]

Earl's Rectilinear Look

Earl modified his steady and directed progress toward the rounded envelope in the second half of the decade when he toyed with a parallel idea. The change came about through Bill Mitchell, who eventually replaced Earl as vice-president of styling in 1958 and then supplanted Earl's taste with his own lean, "London-tailored" look. The shift that Mitchell proposed in early 1937 was not unprecedented, because Earl already had paved the way for a more "rectilinear" look in the cars of that model year. In those cars, Earl kept pace with the squarer look of

other late-thirties' commercial arts like clothes and furniture; he introduced all-steel bodies and made the first complete change in the GM line since 1935. The direction veered toward a less voluminous and more open, rectilinear shape, as seen in the 1938 Pontiac and Oldsmobile (Figs. 24, 25), which retained the body of the previous year. Rather than keep the full torpedo outlines of the earlier model (Fig. 18), he reduced the projecting curve on the side and front of the fenders and flattened them on the top (Fig. 25). He extended this upper fender surface across the front, bridging the valley separating the fenders from the hood. He emphasized this new horizontal surface by attaching the previously suspended lights to it. Similarly, he reinforced the more rectangular contour by squaring the radiator cover, projecting it down and across the front fenders, and realigning the grilles in a horizontal direction. Finally, he flattened the top of the hood to correspond to the changes below it. He echoed these shapes in the side windows (Fig. 24), which he laid out as a series of regular rectangular openings rather than irregular and isolated portholes (Fig. 17). Below the windows, he changed the isolated molding "spear" on the side into a continuous horizontal highlight line. And he emphasized the extended straight line of the hood, fender, and beltline by reducing the height of the car by an inch and increasing the width of the doors and front window.

In the 1938 Cadillac, the Earl team pursued the direction charted by these changes by molding them into a completely unified statement (Figs. 28–31). Although the design itself was new, the design process was standard in the Earl system. Typically, the theme was his. It was his idea to produce a sporty, "personalized" special car that was smaller than the normal Cadillac and that looked like a convertible.[21] But equally typically, the visual execution belonged to someone else. Bill Mitchell had been hired in 1935, and six months later, when he became chief designer of Cadillac, he translated Earl's verbal theme into a visual reality, giving it the stamp of his own taste. Mitchell openly credits Earl with the conceptual theme: Earl wanted a "special car" with a "characteristic image" of its own; "he came up with the idea. And this was where he was good. He didn't need a drawing. He wanted to make a sedan look like a convertible."[22]

Although the Sixty Special fulfilled Earl's dream of a personal car and culminated the rectilinear trend he had initiated in the 1937 models, at the same time this special car expressed the bold personal statement of Bill Mitchell.[23] For more than forty years, Mitchell battled for what seems a contradiction: the individuality of each car design and the continuity of his own aesthetic preference. "When you take the antlers off a deer, you got a big rabbit," he is fond of saying about individuality. "It is important that you give a car some identity." If cars "all look alike, they are nothing; there is no soul in them." And yet, he believes that the visual characteristics that distinguish the 1938 Cadillac (Fig. 29) expressed a lifelong personal taste: "I like to have them look like they are going like hell just sitting still."[24]

The Mitchell trademark of a crisply tailored edge already was apparent in the 1938 Cadillac, he says (Fig. 30): "I like the crease in the trousers. I like sharp things. I'd go to the museum to see breastplates with wind-splits on them, and that always influenced me." Tracing his sketches within the Cadillac studio, one finds that the most radical expressions of these ideas, conceived in the first months of 1937 (Fig. 28), show an abrupt shift from the more fluid and rounded contours of the previous year (Fig. 27). The earlier designs reveal his personal tendency to a lean, spare volume closely attached to the car's inside and show a typically aggressive "stance" rendered with a dynamic and continuous line.[25] But the chiseled and creased rectilinear edge emerges only in early 1937, in sketches for the La Salle concept car (Fig. 28), the prototype for the production Sixty Special.

Taking this combination of aesthetic traits he calls his own, Mitchell created something special, with its own identity. He expressed Earl's concept of a hard-top convertible in a homogeneous and complex visual form (Fig. 31). Reducing bulk and emphasizing a fleet lightness, he had the "side glass dropped down" and introduced "thin chrome frames that gave the openness of a convertible."[26] Mitchell heightened the "sporting-looking" image by "taking the moldings off and the running boards off, and having two-piece doors, so it didn't look like heavy doors." By eliminating moldings and constructing doors with distinct uppers and lowers, Mitchell broke through with a formula for delicacy and fleetness that ultimately would change the direction of American car design, as he recognized: "There used to have to be moldings [along the side] because the car was so damned tall and flat," but here there "was no dividing" because this car was "much lower. It was the lowest thing."

Emphasizing that "this ['38 Cadillac] was a young car" with a "sporty image," Mitchell sought to accent the lowness by horizontality: "That is what you need to get a low car. You got to get it low, to accent it low with horizontal lines." In this sense, then, Mitchell's personal goals coincided with the rectilinear trend in Earl's mind, already partially realized in the 1937 models. The horizontal line created by the thin chrome strip on the bottom of the window is reinforced by the continuous tight curve on top of the door, and this highlight line extends from the hood, through the doors, and into the rear, where "there was a deck instead of a little trunk." This continuous straight contour line is emphasized by the rectangular outline of the windows, the flat roof, and the long extended hood, which Mitchell always preferred. The fenders give added strength to the horizontal line by their flattened tops and squared-off sides ("what we called suitcase fenders"); and the grille tops off the effect by echoing the other parts of the car with a series of horizontal slats.[27] As seen in the preparatory sketches (Fig. 28), the headlights originally were meant to be rectangular lamps integrated flush with the horizontal line of the fender, but, in one of his few setbacks, Earl was unable to convince the engineers of their feasibility.[28]

Embodying the best of Earl's strengths—a novel idea and an ongoing theme—

the Sixty Special introduced a new personality, Bill Mitchell. It was he who worked these concepts into a complete and unified visual statement that set the pattern for GM products in the early forties and offered a foretaste of the design direction Mitchell pursued in the sixties and seventies.

The World War II Car Type

The shutdown of the automobile industry during the Second World War allowed for the play of the imagination and a great deal of "paper" design. With planes all around them, perhaps it is understandable that most car designers thought the car should adopt the monocoque shape of an aircraft fuselage (Fig. 45). Often called "bath tubs" or "soap bars," the cars designed during the war resembled a single bulbous egg that hung over the wheels and covered their openings (Figs. 65, 66).

As a result of manufacturing munitions during the war, it took the major car producers until 1948, following a phase of reconversion, to produce a new line of cars. This two-year delay, during which GM and Ford reused prewar dies (Fig. 32), had an enormous consequence for the history of design because it allowed them to move on to real postwar cars (Figs. 61, 74)—not exclusively based on the bulbous monocoque shape—and to participate in a new postwar taste shared with other commercial arts. By contrast, most of the smaller car companies, like Hudson, Packard, Nash, and Frazer, got off the mark right after the war with monocoque designs. It took the major manufacturers only a couple of years to make these cars obsolete with more up-to-date models.

Because of the success of the competitors of the "bathtubs" and the subsequent financial failure of the independents who produced them, the style itself, when it receives attention, is usually disparaged. Critics have used adjectives like "bulbiferous" to describe the "soap bar," or that "big chrome-plated gumdrop." Despite the adverse press, the monocoque shape dominated car design during the war and became the starting point for postwar projects, even in the advanced-design studios of General Motors and Ford (Figs. 67, 49). The monocoque shape reached its zenith with the 1948 Packard (Fig. 35).[29] Chief Packard stylist John Reinhardt remembers that during the war he was asked to rework the grille, preserving as much as possible of the prewar body (Fig. 33). Management "wanted a lower, fatter profile, so we had to work out some of those great, tremendous front ends."[30] Various clay studies (Fig. 34) show that through the winter of 1942 he developed the concept of the Packard with a totally integrated horizontal front that included fenders, grille, bumper, and hood, all within a parallel series of horizontal bars. This all-inclusive formula, well suited to the monocoque shape, became a standard feature of World War II designs (Fig. 68). It was not the public that doomed this type of car, but the decision of the major manufacturers, GM and Ford, to abandon this bulbous style, leaving the independents on a sidetrack of American car design.[31]

THE POSTWAR ERA

Gregorie's Postwar Mercury

It is one of the ironies of the personal and idiosyncratic design situation at Ford that the taste for tightly skinned and chromeless designs that caused America to turn away from bulbous cars after the war was central to Edsel Ford's thinking during and even before the war. He was particularly taken with European cars—in the earlier years by the larger, more exotic makes like Rolls-Royce and Hispano-Suiza, and later by more sleek racing types, like the French Ballot GP car and the Bugatti. By 1934 Edsel commissioned Gregorie to design two special cars based on features of European sports cars he admired, and eventually, in 1938, he had Gregorie conceive a European-type, mass-production car known as the Continental (see Fig. 39 and Gregorie interview).[32]

In 1942 and 1943, when it came to seriously preparing the lineup of Ford's postwar cars, Gregorie, like so many other car designers working under wartime conditions, had no deadlines but "plenty of time to probe the various possibilities." As was the tradition at Ford, Gregorie explored these with Edsel Ford, who was involved seriously with design until his death in the spring of 1943.[33] Gregorie recognizes the debt he owed to his patron in the Ford prototypes for 1942–43. He compares, for example, the final product, the 1949 Mercury (Fig. 50), with one of the initial prototypes, the ninety-eight-inch wheel-base Ford (Fig. 43), conceived in 1942 while Edsel was still alive: "Mr. Ford had certain likes and dislikes . . . and we knew what they were. . . . He liked a trim, delicate effect on a car. He didn't care for this big, bulky, bulbous sort of thing. . . . The only reason we were able to make that postwar car as big and massive as we did was because of not having his objections." Like "Dutch" Darrin, whose European-influenced Packard Clipper (Fig. 33) paralleled Ford's taste at the time, Edsel preferred the tighter, smoother, and conforming skin of a continental car.[34] He sought to express this taste in the 1942 small Ford. Unlike the final 1949 Mercury, on which, Gregorie explains, "the fender was brought out to be more prominent . . . with a little more of a corner on it, a little bit more definition," the outside fender of the 1942 model "sort of melts into one surface—Mr. Ford liked that. That is carried over from the older Fords. . . . He liked the fenders to blend in with the sheet-metal work in the back. He favored the tapered-end look which . . . melts into a big round shape."

In harmony with the smooth melted surface, Edsel preferred subdued colors like mulberry brown and small amounts of fine detail. "He was a stickler for fineness," says Gregorie. "He wanted delicate bumpers and delicate door handles and things like that, which were not quite in keeping with the bulk of these newer cars. So that when he passed on, and we actually got around to seriously going into production with cars of this form and bulk, we were able to step up the size of the lamps and so forth." Unexplored in the literature devoted to cars, this important aesthetic change at Ford can be seen by comparing the cars conceived under Edsel's supervision to those carried out shortly after his death.

The design shift, however, also involved a policy change on the part of the Ford administration. Previously, the compact (Fig. 43) and normal (Fig. 44) Fords, except for size, were almost identical in conception and appearance, whereas beginning in 1944, a decision was made to separate the image of the various models and to make the regular Ford into a more powerful and deluxe car (Figs. 48, 49). The change occurred in the following way. In September 1943, shortly after Edsel's death, Gregorie left the company, but he was rehired six months later, as he explains: "Jack Davis . . . was Edsel Ford's sales manager of the company. On the same day I went back with Ford in April 1944, Jack Davis came back there. . . . He had bought and projected this idea of the smaller and larger Ford—the Ford built in two ranges."[35] The new sales concept was meant to distinguish the full-sized Ford from its compact cousin: "Step the Ford up. You were to have a combination of Fords. . . . We were stepping this up to carry the Ford name in a little higher social bracket. That was my thought on it. I origi- nated this concept, and Jack Davis, the sales manager, went along with it."

In this way, the slimmed-down, finely detailed aesthetic of Edsel Ford's line was to be radically redesigned after 1944. As Gregorie says, "After Edsel Ford passed on, my direct contact to management was pretty much with Charlie Sorensen, who was number two in the company, there not being any vice- presidents. When we were getting the face-lifted version of the line of cars [the first postwar cars were essentially prewar designs] ready for presentation, old Charlie . . . said, 'Well, Bob, let's just deluxe-y the hell out of these cars.' " The aesthetic change was directly connected with the policy shift, and the "face-lift," decided upon in 1944, foretold the new direction of the 1949 Mercury (Fig. 50). Most historians say that the full-scale models Gregorie developed under Edsel became the prototypes for the postwar car; in fact, after 1944, Gregorie instituted great changes and made completely new models, and these played an important role in the final appearance of the 1949 Mercury.

Besides the death of Edsel and the corporate decision to upgrade the full-sized Ford, two other factors explain the visual change in this automobile after 1944. The taste for the monocoque car in the war years clearly was reflected in the more bulbous shapes of Ford prototypes after that date.[36] More important, for the first time Gregorie could express his personally felt ideas, independent of the influence of Edsel. Unlike Edsel, Gregorie preferred the "expressive," the "defined," and the "articulated," to use his own words. Indeed, for him, to *be* expressive, the parts had to be defined and articulated: "When you had separation of fenders and headlamps and bumpers, each one was a piece of artwork in itself. It had a graceful flow. It either was a pretty fender or an ugly fender. But it was separated from the hood and the body. In other words, it had an expression and composition." Throughout the early war years, Gregorie experimented to see if he could articulate the separate parts of the car within a new, larger whole. Both in smaller (Fig. 46) and larger (Fig. 47) models, he preserved the identity of individual elements while he folded or pleated them together, creating a different effect from the smooth and com- pletely fluid articulation he achieved in the postwar Mercury.

According to Gregorie, the peculiar accomplishment of the 1949 Mercury (Fig. 50) is that the parts seem to flow together yet exist separately. Despite the new bulbous quality of the design, or rather because of it, a new articulation was achieved while a separate "definition" was kept. His expressive goal becomes clear when he describes each separate part, like the roll of the hood: "It is powerful-looking, see? That is what you want, a good thrusting—a thrusting look, a reaching look." Similarly, in the "trace" of "surface relief" along the sides, you "literally have an expression."[37] There he used a boat designer's trick to give relief to the side elevation and to pull together all parts of the design. Perhaps best seen in a small prototype from 1946 (Fig. 51), where the bumper does not conceal the rear, the relief begins as a concave tuck contrasting to the bulbous roll of the trunk; it turns the corner and extends as an increasingly indented line, low and straight on the sides and parallel to the belt and bottom edge. In the production Mercury, the rear lights and side spear align horizontally with this sculpted form and give a surface accent to it. Gaining depth as it rises, the highlight steps up in the front door and expands onto the hood, integrating the entire car from front to rear (Fig. 50). Gregorie's organization of form through a variable highlight, ranging from a delicate line in the rear to an all-encompassing front-end section, is almost the opposite of the geometrically uniform highlight system that Earl advocated.[38]

While preserving the partial independence of separate parts, the "bulbous" mode allowed Gregorie to harmonize them together, particularly through the changeable highlight line on the side. He likens "this little effect" to "the drop sheer on a boat," especially "a cabin cruiser," where "you drop the sheer line" to get relief "from a continuous, straight-sided look." The line on this car, Gregorie explains, "was a pretty line. It tapered gracefully, and it dropped down—a kind of a sparky little drop there."

In Gregorie's mind, the dropped line exemplifies his firmly held conviction that "the tail end of the car [should] be low and look fast, at least in the mind's eye. I've never drawn a car in my life that was higher in the stern than it was in the forward end."[39] Compared to the smoothly gathered rear of the Edsel-influenced models (Fig. 43), the designs that evolved after 1944 (Fig. 51) show more fullness and definition in the "aft." In fact, the earlier models show the same tendency as the original Continental, designed in 1938 (Fig. 40): "Strange to say, I never thought much of the Continental. I thought it was kind of weak in the rear end. I didn't care too much for the pinched-in rear end. Mr. Ford liked that, you know. He liked that gathered-in rear end. It reminded me a little bit of a dog with his tail between his legs." By contrast, the rear end on the 1949 Mercury shows "a little more beef," with "full, round shapes, just like these big Italian gals." This articulated tail section was meant "to give the car an identity, and also to relieve the ponderous bulk of it. . . . [It was an attempt] to bring back the feeling of a fender."

Not only was Gregorie interested in expressing the articulation of separate parts, but he was very concerned about the analogy or parallel between them. In

keeping with the other changes from the 1942–43 models, Gregorie also modi-fied the hood, bumper, and grille in 1945 (Figs. 48, 49): "The forms are supposed to be compatible with each other. There is supposed to be a theme there—the *roll of the surface* here and the roll of the surface there. They are all related. Instead of trying to create a clashing contrast or a sharp definition, this flows." While the hood in earlier designs was narrower, peaked, and often scored with surface lines (Figs. 42, 44), the 1945 design was a broader shape with a softer radius curve, tucked in at the grille.[40]

In sum, the design of the 1949 Mercury owes its appearance to a number of coincidences: the corporate decision to change the Ford image—to "deluxe-y" the Ford—which eventually led to its becoming a Mercury; the death of a patron, Edsel Ford, and the reduced influence of his taste; and the corresponding opportunity for Gregorie to express his own ideas more fully and, for the first time, with completely new dies ("I think the '49 Mercury is one of the nicest cars I have done . . . [it] was the first time we had a chance to start out with fresh sheet metal").[41] The design of the Mercury brought together a number of specific visual sources: the sheer, nonchromed, European aesthetic that Edsel preferred and Gregorie developed in the 1942–43 prototypes; Gregorie's personal taste for full-bodied and well-defined forms; and the prevailing wartime preference for bulbous, monocoque shapes. After a second corporate change at Ford in 1946, this creative blend was lucky indeed to find fulfillment in a production car.

The second turnabout at Ford came in 1946, as manufacturers began to under-stand and to react to the real pressures of the postwar market. After shortages and gas rationing, the American public desired new, luxurious, and large cars. Instead of immediately satisfying those desires with modern cars, however, the major companies concluded that shortages of new cars should continue, forcing the American public to accept reconverted old 1942 models during a period of retooling.[42] General Motors even shelved its new compact in the summer of 1946, when Ford also dropped plans for a new small car (Fig. 42), leaving its designers with only a single large deluxe Ford (Fig. 49).[43] This car was too massive, heavy, and prestigious to carry the lower end of the line, and therefore practically without change it was turned into a Mercury (Fig. 50). Its place at the bottom was taken by an all-new Ford (Fig. 61), which management modeled on the highly successful Studebaker, introduced in 1946 as the first completely new postwar car (Fig. 57).

Earl's Postwar Designs

Like most American manufacturers during and shortly after the war, General Motors was headed in the direction of the monocoque. Mitchell returned as chief of the Cadillac studio at a crucial time, in the fall of 1946, just as preparations for the first new postwar designs based on the monocoque were being finished. Mitchell recalls, "It looked like a trend was coming. I was in the Navy for three

years, and I came back, and I saw what they were doing [Figs. 65, 66]. They were covering the wheels. . . . With Earl, we too were modeling one. . . . None of us liked it, but you get mesmerized into that, with everybody working it."[44]

At GM the wartime preoccupation with the monocoque fuselage had been reinforced by Earl's personal fascination with the P-38 Lockheed Fighter (Fig. 64). In 1941 Earl and a group led by Mitchell visited the still-secret fighter. As Mitchell tells it: "We absorbed all details of [its] lines. Every facet of the twin tails and booms stretching out behind the engine enclosure was recorded mentally. After returning to the studios, Mr. Earl immediately put the designers to work adopting the ideas to automobiles. Small models of automobiles embodying the P-38's characteristics were made."[45] Earl impressed upon his men the significance of the bulky pontoon shape of the P-38 and encouraged them, as he later wrote, to "soak up the lines of its twin booms and twin tails." The fishtail, he said, "helped give some graceful bulk to the automobile."[46]

Both Hershey and Mitchell went off to fight during the war, but neither forgot Earl's fascination with the P-38 design. Hershey returned first, in 1944, and as chief of the Advanced Design Studio, he began to formulate the new Cadillac, the company's postwar style leader. According to Hershey, his concept at this time began with the monocoque models completed in 1941: "When design work got going again, the first car pulled off the shelf was the 'Interceptor,' as the P-38 design was labeled."[47] From then until March 1946, the Hershey team, with Ned Nickles as chief assistant, drew two-dimensional prototypes (Figs. 65, 66) and created a full-scale model, known as the "C.O."(Fig. 67).[48] During these same months, Nickles also supervised the prototype for the GM compact car, and these two models looked very much alike. In both, a full-envelope shape enclosed the wheels, and chrome extensions linked the front with the rear. "That was in the wind then," Nickles says. "It was just the thing to do . . . small wheels allowed a longer look with two chrome strips from bumper to bumper."[49] Specific features of the P-38 were pronounced in the larger C.O. design, especially the bubble-cockpit windshield and pointed pontoons. The unified appearance of the C.O. was typical of cars designed during the war; not only was the shape all-inclusive, but the lines of the horizontal grille blended into the massive bumper, which extended as a chrome strip along the side.

A prejudice by today's designers and critics against the monocoque shape obscures its high standing with Detroit designers during the war. Similarly, the current fascination with the P-38 and the influence of its fins on car design overshadows the actual events of 1946 that led to the creation of the postwar Cadillac (Figs. 74, 75). It was in the fall of that year that Bill Mitchell returned to head the Cadillac studio, and while he was there, changes suddenly happened.[50] He recalls, "I had just come back from the Navy, and we drove out to the farm to see a model that Frank Hershey was doing at his home. . . . The car was modeled, and it looked like a turtle to me. It was so covered up and everything." According to Mitchell, Harley Earl appeared one day at this time and abruptly

changed his mind about the monocoque design. Earl simply said, "To hell with that big blown-up thing!"

Earl's decision to drop the beltline had a tremendous impact on all postwar GM design. Earl made up his mind "all of a sudden," Mitchell remembers. "He came in one day, threw it out, and put the fender down—right through." From Mitchell's perspective, the decision to abandon the World War II car type was a turn-on-a-dime move typical of Earl: "You have to always be in a position, if it doesn't go over, to get off the boat and run. That was where Earl was clever. If he saw something wasn't going, he wasn't a diehard. . . . Earl just came upon the fact that it would look longer and leaner if you divided it and got that [belt]line."

While it may have seemed to Mitchell and others in the studio that Earl had made a snap judgment, Earl usually formulated a direction and made a decision after surveying the visual information around him.[51] The critical months before Earl completed the Cadillac design provided crucial new sources for him. In the fall of 1946, jet-powered fighters were making their first public appearance, and they displaced the propeller-driven P-38 in the imaginations of designers. Unlike the propeller craft—whose fuselage looked like the bulbous monocoque—the jet shape resembled the slimmer and more sculpted profile Earl later selected for the postwar Cadillac. In an unveiling in February 1946, *Aviation* magazine described the Lockheed Shooting Star (Fig. 71) as "marked by unusually fine finish and streamlining," and like the false air intakes on the 1948 Cadillac, the actual openings on the fighter created a low and sculpted through-line.[52] As the volumes changed from the thin, razor edge on the front to the rounded tail fuselage, they significantly modified the typically bulbous monocoque. As a commercial airliner, the revolutionary Lockheed Constellation perhaps was the dominant visual form of this era, and its undulating S curve and tail section established stronger analogies to the production Cadillac than any previous airplane design.[53]

Although Earl was ready to "confess . . . that I have been deeply affected by airplanes," he usually relied on multiple sources rather than on "one-liners."[54] It is known, for example, that Earl bought one of the first postwar Studebakers (Fig. 57) in the fall of 1946 and brought it back to the studios for his designers to study.[55] Perhaps it was only coincidence, but on the Cadillac (Figs. 74, 75) they created a projecting rear fender strikingly like the Studebaker's. Virgil Exner, the designer of this Studebaker, describes the reasoning behind the new fender line; he especially points to how it lightened the effect of a flush-sided car, and this logic could not have completely escaped Earl: "We built a full-sized wooden mock-up. . . . This was a flush-sided job, and that's what convinced me that the first postwar car shouldn't be completely flush-sided. It should have a pontoon fender because of the beltline at that time. It seemed to have an awfully heavy look."[56]

Earl may have borrowed more than the effect of this single device, for in the Cadillac he smoothly integrated this projecting fender with the rest of his design in the same three ways as on the Studebaker. In both cars, a lowered beltline links the headlights to the taillights, and the rear fender merges with them as a single

volume; above it, the hood extends as a small band beneath the windows into the deck and trunk lid; beginning with a false air vent on its lower edge, the rear fender projects into the shape of the tail bumper and, on the Cadillac, becomes part of the bumper itself. By means of these separate but integrated volumes, Earl emphasized a series of continuous horizontal highlights and achieved a longer, lower, and sleeker look than in the original C.O. design (Fig. 67). Earl was very satisfied with the results and designed the full line of GM postwar cars around them. The new Chevrolet, for example, showed a similar combination of features (Fig. 76). The design for the flat-sided Studebaker can be traced directly to sketches made by Robert Bourke in the Loewy studio and to the preference of Raymond Loewy for the slab shape (Fig. 56). Earl, by contrast, emphasized gently rounded curves in the Cadillac and Chevrolet, and in this sense, Earl still kept within the limits of his own taste. Compared with the proposed massive C.O. car (Fig. 67), however, he substantially modified his preference in tune with new trends from Europe represented by the Studebaker.

While the GM family of cars depended upon the Studebaker as one important source, the Studebaker design hardly explains the whole picture. In Europe, Pininfarina revealed his Cisitalia coupe (Fig. 72) to worldwide acclaim in September of the critical fall of 1946.[57] He created a sleek round shape unlike the bloated American wartime car. Pininfarina accentuated the tight outline by the thinness of chrome trim, the delicacy of reveals around windows and wheels, and the tautness of surface undulations (contemporaries described the surface as a "smooth metal skin").[58] While the massive bulk and thick reveals of the American wartime car (Fig. 68) shared a certain roundness with the Cisitalia, these shapes hardly related to the interior, and the thick chrome ornament spread well beyond points of accent on the exterior. Combining style currents from both sides of the Atlantic, Earl retained some of the "graceful bulk" of the American wartime fashion, but he pared down the bulging sides, narrowed the chrome strips, and sculpted the curves into tighter surface undulations (Fig. 75).[59]

Men like Dave Holls, who joined the Cadillac studio in 1952, describe the impact of postwar Italian sports designs like the Cisitalia as second only to airplanes in their impact on designers. Mitchell, who headed the Cadillac studio during this period, admits to having been crazy about European sports cars.[60] Earl himself described his attraction to foreign cars and his desire to keep up with the latest trends: "Foreign makers have interested me for years and, except for the war period, I have never missed the Paris automobile show."[61] Just before the war, Bugatti, Talbot, and Delahaye created a cult for the small, sporty, two-seater French coupe, and together with the tight, smoothly undulating shape of the Cisitalia, these European sports cars surely added to the sources Earl perused before he "suddenly" altered the direction of General Motors' postwar design.[62] "The other boys didn't do it, and they looked like bloated pigs. Packards [Fig. 35] and all of them," Mitchell ruefully comments on the smaller manufacturers who committed themselves too soon to American wartime shapes. Gregorie and Earl expressed their personal tastes in the first postwar GM and Ford cars by blending

the influence of European-inspired design with the prevailing American wartime style (Figs. 50, 74). The direction for Gregorie was from the continental styling supported by Edsel to a more defined and "meaty" appearance; for Earl it was just the reverse, from the standard World War II bulbous car to a more pared-down and sculpted look.[63] The synthesis he achieved became the basis of GM postwar design, while Gregorie's blend was immediately discarded at Ford in favor of the European styling of the slab-sided Studebaker (Figs. 61, 57).

Loewy, Walker, and the Postwar Studebaker and Ford

Studebaker was in a unique position during the war because its styling was handled by an outside consulting firm, Loewy Associates, that was free to work on nondefense projects.[64] Studebaker took advantage of that situation in the spring of 1946 to introduce the first all-new postwar car. Loewy was well aware of his unique position, and he expressed a design philosophy quite different from the accepted wartime bathtub approach: "An independent, in order to succeed, must be courageous and progressive. The results may be somewhat of a shock, but it is far better than blandness."[65] In 1943 his studio began to design the Studebaker; Robert Bourke, Holden Koto, and Richard Caleal made up his project team, and Virgil Exner led it.[66] Although their collaboration fell through, three of the four directly contributed to the design of the 1949 Ford, and that Ford represents a fulfillment of their Studebaker concept.

The specific design philosophy and project goals for the Studebaker can be learned from Loewy, who in 1943 criticized the appearance of the American car as too bulky and laden with chromium "spinach and schmaltz." Reflecting his European background, Loewy aimed for slimness, grace, and better visibility: "Weight is the enemy . . . whatever saves weight saves cost. The car must look fast, whether in motion or stationary."[67] He and Bourke illustrated these ideas in sketches (Fig. 56) showing cars with expansive glass, minimum chrome, flat sides, sharply creased center wind-sweeps, and spinner grilles.[68]

In one of the classic dirty tricks in the car industry, the Loewy design team had the rug pulled out from under them with help from one of their own designers. In the early spring of 1944, Studebaker Engineering Vice-President Roy Cole and Board Chairman Harold Vance approached Virgil Exner and asked him to complete a new Studebaker car secretly in his own basement. Not unexpectedly, they selected his design over the proposals of Loewy, whom Cole had supplied with incorrect dimensions.[69]

Although he broke with his colleagues, Exner reused many of their ideas. According to Bourke, "Ex took most of the materials we had developed prior to the split. . . . Not surprisingly, most of our ideas were pretty much in line with each other's. Ex was working along principles he and I had previously developed with Loewy."[70] Koto confirms this agreement: "We were all kind of working the same way there."

Seeing their ideas for the Studebaker go out the window, the Loewy team

found a roundabout way to realize them in the design of the 1949 Ford. In September 1946, Ernest Breech set the stage for an all-new Ford when he transformed Gregorie's Ford project into a Mercury. "I have a vision. We start from scratch," Breech decided, and pushed back the Ford introductory date at least a year.[71] Chief Engineer Harold Youngren worked out a formula that set unusually numerous and strict limits for the package. Breech then asked his friend, industrial designer George Walker, to submit an alternative model to the in-house project of Bob Gregorie.[72] After a competition among his staff, Walker selected the model that Richard Caleal had prepared with the generous help of former colleagues Robert Bourke and Holden Koto, the core of the initial Loewy team. The group created the quarter-scale model (Fig. 58) in Caleal's home and baked it in his oven, and then Walker enlarged it into a full-scale model at the Dearborn plant (Figs. 59, 60).[73] Walker and his assistants, Elwood Engel and Joe Oros, managed to incorporate some of Gregorie's ideas and a few of their own but largely kept the Studebaker concept from the quarter-scale model. In describing the concept of the car, Walker seems to repeat Loewy's earlier objectives: "Practically all cars at that time had bulging sides, particularly around the front and rear fenders. We smoothed those lines out and began the movement toward integration of the fenders and the body" (Fig. 61).[74]

The connection of the 1949 Ford to the postwar Studebaker goes beyond philosophy, design, and designers, to actual engineering and construction. Ford, like GM, immediately purchased a Studebaker, and the Ford engineers lost no time disassembling it. They weighed and tagged each part (Fig. 57) and used the figures to guide Youngren in packaging his "formula" car.[75]

In describing his part in the Ford competition, Gregorie argues that the dependence on the Studebaker and the strict limitations set down by management allowed very little leeway for styling of any kind.[76] "The all-new Ford, as they called it, was based on a Studebaker. They just simply had the Studebaker out there at the test track. They had it all measured up," and from it the Engineering Policy Committee established the dimensional specifications: "It was practically a blueprint for the car, except for the skin on the outside. . . . That was a Policy Committee car, a formula car. Dimensionally, mine was practically the same as the one they built." To explain the number of restrictions, he lists among the given dimensions: window height, shoulder width, headroom, body and fender depth, panel surface, and hood length, in addition to the overall length, width, and height. Besides limiting the dimensions, Youngren's committee also wanted the car to *look* somewhat like a Studebaker. Walker says that they didn't want anything broken down the sides, and Gregorie agrees, "What they wanted was a straight slab-sided car like the Studebaker. . . . They wouldn't have put up with any offsets in the panels, or anything like that. It costs more money for dies and metal finishing. What they wanted was a basic bread-and-butter car, which is what resulted."

The question that remains, then, is this: Given the rigid dimensional requirements, is Gregorie right when he says that both projects (Figs. 54, 55, and 59, 60) "for all intents and purposes . . . were basically the same cars"? or does the truth lie

with Walker, who replies that the designs were fundamentally different? Without trying to be diplomatic, I think we can say that both are right, or at least partially right. Although the direction of design and the basic specifications were very close in each case, the personality of Gregorie—as opposed to the approach of the Loewy studio—comes across strongly in his project. Gregorie's self-described preference for defined and meaty shapes distinguishes his from the tighter, sharper, and more flowing lines of the final product. For example, in Gregorie's model, the trunk projects as a massive round shape separate from the full form of the rear fender (Fig. 55). The beltline below the window tucks in more fully on the Gregorie model, and the sides bow in two gentle swells, in contrast with the production Ford, where a pure slab descends on the side and a spear molding is simply applied to it (Fig. 61). In the Gregorie model an added bulbous swell extends from the rear wheel opening and connects the bumper as part of the body.

The swelling forms of the Gregorie design may have been influenced by the appearance of the postwar Kaiser and the purchase, examination, and photographic studies of this car by the Ford design staff in October 1946 (Fig. 52). In that month, Gregorie prepared models closely resembling the Kaiser (Fig. 53) and completed a quarter-scale model of his postwar Ford design. The next month, in his first full-scale model of the Ford, Gregorie partially masked the indent on the side of the body with a decorative spear, restricted the grille to the radiator opening, and ornamented the hood with a wide parallel strip—a trademark of Gregorie's designs during the war. In the final competition model, however, he left the indent on the side exposed, widened the grille to include the parking lights, and added a new hood with a narrow crease line, corresponding to the design on the rear deck (Figs. 54, 55).

A portion of Gregorie's distinctively rounded design actually may have found its way into the production Ford.[77] In his first full-scale model, Walker attached vertical taillights to the initial Koto-Caleal design, which originally had sloping rear fenders (Fig. 58). In the production car, however, Walker modified this tail section into a curved projecting shape (Fig. 63), similar to the design on the Gregorie competition model (Fig. 55). According to Walker, he made the change to alleviate the impression of a severely flat slab: "It was naked back there. It needed a relief." Following the curved outline he added a horizontally set taillight and combined it with a sharply projecting side molding: "As the highlight line came back [around], it had to have a break or something to make it look more important." This change converted the light from a vertical extension of the flat slab into an integrated part of the body. Walker justifies this change to his first full-scale model: "If it weren't for that [break] on the side, it [the light] would have just been floating in the air."

In the end, the exceptional appearance of the Ford may owe less to Loewy's team and to designers like Walker and Gregorie than to experienced modelers at Ford, to Walker's assistants Oros and Engel, and to the collective design process itself. There is an unexplained quality of smooth, irregular volumes, seen, for example, in the hood (Fig. 62). The shape of its rounded forms is neither bulbous

nor consistent, and its undulating surface, delicately scored in the center, smoothly merges with the fenders and lights on the sides through a series of irregularly changing curves. The roof partakes of this smooth, uneven flow, and it, too, is delicately pinched in the front, dying off as a wind-sweep in the back. The quality of subtle modeling is especially evident around the windshield (Fig. 61), where the sculptors took the basic quarter-scale shape (Fig. 58) and molded it into taut, concave, and shifting surface curves.

The chrome detailing of the grille (Fig. 62) perfectly complements these simple, smooth, and irregular volumes. The airplane motif with spinner and wings lacks the heaviness of chrome, regularity of shape, and imbalance of size of the grille openings sketched in the Loewy studio (Fig. 56).[78] The upper chrome bar echoes the irregular volumes of both the fenders and hood in a series of broken, uneven curves, and it serves to outline, not to dominate, the dark spaces of the grille. In the end, the balance and continuity of these many irregular forms combine with the overall simplicity of shape to make the 1949 Ford a great American car.

Indeed, the Ford is a rare example of a committee, or a group, that pieces a design together, producing a car worthy of a place in a museum of art. The frustrated creativity of the Loewy studio, the successful ambition of Walker, the doomed but noble effort of Gregorie, and the long-time experience of Ford modelers all played a part in this unique synthesis.

The artistic and economic success of this car largely determined the design direction of the company and ensured the victory of Earl's system over Gregorie's. Breech was committed to the GM design process, and subsequent to the success of the 1949 Ford he installed Walker as vice-president of styling. More visually skilled, if lacking Earl's incomparable presence and critical discernment, Walker was a tremendous salesman who believed that design was an indivisibly collective process. That idea, that the creative act is above all a group activity, we owe to Earl, as the primary source, and to GM, as the working model. Earl's assumption and his working methods underlie the history of modern American car design and distinguish it from other fields of commercial art. Having literally created their own jobs, designers like Earl and Walker could lead with their singular personalities and push for their ideas, yet they believed that committee action is the cornerstone of creativity. Walker faithfully credits all "nine hundred craftsmen when I was at Ford Motor Company"—even the sweeper who cleared the way, the modeler who sculpted the clay, and the "jewelry guy" who made hood ornaments. They all contributed to the final product: "I helped them. But because I was vice-president during that time I got credit for it."

THE MODERN ERA

Even with the best intentions to be impartial, no one studying modern cars is going to be as detached as someone writing about art from a distant historical

perspective. It might be argued that General Motors in particular has been criticized for its present as well as its past cars, and, in a certain sense, that reflection is true. After all, a major conclusion of this book has been to show that the collective and anonymous system Earl invented at GM made it impossible for outstanding individual designers like Gregorie and Hershey to work within the profession.

If the truth be known, however, I criticize the current generation of GM stylists out of a grudging admiration and respect, in the belief that their work, even if it is not all it could be, is still miles ahead of other American designers in taste, complexity, subtlety, and in just the basic skills of design. For all its drawbacks, and however much it mirrored his deficiencies, Harley Earl's system of corporate car design survives at GM largely intact, and it consistently produces the best cars of any large automobile company. The level of General Motors quality can be seen from the sampling of outstanding designers interviewed here: Except for Walker and Gregorie, who were trained in nonautomotive design fields, all the others apprenticed with Harley Earl at General Motors. In fact, Earl and his design system so dominated the profession and so monopolized talent for more than fifty years that the company policy was not to hire top designers from other firms. The only significant designers who practiced elsewhere were either GM refugees, such as Virgil Exner at Studebaker and Frank Hershey at Ford, or nonautomotive industrial designers, like Raymond Loewy.

The consequence for other companies of GM's near stranglehold on talent has been predictable. When smaller firms tried an individualistic design, like the Airflow in the thirties, the monocoque in the forties, or Raymond Loewy's Studebaker in the fifties, they usually lost money, and most companies became resigned to playing catch-up with whatever styling trend General Motors set. It is no exaggeration to say that after Hershey left Ford and Bill Boyer completed the 1961 T-Bird, GM's main rival did not produce an automotive design of distinction. Even best-sellers like the Mustang showed little originality or subtlety; only since 1980 has Ford pursued a design direction significantly different from that of General Motors.

Few would disagree with this assessment of the styling of non–General Motors cars during the postwar years, but many would dispute the value of the GM designs during the same period. There is a prejudice in the air today against large cars made in the thirty-five years since the war. Wherever the prejudice is originally derived—from a concern over the waste of fuel or a reaction against gas-guzzlers—certainly recent General Motors design leaders have endorsed this opinion opposing Earl's ostentatious cars. If instead of being criticized by contemporary standards of practicality and morality, these cars were judged on their design appearance alone, I think a fair assessment would show that Earl hit his stride by 1955. In GM show cars of the mid-fifties (Figs. 79, 80), Earl combined his constant love of large, rounded, and original forms with a new sense for muscular, powerful, and refined irregular swells. With these new complicated shapes, he expressed both his own artistic preferences and the strength Americans felt in the world at this time.

Earl's Fifties' Designs

In his first postwar vehicles (Figs. 73, 74), Earl created a distinctly American design by combining the sleek and tight curves of European cars (Fig. 72) with the more fully rounded American monocoque developed during the war. During the next decade, Earl widened the typically European small radius curves to include more fully rounded shapes, and the result was a distinctly American car type that reflected the self-confidence and self-reliance of the country. In the Wildcat III show car from 1955, for example, he no longer depressed the fender line beneath the hood, trunk, and the rest of the car but integrated it into a more upright and closed shape (Fig. 78). Complementing this idea, he defined and articulated the form with muscular ripples on the surface (1953 Corvette; Fig. 115), not with curves dividing the body itself. Enhancing the power and dynamism of the whole, Earl replaced delicately irregular shapes, like the gentle, tight radius curves around the hood and lights on the '48 Cadillac (Fig. 74), with massive but no less subtle or irregular swells.

In the early fifties white pigment, the most reflective paint, became stabilized enough to avoid uneven chalking, and Earl immediately used it to highlight his new massive shapes in pure whites and two-toned high-value colors like salmon pink (Dupont's most popular shade for 1954).[79] By the mid-fifties he further stressed unity by "color coordinating" entire shapes in hues of turquoise and coral pink from the steering wheel and upholstery down to the hubcaps. Chrysler's design chief, Virgil Exner, perhaps best exploited this industry-wide concept. As he explained in 1953, color harmony introduces a third dimension in automobile design, becoming as important a sales factor as body styling and engineering. He predicted that Plymouth would "establish a new era in styling with the introduction of a new series of cars whose interiors right down to floor mats will be keyed harmoniously to their two-tone exteriors."[80]

Harley Earl's concept of chrome changed to meet this new coordinated vision. He thought of chrome no longer as a delicate finishing touch—what Frank Hershey called a "Tiffany" grille on the Cadillac—but rather as a complement and extension to the shifting masses of the whole. In the case of the Buick, this chrome extends as parts of the body, like delicate lips around a mouth (Fig. 78). He also developed a new vocabulary of chrome details to coordinate the organic masses. The "Sweep-spear" was an Earl favorite, and he used the gentle, curved S line to coordinate the full length of the Wildcat design. Earl frequently used a more dynamic line—the "Blitz Line"—to join the upper to the lower body through a whiplash curve (Figs. 88, 89). A top designer from the fifties explains the interweaving of chrome lines and body swells in the 1958 Buick: "The drip line [the molding above the side window] becomes the rear-window molding. As one continuous molding, the C line [the rear pillar] just swept it [the drip line] all across the doors and down the back and across the base of the rear deck."

The importance of these new "muscle flex" bulges and curves within the whole

was best demonstrated by the designer, Homer La Gassey, Jr., as he drew a summary concept sketch at the time (Fig. 79). La Gassey headed the Wildcat III project as the assistant studio head under Ned Nickles, and his sketch presents the final project as a continuity of massive projections: the bulge of the bumper; the round, protruding rear fender; the mounting swelling over the rear wheels—all ending in an open, mouthlike grille.[81] The car reads as total shape without an upper. Indeed, La Gassey admits that "we never put a top on it. I don't ever remember even drawing a top for it." Unlike GM's postwar cars of the forties, in which Earl's lifelong preference for massive and rounded curves was somewhat contained within the delicate details of tightly undulating surfaces, these cars express a new dynamism and power within a single form. This is a truly monumental and original American statement that grew out of the postwar synthesis of American and European styles.

La Gassey believes that the powerful bulges in his car reflect postwar American design training and aesthetic sources. For him, World War II was the watershed between the "old school" of "profile designers" and a new approach based on a "three-dimensional understanding" of design problems: "What you recognize [in the Wildcat] is the art form. The generation after the war was properly trained, and they could draw things in perspective. Only a few before the war really could design the car in perspective so that you could 'cube the car'—that is, walk around it with a pencil and look at it from all aspects. All of a sudden a new art form, a new visual control, had come into the automobile: We could sense the other side of the car. We could feel that we had a hand on it. This was a 'second sensitivity,' we called it. We could conceive it in our mind's eye and then draw it in perspective on a flat piece of paper or two-dimensional form. So there was nothing we couldn't do. The earlier guys were not trained this way. They were trained as draftsmen in the old European body school to see things in profile, drawn in front, side, and top elevation."

La Gassey recognizes that the sources for his Wildcat design were distinctly American and different from those of prewar cars. Like so many designers of his generation, he was drawn to the new shapes of American jet planes, power boats, and racers: "I was in the Air Force, and Rybicki and I followed the power boats down the river, the big hydroplanes. We were always around fast equipment like the racers at Indianapolis. In my designs I brought a lot of that with me. I could see these aircraft shapes and the big hydroplanes. That power shows in my cars. That was part of my background, as opposed to copying a 1927 Delahaye in Europe. I was after speed forms and fast shapes, a power-swift movement."

The attraction of these new American forms was not just their brutish strength but also their simplicity. La Gassey explains how he expressed his interest in three-dimensional, powerful movement through unadorned sculptural shapes: "We went for simplicity. There was a lot of chrome around at that time. We cleaned up this car. We took a lot of chrome off of it and went more for the sculpted shape on the side. We started getting sheet-metal sculpture as opposed to applied chrome all over; we started to bend the sheet metal just a little bit

differently, with undercut cavities. [We achieved] sculpturing—meaning three-dimensional curves going in several directions—as opposed to chrome appliqué or simple curves."

He applied the three-dimensional curves in several directions, to small details as well as large ones. For example, he extended a crisp wind-sweep into the projecting, flared reveal above the grille: "You will see that [flared reveal] on the front of my full-size rendering [Fig. 80]. That car was very delicate for the times. Everything was shrunken down. It was all delicate and refined." He merged the fine details on the side of the grille into this dynamic, organic sculpture: "It has the oval front end, what we call the rubber-band front end, and then the bombs come off the corners into two chrome blades. Those couple of razors come off those Dagmars and then wrap around the fenders." In the original project (Fig. 78), he aligned the curved inset in the hood above the grille with the side-sweep, extending this small sculpted detail the full length of the car: "That was a 'sculpt' thing that came right off the offset of the hood and came right around the mouth of the grille. Again, I have to say that it was delicate for that moment in time."

The Wildcat III was a typical mid-fifties' show car: fiberglass, one-of-a-kind, and monumentally impractical. Designers called these show cars "pushmobiles" because to achieve a car eight to fourteen inches lower than anything on the road they had to "cheat." They provided an engine barely strong enough to move the Wildcat III and forced the passengers to stick their heads completely above the windshield. According to La Gassey, at the showing in New York the car was tilted off the floor to hide this jacked-up seating arrangement.

Earl perhaps best stated this new mid-fifties' aesthetic with a production car like the '58 Chevrolet (Figs. 82, 83). Once again, he used asymmetrical, bulging, and muscular shapes to articulate a rather upright and full body. It is a moving experience to watch the changing, full swell of the rear fender (dubbed a "barrage balloon" by Chevy designers) as it encounters the more regular and squared-off trunk.[82] The trunk is hardly static, however, as it rises in the center with subtle entasis. The play between these two voluptuous shapes creates a shifting valley above the continuous crack of the trunk lid, where they meet. Earl described this meeting as "baby assing," and it is that effect of irregular curves coming together that gives a fleshy, complicated, and powerful definition to the whole rear end. This movement is delicately set off by a thin chrome line that charts the path of the undulating form and reveals, especially in the two-tone model (Fig. 83), a complete underform extending along the side into the rear of the car.

It would do a great injustice to the originality and scope of these designs to dismiss them as exercises in appliqué and chrome, typical of all late-fifties cars. Without arguing the virtues of appliqué and chrome—although they are many—I think that a strong case can be made that the articulation, complexity, and power of the Chevrolet and Wildcat derive from shifting forms, not from surface ornament or bulk, and that the chrome on these cars complements the large new moving shapes. As the culmination of Earl's thoughts on style at the time, the design of these cars amounts to a new aesthetic direction.

Insiders' accounts verify that Earl changed his thinking about design in his last years as vice-president. True to his nature, he orchestrated three rapid turnabouts within three years. The first, a panic-stricken response to Chrysler's fins (Fig. 87), took place in the fall of 1956, when Earl applied hundreds of pounds of chrome to the 1958 Buick (Fig. 88) and Oldsmobile in a last-minute attempt to freshen their massive, rectangular bodies.[83] Two other cars from 1958, the Chevrolet (Figs. 82, 83) and Pontiac, appeared with completely new sheet metal, revealing the direction of Earl's long-term thinking before the Chrysler debacle. In the '59 models (Figs. 91, 92), conceived during the last years of his reign, Earl brought about a final change: He synthesized his long-term aesthetic goals with new ideas, stimulated by his competitors at Chrysler and his successor at GM.

Bill Mitchell vividly recalls the panic that the sharklike appearance of Chrysler's fins created in the fall of 1956. Pressed for time, stylists developed themes directly in clay: "When the panic hit, the Chrysler thing, some of that stuff we did really fast, without drawings." Stanley Parker remembers the spur-of-the-moment chroming of cars like the 1958 Buick. Returning from the service in 1956, Parker became Ned Nickles's first assistant, and in 1958 he inherited Nickles's position as Buick chief designer. "Buick was the prime field for doing design because Harlow Curtis was with Buick [as general manager] before he became GM president. Buick was the prince of the whole design staff—Curtis was not about to compromise Buick. . . . In 1956 Chrysler came out with their line of cars with thin uppers: It came as an absolute shock to General Motors. And I recall there was a crash program on the '58 Buick [Figs. 88–90] to do something to get it off the old look. The rear quarters were tooled and the doors were tooled, so the transition had to be done by die inserts in the rear doors and in the quarter-panels. About eleven o'clock in the morning, Harley Earl called us together and told Ned Nickles to get Stan Parker to put one hundred pounds of chrome on the sides. So I worked all through lunch doing chrome side-vellum-overlays on the rear quarters, including the rear door on the four-door sedan. It was an insert on the old Buick sweep-spear—just where it comes down and takes a jump over the rear wheel. I worked all through lunchtime making the overlays, and Earl came in after lunch. I had done about eight or nine different ones, and he said, 'Well, I thought I told you I wanted one hundred pounds of chrome. You only have eighty pounds here!' " Complementing the massive tail section Parker created, Earl burdened the front with a "Fashion-Aire Dynastar Grille," consisting of 160 small faceted chrome squares topped by eyelidded "Vista-Vision" dual headlights. With all these last-minute "soft-trim" changes, fifties' designers said that this Buick, more than any other car (with the possible exception of the '58 Oldsmobile, nicknamed the "King of Chrome"), "sang with stinkle" (shone with glitter).[84]

It would be a mistake to think that Earl wished, in the language of the industry, to "throw on chrome with a trowel." A top GM designer expresses the widespread belief that Earl supported undirected excesses in his last years: "Earl really got stuck at the end. He really didn't know what to do for '58. He made us do heavier bumpers, more chrome: 'Let's try this on the end of the car, and try this on the

front of the car. Then I'll decide what we take off.' And he never took off anything. He really was lost." Seen from the perspective of history, however, Earl's reaction to Chrysler's new aesthetic direction indicated the force of circumstance and not the direction he was pursuing on his own. When, simultaneously, Chrysler put the gun to his head and the public refused to buy his ponderous '57 Buick, Earl responded as best he could, by masking the bodies he inherited.[85]

Completely redesigned cars like the '58 Chevy, conceived before the Chrysler's 1956 fall showing, prove that left to his own devices Earl preferred to shape form rather than ornament it. Writing in 1955, Earl made this very point about the car stylist's role: "His is the task of making these useful things beautiful, not in the sense of applying superficial surface ornamentation, but in developing a form of beauty . . . evolved from within."[86] One top body-room expert recalls Earl's implementing that direction: In the 1958 models "came the philosophy of putting the shape into the sheet metal rather than adding on the moldings. That became the general theme. If you take a look at the '57 cars, you don't see much sculpturing in the sheet metal. But, in the '58 Chevrolet [Figs. 82, 83], you started to get a little sculpturing along the sides with an indication of wings."

After only one year, in 1959 the completely restyled '58 Chevrolet and Pontiac were replaced as part of the revamped GM lineup. The glittering chrome face-lift of other '58 models (Fig. 88) and the striking wings on the next generation of '59 cars (Fig. 92) overshadowed these subtle, short-lived models and obscured the important new trend they initiated. But their significance can be judged by Earl's financial commitment (the routine tool-and-die bill for the 1958 Chevrolet was in excess of $400 million) and his design response to them: Earl never reversed the seminal first steps he took in 1958 toward what GM designers quickly termed "body side-sculpturing." GM designers even came to justify the direction as "putting design back into the car," and Chevy's ad agency trumpeted the new theme as "sculpturamic fender styling." Meanwhile, their engineering counterparts at Fisher Body resigned themselves to the same change with different words: "torturing sheet metal."

Exner and the Transition to Mitchell

Earl hit snags with this initial attempt in the '58 Chevy to "design" sculpture into the large, rounded shapes he had favored since the thirties. The biggest and most unexpected obstacle was the "Flightsweep styling" of Chrysler's "upswept" fins. As a top GM designer recalls, Earl realized that he had to lighten up his designs as he moved into a new era: "I don't think Earl ever considered that he followed Chrysler because, as you look at the side-sculpturing, it in no way was a take-off on Chrysler. But it was an indication that the American public was tired of the old bathtub-looking cars. They wanted something more entertaining."

The mastermind behind the novel Chrysler scheme was the former Pontiac studio chief from 1934 to 1938, Virgil Exner. When he was appointed Chrysler design vice-president in 1952, he faced the reality of a contemporary joke: "Leave a

Ford and a Chevy in the same garage overnight and nine months later you get a Plymouth."[87] Exner's first task was to become design competitive, a goal he achieved with the lineup of new "Forward Look" cars in 1955. Testing the water, in 1956 he grafted delicate, upswept fins onto these models and created beauties like the Chrysler 300B hardtop coupe. Then, throwing caution to the wind, he integrated larger fins into a radical, "Suddenly-It's-Nineteen-Sixty" shape for 1957. The crisis Earl faced came not so much from a new device, in the form of a fin, but from a significantly new approach to styling that lightened the entire design package. According to Exner, "An automobile cannot be properly styled unless it is first conceived as a whole unit. The theme must be a single one to which all components are intimately related." He selected none other than Homer La Gassey to be his chief designer responsible for the '57 Plymouth (Fig. 87) and Dodge.[88] La Gassey explains that he produced these cars in eighteen months and based them on new functional and aesthetic considerations: "The fins came out of the theory that Virgil Exner had. He wanted to move the stabilizing forces, the center of pressure, toward the rear of the car. He was a race-car nut and had a lot of good theories about driving pressures." Exner contended that the high, upswept fins stabilized his cars in crosswinds.[89] For the aesthetic shock to be profound, it had to include more than fins, however functional. His aim was to thin the body section, especially on the upper, and expose sheet metal as a delicate membrane, as around the lights on the Plymouth. These cars were six to seven inches lower than their competition from GM, and they were wider, sleeker, and airier, as La Gassey recalls: "We went for low and a lot of glass in the uppers. And we changed the proportions of the car. In the forties and early fifties, the ratio of upper glass to lower sheet metal was about one to three. In the '57 Chrysler fin cars, we changed the ratio to about one to two, with the big glass upper, large fins, and wider tread."

The pressure on Earl to lighten up aesthetically also meant releasing his administrative and artistic control. Anticipating retirement in 1958, Earl began to take a less active role by permitting his replacement, Bill Mitchell, more freedom to develop the '59 models. Stanley Parker noticed that, as Earl "groomed Mitchell to be his replacement," Mitchell responded to the opportunity by pushing a new aesthetic direction: "On the '59 program, Mitchell said, 'Go as far out as you can go.' It was just one of those things where you pulled the stoppers out and went as far out as you possibly could [Figs. 91, 92]. When Chrysler came out with the fins, everyone said, 'Let's out-fin Chrysler.' " Mitchell himself describes the turnabout with very similar words: "Those two years [were] when the chrome was just put on, lards of it. And then, in [our models for] '59, Chrysler scared us with the fins. They lowered the car and really scared us into a trap. We had been lading [on chrome], and we panicked. Harlow Curtis was in charge, and it just scared him and Earl. So we tried to out-fin." The move toward thin uppers was a truly fortunate coincidence for Mitchell, for it allowed him to implement his long-standing taste along those lines. Throughout his life, Mitchell preferred what he called the Sheer Look of trim and creased cars, and he loathed GM's postwar aesthetic of fully rounded shapes.

With Mitchell eagerly waiting in the wings, Earl responded to Chrysler's move by altering his experiments with surface modeling in the '59 lineup. From his central vantage as body-room chief, Vincent Kaptur, Jr., explains specifically what happened after 1956 as a conjunction of events, with Earl very much in charge. Kaptur begins his story in the summer of 1956, while Earl was preparing to leave for Europe on one of his annual tours of automobile shows. Normally, cars were introduced to the public in the fall, and therefore in the summer there was a rush to put "to bed" the program three years hence. Before he left, Earl decided to use the shape of his 1950 Le Sabre (Fig. 77) as the basic design theme for the '59 line of cars. Indeed, he was so adamant about using the Le Sabre as his "lead car" that he prevented designers from touching the car. Instead, he wanted a "surface man" (a technical stylist) to take the proportions of the Le Sabre in the body room and "proportion it up" to a production-sedan size. Following Earl's directions, a design draftsman worked more than two weeks making detailed surface drawings of the Le Sabre as a sedan.

Earl responded very favorably to these drawings, and he described the sedan as a "beautiful thing." Most of his designers, including Mitchell, had the opposite reaction. They could not imagine turning a low-proportioned car like the Le Sabre into a sixty-inch sedan. Despite their objections, Earl gave the go-ahead for a full-size clay model to be built while he was away in Europe. As the number-two man in charge during Earl's absence, Mitchell became very upset when he saw the results. Earl was expecting to show the Le Sabre sedan to President Curtis in a triumphant unveiling, and Mitchell felt that there was no way his boss would want to exhibit such an ugly thing.

Not wishing to decide the lead car himself, Mitchell sent photographs of the model to Earl, and shortly thereafter work suddenly stopped in the body room on the Le Sabre sedan. Not much time passed before a meeting of top design brass took place in the conference room. Chief Designer Joe Schemansky passed around pictures of the latest Chrysler products that he had taken through the fence of the Dodge main plant; everyone laughed at the big fins, and some, recalling the Chrysler debacle of the thirties, observed that "here is another Airflow in the making."[90] The laughter stopped in the fall, when the body room received word to do fins after the Chryslers sold well.

In hindsight, the shift in design at GM in 1959 occurred in two stages: First, Mitchell prompted Earl to take a second look at his Le Sabre project, which caused the 1959 lead-car prototype to be suspended in the summer of 1956; then, with the success of Chrysler's products in the fall, Earl warmed to Mitchell's aesthetic ideas. Earl allowed Mitchell to infuse the current interest in bold surface modeling with lean, sharp forms and a taste for the way-out.

Some of Earl's final cars, like the '59 Chevrolet (Figs. 91, 92), repay careful scrutiny and reveal the originality and refinement of great works of art. That the car has big fins is the least of it. The sheet metal reads like a thin membrane sucked in toward the inside, leaving the chrome lights, side strip, and fin edge as the outermost projections. In the few locations where enough of the surface

projects to be mistaken for a bulky reveal, as around the tip of the taillight or between the two halves of the trunk, the designers have carefully drawn sharp wind-splits to break up the surface. It would be hard to imagine a more contrary statement to the muscled Earl aesthetic in the very same car of the preceding year (Figs. 82, 83). Nevertheless, the quality of modeling from that earlier exercise was not forgotten; rather, it was used to achieve a new, sheer aesthetic end. The shape of the car develops from the back to the front through a series of progressively larger radial sections, and this effect is reinforced by the curve of the taillight, the undersection of the fin, and by the chrome strip, which is narrower and more pointed in the rear. The impression given by these details, of the fender moving forward, is enhanced by the countermovement of the fin, which gains in sheer size and air volume toward the rear. The rear opened so widely that its designers dubbed it a "butterfly tail" and a "seagull."[91] Startling for its uniqueness and subtlety, the design of this car also marks a transition. It bridges the gap between the massive and complex curves of the Earl era and the sheer and sharp silhouettes of the future.

Mitchell Consolidates

In 1958, when Mitchell succeeded Earl as vice-president at General Motors, he advocated set principles of car design based on a long hood, short deck, crisp, folded edges, and a lack of applied decor. He admitted that he adopted these principles from late-twenties' cars like the Rolls-Royce and Hispano-Suiza, which he learned to love as a child on the streets of New York. "I was brought up with big cars. In New York, as a kid, the Isotta-Fraschinis and Hispano-Suizas, with long hoods, were always my cars." Driven by his belief in the everlasting virtues of crisp "London tailoring," Mitchell urged his designers throughout the sixties and seventies to pursue this particular direction. Fortunately for the younger designers of this period, who were taken with the new creased and harsh look of the latest Italian sports models, Mitchell's taste for lean and sharp vintage classics was compatible with their own preferences. Gene Garfinkle explains how the tastes of two generations at GM coexisted better under Mitchell than under Earl: "The shapes Mitchell liked himself were more amenable to being worked with by the designers of the generation before, during, and after him. . . . Mitchell tried to refine things more; he was after a slimmer look. Even though his shapes might have reverted back to an earlier time, they were still more amenable to being worked with."

Within this broad taste preference, Mitchell gradually changed his point of view. His style divides into two broad periods, corresponding to the sixties and seventies, with two phases in each decade. Ron Hill, chairman of the Industrial Design Department at the Art Center, explains how the first period began with a moment of consolidation: "Bill did a wonderful turnabout in terms of consolidation. What he tried to do was draw back from the brink of excess that was going on in the late fifties—to bring back some rationality and good design. I don't

want to say that the early-sixties' cars were conservative designs because they weren't. But some of those cars were finely wrought; they were pretty tailored; they addressed all the needs as opposed to the late-fifties' vehicles. He was establishing credibility. Once he consolidated, he tried to strike off on his own, and that culminated with the concept of trying to bring the classic idiom back." Mitchell consistently succeeded in this style with cars like the 1961 Buick and Chevrolet. Chief Pontiac Designer Jack Humbert was the acknowledged master of subtle surface development from this period.[92] In cars like the '63 Grand Prix (Fig. 93), he epitomized the quality of finish of early-sixties' designs as opposed to the sculptural forms from the end of the decade. He calculated entasis and sweep changes to the fraction of a millimeter, so that, although the broader forms seem relatively staid, their surface radiates life.

Mitchell's "Flair"

With his position assured in the early sixties, Mitchell pushed for more "flair"—the most common word used by his designers to describe originality and sculptural expression. By almost all accounts, his cars from 1965 to 1968 were his best. They not only reflected Mitchell's self-confidence but his designers' freedom, executed as these cars were during the last moments before mandatory safety and emissions standards were imposed. Hill explains the designs from that period: "In the late sixties, there was just a tremendous, unbridled enthusiasm for styling, for design excitement. They were wonderful cars. They were these incredible street hot rods, if you will. And then, all of a sudden, social consciousness took hold." As the designer of the '65 Corvair (Fig. 97), Hill created one of the outstanding cars of the period, and he gives an inside look into the new interest in excitement and form. As chief designer, he formalized the design in Advance Three Studio before Henry Haga "productionized" it in the Chevrolet Production Studio: "The Corvair was a project given to us to follow up on that wonderful first Corvair. We tried to give it a little more form, a little more flair. . . . That was still the era when you were doing sculptural forms. The typical automotive gesture indicating that the car has four wheels was [expressed in] this abstract line that is a long sweep and then a bump over the wheels. That is about as automotive as you can get." For further sculptural expression, he looked to Italy. There the hard-edged, chamferred forms had a sculptural quality in tune with the interest of younger designers at GM in the sixties. Hill continues: "We definitely were influenced by Italian designers of the time, particularly Pininfarina and Bertone. We looked at developments there as the harbinger. We looked at their work as being exemplary of good taste and judgment in automotive design."

Besides encouraging a new "automotive" sculptural flair and an older style compatible with the prevailing current of chamferred Italianate design, during the sixties Mitchell also encouraged individual design expression, something almost unknown under Earl. Mitchell fueled his own aesthetic objectives with the new

ideas he elicited. By loosening the administrative reins, however, Mitchell allowed a few of the cars conceived and directed by single men to slip by him, and these, ironically, turned out to be the best designs created under his directorship.

The '67 Eldorado (Figs. 98, 99) was a remarkable project because it was so long in gestation. It started in the very early sixties as a project for an ultra-luxury sporty vehicle, known as the XB-727.[93] Chuck Jordan was keenly interested in the production version of this car, but he lost interest and moved it from the Cadillac studio to a little walled-off area in a supportive engineering studio across the hall. Mitchell dismissed the project, allowing one of GM's best designs to elude him, as the Cadillac chief designer at the time, Stanley Parker, explains: "No one ever thought that Cadillac could afford to do that car. We thought it was just an exercise in design. Mitchell said at the time, 'You know, I never thought they were going to make that car. If I were going to do it over again, I don't think I would have let that design go out the way it did.' " With the lack of corporate interest, the Cadillac studio could pursue a single design theme under one artist, without outside interference, as Parker recalls: "I had three or four quality designers, and it [the Eldorado design] was a little bit of everybody. But I think what happened was that we were all thinking alike. We all had the same concepts, the same goals in the design. That is why it looks like one guy designed it . . . instead of a committee. If you have one designer to design a car, and if he designs it from front to rear, it is going to look like one man did it."

Mitchell started Parker off with the words, "You ought to make those fenders look like razor blades," but then Parker created a new kind of sculpture, extending Mitchell's sheer aesthetic to a subtle extreme never seen before. Not restricted by the later bumper regulations, he reduced chrome to the delicacy of Rayonnant architectural details (Fig. 99), and he sacrificed vast quantities of sheet metal to make the fender "stand up" in the quarter-panel, with a "hollow valley" behind it. To "reduce body thinness" further, Parker played with the "light and dark contrast" in the traditional beltline. He lowered the belt below midline, emphasized its continuous, pointed profile, and extended it horizontally the full length of the car. As a result, the "bottom part is dark [and obscured] and the top part becomes light from the crease line up, and the body appears thinner and longer." Minimizing the visual weight of the side panels, he suppressed the bottom plinth, the standard feature on GM cars that implied body support.

The Eldorado was a landmark for younger GM designers because it expressed their interest in creating a totally sculpted shape. One of Parker's principal designers, Don Roper, followed the production version of the car from beginning to end ("from basket to casket"), and explains the integration of the rounded glass upper with the lower: "We had just barely gotten into curved glass. The '65 cars were the first of our cars to have curved side windows, but they just had curved side windows on a body. Once you saw a curved window, it just seemed to flow better when all of the other surfaces were at least slightly curved instead of all of a sudden a straight slab appearing [right below the window]. With the Eldorado

and [Oldsmobile] Toronado, there was an effort to get rid of the humped body with the upper on top of it. We tried to blend the curved glass more into the sides, to make the whole car more of total shape than a bottom with a top."

Taking the sculptural integration a step further, Roper increased its effect by contrast:

> For a couple of years, everyone had been enamored with the '61 Lincoln Continental. It was very slab-sided with a little low upper. But the windows had a whole lot of tumble-home to them. So they tried a car [the Eldorado] with a lot of tumble-home, but it was not flat-sided: The whole side of the car had lots of tumble-home. They just kept doing this, but it didn't work—it just wasn't coming off right because it didn't look as if it had as much tumble-home as you would draw on paper with a section of the car.
>
> One day it hit me that the reason that the Lincoln looked like it had so much tumble-home was that there was a vertical slab side to contrast with the glass, so that you really saw how that glass leaned in. So I came up with some drawings utilizing just the wheel lips of the car. Rather than bending the wheel lips over with the body, I let the wheel lips come up vertical. That way there was a vertical element on that side to relate all the tumble-home to. It really made the car lean in a lot more.

Contrasting the stand-up wheel openings ("paddle wheels") with the tumble-home integration of the upper and lower became a standby of GM design, as Roper explains: "The earlier version we had in the Cadillac studio had round wheel openings. The car was put on hold, and someone saw fit to transfer those openings over to the Toronado [which appeared a year earlier, in 1966]. That is how that Toronado got those openings with the wide flap running around them. When we got back to the Eldorado, they said, 'Wait, we can't do the round openings anymore; we got that on the Toronado.' That is how it got the more square wheel openings. But we did end up with a larger lip and tumble-home."[94]

The other masterpiece of Mitchell's best years, the 1970½ Firebird (Figs. 108, 109), also expressed the idea of total sculptural form so popular among young GM designers. Pontiac Chief Designer Bill Porter integrated the front end by using an Endura bumper (tough plastic cast over steel and painted the same color as the body), a material first introduced on a production car in the 1968 GTO (Fig. 107). He also sought to unite the curved upper and lower; however, he expressed the idea in forms representing the opposite aesthetic pole from the Eldorado. Instead of pushing the prevailing current of hard-edged design to the extreme, Porter intentionally ran against the tide. The end result of both cars, however, reflects similarly on Mitchell. The Eldorado and Firebird show Mitchell's administrative strength—in that he permitted independent aesthetic expressions—but they also indicate the Achilles' heel of his personal taste. Like Parker's Eldorado, Porter's Firebird emerged as a production model only because, by chance, Mitchell was distracted. Whenever Mitchell came by, he concentrated on the Chevrolet version

of the car, as Porter explains: "Of any production car I worked on under Mitchell, this car made it through the gauntlet to production in a form closest to my ideal of it. . . . Throughout the entire project . . . Bill Mitchell spent far more time with the Camaro [Fig. 110] down the hall than with the Firebird. Except for one or two isolated instances, he made very few changes. He simply did not take the hands-on interest in this car that he did with the Camaro in Hank Haga's studio."

Mitchell gravitated to Haga's studio because Haga, caught up in Italianate design, covered the same package with sharp-edged forms. In his search for a unique direction derived from an American tradition, Porter developed Earl's orthographic and highlight system to create a new system of "power bulges" based on conic sections.[95] He was searching for "fullness that is muscular," a particularly American quality he found in the outline of a Duesenberg fender, the underside of an Eames fiberglass chair, and the top of a GI helmet.

In one sense, Porter's experiments in the early sixties followed the upheavals in design at GM in the late fifties, when he began working for Earl. Porter is quite unusual in that, instead of replacing Earl's curves with Mitchell's brand of hard-edge design or the prevailing Italianate taste, he consciously returned to the source. Porter sought to expand Harley Earl's curvilinear vocabulary in complicated new directions. He was particularly influenced by Norman James, who introduced radical new shapes through the fusion of art and technology in the '58 Firebird III (Figs. 100–104): "In 1963 and 1964, when I was working with the new designers in the studio called Design Development, some of us began developing designs with these ever-changing forms [Fig. 106] as opposed to the older, more constant section forms. The Harley Earl formula called for a highlight that marches down to the end of the car. . . . Yet a lot of the next generation of designers were feeling that this was like having a ten-word vocabulary. . . . We just had to expand our range. . . . James had broken through with the Firebird III. The Firebird III had shattered Harley Earl's highlight rules, but it was almost as if no one noticed because the car looked so much like an airplane. Nevertheless, it was a foot in the door."

Instead of continuing the same highlight down the side of every car, James based his design around a series of axes radiating differently in side (Fig. 103), front-rear (Fig. 104), and plan view. In his Firebird (Fig. 108), Porter created his own dynamic movement by implying a single monocoque shell but varying the conic sections infinitely. This play-off he describes as a "unity-yet-difference" between the upper and lower body sections. On the one hand, "the curvature of the very leading edge of the roof just above the windshield, if continued forward, would *not* flow down to become the windshield surface but would arc out over it, forming an imaginary bubble that would reconnect with the cowl surface." On the other hand, the "bubble" suggests independent variation and movement within itself: "The curved cone" of the roof "gets wider and wider as it goes back, until it curves down and passes alongside the rear window, where it flattens way out just in time to fuse with the lower. Think of it sort of as a thin shell that,

while structural, is like a cape that is unfurling. It is as if the cape were held by the front edge and unfurls toward the rear, imparting a subliminal sense of something having been affected by motion." Porter also speaks about stretching the monocoque into the lower by means of barely perceptibly changing curved sections that he extended through the front (Fig. 108) and rear fenders (Fig. 109). He intended for the radii changes to be simultaneously subtle and repetitious—to be as much felt as understood (see Porter interview for full details).

Mitchell relieved Porter of his position as chief designer shortly after the '70½ Firebird was created. Porter's experiments in conic sections had to wait another fifteen years before an interest in aerodynamic curves made their acceptance possible. Reappointed in 1980 as chief designer—this time of Buick—Porter created the '85 Buick Electra (Fig. 112) as a study in exquisite surface development and subliminal reference. This time, Porter joined the old Earl concept of pyramiding (Fig. 114)—angling the sides of the car toward the center to give a sense of weight and stability—with his own interest in conic sections. Playing off the two effects where they joined, he created a continuous "power bulge," girdling the car (Fig. 113) and implying the "density" of "an exploding torpedo." In one sense, Porter is a throwback, fulfilling the full potential of car design as it was conceived during the sculptural and free period of the late sixties. Besides fusing art and technology, he infinitely adjusts linear and sculptural relationships and makes original, tight, and dramatic vehicles look so uncomplicated.

Mitchell Downsizes

During the interval between the '70½ Firebird and '85 Electra, General Motors experienced a period of upheaval that reflected the American social revolution of the late sixties. The changes in design appeared in two stages, in response to federally legislated standards. Beginning in the very early seventies, cars were required to meet bumper and side-impact regulations. While the 2.5-miles-per-hour bumper was not required until the 1973 model year, most domestic manufacturers included it on their '72 models. Two years later, the 1974 bumper standard restricted the range of bumpers to a height of sixteen to twenty inches.[96] Former GM Chief Designer Ron Hill describes the reaction to this legislation at the Tech Center: "All of a sudden, social consciousness took hold. There was a push for safety. . . . We had to respond to it. The bumper laws became paramount. You had to design your cars around bumpers. The transition was a difficult one. As it turned out, we eventually learned the vocabulary to deal with these sorts of things. [Nevertheless], that was a time that was fraught with peril because it was transitory. That was an era of trying to deal with different proportions, trying to have a more compact vehicle plan form." The federal government forced a more blocky appearance because of the requirement for collision protection on the sides and front, and Mitchell piggybacked the opportunity by pressing for a fuller expression of his own edged, classical taste. Hill explains: "Bill Mitchell at that

time was turning around and wanted to do more linear forms, more defined, less sculptural. . . . That taste was innately there [in the sixties], but it was more subliminal," and it was clearly overpowered by the sculptural taste of the time: "When he got into that [new style] was in the early seventies. I remember in the early seventies talking to Bill about the Camaro and Firebird and how wonderful they were, and he said, 'Yeah, but we have to go on. We are looking at something new.' That of course started the era that culminated in the late seventies 'B' cars like the Chevy Impala—rather well-done hard-edge cars."

In the mid-seventies, a second turnabout came after the gasoline crisis in 1973 and the passage of the Energy Policy and Conservation Act of 1975. As part of that act, the National Highway Traffic Safety Administration created Corporate Average Fuel Economy Standards (CAFE), to begin with the 1978 model year.[97] Already facing impact legislation and a country sensitized by an "unsafe at any speed" mentality, GM suddenly had to face a new challenge to reduce the size of its cars to meet the gas crunch. Coupled with these legal pressures, designers, like other Americans, were experiencing a period of insecurity and doubt, and the cars they produced reflected a deflated image of themselves. In the decade after World War II, victorious Americans used half the world's steel and oil and produced three-quarters of the cars and appliances on earth. By contrast, in the decade after the Vietnam War, defeated Americans faced social unrest in the inner cities, political humiliation with Watergate, a fuel shortage from the Arab embargo, and economic imbalance from deficit, unemployment, and inflation. Is it any wonder that American cars lacked joy, swagger, and panache?[98]

Hill recalls the legal and social pressure: "All these [issues] came together to try to produce a vehicle that was socially responsible. And that was not always easy. It was very frustrating and very unnerving for people at the time." One top designer calls the period of design after 1973 "sleepwalking." There were a few outstanding successes like the long-lived '71 Eldorado convertible, the '75 Seville, and the '77 Chevrolet. But this was a time of many inoffensive cars, acceptably clean and simple, but lacking originality, refinement, and—most important—distinctiveness. Just as the current top GM designers believe that Earl's late-fifties' cars were blemished by extravagance, they agree that Mitchell's final cars were his least distinguished. From their point of view, the government-regulated corporate mileage standards required excessive downsizing, and thus induced the characteristics of good-taste blandness in these late-seventies' cars. Irv Rybicki all but admits his company was unprepared to produce anything but derivative automobiles during Mitchell's final years: "CAFE regulations certainly had a pronounced effect. We were doing automobiles 230 inches long for a great many years, and then, suddenly, someone rings the bell and says, 'You are going to do them two feet shorter.' This team had been doing long cars for thirty years. We had to reeducate ourselves. Because the price of fuel was higher elsewhere, the other design houses around the world were doing small cars for a long time. They had a step or two on us at that point in time. But I think we are learning

fast." A top GM designer explains how the economics of downsizing produced characterless interchangeability: "That was an era we lived through when we did a lot of downsizing—all the way from '73 on, when we started with the big cars. Now [1983] we have gone through that. We couldn't afford at the time to do anything else. I'd say the Cimarron and Chevrolet Cavalier [GM "J" cars] are the same cars. If someone asks, 'How come they all look alike?' I say, 'Cause they are alike.' You know, we are not magicians. You can't hold all the side panels to be interchangeable and expect anything else."

Dave Holls is even less circumspect about the appearance of cars from Mitchell's final period: "The era I hated the worst was the first size-down—'77, '78, '79. Those cars I hated with a passion. They were awful. It was a horrible era. When I came back from Europe and saw those cars—I had been working on the Opel Senator. I came back and saw those Malibus, the '77 'B' cars, and even the Citation." Holls is probably right in spreading the blame: "Everyone else was just as bad then. The Chrysler 'K' car was even more square. Ford was terrible then, too. What did they have: a Fairmont? They had nothing. Thunderbirds had disintegrated into the worst; the model before this [the 1983 model] was an incredibly awful car. They were still worse than us."

The Rybicki Era

Mitchell's top lieutenants, Rybicki, Jordan, and Holls, criticize Mitchell's final cars, but have they succeeded in returning the company to its glory? Certainly they do not lack for challenges. Still reeling from the dislocation of downsizing, they face the first domestic design competition from Ford in thirty years. Ford's president, Donald Peterson, is looking for a unique identity for his products and is "really giving design a chance to express itself," according to Design Executive John T. Telnack.[99] It's a question whether the 1986 Ford Taurus (Fig. 111) signals a substantially new design direction or whether it is an overstuffed hodgepodge of aerodynamic gimmicks. Rybicki calls it a hippopotamus: "To do a round car is very easy. You can do it so that it looks heavy and sluggish, as if it won't move away from the curbstone and it will take 500 horsepower to get it running." I think the car, at least from the front, offers a reasonably good synthesis of the latest avant-garde clichés. In any case, it represents a distinctively new (and so far successful) image for Ford in the domestic market. With Ford's profits exceeding GM's in 1987, the real question, however, is whether Telnack will have the courage to heed Walt Disney's advice that "you can't top pigs with pigs." Will he interpret the Taurus's success to be that the public craves striking innovations or pale derivatives of the aerodynamic shape? In 1988 Telnack has produced the Ford Tempo and Lincoln Continental, two cars that should reassure GM about its design leadership.

GM faces competition from abroad as well. Rybicki explains that even under Mitchell "business . . . was very simplistic, simply because we had a domestic

market that was all our own. . . . Now what have we got? We've got everybody here in America. In the focus of this staff, we very seldom talk about Ford. . . . We have got an international market in the United States, and we have to cover all those bases with our products." Having abandoned the bottom of the market to Asians, GM designers are struggling against the Europeans to keep the top. And the revised market strategy makes new demands on General Motors stylists, who must pigeonhole specialized cars based on consumer studies.

The leading GM designers think they are turning the corner to success. "With all the vehicles we have at General Motors, yes, we make a mistake occasionally," Rybicki admits, but he is confident that "we are coming to understand the elements that are necessary for doing shorter vehicles, for making them attractive to the eye as exciting packages." His top lieutenant agrees that GM is "building excitement": "I think some of them have got that excitement today—the Corvette [Fig. 115], the Camaro-Firebird. You have got to be blind if you don't see that car [as exciting]. When people saw that car, they said, 'Forget the interest rates. Forget fuel economy. I want that thing. That's excitement.'"

General Motors still maintains the American standard for exacting finish and execution and even for complexity of theme and form. A certain rightness about all GM products persists under Rybicki. He personally is recognized as an excellent "refiner," similar in temperament and outlook to Jack Humbert, the best surface developer in the business. However, most of the former great designers, including Bill Mitchell, believe that Rybicki relies on slickness as a crutch. These men believe that, instead of refining a bold, original statement with a sense of balance and grace, Rybicki has reversed Mitchell's dictum, creating cars that *are* "simple like Simon." Refusing to impose his own design taste on others, yet discouraging personal expression, he fosters an acceptable level of design blandness. Instead of creating new statements, he relies on anonymous correctness and the excitement generated from consumer polls to mask simplistic shapes.

The simplicity can be especially seen in the 1985 Cadillac Sedan de Ville, where the variables have been reduced to the extreme. Not much in the way of subtle progressions, clever articulations, or dynamic shifts is offered, and we are left with little to appreciate except the very largest of elements—overall proportion and volume—and the very subtlest of details—chrome fit and bumper adjustment.

Typical of the best of Rybicki's genre is the 1986 Eldorado (Fig. 116), jointly developed by Cadillac Chief Designer Wayne Kady and Assistant Chief Designer John Manoogian.[100] Although the car lacks a powerful theme and individual expression, its details are handsomely nestled in a simple, large volume. Rather than project a stand-up "egg-crate" over the hood, the designers achieve the trademark focal point of the grille in more subtle ways. Increasingly smaller segments of the hood bend around the grille in the front, where the wind-split also becomes more pronounced. And the grille's importance is extended by subtle breaks on either side of the hood, carrying the grille's leading edges into

the body itself. Within the grille, the pointed center is emphasized by the tighter radius sections leaning in at the top of the grille, by the progressively curved "sweep" lines pushing through the top of the egg-crate, and by the exaggerated pinnacle crowning the chrome stripwork. Bill Porter explains the Rybicki design philosophy, known as the "proud crown," expressed in the Eldorado design: "In recent years, several GM cars have made use of an exaggerated progressive entasis in the center section only of the front end, which Irv Rybicki has termed 'proud crown.' But its presence is easily recognized, while its effects are intentionally forceful and go well beyond subliminal form adjustment."

The designers enhance the importance of the grille with the bumper. The colored top of the bumper contrasts with the grille's gleaming surface, while the chromed face of the bumper reveals its shape. Playing off the grille with negative and positive forms, the designers open a space in the center of the bumper precisely equivalent to the bottom row of the grille, while just above it they continue the next row of the grille as a solid form, a plastic strip beneath the lights.

These are nicely executed touches, and remarkably consistent and effective compared with the nuances of its sister car, the 1986 Toronado. But even as details, do they work together as a Cadillac face that powerfully conveys the image of the GM flagship? Can it even be said that they reinforce the large frontal volume—the only other pronounced element left on the car? It is hardly an exaggeration to say that, despite these delicate flourishes, the bumper dominates an essentially simplistic shape left lifeless without formal shifts, significant articulation, and subtle movement.

Thinking of themselves as businessmen more than as artists, GM leaders do not care if their designs bespeak simple slickness rather than artistic excellence or if their designs lack the wholeness and the spark of personal identity. Chuck Jordan and Dave Holls curiously adorn their corporate desks with Ferrari models. Yet neither concedes that the Italian formula for design success—using the work of geniuses like Pininfarina, Michelotti, and Bertone—can be applied to GM in the United States. A likely candidate for design vice-president said that he didn't care if more than one man designed a GM car as long as it looked good and expressed the "personality" of the group enterprise: "We don't have a vice-president like Mitchell—flamboyant and running around. We are more like a business, you see." Reminding us that "everybody is not a Van Gogh here," Dave Holls explains his concept of designing as a collective activity: "You see, you really work as a design team. That is really true. Unless you are a Bill Mitchell and in total control, it is a very difficult thing to say you do everything on a car. You work with other people on the car as a team. Sometimes it is one guy who starts the idea out, and then somebody evolves it into a little better way to do the rear. Who did the rear then? Did the first guy do it, or did the second guy do it?"

There are many advantages to a team approach, and most GM designers

believe that the volume and time schedule of a mass-production business require a group effort to maintain high standards and a uniform corporate appearance. Many argue that the problems are so complex that they necessitate group interaction, with the exchange of ideas sparking new options unlikely to occur to just one person. That is precisely the idea of Roger Smith, who became chairman of General Motors in 1981; he seeks to decentralize and diversify his organization through a team-oriented approach. Faced with a decreasing lack of identity among GM products due to cost-cutting interchangeability, Smith aims to restructure the company by pouring manpower into the early stages of a program to reduce work load and lead time.[101] He assigns pollsters, engineers, stylists, salesmen, and admen to work together at the beginning of a project in what he calls "front-loaded" design. Sequential and compartmentalized tasks are downplayed, and as a result, the single designer's control in the production studio will be reduced as shared input increases.

As part of his front-loaded approach, Smith in 1983 established a multidiscipline-concept center in Thousand Oaks, California, to integrate the design, research, and engineering of GM's future cars. This Advanced Concept Center (ACC) will not affect the current six advanced-design studios at the Tech Center in Detroit but is, in the words of Irv Rybicki, simply "a step beyond our advanced-design studios." The vice-president of design says that the center gives him the time to think through his designs and the opportunity to tap California's pool of talent. Believing that "maybe 50 percent of the creative people in our business" come from this "bellwether" state, he can spot the latest trends at schools like the Art Center in Pasadena and consult electronic firms in areas like the Silicon Valley.[102]

Complementing the "blue-sky" advanced work going on in California, Smith intends to front-load the advanced-design studios in Detroit, under the supervision of Executive Designer G. E. Moon. Whereas the studio chief is now largely responsible for finalizing a design, Smith will deemphasize his role in production styling and insist on a much more complete design state for a car once it leaves Moon's sphere of influence. As part of this initial stage, engineers and marketing specialists will participate in a project to ensure that it hits its intended niche on time and within cost.[103] Isn't there a danger that designers will lose their initiative and spark of creativity? Won't this further reorientation of styling away from the individual and toward a group effort create "inertia problems" in the design process? "No—the designer welcomes this," according to GM Design Director Chuck Jordan, who claims that *total* design means *efficient* design: "First of all, you save all of the re-do. In our end of the business we much prefer that, because when you've finished the design it's a much more satisfying experience—you've done it efficiently, you've done it so it can be manufactured, and it's a *total* design. We much prefer that way of working to working in a vacuum; it's more fun to get a 'total design' and not just a pretty hunk of clay."[104]

Despite the economic and technical importance of "front-loading" research and "interfacing" market analysts, cost accountants, and space-age engineers,

these advantages may only add to the problems inherent in Rybicki's design approach. By nature the man is a competitor. When he worked under Earl and Mitchell, he skirted the usual practice of chief designers to abstain from in-house competitions: "They kept me out of it [only] a few times," he recalls with a smile. "Yeah, I loved it. Hell, that is the heart and soul of this business: competition." But when he became vice-president of design, he turned cautious, withholding his own strong personality from the creative process while discouraging individualistic designs among his staff and demanding classic, conservative cars of the company. That course of action only played to the weaknesses in Roger Smith's system, accenting as it does long development and slow turnover.

Rybicki admits that he supports less daring designs than Earl because of the slow turnover: "Back in Earl's time, we could tool cars faster. We did a new car, introduced it, and three years later we did a major face-lift." Today, by contrast, "You are living with the basic theme for five to six years. Make a mistake today, and you're going to lose your shirt." With high risk and slow turnover, design development takes longer. Under Rybicki, themes are mulled over for years: "We are testing to see how it lives among the team. Two years from now, if you set it out in the hall, do people just walk by it like there was nothing there, or are they still stopping and looking at it? . . . In two years, when you see them stopping and looking at it and making positive comments, you know that you are on to something lasting."

By minimizing risk through slow development, the company produces conservative, dated, and team-designed automobiles that from the start are intended to go unchanged for six years. Even for Rybicki the forecast is discouraging: "From our point of view, from the point of view of the people who create the look five or six years down the road, [the lag time is too long]. You consider that [in addition to lag time] the vehicle has to run [and look good] five or six years, so that [the interval] is twelve years from the time we started the idea sketches. There is a lot of risk involved in the delay. We would like to be two or three years away from the market."

As a high-class designer, Irv Rybicki is caught between his own reticent aesthetic philosophy, Roger Smith's noble effort to improve quality and technology, and the corporation's insensitivity to (and neglect of) a system of anonymous design formulated fifty years ago under very different circumstances by Harley Earl. Nothing fundamental has changed from the system Earl created around his own personal strengths and weaknesses in a daring attempt to style mass-produced products in a domestically controlled market. The system allowed one man with extremely strong impulses to organize all creative decisions, to retain the final image of the car in his mind while opening himself to improvisations that could change those ideas along the way. Without that guiding directorial mind, all that's left is the established process on its own—a venerable old chicken with its head cut off. Instead of selectivity with direction, what results all too often is a compromise that settles on bland design.

The aesthetic malaise that GM suffers is an internal disorder only aggravated by the "outside" infection of foreign competition and federal legislation. If the problems GM faced in the eighties were just low-cost, high-quality foreign competition, Roger Smith's investment in the latest automated factory facilities and technical companies would be a good long-term strategy, especially coupled with his effort to pool talent by "front-loading" projects. But in addition, the buying public is unhappy with the appearance of GM products, and that dissatisfaction poses an almost insurmountable problem for someone with Roger Smith's "bean-counter" background. As a power unto himself, Earl relegated senior executives like Roger Smith to selecting among finished mock-ups at executive showings and discouraged them from participating in the design process. As a result of this tradition, the chairman has gained little experience or insight into solving the problems of design structure and aesthetic change.

The well-intentioned corrections undertaken by Roger Smith may solve an artistic problem from an accountant's point of view, but they cannot substitute for the assured judgment of a single creative designer. This ultimate truth Smith will have to face even if he should turn to outside counseling to change the structure, process, philosophy, and aesthetic of the Tech Center. Unlike certain business judgments, taste is an elusive thing that does not improve by conference calls. Some *one* at the top of General Motors has got to have it, and *use* it. The future rests in the hands of men like Design Director Chuck Jordan, but when he speaks of the advantages of the cooperative system of anonymous design his perspective is that of an engineer, unknowledgeable about art and uninterested in the history of automotive design. The best he can do are neat but jejune and gimmicky cars like the Opel Manta. He looks through multi-valued, gray-tinted aviator glasses, wears an Italian custom-tailored suit with tiny, iridescent blue patterns, and sports a white-on-white shirt, with his monogram projecting at the wrists in neo-Gothic script. One is reminded of the simple truth in Frank Hershey's words: "You never hear of any of the great artists working in a committee. They were all single guys. All the great architects were single guys. And all the great automobile designers were single persons. Sometimes people forget it. You know the old story that a camel was designed by a committee. You design a car with a committee, and you get what you get. You get a camel. I am not kidding you."

The advantages of anonymous team design extend only so far, and they may not be sufficient to offset the appearance of a work of art created by one man with taste. Not only do competitors like Volkswagen and Mercedes increasingly select design personalities like Giorgio Giugiaro and Bruno Sacco to shape their products, but General Motors itself chose Sergio Pininfarina to design its most prestigious flagship car, the 1986 Cadillac Allanté. Cadillac and Pininfarina studios were each asked to submit full-sized models, and the Cadillac management preferred the prestige and distinction of a car created by an individual designer. Cadillac General Manager John Grettenberger candidly explains his decision: "Certainly we want to

highlight the Italian heritage coming out of Pininfarina. . . . We want Allanté to bring to Cadillac a sense of image we haven't achieved so far with our entirely domestically produced automobiles."[105] The selection of an Italian—a foreign—design for a major American car is a surprising fact in itself. But even more significant, perhaps, the rejection of an in-house design for the company's standard-bearer is a striking setback for the anonymous Harley Earl studio system. Indeed, the very fact that an outside design house was called in to compete for the prize is an ominous sign of the future. Perhaps we are witnessing the death knell of an entire system of creating cars without individual expression.

In my book, for a car to have character, it must somehow express a strong artistic personality. Time and again in the course of the interviews, most of the great designers insisted that to have a single talented man control the process is the best way to ensure artistic quality. Indeed, the purpose in writing this book has been to show that cars are or, rather, can be art. When that is true, the history of car design becomes art history. The process of designing cars can be as unique and complicated as painting pictures, and, like the best of fine arts, classic car designs withstand the test of time and reflect the rich personalities and ideas involved in their creation.

If the best cars are art, then their designers deserve the same kind of respect and attention as other artists within the cultural community. Similarly, knowing the role of individuals in the creation of the most outstanding cars may serve to reorient the automobile industry toward nurturing designs that express the will of an artist, not of a committee, or a group of anonymous designers, or, worst of all, consumer advertising polls.[106] The position taken by the design leaders at General Motors—that foreign competition, government regulatory pressure, and labor expense determine a consumer-oriented style philosophy—is a distortion that eliminates one real advantage American manufacturers have enjoyed up to this point. We are a country of creative mavericks, and since the beginning of the industrial-design profession, our strength has always been individual expression. Rather than team players huddling together against a foreign enemy, we need a new breed of free-spirited Renaissance men to battle the threat of high-quality, low-cost imports. Of course we demand cars that don't fall apart, but that is the bottom line. In this competitive and sophisticated environment, we must create more than tit-for-tat, cost-competitive, functional, road-feeling cars. We should take advantage of American originality, personal expression, and refinement, qualities that traditionally have distinguished our best stylists. Today, the business of art is complicated, and we require complex designers who are capable of going beyond nostalgia, plagiarism, and one-liners, designers who can merge car design with the other commercial arts instead of consciously rejecting any cross-fertilization. Strange to say, we need someone on the order of Harley Earl, someone who can reach beyond a passive receptivity, beyond a fifties' belief in perpetual truths, someone who, unafraid of novelty and fun, can inspire designs of great originality and depth.

Illustrations

FIG. 1. Harley Earl (center), General Motors Styling picnic, June 20, 1949 (photo: General Motors Photographic)

FIG. 3. Bill Mitchell (right) at General Motors Styling picnic, June 20, 1949 (photo: General Motors Photographic)

FIG. 2. Bill Mitchell (left), Harley Earl (center), and Ned Nickles (right), 1955 (photo: General Motors Photographic)

Top: FIG. 4. LeBaron, Carrossiers, 1931 Model CG Chrysler Imperial Eight (photo: Chrysler Historical Collection)

Bottom: FIG. 5. Frank Hershey, Peerless, cardboard mock-up with the designer, Walter M. Murphy Company (photo: Frank Hershey)

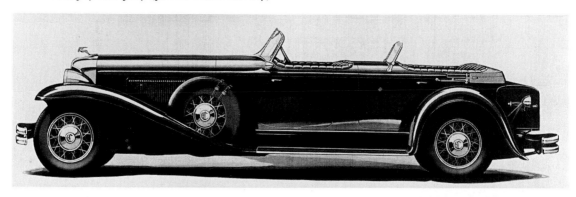

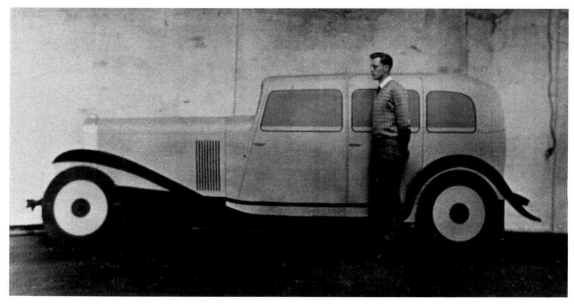

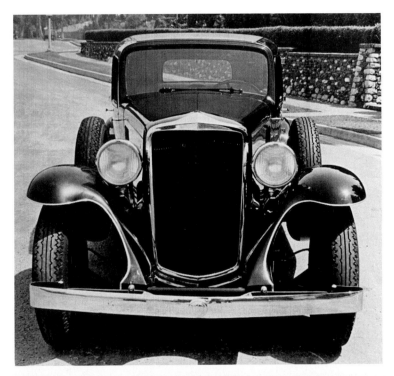

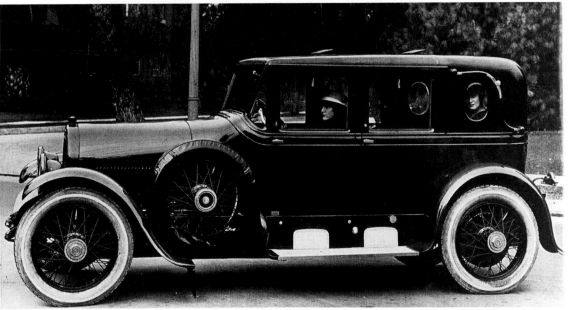

Top: FIG. 6. Frank Hershey, Peerless, Walter M. Murphy Company (photo: Frank Hershey)

Bottom: FIG. 7. Harley Earl (Don Lee, Incorporated), 1920 Cadillac Touring Sedan (photo: General Motors Photographic)

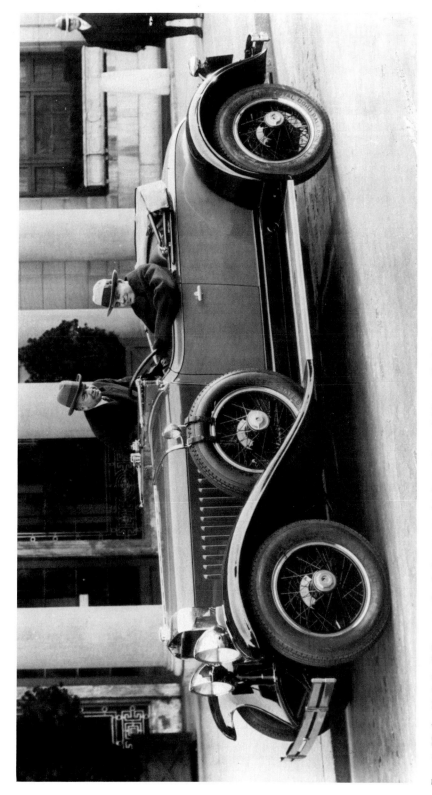

FIG. 8. Harley Earl, La Salle, 1927, the designer seated (photo: General Motors Design)

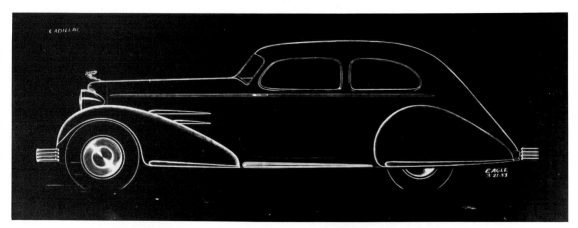

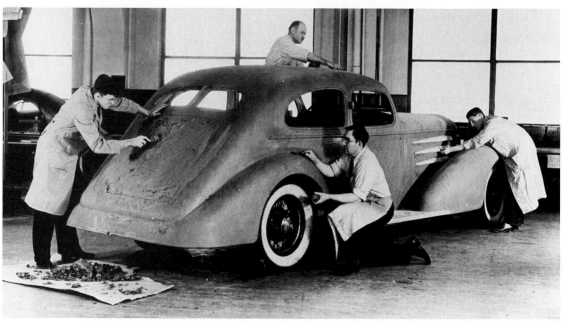

Top: FIG. 9. 1934 World's Fair car, Cadillac V-16, designed in 1933, full-scale orthographic drawing (photo: General Motors Photographic)

Bottom: FIG. 10. 1934 World's Fair car, Cadillac V-16, designed in 1933, full-scale clay model (photo: General Motors Photographic)

Top: FIG. 11. Modelers applying wooden template to full-scale model of the 1955 Buick "Wildcat" show car (photo: General Motors Photographic)

Bottom: FIG. 12. 1934 World's Fair car, Cadillac V-16, designed in 1933, full-scale mock-up (photo: General Motors Photographic)

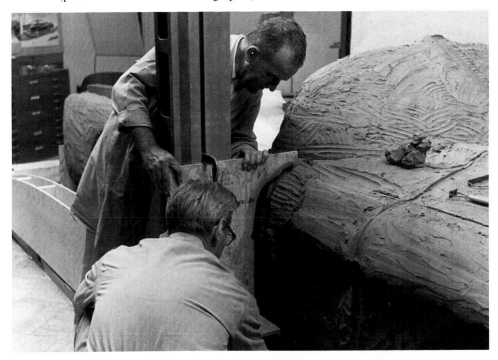

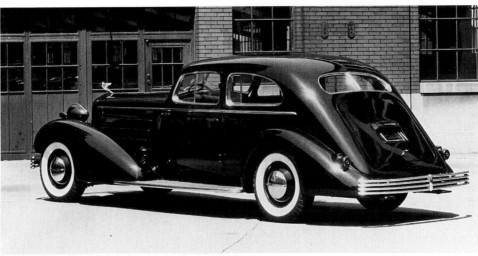

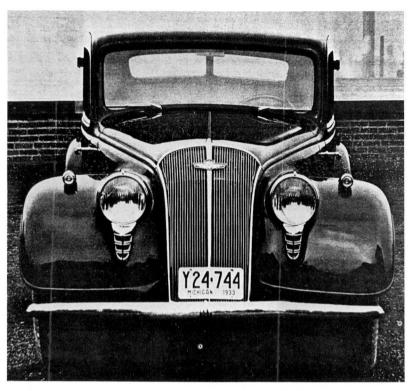

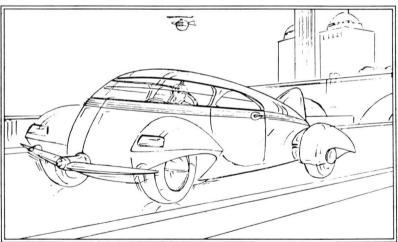

Top: FIG. 13. General Motors, experimental aerodynamic car, 1933 (photo: Frank Hershey)

Bottom: FIG. 14. Paul Browne, drawing, design of a torpedo car, May 15, 1935, Collection of Strother MacMinn (photo: General Motors Design)

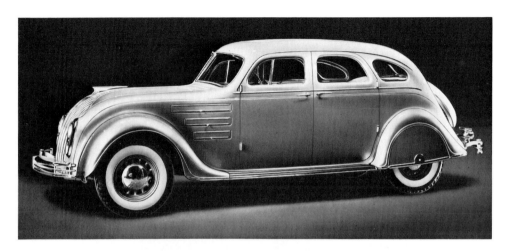

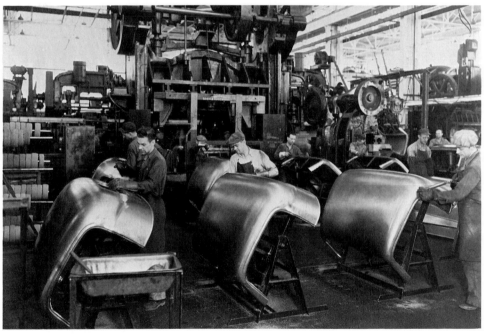

Top: FIG. 15. Chrysler C-9 Airflow, 6-passenger coupe, 1934 (photo: Chrysler Historical Collection)

Bottom: FIG. 16. General Motors all-steel turret-top assembly line, 1936 (photo: General Motors Photographic)

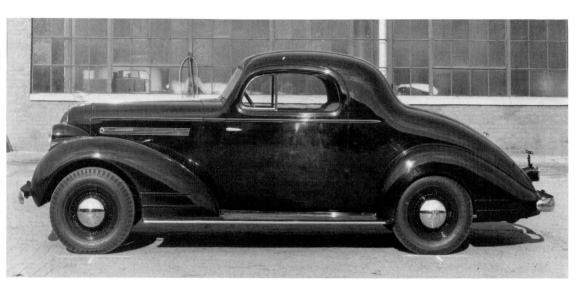

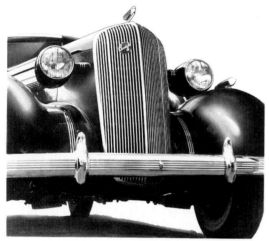

Above: FIG. 17. Frank Hershey, Pontiac Business Coupe, 1935 (photo: General Motors Photographic)

Left: FIG. 18. Buick, 1936, detail of grille (photo: General Motors Photographic)

FIG. 19. George Snyder and William McVaugh, Jr., "Suggested Oldsmobile-Eight Front for 1937," April 17, 1936, Harley Earl Sketchbooks, General Motors Design Center Archives (photo: General Motors Design)

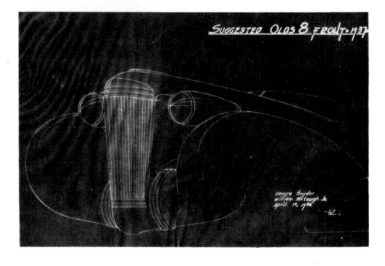

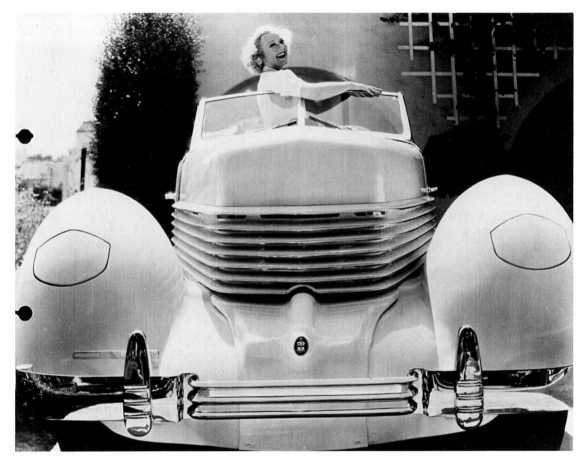

FIG. 20. Gordon Buehrig, Cord 810, 1936
(Sonja Henie is the model) (photo: Detroit
Public Library, Automotive Collection)

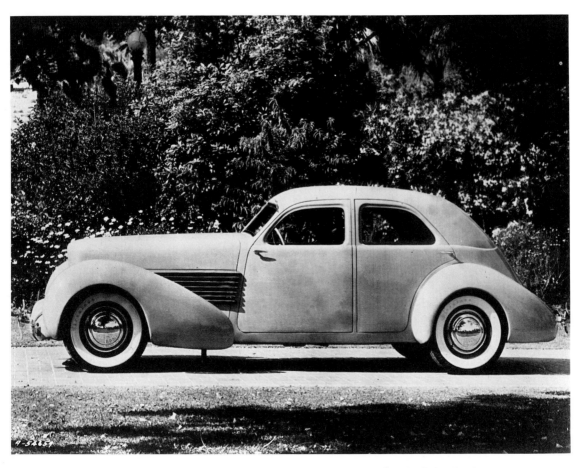

Fɪɢ. 21. Gordon Buehrig, Cord 810, 1936
(photo: Tri Kappa Collection of Auburn
Automotive Literature)

FIG. 22. Gordon Buehrig, theme sketch for a small Duesenberg based on the GM Harley Earl competition of 1933, November 7, 1933 (photo: Gordon Buehrig)

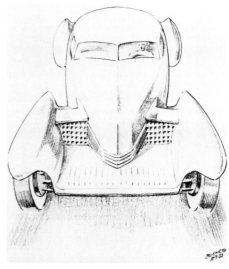

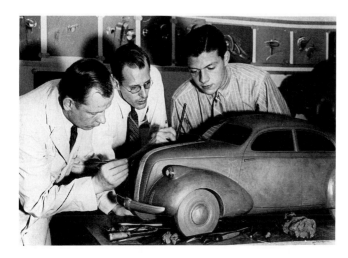

FIG. 23. Frank Hershey (center), in front of his 1935 Harley Earl competition entry model (photo: Frank Hershey)

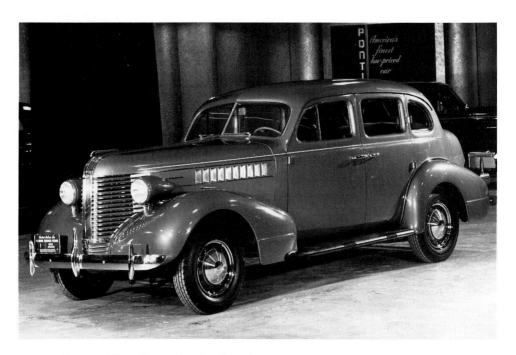

FIG. 24. Virgil Exner, Pontiac, four-door sedan, 1938 (photo: General Motors Photographic)

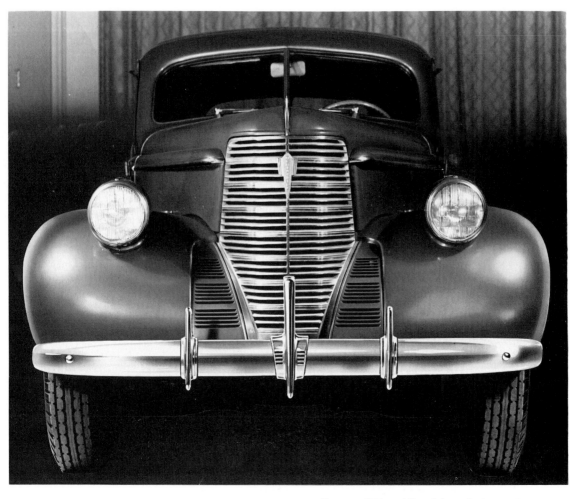

FIG. 25. Oldsmobile, eight-cylinder, 1938
(photo: General Motors Photographic)

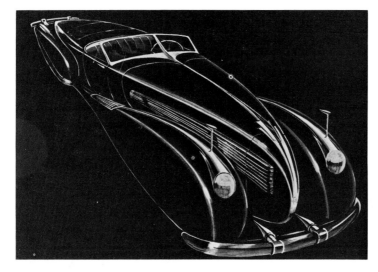

FIG. 26. Bill Mitchell, portfolio drawing, September 10, 1935 (photo: Bill Mitchell)

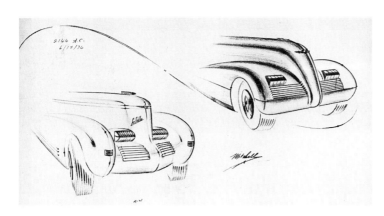

FIG. 27. Bill Mitchell, La Salle front-end studies, pencil, June 12, 1936, Harley Earl Sketchbooks, General Motors Design Center Archives (photo: General Motors Design)

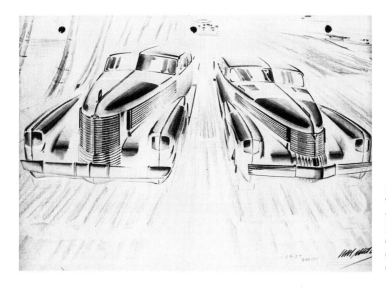

FIG. 28. Bill Mitchell, "Cad-21," pencil and wash, January 29, 1937, Harley Earl Sketchbooks, General Motors Design Center Archives (photo: General Motors Design)

Top: FIG. 29. Cadillac Sixty Special, 1938
(photo: Detroit Public Library, Automotive
Collection)

Bottom: FIG. 30. Cadillac Sixty Special, 1938,
detail of grille (photo: Detroit Public Library,
Automotive Collection)

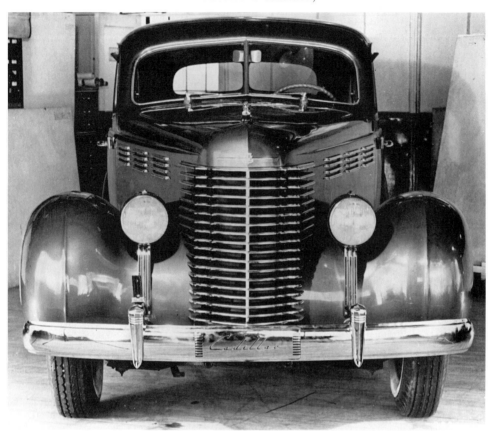

Top: FIG. 31. Cadillac Sixty Special, 1938 (photo: Detroit Public Library, Automotive Collection)

Bottom: FIG. 32. Cadillac, series sixty two convertible, 1947, reconversion of 1942 model (photo: General Motors Photographic)

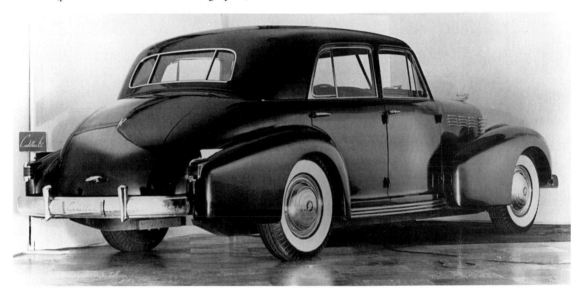

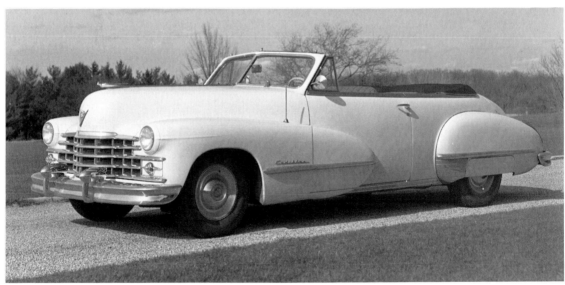

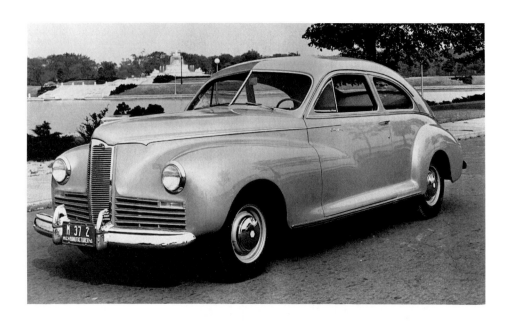

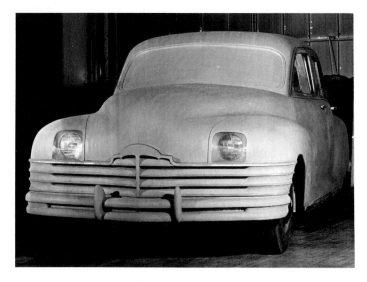

Top: FIG. 33. Packard Clipper, 1941 (photo: Detroit Public Library, Automotive Collection)

Bottom: FIG. 34. Packard, proposed Twenty-First Series car, December 18, 1942 (photo: Detroit Public Library, Automotive Collection)

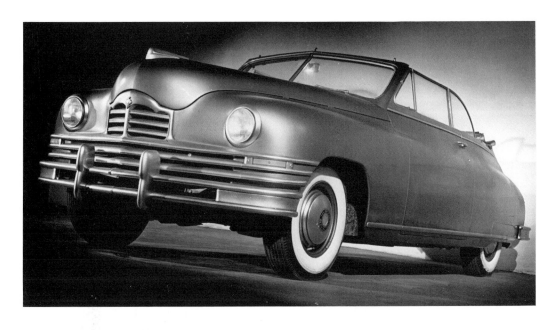

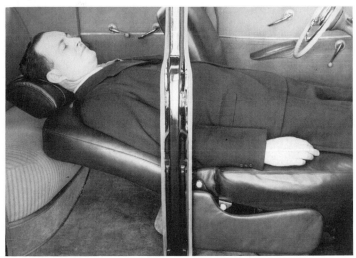

Top: FIG. 35. Packard convertible, eight-cylinder, 1949 (photo: Detroit Public Library, Automotive Collection)

Bottom: FIG. 36. Bob Gregorie, reclining in front seat, March 1, 1946 (photo: Henry Ford Museum and Greenfield Village)

Top: Fɪɢ. 37. Lincoln Zephyr, 1936 (photo: Henry Ford Museum and Greenfield Village)

Bottom: Fɪɢ. 38. Lincoln Zephyr, 1938 (photo: Henry Ford Museum and Greenfield Village)

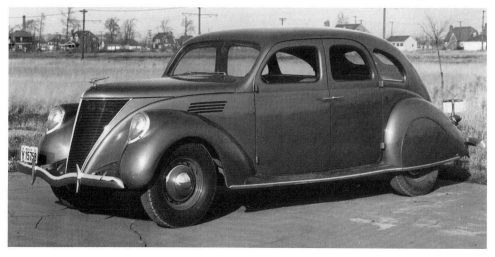

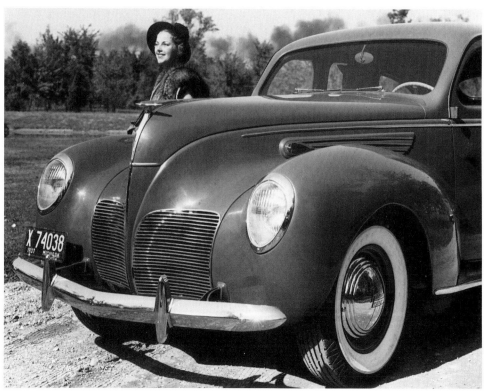

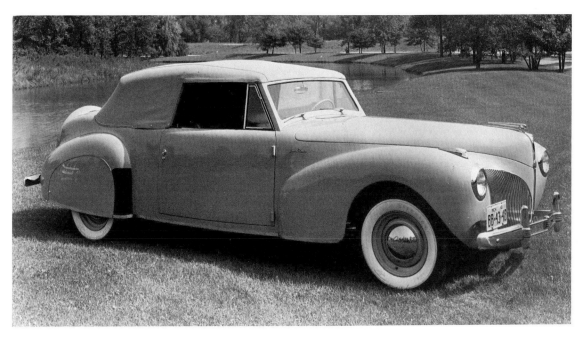

FIG. 39. Lincoln Continental convertible, 1940
(photo: General Motors Photographic)

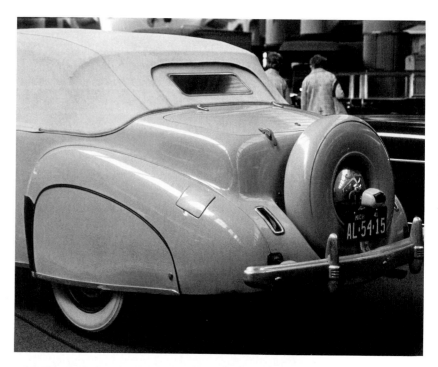

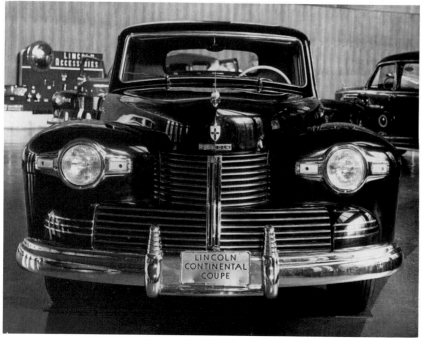

Top: FIG. 40. Lincoln Continental convertible, 1940 (photo: author)

Bottom: FIG. 41. Lincoln Continental coupe 1942 (photo: Henry Ford Museum and Greenfield Village)

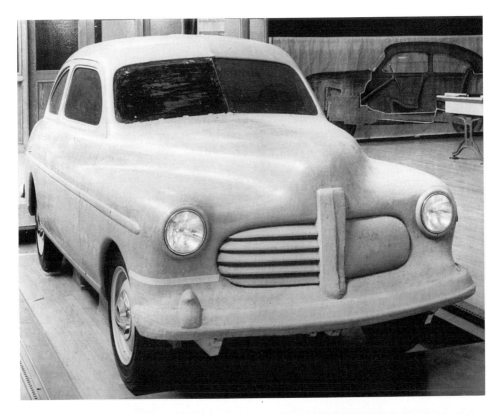

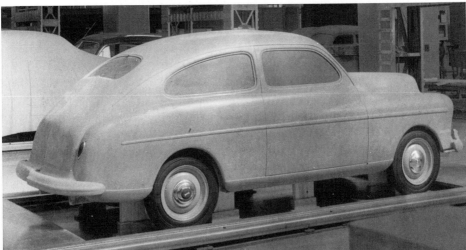

Top: Fig. 42. Ford, ninety-eight-inch-wheel-base clay model, September 12, 1942 (photo: Henry Ford Museum and Greenfield Village)

Bottom: Fig. 43. Ford, ninety-eight-inch-wheel-base clay model, September 12, 1942 (Henry Ford Museum and Greenfield Village)

FIG. 44. Ford, standard size, clay model, February 2, 1943 (photo: Henry Ford Museum and Greenfield Village)

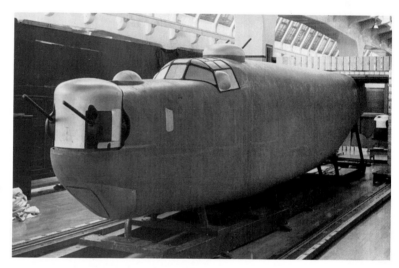

FIG. 45. Ford, designs for Emerson bomber turrets, June 15, 1943 (photo: Henry Ford Museum and Greenfield Village)

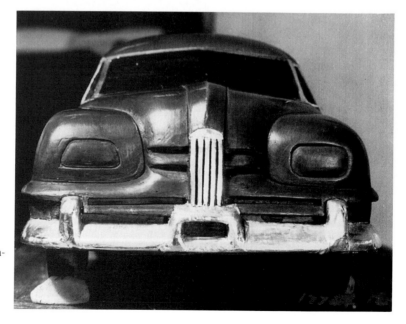

FIG. 46. Ford, small clay model, experimental car, December 9, 1942 (photo: Henry Ford Museum and Greenfield Village)

Top: FIG. 47. Lincoln prototype, clay model, June 10, 1941 (photo: Henry Ford Museum and Greenfield Village)

Bottom: FIG. 48. Ford (Mercury), full-scale clay model, March 3, 1945 (photo: Henry Ford Museum and Greenfield Village)

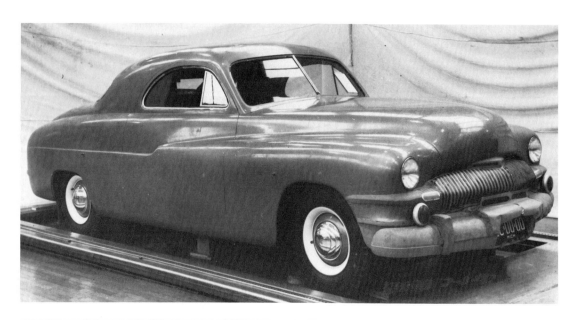

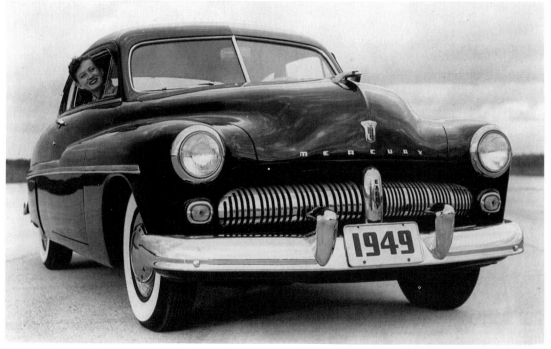

Top: FIG. 49. Ford (Mercury), full-scale clay model, March 3, 1945 (photo: Henry Ford Museum and Greenfield Village)

Bottom: FIG. 50. Bob Gregorie, Mercury coupe, 1949 (photo: Henry Ford Museum and Greenfield Village)

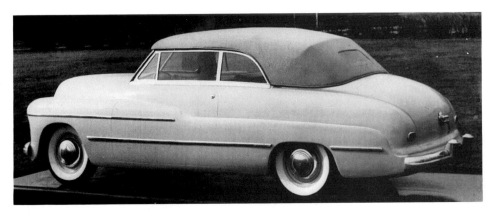

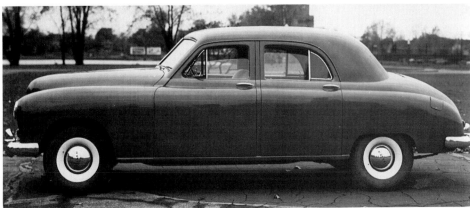

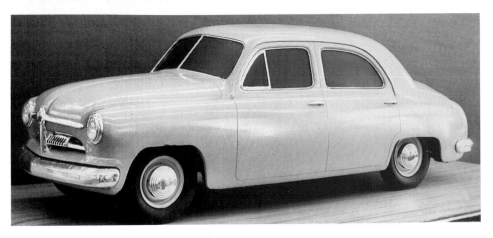

Top: FIG. 51. Ford (Mercury), one-quarter-size clay model, convertible prototype, February 11, 1946 (photo: Henry Ford Museum and Greenfield Village)

Center: FIG. 52. Kaiser-Frazer, Kaiser Special, 1947, Ford Design Staff photograph, October 22, 1946 (photo: Henry Ford Museum and Greenfield Village)

Bottom: FIG. 53. Ford, clay model, October 11, 1946 (photo: Henry Ford Museum and Greenfield Village)

Top: FIG. 54. Bob Gregorie, full-scale clay model, front view, 1949 Ford prototype, December 3, 1946 (photo: Henry Ford Museum and Greenfield Village)

Bottom: FIG. 55. Bob Gregorie, full-scale clay model, rear view, 1949 Ford prototype, December 3, 1946 (photo: Henry Ford Museum and Greenfield Village)

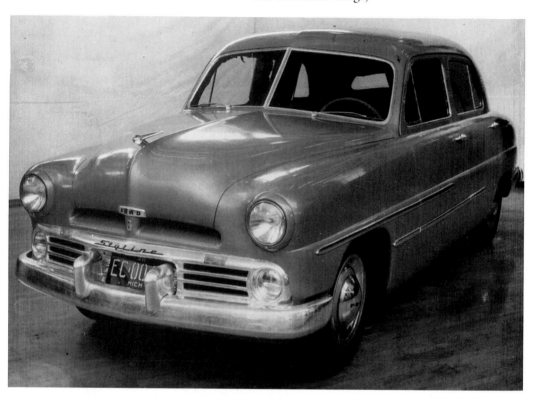

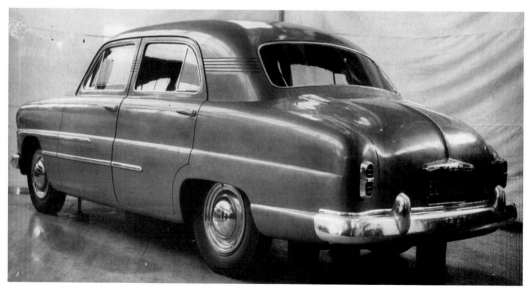

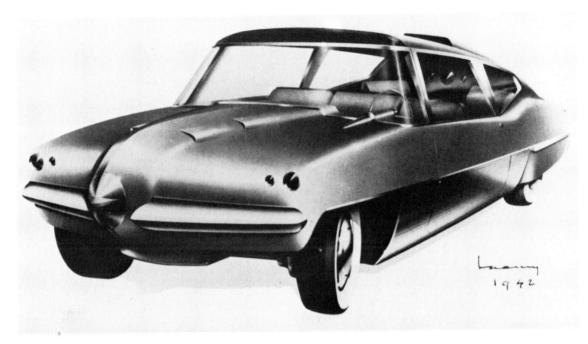

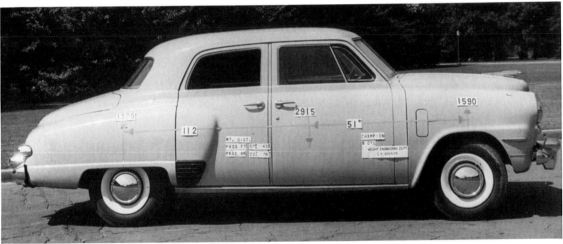

Top: FIG. 56. Raymond Loewy, rendering, dated 1942 (photo: Raymond Loewy Associates)

Bottom: FIG. 57. Studebaker Champion, six-cylinder, 1947, photograph August 28, 1946, taken by the Ford Motor Company under the supervision of E. P. Grenier, Weight Engineering Department. The photograph records the weight distribution of the Studebaker as part of Ford's complete inventory and study on this first postwar automobile. (photo: Henry Ford Museum and Greenfield Village)

Top: Fig. 58. Holden Koto, Richard Caleal, Robert Bourke, one-quarter-size clay model, 1949 Ford prototype, April 15, 1946 (photo: Henry Ford Museum and Greenfield Village)

Bottom: Fig. 59. George Walker, full-scale clay model, front view, 1949 Ford prototype, December 4, 1946 (photo: Henry Ford Museum and Greenfield Village)

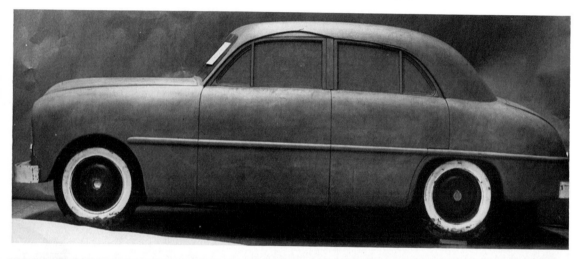

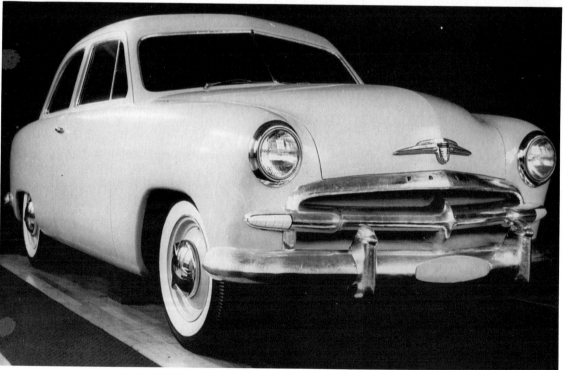

Top: FIG. 60. George Walker, full-scale clay model, rear view, 1949 Ford prototype, December 4, 1946 (photo: Henry Ford Museum and Greenfield Village)

Bottom: FIG. 61. Ford, Custom, two-door coupe, 1949 (photo: Henry Ford Museum and Greenfield Village)

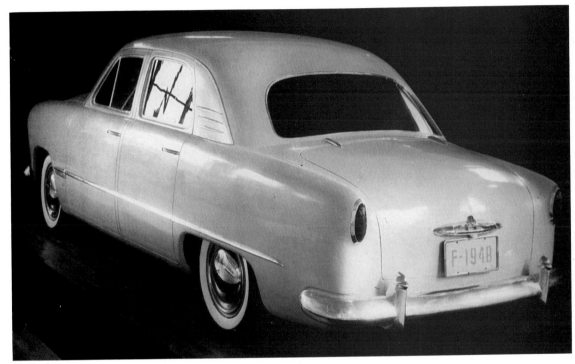

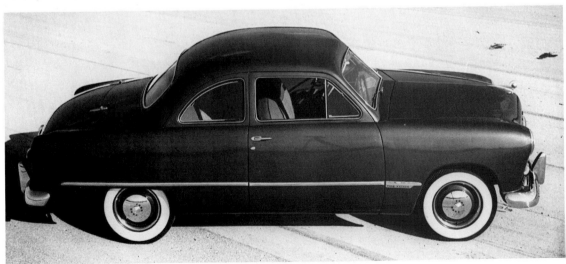

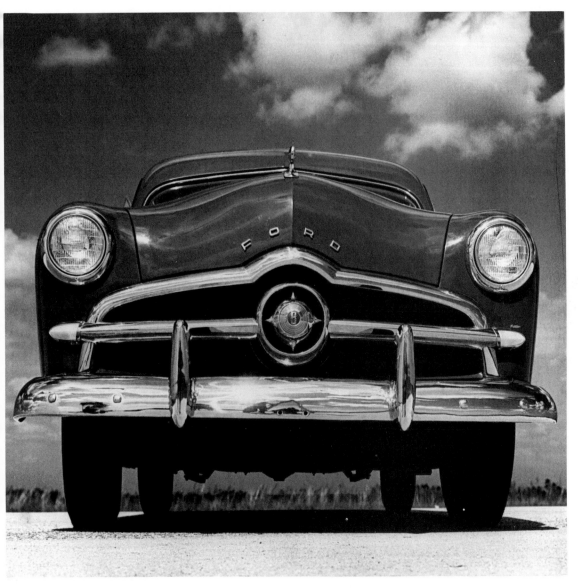

FIG. 62. Ford, grille, 1949 (photo: Henry
Ford Museum and Greenfield Village)

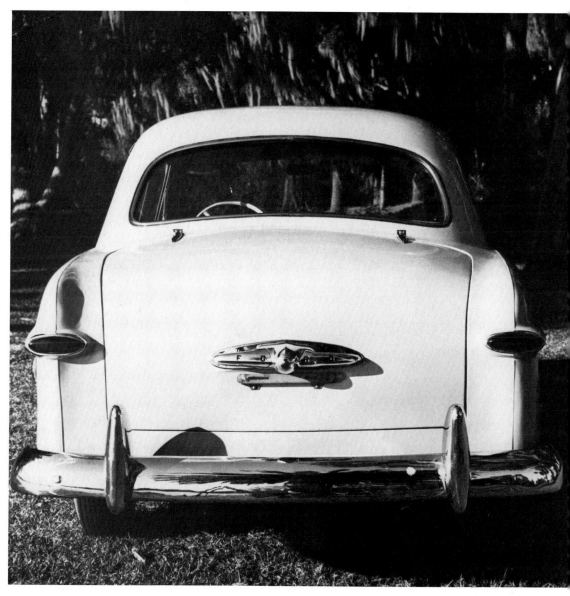

Fig. 63. Ford, Custom Tudor Sedan, 1949
(photo: Henry Ford Museum and Greenfield
Village)

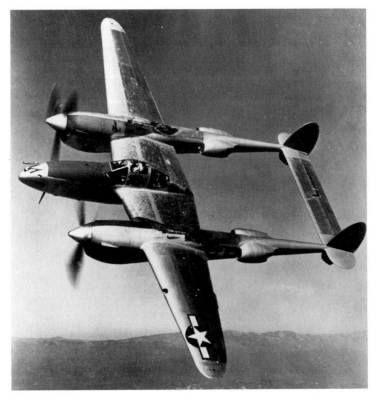

FIG. 64. Lockheed, P-38 (photo: General Motors Photographic)

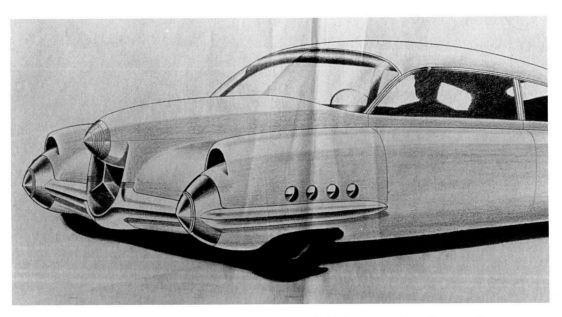

FIG. 65. Ned Nickles, drawing of proposed postwar GM car, Frank Hershey Advanced Design Studio, 1946, Collection of Frank Hershey (photo: author)

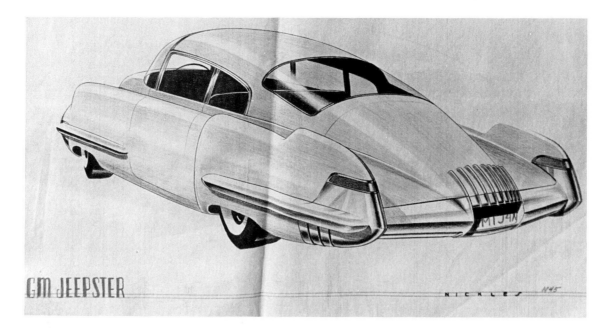

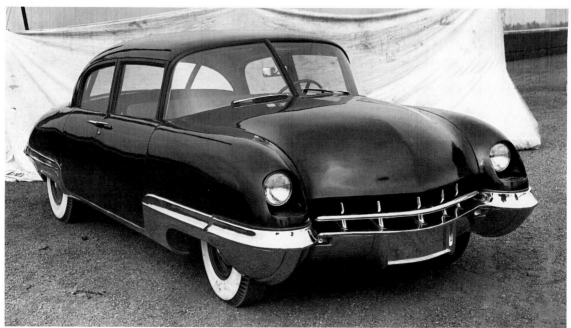

Top: FIG. 66. Ned Nickles, drawing of proposed postwar GM car, Frank Hershey Advanced Design Studio, 1945, Collection of Frank Hershey (photo: author)

Bottom: FIG. 67. Frank Hershey, Cadillac "C.O." design study, October 8, 1946 (photo: General Motors Design)

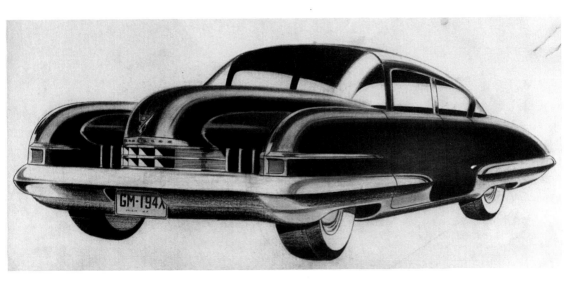

FIG. 68. Weiland drawing of proposed post-
war GM car, Frank Hershey Advanced De-
sign Studio, 1946 (photo: author)

FIG. 69. "All Change Is Not Progress," illustration from *Bulletin, Museum of Modern Art,* December 1942. Accompanying text reads: "Toaster of 1940 which is streamlined as if it were intended to hurtle through the air at 200 miles an hour (an unhappy use for a breakfast-table utensil) and ornamented with trivial loops, bandings and flutings. This object has never been exhibited by the Museum." (photo: author)

FIG. 70. Mathew Leibowitz, "Duke Ellington Classics," album cover for RCA gramophone record, 1947 (photo: author, copied from *Graphis* magazine)

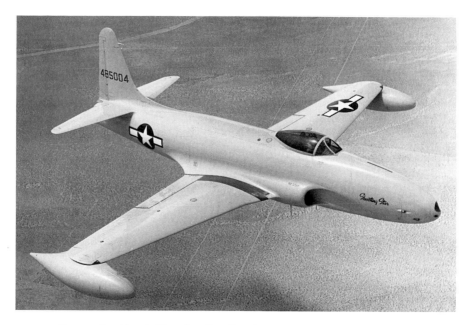

FIG. 71. Lockheed, Shooting Star P-80A, 1945
(photo: Lockheed-California Company)

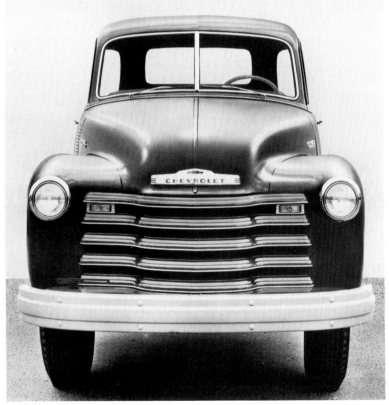

Top: FIG. 72. Pininfarina, Cisitalia, *Gran Sport,* 1946 (photo: author)

Bottom: FIG. 73. Chevrolet, "Advanced-Design" Series 6100 truck, 1947 (photo: Motor Vehicle Manufacturers Association)

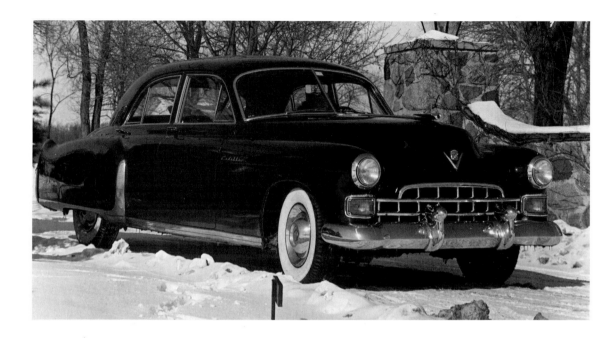

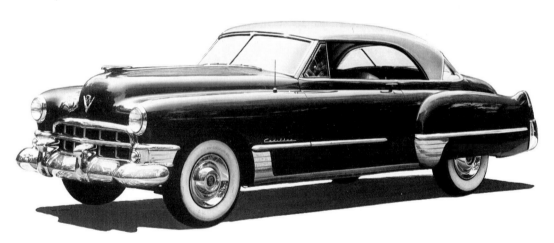

Top: FIG. 74. Cadillac Sixty Special, 1948 (photo: General Motors Photographic)

Bottom: FIG. 75. Cadillac 62 Coupe de Ville hardtop, 1949 (photo: General Motors Photographic)

Fig. 76. Chevrolet Fleetline sedan, 1949
(photo: General Motors Photographic)

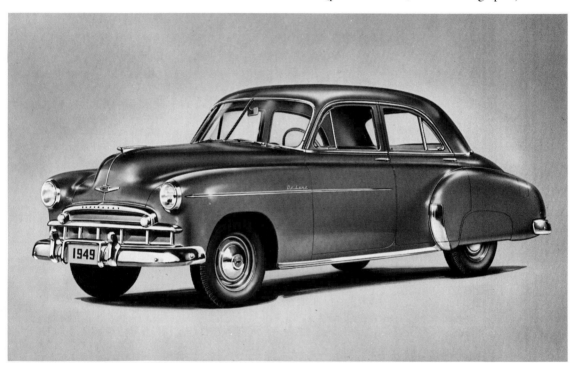

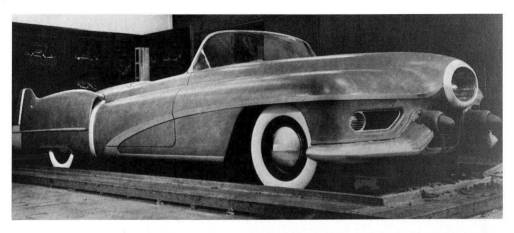

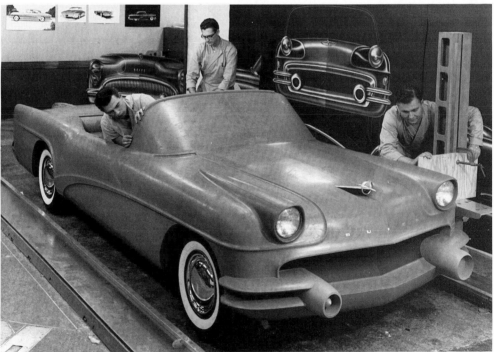

Top: FIG. 77. Le Sabre, full-size clay model, July 7, 1949 (photo: General Motors Design)

Bottom: FIG. 78. Full-scale clay model of first project for the 1955 Buick "Wildcat III" show car, photographed December 18, 1954 (photo: General Motors Photographic)

FIG. 79. Homer La Gassey, final project for the Buick "Wildcat III" 1955 show car, schematic drawing, November 18, 1954 (photo: General Motors Photographic)

FIG. 80. Buick, final project for the "Wildcat III" 1955 show car, orthographic drawing, November 18, 1954 (photo: General Motors Photographic)

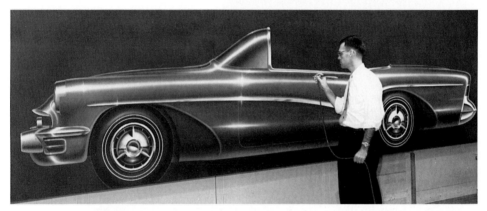

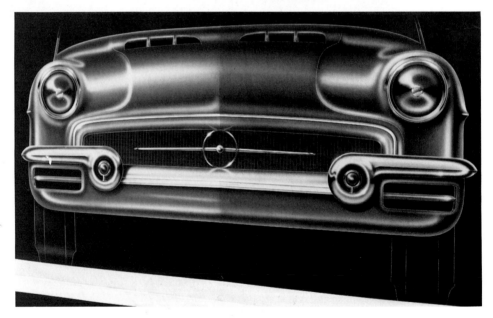

FIG. 81. Buick, final project for the "Wildcat III" show car, full-scale front view, orthographic rendering, 1955 (photo: General Motors Photographic)

Fig. 82. Chevrolet Delray, two-door, 1958
(photo: General Motors Photographic)

Below: Fig. 83. Chevrolet Biscayne, 1958
(photo: General Motors Photographic)

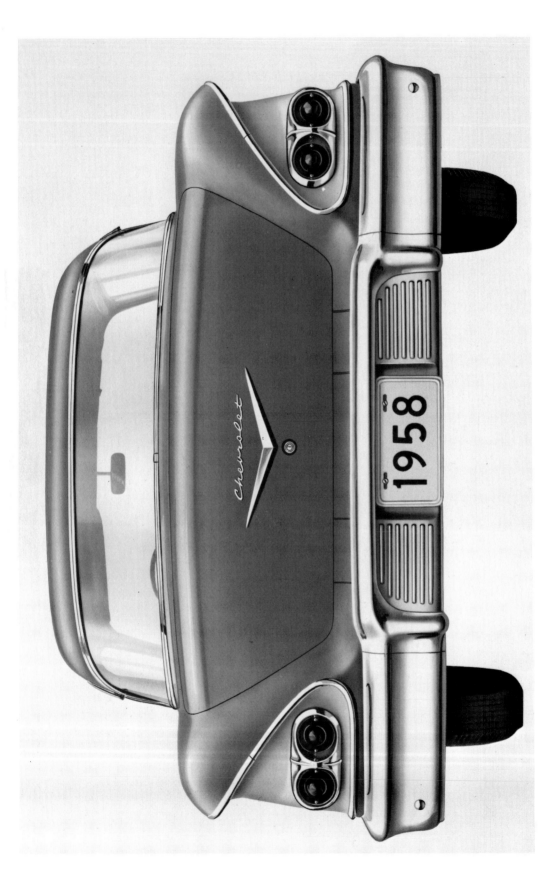

Top: FIG. 84. Frank Hershey, Ford Thunderbird, soft-top, 1955 (photo: Henry Ford Museum and Greenfield Village)

Bottom: FIG. 85. Frank Hershey, Ford Thunderbird, 1955 (photo: author)

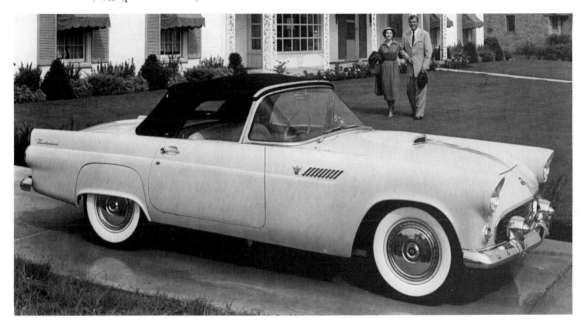

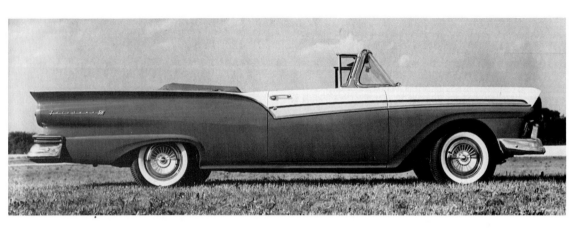

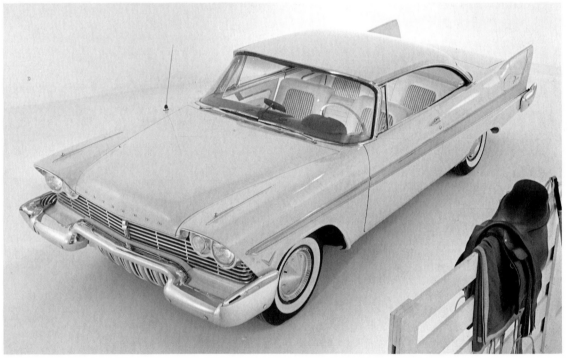

Top: FIG. 86. Frank Hershey, Ford Fairlane 500, 1957 (photo: Henry Ford Museum and Greenfield Village)

Bottom: FIG. 87. Homer La Gassey, Plymouth Fury hardtop, 1957 (photo: Chrysler Historical Collection)

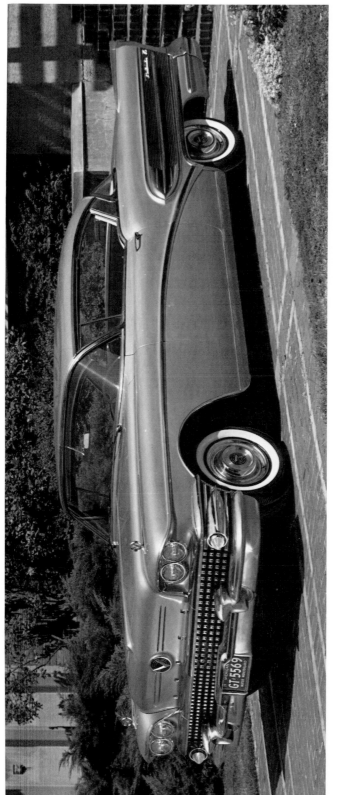

Fig. 88. Buick Roadmaster, 1958 (photo: General Motors Photographic)

FIG. 90. Buick Limited Riviera (1958), detail of taillights and bumpers, full-scale mock-up completed in 1957 (photo: General Motors Photographic)

FIG. 89. Buick Roadmaster, 1958, detail of "C" pillar (photo: General Motors Photographic)

Top: FIG. 91. Chevrolet Impala, four-door sedan, 1959 (photo: General Motors Photographic)

Bottom: FIG. 92. Chevrolet Bel Air, two-door sedan, 1959 (photo: General Motors Photographic)

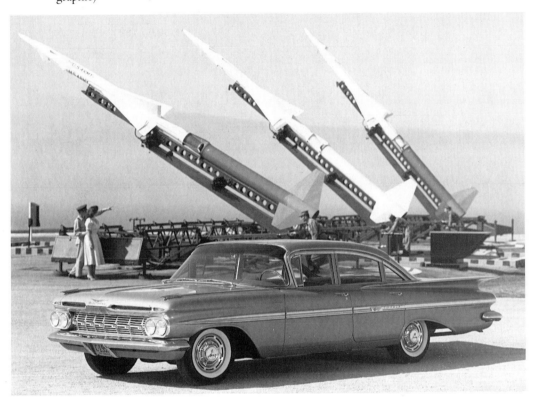

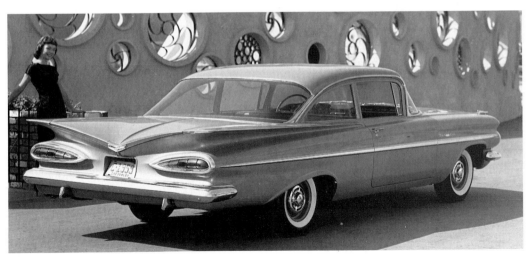

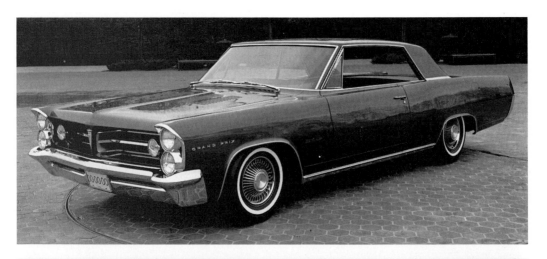

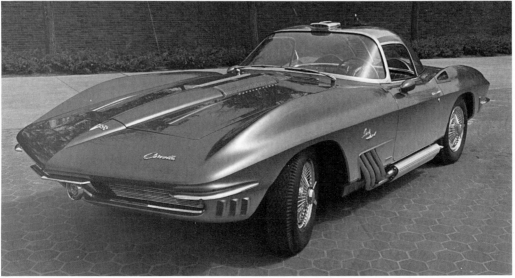

Top: FIG. 93. Jack Humbert, Pontiac Grand Prix, 1963, GM Styling fiberglass model, December 21, 1961 (photo: General Motors Design)

Bottom: FIG. 94. Chevrolet, Corvette Mako Shark I, 1969, based on XP-755 Shark, auto show car, 1962 (photo: General Motors Photographic)

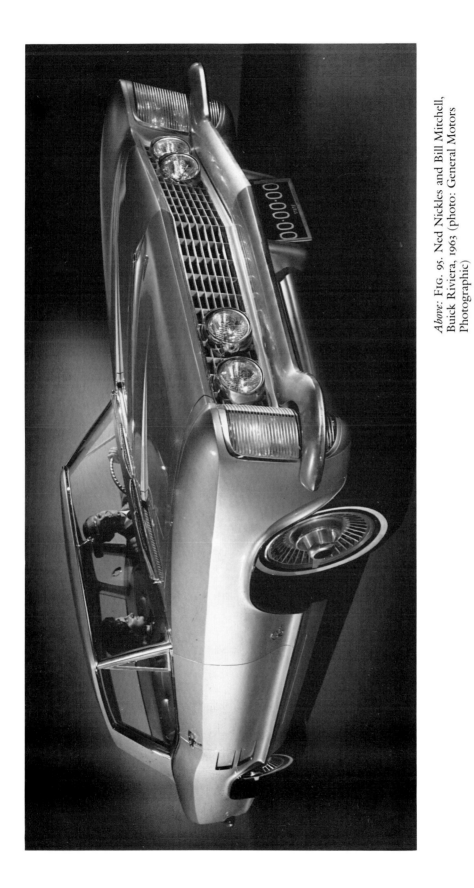

Above: FIG. 95. Ned Nickles and Bill Mitchell, Buick Riviera, 1963 (photo: General Motors Photographic)

Below: FIG. 96. Ned Nickles and Bill Mitchell, Buick Riviera, 1963 (photo: General Motors Photographic)

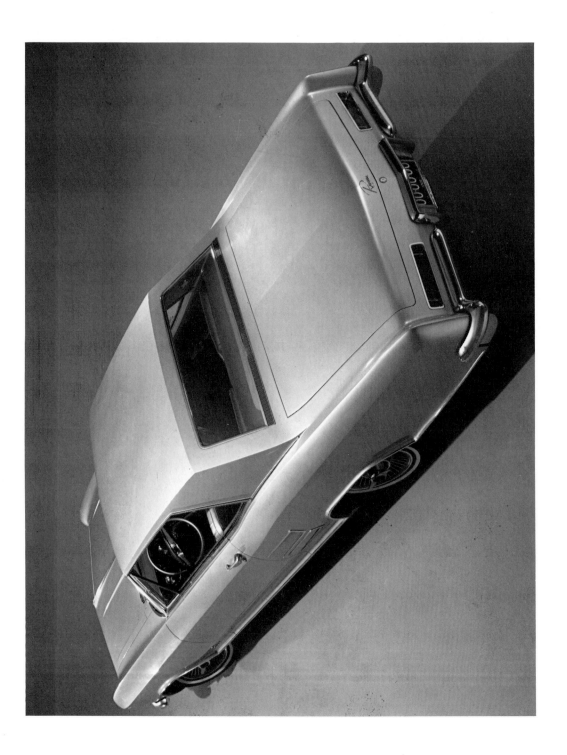

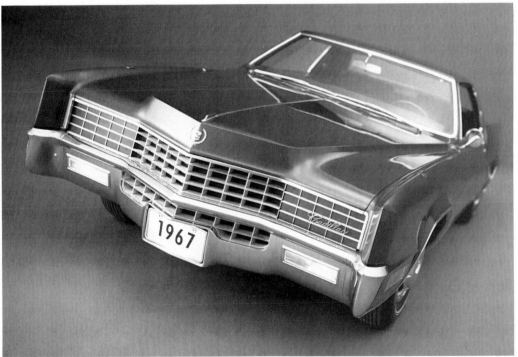

Top: FIG. 97. Ron Hill (chief designer, Advanced Studio), Chevrolet Corvair Corsa sport coupe, 1965 (photo: General Motors Design)

Bottom: FIG. 98. Cadillac Eldorado, 1967 (photo: General Motors Photographic)

Top: FIG. 99. Cadillac Eldorado, 1967 (photo: General Motors Photographic)

Bottom: FIG. 100. Norman James, Firebird III, space buck, December 2, 1957 (photo: General Motors Design)

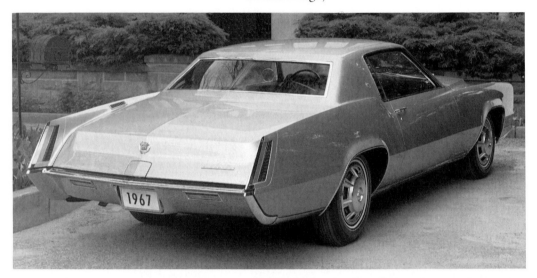

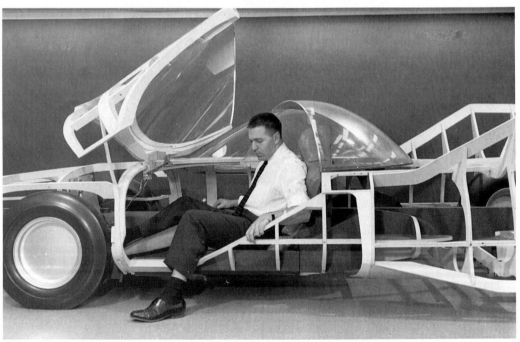

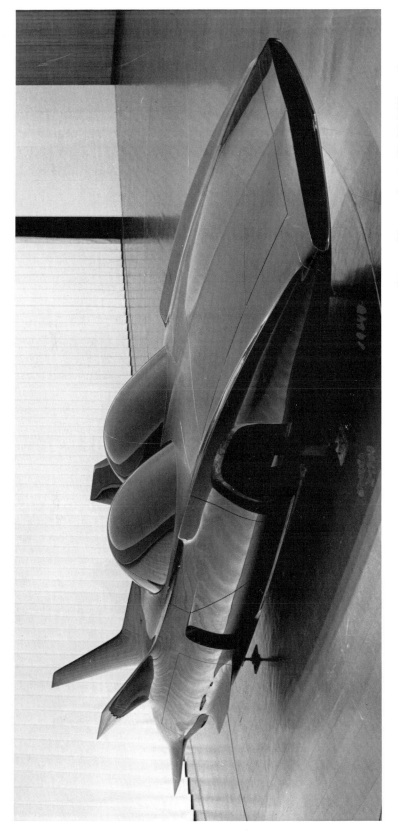

FIG. 101. Norman James, Firebird III, mock-up, March 17, 1958 (photo: General Motors Design)

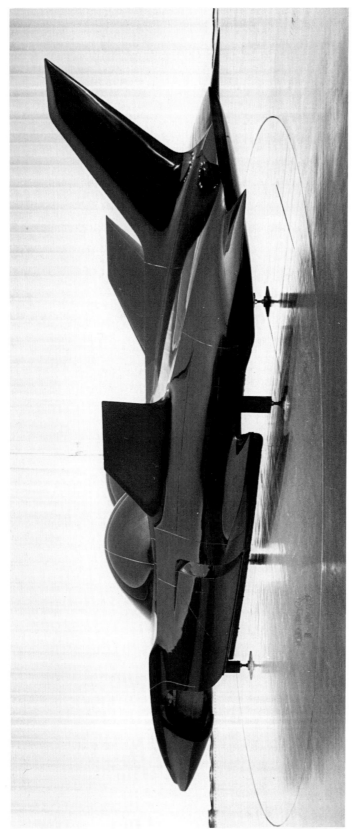

FIG. 102. Norman James, Firebird III, mock-up, March 17, 1958 (photo: General Motors Design)

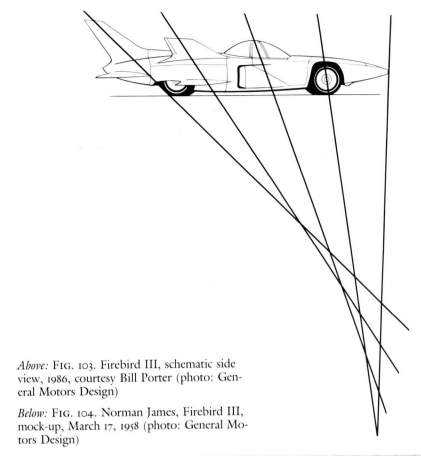

Above: FIG. 103. Firebird III, schematic side view, 1986, courtesy Bill Porter (photo: General Motors Design)

Below: FIG. 104. Norman James, Firebird III, mock-up, March 17, 1958 (photo: General Motors Design)

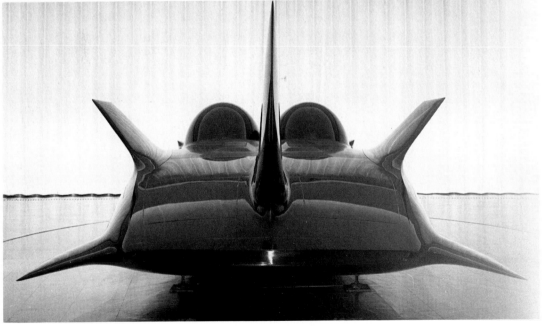

Left: FIG. 105. Bill Porter (photo: General Motors Design)

Below: FIG. 106. Bill Porter, GM Dragster model, c. 1963–64 (photo: General Motors Design)

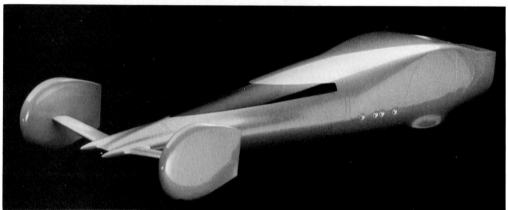

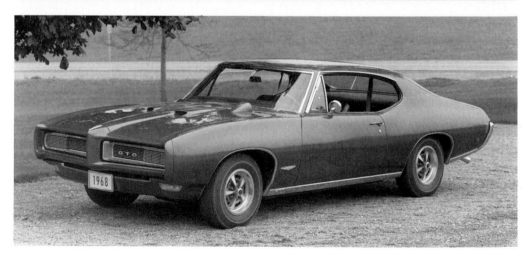

FIG. 107. Bill Porter (Advanced Studio designer), Pontiac GTO, 1968 (photo: General Motors Design)

Left: FIG. 108. Bill Porter, Pontiac Firebird, 1970½ (photo: author)

Below left: FIG. 109. Bill Porter, Pontiac Firebird, 1970½ (photo: author)

Below right: FIG. 110. Henry Haga, Chevrolet Camaro, 1970½ (photo: General Motors Photographic)

Fig. III. Ford Taurus, 1986 (photo: Ford Motor Corporation)

Right: FIG. 112. Bill Porter, Buick Electra, 1985 (photo: General Motors Design)

Below left: FIG. 113. Bill Porter, Buick Electra, 1985 (photo: author)

Below right: FIG. 114. Bill Porter, Buick Electra, 1985 (photo: General Motors Design)

FIG. 115. Chevrolet, Corvettes: 1984 (foreground), 1968 (left), 1953 (center), and 1963 (right) (photo: General Motors Photographic)

FIG. 116. Cadillac Eldorado, 1987 (photo: author)

Part Two:

Interviews with the Car Designers

*I would give anything to be
able to go back there and
drop back into the old days.
Knowing what I know now,
I would never have left. But,
let me tell you, of the guys
that stayed, most of them are
old men or dead right now
because it was a tough life—
and you were married to it!*
—Frank Hershey

THESE nine interviews were conducted over a year and a half, from December 1983 to July 1985. The conversations took place in designers' homes, except in the case of active designers, who usually met me at their offices. I had never met these men before, and therefore we exchanged some casual words before the interviews, which were tape-recorded with their consent. The interviews were condensed from an average five hours of dialogue, although the longest, with Frank Hershey, stretched over two nonconsecutive days.

Most of the designers had never discussed cars with an art historian, and at first they were wary of talking shop with an industry outsider. Also, the subjects I pursued were unusual to them. They were accustomed to answering questions from automotive journalists relating to historical issues and design "firsts," like how and when the first fin and hardtop appeared. To most of these men, the idea of talking about artistic process was new, as were questions asking why they had used the shapes they used. How each designer reacted to such unanticipated probing is perhaps the most revealing aspect of these interviews.

The designers were called upon to analyze their actions as well as to recount anecdotes about their experience, and some were more willing and able to do it than others. The reluctance of some of the men to respond to causal questions may be disappointing, but it should not prejudice our opinion toward the verbal and analytical designers and away from those with intuitive and imaginative skills. Despite their differences, they were all pleased with the respect given to them as creative artists, and most talked intimately and expansively about designing cars.

Gene Garfinkle

GENE Garfinkle designed cars for GM for only two years as a young staff member. Although only a staff designer, he contributed significantly to cars to which two vice-presidents attached great importance, including the Cadillac Cyclone, prepared for Harley Earl's retirement, and the Corvette Mako Shark, perhaps Bill Mitchell's favorite automobile. His talent was readily perceived, and within a short time he was moved to the Buick production studio. Garfinkle recalls the system of design from the point of view of a young designer who entered GM filled with new ideas and creative ideals. After only two years, he found the system so repressive that he left to design cars on his own.

But these two years—1957 and 1958—were very important at General Motors, seeing as Earl retired and Mitchell took over. Viewing the Tech Center from the underside, from the lower level, Garfinkle explains how the GM system affected idealistic young designers, and he tells how their ideas either made it or didn't make it to the top under Earl and Mitchell. He compares these two vice-presidents, whose tenure spanned fifty years, and the systems of design they created. Both leaders abhorred theory, consciously rejecting verbal dialogue, and both insulated themselves through a hierarchy and a rigid sequence of operations. Gregarious by nature, Mitchell was insecure and distant at work, where he asserted himself by a "frenetic belligerence." Earl, by contrast, was an inherently shy man who dominated by his authority and presence on the job. Earl could get

closer to his employees, but Mitchell better tolerated their independence, and he was more receptive to new shapes and directions. Mitchell replaced Earl's random, or "shotgun," approach to styling with more advanced planning, and as a consequence, Garfinkle believes, Mitchell produced higher-quality designs.

It should be pointed out that Garfinkle, like other young postwar designers at GM, shares the prejudice against Harley Earl's aesthetic values. Like avant-garde designers throughout the country after the war, they valued purity, elegance, and functional honesty over distinctiveness and uniqueness. It was better to be good than to be different. When Mitchell retired in 1977, Garfinkle's generation turned the tables at GM by introducing avant-garde principles of the fifties as the reactionary taste of the eighties.

Gene Garfinkle's unusual gifts make his interview a good place to start. He scrutinizes and analyzes the process of creating cars and skillfully articulates his conclusions. Garfinkle thrives on the probing question because he has reflected on his own experiences as a designer, and he has the rare ability of a true raconteur to capture the essence of those experiences through anecdote.

CEA This is the problem. You have an art audience who is unfamiliar with the process of design in a studio in the fifties. Anything you can tell me? You came there in '57.

GG Yes. I was hired right out of school. And at that time, they had what was called an orientation studio. First, the new arrivals would be given a sort of playpen to work in, where they could show their wares and get used to working in a corporate environment without damaging anything. They were not given any really serious projects. We were not working on production cars. And that usually lasted for six months to a year. Then, in the next step, they put you into a pre-production, or experimental, studio—an "advanced studio" they called it then.

CEA Why do you think they would put you in an advanced studio rather than in an actual studio?

GG Well, I think part of it was just [a matter of] security. They never had a real feeling about how long you would last. And each studio was secure. A designer in one studio didn't normally have access to another studio. And in the advanced studio, they were still doing a lot of what they called experimental cars. They were really just design studies—showcase cars. There was a chance to exercise your creativity without really impacting anything in the normal pipeline. And sometimes it [the studio] was used to stimulate other designers in the other studios—to give them a boot, to say, "See, here is the next generation coming up. This is what you are up against." Also, it was a way of acclimatizing you into a process. The kind of cars they were doing at that time—I guess it could be called the great heyday of the American bonanza—I mean, everything was just a great free-for-all. Just about anything went. And the further away you got from reality, probably the more realistic it seemed to be. The kind of cars we were doing had nothing to do with transportation. The show cars, the experimental cars, they were really just absolute fantasies. That was the sort of thing you got to work on and play with for a while until they finally had a slot available for you.

CEA I think it is interesting how they thought of advanced design then. From what you say, they really didn't think of it as advanced design but more as a playpen for people coming in.

GG Well, no, really, the thing had four uses. It was a place for the entry-level people that came into General Motors to demonstrate their skills and to have the staff production designers get acquainted with them so that they could be slotted into the area where they were most appropriately fitted. The second was actually to develop ideas. A lot of the ideas were incorporated into production cars. At that time we were really styling. It wasn't design; it was a very superficial, fashion-oriented activity. The third was to stimulate the production designers, showing them other areas they could be directed toward. And the fourth was just as a marketing vehicle: to publicize, to see how far out we were really getting, to build up an appetite for the next generation of cars.

CEA What kind of direction were you going in?

GG Well, the whole group of us that came in at that time were becoming very aware of the impact of the European cars. The Volkswagen was just beginning to get strength at the time. And we were not only conscious of that, we were falling in love with the purity of the Italian school of design and the romance of the English tradition. We were the Young Turks coming into an established structure that still fashioned a car after an F-84 jet or that tried to convey something else in the look of a car other than what it was.

CEA That must have caused friction. How did it work out?

GG It seemed awfully bitter at the time you were in there. But when you look back, you can laugh at it because it does not seem that serious. It is such a transitory kind of industry. When you know that everything is going to be replaced every three years, it is hard to take what you are doing very seriously. And we weren't building good products, either. I mean that was the era of the '59 Chevrolet [Fig. 92].

CEA When Mitchell talked about the advanced design studio, he talked about it as something that was a fundamental change from Earl, in that he was able to look more than a year or two ahead.

GG He did that, very definitely, because Mitchell had something—he was a bit of a throwback. He was of the more flamboyant, gee-whiz school of design, but I think he had a genuine appreciation of the forms and the kinds of feelings and shapes that were being generated by some of the people he had under him. And he gave them much more of a chance to exercise that than Earl did. And the shapes Mitchell liked himself were more amenable to being worked with by the designers of the generation before, during, and after him. Earl was like using a big hammer when you only needed a little tapping lever to knock something in place. He was a very strong, big man, and his sense of form had that—everything was like an overstuffed couch. Mitchell tried to refine things more; he was after a slimmer look. Even though his shapes might have reverted back to an earlier time, they were still more amenable to being worked with.

 Mitchell did give the younger designers a chance to go further and to demonstrate the kinds of forms that turned into the Camaro [Fig. 110], which I think were just a marvelous bunch of shapes. The first Buick Riviera was a genuine

Mitchell expression [Figs. 95, 96]. He called it the "London look"—fine-edged and crisp, with a folded edge—that very much defined the lines down a fender, complementing the curve or radius and giving it strength. The razor-edged look was something that pulled the shape along. Mitchell wanted to show that he could take a shape, such as a Rolls or a Bentley might use, and make it contemporary. And that is what the guys doing that first Riviera did. Then they started to stretch it and to give it a little more grace and a little more flow. And it got to be something I don't think he could have drawn himself, but he appreciated it a great deal and pushed very hard for it when he saw it.

I think there was a great flourishing [under Mitchell]. It always takes somebody strong at the top. His feelings don't matter so long as he has a definite conviction and strength of character about what he is doing. Somehow people will react to it, and you'll get a positive result. If you have somebody at a high level directing or administering a program, and all he is is politically motivated, he'll take everybody's consensus and put it together in a way that will please the most people. But you have nothing significant left.

CEA This is very interesting because you were at GM just when Earl was turning things over to Mitchell [1958]. Earl was a very strong person who didn't put ideas on paper, who didn't put them in visual form, and yet Mitchell was a very strong person who could put ideas down. How did that affect things?

GG Mitchell could draw, yes. It was hard for somebody like myself to judge, because I worked more closely with Earl. I worked more on Mitchell's projects, but I had a closer relationship—as far as the day-to-day contact—with Earl. Mitchell kind of divorced himself from the working process.

CEA Can you tell me about that contact with Earl?

GG Well, Earl liked to tramp through the studios in the evening, after everybody was gone, to see what was going on. And it seemed that most of the time I was there we were doing an awful lot of overtime. I happened to be one of a couple of guys on what they called the "fin and bomb squad." Hank Haga and Larry Shinoda were the other two. And if another studio was having a problem and was either shorthanded or had reached a block on something, one of us would be sent down to work with them for a while. Or maybe it would be just to do an illustration or do part of a presentation.

CEA The "fin and bomb squad"?

GG Yes, because that was all the shapes we were working on at that time: bomb shapes for the front bumpers or in the grille, and fins on the back fenders. So, Earl would come at night. We were there at night too. He would come in—and oh! he had a marvelous eye! His favorite draftsman, who started work at the same time he did back in 1927, was Carl Pebbles. Carl always stayed a draftsman, but Earl always had Carl sign any project he had a personal interest in. And he always picked on the man unmercifully. I mean, he would just badger Carl incessantly. He'd even sneak up behind Carl. Carl was in this advanced studio that I was in, doing the Cadillac Cyclone, and Earl would come in. And Carl would be sitting on his little stool, and Earl would start in. "Gee, Carl, remember when we worked here and came in together. We both started at the same time, and now I can tell you what to do. And you have to take it. You always have to listen to me, don't

you, Carl?" He'd just go on and on, just rubbing that in. Then he'd make it up in some way. Carl was awfully well paid, and he got a lot of little perks, like getting to design his own vehicle of some sort. But Earl had this need to always have somebody whom he was prodding. But he always picked people to demonstrate his expansive heart or good-naturedness, too.

Another Carl, Carl Tacke, he became a board man too. Usually board men, the technical stylists, would be the ones who did not have the creative flair. They might have started as designers, and they were still considered valuable. The company would keep them on as technical stylists, but they would really be the design draftsmen. And Earl would look at Carl. He was almost as tall as Earl, about 6′3″. In fact, Carl Tacke and Carl Pebbles worked together. Carl Pebbles was a very short, slim little guy, with a very wizened face. So anything good Earl wanted to say, he always addressed to Carl Tacke, and anything bad he'd always address to Carl Pebbles. If it were a put-down, even if he weren't talking to Pebbles, he'd be addressing him.

Earl's big thing at that time was to get a small sports car done—a two-seater open car. And he'd always go, "Gosh, I'll bet if we built one of those things and sold it for fifteen hundred dollars, why, we'd sell thousands of them, right here at the Tech Center." And he'd look over at Carl Tacke. "You'd buy one of them, wouldn't you?" And Carl would go, "Wooah, oh yeah, yeah, I would, Mr. Earl." "Even a big fella like you, you'd like a little car like that, wouldn't ya, Carl?" The pleasant aspects were always with Carl Tacke.

CEA So you actually had more contact with Earl than with Mitchell.

GG Mitchell was very strange because I did three of Mitchell's cars. He usually had one car from each division customized for himself, and always one of the show Corvettes would be for him. And I worked on a special Buick for him.

CEA Still in the Advanced Design Studio?

GG No, that came after I went into the Buick production studio. They would still pull me out, like they pulled me out for a six-week period to work on what became the '63 Corvette. And out of that came a special Corvette called the Mako Shark [Fig. 94], which I did the top and some other detailing on.

CEA Mitchell must really have trusted you, because those cars were the dearest to him of any.

GG They were. But he never spoke to me! Mitchell always had a way of dealing with what he thought were underlings. I think it may have been shyness. I don't quite know what it was. When I was doing the Corvette, there were only two of us in the studio; there was an engineer and myself. Mitchell would come in, and there would usually be one of the two male secretaries with him. (Both Earl and Mitchell always were followed by a male secretary.) [In this case] it was Harry Elsworth, an ex–football player, a great big, typical-looking ex-jock. Mitchell would just sort of loom around and never say anything. But then, later, if there were something that had to be said to a person or directions given, Harry'd be the one to come back and do it. There were a few people Mitchell would talk to. For instance, down in the Corvette studio, he'd always say, "Well, I want to do this. I'd like to do that. And, well, no, I don't want a scoop there." But he'd always be addressing the engineer, whom he knew for twenty or thirty years, as if I weren't there.

I remember [how his way of treating people on the job] really became apparent to me. At lunchtime we used to go to a restaurant behind the Tech Center, and we used to meet Mitchell and some of the higher-level people there. Sometimes they'd ask us to join them at table. On those occasions he was very affable and outgoing. He was a very gregarious kind of guy. But in the studio, for some reason, he kept himself very insulated. He'd come in and not tell me anything. I remember after I left the Corvette thing, they would just shunt me in and out and not tell me what was happening to it. They just told me to go on back up to Buick, and I went back up there.

CEA This is a question I kept asking Strother MacMinn. How did anyone get a sense of what the director wanted done? This seems to be a key question to understand the process of design.

GG Usually it would get fed down to you through the studio head. But that was in the process of changing during the time I was there. They were just starting to get together, talking over objectives and trying to get a sense of direction in the studio before anyone actually committed something to paper—so that we all knew what kind of areas we should be working towards, what kind of shape goals we were after, and what kind of character we wanted to see in a car. Henry Haga was the first one in the studio to do that, to sit down for three or four days and brainstorm the thing. Before that, it was just kind of chaotic. Before that, they would just come in with a body package—without any front, back end, doors, fenders, or anything. And then they would say, "Stan, why don't you take the front end?" and "Hank, why don't you do some sketches, maybe tying them all together?" And that is the way it started.

CEA This would be in '57.

GG Yes, that was starting to change. Guys like Irv Rybicki, Clare MacKichan, and Hank Haga, Dave Holls, and Chuck Jordan—those were the guys who were really influential in making it more of a directed activity. That didn't exist before. Before, it was more of a shotgun approach: "Let's sit down and draw, you know, twenty sedans by Thursday." And then they would look at the wall. Earl or Mitchell would come and say, "Naw, I don't want any of that fruity crap there!" That was Mitchell's way of talking.

CEA It sounds like him. To play devil's advocate for a moment, can't one argue that the system fostered creativity because there *wasn't* one sense of direction? The head said, "All right, let's see what happens," and then he picked out a certain direction from what you were doing rather than imposing it.

GG No, designers need to have direction. It's great to think about blue sky, but that could be a very formless way of working. It is good to have parameters laid out. They are not really constraints.

CEA But here is the interesting thing. Earl had a very strong aesthetic sense—almost tyrannical—so it is very surprising to me that the process itself was rather haphazard and scattered.

GG Well, he enforced it through the studio heads. I remember some very selective picking of this or that, but there were no directions given. But in the selective process, we helped—were a very prolific bunch, all the way through. It would be nothing for eight to ten fully realized, almost rendered sketches to be done in a

day's time. So, after a couple of days, with five guys in a studio cranking out stuff like that, you had a lot of material. And there were some awfully good artists there, too! They had all the presentation techniques. They knew how to set things, back things up, and what kind of colors attracted whose eye.

CEA How did you present it to Earl? Was it like an architecture class?

GG Just like a Beaux-Arts class—everything went up against the wall. Normally, Earl did not come in during the day to select; he would come in during the evening. If the studio head wasn't there, Earl would leave instructions for which of the things he saw on the wall he'd like to see pursued. He would not talk to the designers directly, except in general terms; specifics always went through studio heads. And then, the next morning, the studio head would say, "Mr. Earl was in last night, and we've got to do this and we've got to do that!" That is pretty much the way it happened.

The good stuff would be left up—that's how it was edited. The things they didn't want you to be bothering about were taken down, and the good stuff would stay up there. So, gradually, by that process of selection, you had a wall full of the kinds of things that Earl, or the studio head, or whoever had the voice that day, wanted. It got chaotic.

CEA It sounds like a hierarchy. Basically, you didn't see Earl. Earl saw your stuff when you weren't there, and then he voiced his concern through the chief of the studio.

GG Right. And if you were going in the right direction, you'd get some sort of a little tap on the head or something. The man had an incredible eye. He would walk in the door, and the door of the studio would be forty feet from the vertical boards. And there would be guys drafting lines the width of a 2H pencil—tenths of a millimeter wide—on a full-size drawing. Earl was more comfortable badgering the tech stylists because he saw things in just two dimensions. The sketches he didn't usually pay much attention to. It was what was up on the board that he looked at. He'd come in, he'd throw the door open, and all of a sudden there would be this great big foot, you know, striding through the studio. The designers trained themselves to curl their toes down, too, so they'd never crease their shoes, so their shoes would always look smooth on top.

CEA When you say that he saw in two dimensions, what do you mean exactly?

GG He was more comfortable with reading in two dimensions, with reading drafting or lofting-type drawings, than three-dimensional or perspective sketches. The point I was going to make before is that he had an eye and he had a memory. He might have been in a studio three nights before and asked if that fender line could be lowered a little bit. As soon as he had that [studio] door open, I mean you could hear his voice. It wasn't a bellow, but he had a very strong voice. "I thought I told you to lower that line!" He could see it from forty feet away—he knew exactly where that line was supposed to be. That was the sort of sensitivity he had. It was a very blunt kind of sensitivity.

The only thing I ever got caught in, as far as Earl goes, was when he wanted to build that two-seater sports car. There were three of us in this advanced studio at the time—Jim Hulbert, myself, Lee Knight, and Carl Renner as studio head. Chevy was going to back this project to make use of an engine derived from the Corvair, to do a little two-seater sports car. We started doing something, but I

got disturbed about the way it was going. It looked like it wouldn't work. It just didn't feel right. It was still old, with very bulbous shapes and everything. So I sat down one afternoon and did a bunch of sketches—just to get something out of my system—and I left them on my desk. I didn't tack them to the wall or anything. They were just lying on my desk.

The next morning, Ed Glowacke came in. At that time, it was between him and Mitchell who was going to succeed Earl. I think Mitchell was always a foregone conclusion, but Glowacke was a dark horse. Glowacke came in, and he just went right past Carl Renner up to me, and he said, "Ed Cole and Mr. Earl were in the studio last night, and they want you to pursue this thing here that you had on your desk, there." So, I thought, "Gee, that's great." And they walked out. He didn't say anything to Renner at all.

Now Renner is the studio head, and he is the one who is directing the program, and I am supposed to start corralling tech stylists and model-makers and everything and do it all. We were working on full-sized models then. We had two modeling platforms in the studio. Renner evidently had been told by Earl that I was supposed to do the other project too, but Renner didn't know how to handle that, either. So he said, "Gene, we have to pretend that you are working on Mr. Earl's project, and then, when he is not around, or he is not looking—and we never know when that is—you can work on yours." And I said, "Yeah, but Mr. Earl is the one who asked me to work on the other one." He said, "Yes, but the first one is still Mr. Earl's project." And it just went on like that for weeks.

CEA Did you get any feedback from Earl?

GG He would never involve himself directly at that level of activity. It was always through the studio head. Glowacke was the conduit to me for some reason. But, finally, Renner, I guess, was ordered to forget the first project that Mr. Earl didn't want. Isn't that funny—you just keep saying Mr. Earl. You don't say Harley Earl. You never thought of him as Harley. It is always Mr. Earl. Almost like one word: Mistearl! But he would be very engaging: He'd come in, and we would all huddle up around him—he was like a big Smokey the Bear—and he'd always have something engaging to say. But it would always be in very general terms. He'd give a little treatise on what he thought windshield pillars ought to look like, but never on anything specifically that you were doing in the studio.

CEA You always had to go through your boss.

GG That's the guy that directions always came from or, sometimes, from guys like Glowacke or Mitchell. They'd sneak in and would say, "What if you tried something like this?" It was the classic thing, you know—sketch it on the back of an envelope or something.

CEA Dave Holls said that at General Motors they have a saying, "I can see but I can't hear." In a way, it seems to me that this system, this hierarchy that you describe, in a way reinforces that idea. If it can't be seen without your having to talk about it, then it's no good.

GG Mitchell, in particular, had a great aversion for designers who were always quoting theory. He would just turn on them and walk out. He would not sit still. Maybe that was part of it. If you showed him something, he'd look at it and say, "That's great," or "That's crap," or whatever. You know, it was always very

direct. But he very much avoided the kind of people who were steeped in the theoretical aspects of shape, form influence, and that sort of thing.

At that time I was just a staff designer. And going back to that one experience with Mitchell, that really drove home what a very junior position that was. I got back up to the Buick studio after the Corvette venture, with no one saying, "Oh, we'll take it up to Chevy, or something." You never knew what happened to whatever you did. One day, Mitchell comes into the studio, and Henry Haga and I were just standing somewhere near one of our boards. Mitchell comes over, and he starts talking to what I thought was the two of us. He was talking about the Corvette, and he says, "Yeah, we are going to do this, and we are going to do this." He was drawing on a little pad, and he looked over and saw me looking there, too. I thought I was part of the group. Then he turns himself around so that he is only showing it to Hank, although he was talking about the thing I had just spent six weeks on down there. We were always conscious of our position.

But Mitchell was a genuine car enthusiast. It really got to him if he felt anybody was doing something they really enjoyed with cars. I remember when Tony Lapine had one of the first Porsche Carerras, back in 1958–59. Tony had bought it from Germany and had it shipped over here. When he finally had the thing running right, he drove it over to the Tech Center. Mitchell's office was located over a little drive-under that goes into the executive garage. It is cantilevered out over the space. Tony grabbed me and said, "Let's go out and play with my Porsche." We got into Tony's Porsche and bumbled around the lake for a while, and then he just drove it underneath Mitchell's office. He had what they called a "stinger exhaust"—the exhaust was one great big exhaust pipe straight out the middle of the back of the car. Tony just sat there, directly under the office, with Mitchell right up there—and went, "Wraam, wraam, wraam," until it looked like the glass was shaking. Then he just trundled away. That afternoon, here comes Mitchell, throwing open the door of the studio. He was always like this—elbows flying—a red streak moving through the studio. He came right up to Tony with this great big smile on his face, and he goes, "How's the racer, kid?" That was marvelous.

I understand Mitchell better now. After I left General Motors, I did two cars myself as a consultant, and both clients said it was Mitchell who was their reference to me. I saw Mitchell at a New York auto show, where one of the cars I had done was on display. On preview night, everyone sort of wandered around, and there was Mitchell, with Christiansen and [Warren] Fitzgerald [supervisor of Automotive Information Services, General Motors] both holding him up. The guy could barely stand. He had had it. All day long he had been going at it. They were trying to drag him away, but he muscled his way through. He dragged Warren Fitzgerald—who was bigger than he is—over to me, and he swung his glassy-eyed head around to the car. We were almost near the booth with the car I had done, and he said " 'At a way, kid," and then he went on. You see, he really believed in the romance of the thing.

CEA Strother MacMinn told me two things about Mitchell: that he consciously caused friction to promote creativity, and that he set up release-valve situations. Do you have that sense too?

GG Yes, when it is explained to me. I was too young to know it then, too young to be perceptive. Guys like us in that situation (that was my first job) are awfully sensitive. You think anything that even smacks of negativity is just a permanent abrasion of some sort; so you don't get into an analytic mode about it.

CEA Would he take a bunch of the guys and just go off on a sort of stag's night?

GG Oh yeah. There was a lot of that going on.

CEA Organized by him?

GG No, others. I was part of the group that resented that kind of activity and stayed away from it. That is one of the reasons he didn't respond to us that closely. There were a number of us that he just never got close to in the working situation, yet you never felt that he was antagonistic toward you. He just wanted to be removed in that situation.

CEA And Earl's working image?

GG Earl was one of the great Americans, and he could only have been created in this country. He is uniquely American. It is funny to me that the two areas that have most affected the culture of this country—the movies and the automobile industry—are the only two creative areas of expression that are giant businesses, too. I'm talking about industries with magnitude of impact. But those two are the areas that are the least known as far as what it really is like to go through them—to be a creative person in a business where the primary goal is to make money and not to be creative. And yet they need creative people to do it. It's difficult to define the kind of people who can go through that.

CEA How frustrating was it to be a designer in that kind of situation? One, you know the goal is money, and two, you are underneath a whole hierarchy of other people. How could you be creative, working for so many years without having your own head?

GG You find a way to express it as well as you can. And only a few will make it. There is a kind of person who can stick with it. I couldn't.

CEA Only one will make it, right?

GG No, you get into areas where you are given at least enough freedom, enough authority, or enough responsibility that you can see an effect. You might not be up at the top, but you might be in an area where you are far enough removed from the kind of autocracy that they've built up there. Or they may have enough respect for you to let you do your own thing for a little while. It happened, I think.

CEA Was creating a nine-to-five activity?

GG Eight-thirty. If a program ran afoul of time—that is, if they were due to have a project, and they were not satisfied with the results—then they would go into overtime. And they would do that all the time.

CEA When you worked in the evening, it would be a supervised group activity. You couldn't free-lance at all?

GG Right.

CEA And how often would that occur?

GG When I was there, between '57 and '59, it was almost continuous. Once I got into the Buick studio, it was overtime through the whole year. We'd stop anywhere from ten o'clock at night to two o'clock in the morning.

CEA So how did this work with both Earl's and Mitchell's tendency to walk through the studios by themselves at night?

GG I think they enjoyed that part of it. They really did. There was a looser atmosphere in the evening. They didn't seem quite as formal. Earl never was formal, but you knew he was the presence in the room when he was there. I remember seeing Earl once, at the races. He would be visible, but he was a very shy person. He normally walked with his hands behind him, and he bent over to look at things. He almost looked like he kept his hands behind him to keep from bumping into something. And he was always careful not to be in somebody's way. For example, he'd move out of the way if somebody else came up to look at a car. He never intruded on anybody.

CEA Are you saying that he was an innately shy person?

GG I think he was a genuinely shy person. But, in spite of that shyness, he had an incredible authority about him. He looked at somebody when he said something. He was very convincing in what he said—even if he were asking a question in a kind of querulous way, like, "Hey, what do you think about that?" You knew what he thought about it, and you knew he would make a very quick decision as to whether he accepted your answer or not. I think if you saw two naked men in the shower, you would know who was a commanding general and who was a noncom. I think people just carry that authority with them, and that is something I don't think you can learn, either. You just have it. Earl had it, he really did. He exuded it. I am not sure it was confidence, but rather just a rightness about him. He was convincing when he did something. It was right. And it wasn't as if he was bullying. I don't think he meant to be bullying. It was just something that people do without intending to.

 Mitchell very often could assert himself only by that frenetic belligerence that he has. The first couple of times I saw Mitchell in a board of directors' presentation was ridiculous. He was like a little boy coming into a fancy restaurant trying to sell newspapers. I mean, that is the picture of him I formed immediately. He was running around, grabbing people. "What do you think of that? Hey, don't you think that's great? What do you think of that?" When Earl would come in with the board of directors, the board of directors would move as a great mass from studio to studio. All these black suits moving around. That is when the final decisions were made.

CEA Tell me some more about that.

GG It may not have been final decisions, but it was final approval. The design process worked like this. You'd start off in a blaze of creativity and enthusiasm. You'd run down through about three or four different paths, and you'd develop about three or four different themes. Usually, a production studio had three full-sized modeling platforms, so you could have at least two clays going at the same time. (The third was usually a fiberglass one that they were playing with.) So, you had the ability to see at least two definite concepts done at one time. Plus, we had a couple of fifth-scale stuff lurking around, too, and we were able to play with those. But it didn't really assume importance until it got into the full-sized clay.

 What would happen was this. They were constantly searching. It wasn't for something pure or elegant. It was for something attention-getting, unique, and

distinctive. But distinctive didn't have to particularly mean quality. It just had to be different. So, in the constant push for something new, it often became bizarre. And there would be constant changes. You didn't start with something that looked right or looked like a good direction, and refine it. Then, come September—tooling had to be produced in November—they would have to make a decision. And so, all of a sudden, it would be grabbing at what looked like the most likely things up on the walls or in clay.

Earl or Mitchell and the studio heads would conspire to see these. Sometimes there would be panic meetings, where Mitchell would get involved and give us a little haranguing about what we ought to be doing. And sometimes there would have to be some coordination between Buick, Pontiac, and Olds. The three of us would get together and see how we could trade things to make all of them come up to snuff.

Then we would have a presentation. It was usually about two weeks delayed from when it was supposed to be. That would be the studio's gift to the corporation, and that is when the first of these mobs would come through for the final blessing.

CEA You were describing the difference between how Earl and Mitchell acted in that mob scene?

GG Right. When Earl was in it, he was controlling it. It was his show.

CEA How did he do that, for example?

GG His size had a lot to do with it. He was a presence. Everybody in the room respected him. He was a man's man. He had both the stature of character and size.

CEA He could control both the corporate people as well as the artistic staff?

GG Oh yes, every one of them. He was the man in the room. No matter whether it was the chairman of the board or the general manager of any one of the divisions. Earl was The Man.

CEA Did he do that in large part because of the way he dressed?

GG Oh, he dressed like everybody else! They all wore black suits. I think you were ostracized or something if you didn't. At the board of directors' meetings, he didn't dress flamboyantly—he had on his three-piece suit and his straight-toed shoes.

CEA Do you think his educational background—he went to Stanford—made him more acceptable to the presidents than Mitchell?

GG Yes. He fit much more into the kind of environment that they were used to. It's funny, he didn't have a great speaking voice. He stuttered.

CEA When he stuttered, what made his speech pattern such that they would just give in?

GG Confidence. He exuded confidence. When he said something, you couldn't quarrel with it.

CEA Did he have it arranged so that, when he brought the directors in, he knew what was going to happen and when it was going to happen?

GG Yes, everybody followed his lead. There'd be thirty-one directors. There usually would be one or two people from the particular division—hell, there'd be more than one or two, there'd be all the vice-presidents and general managers from

marketing and advertising. And the Fisher Body people would be over there to make sure that the cut lines were makeable, and that they could seal taillights, and things like that. But Earl would lead. There would be at least forty people in his entourage, plus his own two secretaries—both of them would be in attendance. And then the studio people: There were five designers, five modelers, and a couple of board men. So there were about fifty-five to sixty people in there.

And it wouldn't be orchestrated in any way. It just somehow came together. Here were all the board of directors in a great half circle, and Earl was sort of in the middle. All the studio people were on the opposite side. And it was like this: Earl would go, "Now, look at this here—the-the-the hhhhheeeeadlight treatment here." He'd walk over to the headlight, and his half of the big circle, with all the black suits, would wander along behind him and nod, "Oh yeah, wow, I sure like that direction myself." And we would all walk around so that we'd always be in front. We wouldn't be overlooking the headlight or anything—we knew it was there. It was like a waltz. You'd go back and forth, and, eventually, he got them all the way around the car. But he was always in control. He knew what the weak spots could have been. And I think he could have done this only by coming in at times when nobody else was there, except maybe the studio head. Because he knew the weak spots, he played those up as strengths in some way. He never did a big sales pitch. It was always, "Ju-ju-just loo-look at that line there." That is all he would do.

CEA He wouldn't give a theoretical statement?

GG No! Theory was frowned upon there. That wasn't a man's way of doing things. You didn't theorize about it. You just did it!

CEA So basically he would just point to details, say they were good, and move around the car.

GG Yes. Sometimes he would have to make a statement. He wouldn't do it in Buick because we were at the tail end. He would start out in the traditional manner, with Chevy, and work up. So, we were the fourth ones. It might be two days before they got through all the studios, so he'd already made his key points before. Somebody might have asked him, "Why are we getting rid of fins?" One of them might call out, "Say, Harley"—because he was one of the boys, they would call him Harley—"are we dispensing with fins completely?" And he would just pull out, "Yeah, sure, all our dealers say the people are tired of those things. They don't want to see 'em anymore." That is all he'd say. He wouldn't reel off a bunch of marketing numbers. He wouldn't do anything else. That's all it needed.

Mitchell, on the other hand, was completely different. I had a year of Earl and a year of Mitchell. When Mitchell came in for those presentations, he was not in control at first. They would come in this big formless mass, and they would make their half circle on the one side, and we'd make our half circle on the other side. Mitchell was not addressing a group. He was sort of buttonholing each guy—almost dragging him over—saying, "Look at this. See what we did here. Isn't it good? We are going to do that on all the cars for the next ten years."

And what would happen to his group is that the key people—whom the other board of directors knew were really car people, like the head of Fisher Body—they'd drift around to the back end. For some reason, the back end seemed to be

Fisher Body's favorite to criticize. They had to make sure that the trunk sealed and that they could fold the metal in a certain way. So, when Mitchell was in there, little groups would form. They'd all be looking, and some of them might wander over and look at an old fiberglass model, which had nothing to do with the presentation. "Hey, what did we get away from this for?" And they would be talking about that among themselves.

CEA If that were true, how did Mitchell get them to change every year and do radically different things?

GG I think it was just the system. I am sure he got much more comfortable with it later. He was dictatorial with the design staff—he had that completely under control. But when I saw him operate, he didn't have that leadership quality, the charisma or the authority that Earl had, but he had his own flair and wit, and he became very skillful with it. And I think it was the system that made it possible for him to persevere, because after five or six years some pretty magnificent cars came out of there—better cars than Earl had ever done. The '38 Sixty Special [Figs. 29–31] and the '41 Cadillac, which were Mitchell designs, were maybe the only two cars of the Earl era that might be compared to a '67 Eldorado [Figs. 98, 99] or a '66 Riviera or a '71 Camaro [Fig. 110]. I think those are three of the most beautiful cars ever built, anywhere. I don't think the Italians did better, and certainly not the Japanese. I don't think there have been three better designed and executed cars—as far as shape execution, not quality, but shape—than those three cars.

Frank Hershey

THE world best knows Frank Q. Hershey (Fig. 23) as the designer of the original Thunderbird and the Pontiac Silver Streak. From the two days I spent with him at his home in the Arizona desert, I know him as the most vital eighty-year-old I have encountered. And encountered is the word. He doesn't force himself on you the way a vice-president like Bill Mitchell or George Walker, or a public-relations person, would. He lets his high metabolism and the twinkle in his eye simply overwhelm you. He is a liver. At sixty-nine, he *began* to race motocross, and he still seems bent on the peak life-experience. In this condensed interview taken from two full days of conversations, Hershey captures the essence of the moment through anecdote, not—significantly for his character—through plodding analysis. He remembers the design experience, not so much the design concept.

Coming from a broken home, Hershey looked upon the General Motors studios as a "school"—free from worries—with Earl as the protective guardian and himself as the self-confessed truant. He touchingly reveals that about once a week he dreams about returning to GM to be with Earl, whom he now loves and admires, although at the time he hated him and thought of nothing but leaving.

He can interpret history the way no one else can, because he lived through four phases of car design, beginning with custom studio design in the well-known California firm of Walter Murphy. He moved to Detroit with the loosely formed

GM Art and Colour Section, and stayed there as Earl formulated his rigid system of locked studios. Finally, after the war, as other companies recognized the importance of styling, he worked briefly for Packard and then became divisional styling director at Ford. He can recall his own role in these changes, and he remembers the shifts in personnel and ideas, but he is also able to analyze the transformations within Earl himself. Hershey began his career at GM in 1928, before Earl had worked out a formal order, and he returned as the first chief designer for Pontiac in 1931, at the moment Earl began divisional studios. In 1935 Earl chose Hershey to head the Buick studio, and then, in 1937, Hershey began a three-and-one-half-year stint as the head of the GM overseas studio. Returning to GM after service in the Navy, he stayed only long enough to design the first postwar Cadillac.

Providing a rare glimpse of Earl's insecurity, Hershey describes the early stages of Earl's career, when the Fisher brothers, division managers, and engineers still looked upon him as an unnecessary and even silly interference. Hershey's appraisal of Earl's need to sell himself to these men is in itself a priceless historical insight, and it is especially important because Hershey attributes to this selling game much of the life-style Earl developed. Imperious and hierarchic, Earl fended off interference in his creative activity with a flamboyant exterior and a secretive and rigidly controlled system of internal design.

Hershey lets us see the origins of what came to be the Detroit styling system, and in the process, he also gives an inkling of the creation of his own "design personality." As Hershey sees it, Earl's inconsistency of judgment was brought on, in large part, by his insecurity with division managers. Reacting to Earl's dilemma, designers who worked for him seldom knew where they stood. From their point of view, long-term guidance was unknown in a "system" where random decision-making seemed to be the norm. The ability to verbalize had minimal importance when you could never "sell" Earl a design and he expected you "to just do it."

Hershey's own simple, practical approach, and his dislike of explaining the causes and systems of design, probably stem from his initial contact with the custom-car industry and his long-term experience at GM. The original GM stylists were almost all self-trained custom-car designers, whose pragmatic approach came from hard-earned experience. Hershey describes, for example, how he taught himself to draw and then, on the job at Murphy's, discovered his own techniques for mock-ups and rapid design enlargements. From Earl, whom he admired above all else as a car lover—not as a designer—he acquired a distaste for verbalizing and for dealing consciously with artistic processes. While Hershey is clearly aware of the subtleties and complexities of creation, he, like Earl, prefers not to discuss them.

Perhaps more than anyone in the industry, Hershey was close to Earl. They shared an upper-middle-class Los Angeles background, and although strict in his moral beliefs, Hershey lived with risk and naughtiness, which Earl could appreci-

ate. Hershey stood up to Earl, contradicted him right and left, and insisted on his own designs. Despite sternly rebuking him, Earl always took care of Hershey, and even went so far as to invite him to be design director of Earl's own company after firing him from GM. Hershey earned Earl's appreciation and tapped a secret pool of sentiment within his boss. Hershey also shared with Earl a love of the most up-to-date styling concepts and, like him, sought to apply them practically to production vehicles. Indeed, for a man who created so many successful cars, his approach is disarmingly down-to-earth. He says that if he were offered one hundred thousand dollars to design a dream car he would take the money and go out and buy one off the lot. He prefers to begin his designs from an actual problem, not from a fantasy. The problem suggests a feeling. The feeling turns into a mental picture, and then, as he puts it, "things suggest things." For Hershey, creation is an evolutionary process that won't become clearer by talking about it. "At one moment it looks good, so you leave it alone."

Hershey seems utterly content to deal with the given and to work within practical constraints. He is not driven to change things or to establish a new order, and this outlook underlies the few words he chooses to describe his aesthetic interest. He looks for "clean, simple lines and shapes" without "gew-gaws and hoopla," and he won't say much more than that. Not only does he shy away from physical description of his own products, but he sees his options as limited rather than expansive. An array of choices is not important for him, because he realizes that the essence of design is not the "what" of the direction but the "how" of its execution. Hershey is not a great dreamer or a driven artist, but an explosive and sensitive worker who creates within limits. His vast experience and subtle touch leave any design with the simplicity and cleanliness of a classic.

CEA Can you recall Harley Earl a little bit? I am interested in how you got to be one of Earl's favorite designers in the thirties.

FQH Well, I did not know I was one of Harley's favorite designers until much later. But, in the first place, I was from California, having lived in Beverly Hills up to the age of eleven, and had just come from Walter Murphy Custom Coach Builders when I first met Harley.

CEA Growing up in Beverly Hills, why didn't you become a banker?

FQH My mother had always had money, but she wasn't too good at handling it. We had bought a walnut grove in La Puente—where I had some of the happiest days of my life. There, my love for automobiles had full sway. I had my first car, a stripped-down Model T, at the age of thirteen. We had put so much in the ranch that we were sort of poor, and all I could do was dream of again owning a Cadillac. (My mother had sold our 1920 Cad when we bought the ranch.)

CEA Did she encourage your visual side? How did you develop that side of your personality?

FQH My mother was a very beautiful woman and loved beautiful things, and she had a very strong influence on me. She understood my love of cars. Above all else, I

lived, dreamed, breathed automobiles. I had really never thought about design then, but I was aware of it.

CEA You told me at one point that she would buy a new Cadillac every year.

FQH In 1903 my mother bought our first Cadillac from Henry Leland, president of Cadillac, and he sent his private chauffeur over to teach her to drive. She was the first woman driver in Detroit. Yes, our family bought a new Cadillac every year from 1903 to 1920.

 My parents were automobile nuts. They originally came from Nebraska. My father graduated from the University of Michigan in 1900, and they were living in Detroit about the time autos were first coming to life. My father and my uncle owned a large store down on Cadillac Square in Detroit. Of course, Detroit was a small town then, and most business people knew everyone else. So, many of the auto people traded with my father. He was a friend of Henry Ford, the Dodge brothers, Henry Leland, and many others. Later, he and my uncle opened an automobile agency on Main Street in Los Angeles. My mother had come to California in 1909, and my father shortly thereafter.

CEA So then, you really picked it up from your family?

FQH No—unless I might have inherited it, but how do you inherit a gene that loves automobiles?

CEA But, from a very young age, you were sensitive to changes in style because your parents were?

FQH No, no! My mother and father were divorced when I was seven, and my dad died when I was fourteen. My mother was interested in acting; at one time she studied in Chicago to become an opera singer. She didn't know anything about car design, and we never discussed it—though she had excellent taste. Even when I was in military school in Los Angeles, on Seventh and Alvorado, I would lie in bed at night and I could tell you every car that went by—by the sound of the exhaust. I especially loved the sound of a Marmon.

CEA How was your interest in cars in general transferred to their design? At what point do you think that came about?

FQH Let me tell you. After leaving La Puente, we moved to Engle Rock, where I was majoring in geology and art at Occidental College. I started drawing automobiles at home. I made some pretty good drawings and had them blueprinted. My mother's business manager came over one evening and he said, "Hey, these look pretty good. Why don't you take them over to Murphy's?" [Walter M. Murphy Custom Car Company of Pasadena.] "Show them to him."

 So I went over to Murphy's in November. Frank Spring [general manager of Murphy's and later design chief of Hudson Motor Company] was there. His response was "Sorry, you're not very good. We can't use you." My mother's manager then went to Murphy, and Mr. Murphy studied my drawings and said, "I think Frank is good. You better make sure you get him over to the shop, and I'll see he has a good job." So I went back to Murphy's, and Frank Spring did not look very happy, but he said, "Well, I have gotten orders from the boss to hire you, so go upstairs and George McQuerry will show you around and tell you what to do."

 I was in Heaven! After about four months, George was busy doing other

things and most of the work fell to me—and did I love it! I often slept there all night because I hated to stop drawing and, also, there was a lot of work to do.

It is too long a story to tell about how I got to Detroit, where, incidentally, I was born. I'll tell you, a Californian would surely have to love his work to go to Michigan to live just because of a job. When I landed in Detroit, I had a dollar in my pocket—in small change. I stayed in a flophouse that night, but I was determined to get to GM. They were looking for designers, and I had a bunch of drawings with me. This was 1928.

CEA Whom did you show your stuff to?

FQH I showed it to O'Leary [Harley Earl's assistant at GM's Art and Colour Section], and O'Leary showed it to Harley. I never even saw Harley, but O'Leary said, "You've got a job." He put me in a room in the old GM building where we made name plates, hubcaps, and stuff like that, because they didn't have any formalized studios in those days. They didn't have Buick, Cadillac, and Pontiac studios, that is, separate studios for each type of car.

Then the Depression came along, and we were all pretty scared. Some of us got letters saying that as long as there was a GM we would have jobs. In the meantime, I had met Mr. Lamar Breese at the Chicago Auto Salon, and he asked me to come back to Murphy's. Inasmuch as I was homesick for California, I agreed to go back at $300 a month—triple my former salary—and there I stayed until the end of 1931, when Murphy's finally closed their doors.

Then Mr. Spring asked me to come back to Hudson. After a few months there I did not feel that I would ever get anywhere, although Mr. Spring was a prince of a fellow and we became good friends. Soon I got a call from Mr. Howard O'Leary saying, "Frank, we are setting up individual studios for each car, and we want you to come and head up the Pontiac studio." This was the beginning of the studio system. The salary was great—in spite of the Depression—so I left Hudson. They were very nice and asked me to stay on—offering me stock options and a bonus. Mr. Spring was a good designer, but not quite up to the modern trend.

CEA So you got back to GM at the crucial time when Earl was in the process of creating the closed studio system and elevating the car designer to professional status, overthrowing the pattern the board of directors was used to. How much of Earl's personality was involved with these changes? There seems to have been a contradiction in Harley Earl's character: although suave and polished, he could be tough and even vulgar. He was elegant, yet he could forcefully influence the board of directors. How did he do it?

FQH Oh, he did it by his size! He was a big, big man. He could really stare you down, and he could use some decisive, tough language. Harley was a good salesman, and then, too, he was a different kind of person than the old GM crowd was used to. Also, he was talking a language they were not used to. Physically, he was large, but he dressed very elegantly—though a little on the flashy side. He just was a very impressive guy.

CEA But what about his ability as a designer?

FQH Harley had one thing I always loved him for. He loved automobiles more than anything else in the world. Automobiles were his whole life, and Harley had a

flair, but he depended on other people to give him ideas, which sometimes he built on. See, the divisions did not have to use him. For example, John Oswald and George Snyder came in and designed the '34 or '35 Oldsmobile without Harley because the men who were running Oldsmobile at the time didn't like what was happening and they wanted to do it themselves.

In the beginning Harley had to sell himself to management and win the divisional managers over. And in that he did a great job, but it took some doing. It was only after he'd been there a couple of years that he got control to the point where Fisher Body could not make a change to a design unless they asked us to do it. From then on, very few changes were made, and when they were, we made them. But it took Harley some time to get there. He had a hard row to hoe, which nobody really understood.

Here is a story that is typical of what went on. Chevrolet studio wasn't getting anywhere on the '39 Chevrolet front end, and Harley said, "Look, Frank, you've done your job on the Pontiac. Why don't you take your crew up there and make a front end for the Chevrolet? They are in trouble." Then he left. So when he came back with Mr. Knudsen [managing director of Chevrolet], he didn't like what he saw and bawled the hell out of us in no uncertain terms. Knudsen didn't say a word but went over to a corner and just stood there. Now, these were huge men, both over 6′4″, and Knudsen beckoned Harley over to him and waved his big finger in Harley's face—much to our embarrassment—and said, "Harley, no one who never makes a mistake ever does anything." And both left.

CEA Was there always a hierarchy, where you never skipped a step? Did you always deal with your superior and that superior dealt with his boss?

FQH Never! Never! But back in the thirties, it was different. I worked very closely with Roy Milner, chief body engineer at Pontiac. We became good personal friends. We picked wood grains and things without Harley Earl's overseeing. We did that because Harley was busy doing other things, and we didn't have the big staff then that we have now. And so I did an awful lot on my own with this man at Pontiac.

CEA Let's talk more about the thirties. I want to understand what was going on at General Motors in the way of design in the mid- to late thirties. And you are the perfect person to tell us what the ideas and direction were.

FQH Harley had an idea to keep us very, very isolated from everything financial. We had no money worries. We didn't have to keep any books. It was all done for us. We didn't have to account for our time. We were run just like a big school. He felt that designers should be free to design without worries. But we worked hard. For years, I worked up to nine o'clock many a night and sometimes on Saturdays and Sundays. So much depended on the right decisions.

CEA When you were chief designer at GM in the thirties and early forties, did you have the freedom to organize your studio the way you wanted? The chief designer in those days had pretty much a free hand?

FQH Sure, he did everything. There was a chief designer and two or three artists. The chief designer put the car together. He instigated the direction. He got the blame if something went wrong. This is why there were so few good production-car designers—because it was a one-man job. You never hear of any of the great artists working in a committee. They were all single guys. All the great architects

were single guys. And all the great automobile designers were single persons. Sometimes people forget it. You know the old story that a camel was designed by a committee. You design a car with a committee, and you get what you get. You get a camel. I am not kidding you.

CEA When you were chief designer, how did you organize your studio differently from other chief designers?

FQH Oh, I don't know. I don't think there were any major differences. The team consisted of two or three young designers and modelers. As I said, you become a team. In most cases, you also become good friends. Most studio organizations were pretty loose. Being uptight didn't help. We had fun because we loved our work and didn't mind too much all the overtime. Besides, we were always provided with great restaurant passes.

CEA Earl sponsored internal competitions among the studios during this period. What about the 1933 and 1935 [Fig. 23] GM competition cars you designed?

FQH We worked on little car models all the time. The 1933 competition was the beginning of the Silver Streak [the 1935 Pontiac; Fig. 17]. It became known as the Silver·Streak because of a ribbed chrome band decorating the hood from bumper to windshield. After the 1933 competition, we continued to design this car and made a full-sized model of it. It had built-in headlights, through-flowing fenders, no running board, and a fastback. This was to be the next production Pontiac car after the 1933 competition.

When we made the first mock-up, I was in love with it. Harley brought executives in, and they looked at it and went away shaking their heads. It was a little too much for them. So finally, after a couple of weeks, Harley said, "Frank, you have got to change that car and make it more production possible." It sat there for one month, and I refused to change it. Finally, Harley called me to his office and said, "Look, you want your job? You've wasted too much time doing nothing! You are to go down there and take that car and make it work! You make it like it is supposed to be—more like our present direction—and you've got to use the Chevrolet body. I'll give you two weeks to do it." Well, as you know, the Silver Streak became a big hit.

CEA Even though there were these pressures from Earl to compromise, you repeatedly stood up to him for your creative designs. Earl must have been attracted by your combination of imagination and practicality.

FQH Designers always wanted to design really way-out cars, but we never did, except as future studies. We were not conservative thinkers. One of the reasons I got along so well was because I really loved production cars. Anyway, we were drawing cars like they are building now—fastbacks, very short hoods, and so on—which wasn't the thing to do in those days. One day Harley called us all up into his big office and said, "Now, fellows, I know that I intimidate you. I know that I keep you from doing what you want to do. But we have to plan for the next big step in design. Now, we are going to have a whole new deal. I'm going to listen to you and consider your ideas. Now, Frank, you start." I got up and said, "Harley, I think we should do this and that and so on." Suddenly Harley stiffened; then he said, "That is exactly what I don't want to hear! Meeting's over!" And that was that. He got no further than me.

CEA Can you remember what you told him? What you said you wanted? It must have
 been a turning point.
FQH I think we wanted through fenders. We wanted headlamps in the fenders. We
 wanted all kinds of innovative things. It must have been '45 or around in there.
 [Figs. 66–68] But that was it. We sort of had an idea of what was coming because
 he had already given us forewarning. And everyone went up there loaded with
 what they were going to tell him, but nobody had a chance to say a word—
 except me.
CEA Why?
FQH Oh, you never knew where you stood! You never knew what he was going to
 say. He would like a thing one minute, and the next minute he'd condemn it.
 Ofttimes, when Harley would bring in the managing director of one of the
 divisions—like Harlow Curtis of Buick—who would object to some detail, and
 Harley could not persuade him, off it would go. The division managers had to be
 sold—or else!
CEA Let's talk about the thirties.
FQH You had to be very careful if you brought out a radical car because the public might
 not understand it. So design was always evolutionary in the automobile business.
 Now, you could make a special car and try out ideas—as for instance the 1933 GM
 aerodynamic car [Fig. 13]. But to get it produced, I had to compromise.[1]
CEA I am interested in the concept of interchangeability, especially how far it had
 come when you were working on this '35 model at Pontiac. Was Pontiac allowed
 to have its own fenders?
FQH Oh sure. All we had to keep was the main body of Chevrolet.
CEA Not the hood?
FQH No, no, nothing. Just the body. I was responsible for everything in front of the
 windshield and the rear sheet metal.
CEA And what about the 1936 Buick Special, which shared the Chevy body but was a
 bigger car? How did the stretching process work?
FQH Oh, you took the small Buick chassis and you put the Chevrolet body on the
 chassis that you had to use. It was all done on the drawing board. And you put
 on your own front and your own fenders [Fig. 18]. Simple. Nothing to it. You
 built your car around the Chevy body. The engine, chassis, everything in front of
 the windshield was all Buick.
CEA Where in the back did interchangeability come? At the bottom of the window?
FQH Yes. You could use different belt moldings or window moldings, but all the
 construction was Chevrolet.
CEA As you went on into the thirties—let's say 1938—was it still true that interchange-
 ability of basic body parts was limited, or did the divisions start sharing more
 parts?
FQH Same, the same.
CEA What about the pressure from outside the company—from the competition? Can
 we turn to issues outside of GM?
FQH We found out what they were doing at Ford because we used to go over there
 and chase them at night. Oh, I could tell you stories. I had been authorized by
 management to go and take pictures of what was going on there.

CEA Tell me something about this "chasing."

FQH This was 1934–35. I had a good rapport with the GM photographic department, and I had a special photographer friend there. Together we used to go out chasing quite often. So management wanted us to go and find out what the latest Ford V-8 was going to look like. We took a Lincoln sedan to Dearborn Village and parked on the side of the road. There was Henry and a new Ford V-8 driving around and around on these little streets in Dearborn Village. So we got it: click, click, click, click, click.

CEA Inside? You were inside the Lincoln?

FQH No, no. We were outside, looking over the fence. He didn't pay us any attention because there were some bushes there. So we turned around and started back. We got about a mile down the road, and here comes a huge Lincoln with about four guys in it. They ran us off the road and turned us over in the ditch on our side. We climbed out of the car, and they took this big Graflex and took the film out. But we had hidden the original film under the seat, so they didn't get anything. They smashed the camera, but we had put a new film in the camera to make it look good. They weren't that smart, anyhow.

CEA Did they know who you were?

FQH Well, I don't know. The Lincoln sort of threw them.

CEA Did this affect your designs in the thirties?

FQH No, no. It made us feel better because it was just a Model A, sort of revised. There was another time, I think it was '35 or '36, just before I went to Europe. The same guy, Doug, and I went over to see what Chrysler was doing. They didn't have a proving ground at that time. They used to take their cars out and run them all around up north. So we parked in front of the Chrysler Building. We sat there and got bored. About three o'clock in the afternoon, I said, "You know, their auditorium is on the second floor. Why don't I go in to see what is going on?" I walked in, and there was just a little reception room with a guard and some stairs. He was talking to somebody, so I walked in, hung up my hat, and walked upstairs. On the second floor, I went down a corridor, around a corner, and into the auditorium. They had big cubicles with curtains in front of them, and they had a new model behind every curtain. There was nobody around, so I spent time looking at them. If anyone had come in, I could have hidden, you see. I was young and foolish, and besides, I was so automobile crazy I'd do anything to see a competition car. I got a good mental picture, which is hard to do under stress.

 Just as I left the auditorium and went down the hall, there was a room with many girls sorting out photographs of every one of those new cars. I thought, "If I only had enough guts to go in there and say, 'Mr. So-and-so wants a set of prints of these new cars.'" I hesitated, but I didn't do it. I went down and turned the corner, and there was Breer [Carl Breer, Chrysler executive in charge of experimental engineering] and a couple of other big executives. But I was dressed in street clothes, and as I passed I nodded hello, and they nodded hello, and I walked out, got in the car, and we drove away. You couldn't have done that at GM because we were much more protected.

CEA Let me ask you about your later work.

FQH As you know, I was Pontiac chief designer from 1932 to 1936. I [then] was put in charge of developing a design studio and redesigning the whole line of Opels. To make a long story short, I was made international designer for Opel in Germany, Vauxhall in England, and Holden in Australia. We went to Australia to help organize a design department and train their men. So I was traveling back and forth between the U.S., England, and Germany during those years.

 In 1941 I headed the GM Advanced Design Studio in a little old building down on Milwaukee Avenue. We made all kinds of experimental designs, especially three-eighths clay models and drawings. They were never made to full-size models there.

 Then when we got into the war, I put in for a commission in the U.S. Navy. When Harley found out, he did everything possible to keep me from going; but I had spent too many days living in Germany to be kept from the war. So I finally got a commission as a lieutenant.

 When I returned to GM after leaving the Navy in 1944, the first project was to design a new small Australian car called the Holden. This I did with no help except for a layout man and modelers. It turned out to be a cute little car about the size of a Toyota Corolla. After the Holden, I was put in charge of the Cadillac studio, and the first thing that we did was to go to work on the experimental models.

CEA I can't quite figure out the connection between the drawing stage before the war, the mock-up experiments in 1946, and the first postwar production 1948 Cadillac. I would like to understand your role in these changes. Perhaps we could start with the mock-ups. How did this mock-up [Fig. 67] relate to the creation of the production car?

FQH Well, there were two of them, and we did the designs for them in my studio. We built a mock-up [Fig. 67], and we took it on to the proving ground. They were fantastic cars. Imagine this in 1946! They made these models, and they ran beautifully. They were quite radical, but finally we had all the executives out to see them. They just scared the hell out of them. They were too far advanced. As far as I know, we finally destroyed them.

CEA Did Nickles's drawings [Figs. 65, 66] precede this?

FQH Yes, they were dated '45 and '46. But, remember, Nickles worked for me. These were the preliminaries to the cars we made at the proving ground. These were different approaches to the same problem.

CEA But the full-sized models don't have any of the finishing touches. Were these your own designs?

FQH Yes. You have to remember, when we made those two test cars we left off all the extra design. We just built the basic cars, and they looked great. But because they were just basic test cars, there was no use putting the glitter and stuff on them.

CEA The intention was to put glitter on them later?

FQH Yes, if they were accepted. But you have to understand that this experimental design had nothing to do with the first postwar Cadillac [Fig. 74]. Nothing at all.

CEA How did you make the transition between the far-out ones and the production model?

FQH We had two projects: doing the regular car and doing the far-out stuff.

CEA And what was Mitchell's role in the production model?

FQH Mitchell was still in the Navy. I did the '48 Cadillac. He didn't come back until we had that car all done. Harley kept wanting us to make a Tiffany front end. You know, the '48 [Fig. 74] had a very simple front end, with no guts to it.

CEA Very thin chrome. Beautiful.

FQH Very thin chrome—well, very nice—but it didn't have any punch. So then the '49 [Fig. 75] came along, and they put in the new Kettering engine, and we upgraded the grille. That was all being done in '46, before Mitchell got back. When we were doing the '49 Cadillac with the big front end, we had a clay model of the '48 [Fig. 74] up in the studio, and Harley walked in. He came in sort of excited and said, "Take those damned fins off the back. Nobody likes them. They don't belong on a Cadillac." I covered them up with a canvas and said, "Let's not monkey with the fins," because we were working on the front end. Later he gave me holy hell about it. "I told you to take the fins off." But, two days later, he came roaring back with Mr. Seaholm [Ernest W. Seaholm, Cadillac chief engineer], really a very nice guy, a fair and fine man. Anyway, he came running back and said, "Did you take the fins off?" I said, "No." "Oh, thank God! The public loves them. Leave them alone. Don't touch them." We finished the front end, and that was it.

CEA Tell me a little more about the Tiffany grille on the first postwar Cadillac, the '48.

FQH Harley wanted to make a very jewel-like front end. Nothing spectacular. Earl always had the idea to keep the Cadillac elegant. He wanted it to be elegantly radical, or radically elegant—whatever.

CEA Let me get this clear. Mitchell had nothing to do with the experimental mock-ups of these two cars? Did he have anything to do with the creation of the '48 Cadillac?

FQH No, no. We did the front end, and we did all this in '46. The '48 had to be done in '46 because the lag time used to be two years in those days. Oh, they could cut it short a little bit, but not much. Now, I can tell you the whole Cadillac story. We designed much of the Cadillac in my basement, out on my farm in Rochester. They had a strike [November 21, 1945, to March 13, 1946], and we weren't allowed to work in Detroit. So, they moved the whole Cadillac design department to my farm [Winkler Mill], and there's where we did the whole car. We took the quarter-sized model out there, and we finished it up there—that included the whole body. Harley Earl came out from time to time, but Mitchell wasn't there.

CEA And what was the role of Harley Earl? Do you remember what he told you he wanted done?

FQH No, things just evolved. We would lay out ideas on the board, and he'd come out and we'd make changes. Harley came out all the time. There were two designers, three modelers, Chris Klein (a sculptor), and myself. That was the whole crew.

CEA You were the only chief designer there?

FQH Naturally. I was the chief designer of Cadillac at that time. In 1946 I also concocted an idea of setting up an experimental studio in California, partly because I wanted to get back to California. Howard O'Leary and I were like this [crossing his fingers]—we agreed. Christiansen, O'Leary, Julio Andrade, and I took a trip to California, and in the course of the trip we visited Art Center. Edward Adams,

who ran Art Center School, and Andrade hit it off. He flattered Andrade, and Andrade loved it. So Andrade went back and torpedoed me with Harley by saying, "Don't let's set up our own design [studio] out there. Let's use Art Center." That is how Art Center came into the picture. Anyway, during our visit we went to that very famous, expensive restaurant on Wilshire.

CEA Perino's?

FQH Perino's! Adams, Howard O'Leary, Andrade, Christiansen, and myself were all there. And Adams and Howard O'Leary got into a fistfight over this thing, right in the middle of Perino's. A fistfight! Can you imagine a fistfight in Perino's?

CEA O'Leary was a decent sort?

FQH O'Leary was a sweetheart. He was a big old lovely Irishman. He was Earl's assistant.

CEA How did that work?

FQH He had nothing to do with design. He just helped with management.

CEA A kind of secretary?

FQH Howard O'Leary was a sort of whipping boy, but he knew what was going on. He was a good politician. Anyway, Andrade found out what I was doing in our sheep shed. The party I am telling you about was the final party we had at my farm in Rochester when we finished the '48 Cadillac. And everybody came but Harley. And it was fantastic with all those Italians. They made great Italian food in this huge kitchen we had on that farm. So we all got a little high, and someone took Julio [Andrade] out to the sheep shed and showed him the private design work we were doing in the shed. It had nothing at all to do with automobiles. It was decorative brass and copper ware. Andrade went back and told Harley, and a few months later Howard O'Leary phoned me and said, "Frank, you're fired."

 I was working so hard on my own business that I wasn't very much good to GM—which was a stupid thing to do. So after I had been fired from GM, Howard called me down to the Recess Club one day. And he said, "Harley wants you to run his private industrial-design business." I said, "I just got out of bed with him; I don't want to get into bed with him again." But I want to tell you something. Mitchell did it, and I wish I had done it.

CEA Could you have worked with Mitchell when he became vice-president?

FQH Oh sure. Even though we were quite different from each other, all you had to do was flatter him a little, and you'd get along OK. In reality, Bill was very much like Harley. He had a gift of gab and enough nerve to impress the big boys. Bill did a lot of very good things. Mitchell was a designer.

CEA He was a different kettle of fish from Walker [vice-president of design at Ford]?

FQH Oh yes. Bill was a good sketcher. He had class and could put up a good front, while Walker had no talent, but he was a good salesman and not beyond a little skullduggery. Walker was never a designer.

CEA But why was the decision made to choose Mitchell as vice-president?

FQH Because Mitchell was very much like Harley and he was Harley's assistant at that time.

CEA They wanted a powerful man. Do you think Earl chose Mitchell?

FQH Oh yes.

CEA But why do you think he chose him over you?

FQH Well, I wasn't there.

CEA You had gone to Ford by that time?

FQH Yes. I was doing well at Ford, and I think Harley secretly admired me for that. After all, he had a big hand in molding me. And later, we finished the 1957 Ford car [Fig. 86], which I am sure was a surprise to Harley. I am also sure that GM spies got photos of it and showed them to Harley.

CEA Please tell about that, because that is a favorite car. It even outsold Chevy.

FQH Yes. We had to get a radical car because we had done the previous one to death. We even put a streak on the fender—it was just hoopla. Anyway, my guys were not getting anywhere, so Damon Woods and I went one night and worked till about two o'clock in the morning. We roughed the whole car out. We had the finished model done in two days—and accepted! We were already a month behind schedule.

CEA Let's get into your Ford experience. You seem to be very proud of the time you worked there. How and when did you get to Ford?

FQH It was '51, I guess, or '52. I had been at Packard for a while, and I saw the handwriting on the wall.

CEA Tell me more about Ford, your relationship and experiences and your designs there. The Thunderbird [Fig. 85] and '57 Ford have such a delicate touch. Have you ever thought about your philosophy, about what is important to you and what is not, as a designer? Have you ever put it into words?

FQH No. I have never even thought of it. I just do what I feel. Does that mean anything? I get a feeling or an inspiration—I get a picture in my head and I go from there. But I have a feeling as to whether it is right or wrong. I used to argue with Harley all the time because, of course, I was a young whippersnapper then, and I wasn't mature enough. But when I was at Murphy's, I did what I felt was right.

CEA If you had to describe the direction of the '57 Ford and the original Thunderbird, what direction would you say that was? Others have what you might call a design strategy. They advertise what they have done. Mitchell, for example, talks about the lean, clean, tailored London look.

FQH You can come up with a philosophy to explain anything! What could be more lean or clean than the first Thunderbird?

CEA He visually justifies it by saying that he likes sharp edges. He says that the sharp edge pulls the line around.

FQH Oh, gads! They used to say that a line drags your eye down. We used to talk that way. How can a line drag your eye down? It is stupid. Harley was full of those sayings.

CEA All you tell me is that you have a feeling, a mental image, before you design.

FQH Yes, yes.

CEA That is the only kind of visual language I can get you to use?

FQH I'd get a picture. I'd have a problem and I'd concentrate on the problem. And pretty soon, I'd get a picture. A lot that you see in nature, other design, or mechanical things give you ideas.

CEA A fundamental difference between you and Mitchell seems to be that Mitchell has an idea that he brings to almost any car he designs, while you take a car and

you think about its problems, and then you come up with a specific design solution that is appropriate.

FQH I guess. Now, there is something rather interesting. I was a custom-car designer. I made my reputation with Murphy's. But when I was with GM, I was also completely, 100 percent, a production-car person. I loved stock cars. If somebody gave me one hundred thousand dollars and said, "Go make the car of your dreams," I wouldn't know where to begin. I would just go buy something that is already out.

CEA And fiddle with it?

FQH No, I wouldn't. I wouldn't change it. I never had any desire to have a custom car when I was with GM or Ford. I was 100 percent concentrating philosophically on production cars. Maybe that is odd. I don't know.

CEA Saying that your designs are pragmatic answers to specific problems, or are the result of production needs, reminds me of the difficulty of talking about twelve-tone music. Saying what you did just defines the parameters. It doesn't really say what it is visually that you have done. Someone looking at your designs might observe that they are more subtle, with a finesse to them. But the hard question remains. The question that people will be asking fifty years from now is, What is it that makes your designs finer and more subtle?

FQH Just clean, simple lines and shapes, without all the geegaws and without all the hoopla.

CEA You also told me that you work very fast. You would go in and do a mock-up very quickly.

FQH You must remember that we were working against the clock. They had to be done quickly. And there is an awful lot of pre-conditioning from all the things that were going on. You arrive at a point which is the culmination of a lot that happened. They somehow come together and make a front end. But you have to remember, you have a front end. It's either like this or like that. What can you do in that area? There are just so many things you can do within engineering guidelines.

CEA You can either screw it up or do a great job.

FQH But it is *how* you do it. It's how you interpret the idea that came to mind.

CEA I think the best thing that I could do, if it is all right, is to look at a design, and maybe you'd tell me why you made the line this way instead of another way.

FQH You rough it out, study it, see where it needs refining. You work on proportion until it fits your concept and is good-looking or beautiful.

CEA Were you ever called upon to verbalize?

FQH Oh no. No. Things were very simple then. You either liked it or you didn't. You couldn't sell Harley a design if he didn't like it. At GM, I was the designer, Harley was the expert. At Ford I was the boss.

CEA Seeing as you didn't believe in verbalizing, what did you do at Ford when you had to justify a design? And I hope you understand, I don't disagree with you. I think the idea of having to talk about a visual form doesn't necessarily make sense.

FQH E. L. Cord had a marvelous saying which was sort of a motto for Auburn: "If the car doesn't sell itself, you'll not be asked to buy." Doesn't that tell the story?

CEA You can understand if I keep trying. On the '56 Ford, for example, why did you bring the chrome side-strip up and over the front fender?

FQH Oh, just to have a new twist, to give an old car a new look.

CEA When you look at your '57 Ford [Fig. 86], your chrome lines are very uneven.

FQH They would get awfully boring with just a thin line. See, these were production cars. These are not custom cars. Now, on a custom car, I wouldn't do that.

CEA Why? What is there about a production car that makes you not want to do it?

FQH Because it is a whole different deal. This whole question about custom cars vs. production is difficult to define. You must remember, a custom car is one of a kind and you can individualize it. In most cases, you have a client to satisfy, and that client may have ideas of his or her own, while in production you must appeal to a whole lot of people.

 See how clean the Peerless is [Fig. 6]? I got free reign on that one. I guess I am most proud of it. The first time I ever made a mock-up was this Peerless, and it was just to see the relative size [Fig. 5]. The whole thing was made of cardboard. It is not a drawing. It looks round because we put an airbrush on it to make it look round. We made some aluminum paint and painted the windows out and painted the fenders black. It is just flat cardboard held up by a frame behind it.

CEA How does this fit in with orthographic drawings? Did you use this instead of a clay model in your custom days?

FQH We never made clays at Murphy's. We never even heard of clay out there. We did this mock-up just to get the visual size of the car and especially to see how the height was. But we didn't do it on anything but that one car. They may have done that in the East, but I never knew anything about it. At Murphy's, I had no connection with anyone in the East. I was still very young and uninformed.

CEA It came out of your desire—

FQH —to know what I was doing. In the custom studios, cars were designed mainly from line drawings and little color renderings. And then the chief body engineer and I would lay them out on a board. In those days they went right to the board, right to the layout from which the car was built. They put all the framing and everything right on the drawing.

 Now, the difference between the Peerless and a production car is this. You see how nice and fine the lines are? Well, that is elegance. Custom cars have to be elegant because people are paying the price.

CEA It is interesting that you accepted that production cars were different and that you worked within that.

FQH Sure, because you are appealing to millions of people. You have huge production problems, whereas with a custom car, you are appealing to one person, and [the car] is usually hand-built.

CEA The first Thunderbird certainly was a popular success. The highlight line is much more pronounced in the rear, and in the front you basically stopped it [Fig. 85]. Why?

FQH We didn't know what to do with it when we got it up there. See, a lot of these things, when you work them out, just evolve. It looks good, so you leave it alone. If you worry too much about a design, it becomes staid. It is not alive. It becomes old. Ofttimes, the first thing you do is the best, so you leave it alone.

That is why when people get into the act and start changing, worrying, and so on, things get fouled up and lose personality.

CEA Did you work the T-bird from drawings or did you work it directly from the model? Are you implying that you worked the car from the rear forward in clay?

FQH We started with an outline sketch, which was pretty well outlined in the beginning, and many sketches to try out various applications of parts. We had a pretty clear picture of what this car should be. We did not want to do the same thing. Our philosophy was to make a car that, while it was a sports car, a banker, for instance, could drive it up to his bank in the morning with a certain amount of dignity.

We made an armature [platform] of wood to more or less conform to the size, and from there we molded the design in clay. This was a very standard procedure. You worked from both ends of the car at the same time and molded and remolded until you got what you wanted.

George Walker was an outside consultant to Ford. As I understand it, in his contract it was stipulated that he and only he was to get credit for any designs that came out of Ford and that only he was to figure in any publicity concerning design. He had two of his men, not on Ford payroll, stashed in the design department—one in Ford and one in Lincoln-Mercury. It was a difficult situation at best. Walker spent very little time in the plant. As long as I was there, Walker did not figure in any way in the designs of the Ford cars, the Thunderbird or the trucks.

We knew that the Corvette would probably make a good impression on the public, but it was wholly a sports car. So it was decided—and a Ford man named Chase Morsey, Ford planner, came up with the idea—to make the Thunderbird become the "personal car." When we started, only our department knew of the project. I had a special room off the Ford studio, and we sealed it off. We put a wood armature in the room and a couple of blackboards for full-size layouts and went to work.

I put in charge a new young designer who was a good friend of mine, Bill Boyer, and also a couple of clay modelers, and we went to town. We had the basis of the car pretty well rounded out in short time, and from then on it was a matter of refinishing and trying out various front ends and decorative details.[2]

CEA It seems to me that you came very close to being vice-president at both Ford and General Motors.

FQH Yes. I earned it in both instances. I think if I had stayed at General Motors and had been a good boy and hadn't done what I did, I would have had Mitchell's job.

CEA Tell me, in your photograph of the GM Art and Colour Section in the thirties, why are there no women?

FQH There was only one woman in all Art and Colour, and she was Harley's secretary. There was never another woman in the place.

CEA Here you had a whole Art and Colour section and there wasn't one woman designer or draftsman?

FQH That's right. Although I think I have heard that there were women hired later to help with fabrics and interiors, both at Ford and GM, but I couldn't swear to it.

CEA When Walker became vice-president at Ford, did you leave right away?

FQH Sure did—before he could fire me. I could not have worked for him. I had no respect for him. Perhaps I was stupid, but I was still young and very independent.

CEA And after you left Ford?

FQH Oh, I was hired at Kaiser Aluminum as design director. I stayed at Kaiser for seven years. I traveled all over the U.S. working with our aluminum customers showing them how to use aluminum. We helped design many boats—large and small—some as large as the largest Chris Craft. Also, I designed all the aluminum furniture for the new Kaiser Building, and I designed all of their furniture and decor for the new office in Ghana.

 After I left Kaiser, I went with a good company in L.A.—Rite Autotronics, which made all kinds of auto gauges, test equipment. At three separate times, I won gold awards for excellence in packaging. Then I retired in 1978.

CEA And you didn't miss cars?

FQH Oh sure, but we had a lot to do with cars. The people who were there were car nuts. And I raced motocross motorcycles for five years. I was told I was the oldest motocross racer in the U.S.—maybe in the world.

CEA Earlier you said something very interesting. I asked you whether you worried about your reputation as a car designer. And you said that wasn't too important— you knew what you did. What do you mean by that? I think that is a telling statement. I mean, most artists that I know are so happy with what they have done that they want other people to know they did it.

FQH Well, I want them to know that, too. But I know what I have done, and I am happy in that. And in the end, so what? So many people get lied about, all over, in all kinds of businesses. Of course I'm proud!

CEA Perhaps, one hundred years from now, car design will be like a great Renaissance painting, and then one will wonder. Don't you worry that maybe—

FQH I really have never thought about it.

CEA You don't have a sense for posterity?

FQH Well, I don't worry about anything I can't do anything about. But I guess I do have some sense of posterity.

CEA But you don't seem to be frustrated about it, either. You don't seem to be upset.

FQH Are other people frustrated?

CEA Well, think about the reputation of Harley Earl. At least we can piece together his contribution. But should he get all the credit because others' roles were not defined?

FQH Look, we get ideas from everywhere. And one thing leads to another. You would improve on it and play a little. Like composing music, we made variations on it. We had thousands of drawings. We had books and we had pictures.

CEA What was the role of Harley Earl? What was your role?

FQH Well, Harley Earl was always there, and I was his fair-haired boy, though I didn't know this until later. I had a close association with him in Europe. Harley sort of treated me like his son. And I found out he was a very sentimental man, but he thought it unmanly to show it. And I found out that he respected my opinions. I learned not only to respect him after that association, but I also discovered that I really had an affection for him. And the biggest

regret of my life is that I screwed up so badly at the end. I broke a promise to Harley, and I paid dearly for it.

CEA But afterward, when you had left?

FQH Then I saw that only Harley could have done what was done in the automobile business at that time. I'd say he is the father of modern automobile design. Not that there weren't other designers doing good material—like Amos Northup, who did some fine things, and Dietrich. But Dietrich was a custom designer. Nobody could have put General Motors into the design business like Harley did because Harley had the guts, he had the size, he had the vision, he had the eyes, he had everything to do it with.

CEA But yours was a love-hate relationship?

FQH I want to tell you one thing. This I don't quite understand—well, yes I do. I have a dream which I dream about once a week or every two weeks. I've been doing this for the last five or six, maybe ten, years. The physical quality of the characters changes, but the characters are always the same, regardless of what they look like. If I dream of my father or mother, I don't recognize them in the dream, but I know they are my father and mother. I don't even question it. I dream about being back in the good old GM Styling Department all the time. I never dream about being back at Ford. Only General Motors. And Harley Earl is there. Sometimes Mitchell is there, but always Harley Earl. The situations vary and often are strange, even grotesque. I mean, materially, the design department varies: it's small, it's big, it's this, it's that, but it's always back at GM Styling.

CEA Do you know why? Is it because you felt calm and happy at General Motors?

FQH I did not know how happy I was—even with all the problems—until much later.

CEA But why do you want to go back there all the time in your dreams?

FQH My introspection has shown me that I didn't know how good I was having it, if you know what I mean. I would give anything to be able to go back there and drop back into the old days. Knowing what I know now, I would never have left. But, let me tell you, of the guys that stayed, most of them are old men or dead right now because it was a tough life—and you were married to it!

Strother MacMinn

WIDELY praised as a pure designer, Strother MacMinn has struggled to combine creativity and resilience, the two ingredients he says are required to stay afloat in the business. He worked only briefly for General Motors before and after World War II and then returned to Pasadena to assist Henry Dreyfuss and teach at the Art Center of Design.[1]

MacMinn confirms Hershey's perceptions of the design situation under Earl in the thirties, and his recollections from that time are especially helpful for understanding the dominant role of the chief designer, the incidental role of other designers, and the suggestive, almost nonverbal leadership of Earl. Designers were told no more than an ambience of a theme, and then they were expected simply to "do it." MacMinn goes into detail about the standard design sequence, emphasizing the random-sketch stage as Earl's means of encouraging novel and adventurous designs. MacMinn believes that Earl picked a direction from these sketches rather than plan for the long term, and he concludes that Earl's changeability and inability to make up his mind contributed to the creative state and general nervous condition of GM designers.

MacMinn was an informative, although reluctant, interviewee who asked me to turn off the tape recorder a number of times. As he said at one point, "I'm really giving away all the secrets here."

CEA You got to GM in 1936?

SM December of '36. That was the profit of seeing [Frank] Hershey each year when
 he came out to see his mother and sister, who still lived in California. He'd look at
 my drawings and give them a general crit and would say what I probably ought
 to be doing. He squared me off so that I did not make too many mistakes, and he
 did make a couple of compliments. He was a terrific critic. So I'd look forward to
 those summer visits every year. And in '35 he began to suggest that I get a
 portfolio together. . . . I sent the material to him, and he presented it to Howard
 O'Leary, who was Harley Earl's manager, an ex-lawyer and a very sharp guy. He
 got approval to hire me at a very minimum budget, because in those days they
 didn't have a school. They had been through most of the custom-body builders to
 pick up their chief designers—Hershey being one of them, from Walter Murphy.
 So he began to look around at anyone who was interested in design and showed
 some promise. They'd take them on for a trial period—six months to a year—to
 see how they did. And if things didn't work out, they could gently let them go.
 But at $125 a month, there really wasn't a big risk.

CEA Were they absorbing them into each of the departments?

SM Yes, directly into the studios, because they had no preliminary department as they
 do now and have had for many years. So that is how I got started. Frank put me
 under his wing. He at that time was working in the Buick studio. . . .

CEA What kinds of things did you sense Harley Earl wanted you to do at that period?
 This was '36.

SM Well, Harley Earl's famous cry was, "Give us something new." And, of course,
 that meant adventuring a little bit in design. This is a counterpoint to the business
 of cliché design, which is the inevitable result when people are faced with a
 problem and have to perform under a certain time schedule. So what most
 designers do—this is to generalize—is to get their favorite clichés, which may be
 pontoon fenders or a horizontal band or something or other, and maybe combine
 them. And that really was the essence of design as it was practiced in those times.
 They were assemblies.

 The process developed of evolving them through sketches, then into a select
 series of designs which would apply to a scale clay model, and then, finally, to the
 full size. In the full-sized model, a lot of detail trim changes would occur, and
 they might paint the model. Then they would get final approval on the thing, and
 they'd go to a wood and metal, as they called it [Fig. 12]. That has a whole history
 of its own, because the process of building a wooden model was done by crafts-
 men who had evolved out of the carriage trade and had used those same construc-
 tion techniques in the days before fiberglass. I'm really giving away all the secrets
 here. They used a process in carriages known as "scrimming," or using scrim,
 which is cheesecloth dipped in vegetable glue. It's laid onto the surface, smoothed
 out, allowed to dry, and then filled, primed, and varnished. So they could achieve
 a result of finish on the vehicle just exactly like what they had on carriages, and it
 gave a very high-quality finish to the model. Of course, they were very expensive.
 In those days it cost around one hundred thousand dollars to build a full wood-
 and-metal model. So they didn't commit themselves to that until they had to. But
 that was the manner in which they sold the car to division. And that was the

process, the design approach, of something new, which, as I said, meant an adventure into the enchanting device that would capitalize on the public's appetite for novelty.

CEA You said that you felt Earl wanted something new. How did you get the message, as a young designer?

SM Well, in any designer's language, the first thing you do when you are trying to approach an ideal design—and idealism is very important to the designer—is that you extrapolate all the stuff that doesn't really apply and you try to put into the design something that will give it coherence or totality. This is a by-the-seat-of-the-pants process. And I think many designers at that time were serious and were trying to do that. They were counterpointed by a large number of designers, who inevitably occur in the industry, who are very skillful, intuitive, and will simply apply a whole series of combinations one after the other, very swiftly, and achieve some results. And so, if that combination looks good to somebody, then it achieves recognition and use. It became actually a rather political game. And it was tough on designers who felt they had an ideal to reach for, as opposed to "production-line" designers.

CEA Let me put it this way: Do you feel there was a certain direction that Earl wanted GM to go at a certain time, and you were to refine that? Or did he want a completely new direction?

SM Earl would seemingly not make up his mind, or he would seemingly change his mind from day to day. And that kept everybody rather alert. Bill Mitchell may have told you that he himself had a different technique. He'd come in and stir up a studio that was running placidly. He'd do it on purpose in order to get them upset and angry: "Now, god damn it! I am going to show that son of a bitch." And then they'd plunge ahead on the thing and really turn out something great. Well, Earl did it by not making up his mind. He'd come in one day and seemingly approve a design and suggest some changes, and then come in the next day, having thought it out himself, and say, "No, that's no good. We're going to have to start over" or "Let's try something else" or "What else have you got?" And, of course, it kept everybody in a very nervous state. And that method, actually, worked pretty well.

CEA When you were designing in the Buick studio in 1936, were words like "power" used in relationship to visual form?

SM The vocabulary was actually quite limited, as practiced by most of the people that I knew, with just a few exceptions. With the new adventuring, there weren't as yet symbols, and there wasn't a vocabulary to term any of the things. Earl invented them to some extent. Of course, at that time, people were responding to an increased preference for power. The straight-eight engine was a good example. . . . Earl definitely was a proponent of the high, long, narrow hood, which implied a large, powerful engine.

CEA Can you remember what the working ambience was like, and how you as a young person fitted into the structure?

SM It is just a youthful impression when you are eighteen, but the ambience was very professional in many ways. The people who were working there were a very high grade of people. They were almost in counterpoint to the difficulties that they

encountered—meeting management's demands for time schedules and themes. Now, as I said, Earl would change his mind from day to day, and that made it difficult for someone with a professional viewpoint to try to pursue a course of improvement and refinement. Very tough. And so I think many professionals would tend to retreat a little bit into an area of protectionism and turn out stuff that they thought was appropriate. And every now and then, they would launch forth an adventurous program and do something they hoped was very good and hoped would be well received.

The chief designer, as Hershey will tell you, is *the* designer in the studio at this point. And all the other people working in the studio were not, as they are today, independent designers who have a chance to make an expression. They were merely extensions of the master's hand. So, in most cases, the designers in the studio were doing what the head designer told them to do: "I want you to work on that trunk catch, and here's what I think we want. And let's have a dozen sketches to go on the wall by tomorrow." Whatever it might be, it was the same—it could be a steering wheel, because all those details were done in the one studio at that time. So, for that Buick, for example, the whole car was designed in one studio.

CEA How did the ideas filter down? If you, as a young eighteen-year-old, basically were carrying out the wishes of the chief designer, and the chief designer was at the serendipitous will of Earl as he came in, how, mechanically, were the thoughts relayed?

SM I am sorry. Let me differentiate the chief designers. We called them "key designers," because they carried a key to the rooms. I am getting a little ahead of the story, because they didn't have individual locked-up rooms until we moved into the Research Annex Building in 1937. But before that, the rooms were simply separated by blackboards, and you could hear from one room to the next. The guys that made the decisions, as far as the projects to present to management were concerned, were of course under Earl's guidance or, I should say, affirmation, because Earl didn't tell you what to do. He said, "Do it," whatever it was you were going to do. At most he might give you a suggestion about something he liked or that he thought was good.

CEA Did he get everybody around in a circle?

SM Sometimes, but most of the time he did it spontaneously in the studio with a group that was concerned with the design.

CEA Just whoever was there, even if it was a low person like you or a key designer?

SM That is right, whoever was there. But he was mainly talking with the head of the studio. And if you were around, naturally you were going to hear—hopefully.

CEA And the substance of what he said was, "Basically, I want this." But he didn't draw it, he verbalized it in some way?

SM He would give an ambience of a theme, but he would not define the theme as far as hardware or proportion. He might suggest that he wanted it to be low or that anything that would appear to make it low would be desirable. And he was always trying to get the cars down. So, as an example, on the '41 Oldsmobile, we put a chrome strip on the bottom of the body because Earl thought, and said so, that the chrome strip on the bottom would "pull your eye down." He'd use

phrases like that in order to define one thing. He was trying to get optical effects that would lower the car.

CEA Were those optical effects related to Earl's interest in chrome highlights?

SM Earl said that cars were sold on the street and not in the showroom—people make up their minds before they get there. And so he figured out the highlight principle easily enough himself. The sky is a broad area, and it is pretty generally light from horizon to horizon. Surfaces that face upwards capture the light that emanates from the sky, even on a gray day, and therefore the chrome looks brighter. And so Earl felt that bright work, since it cost a lot, ought to respond well. And it can only respond well in the street, where he felt the sales were made. I can recall several instances where we changed the angle and shape of a grille bar in order to capture more sky tone and thereby make the chrome pay for itself.

CEA What I don't understand is how frustrating it must have been to be a designer in a situation where the goal is money and you are underneath a whole hierarchy of people.

SM You hit the nail on the head—resilience and creativity are the essential elements of survival.

CEA How can you be creative after working for so many years without independence?

SM Because, if you are really creative, there is no end to it. . . . You know, there is another aspect to what you were just touching on, this resilience. The way that many designers—I would say, almost every one of them—can come back the next morning, bounce back into work, tear off another sketch, direct another model, or make a new change, [the way they can do that] is by having an outlet. And it may not necessarily be an escape, but it kind of forms that pattern. Every designer has an outside activity in which they are profoundly involved and which can give them a direct response: painting, illustration, or it may be music. It is some particular hobby. A friend who works at Chrysler is a member of the Ferrari Club and has taken office in the club a number of times. He does illustrations and sometimes composes a newsletter. They all have an outside activity that is parallel but not directly related. When he leaves work at four o'clock in the afternoon—they have an early shift at Chrysler—he cuts the umbilical cord completely and forgets all about work until the next morning when he goes back. It is his method of achieving resilience.

CEA Can you tell me a little more about Earl's way of dealing with creative talent?

SM One thing Earl did, which is very interesting. In order to reinforce his directorial ability (this is in the prewar years), he set up a committee, a hierarchy of people, including Tom Hibbard (who was very well regarded) and Julio Andrade, a Cuban, who, like Earl, also stammered a great deal. Earl would send them around in his absence to review the design process, to give him their inputs on how problems could be solved. And the committee became a very formidable political power.

CEA As yet another step between the chief designers and Earl?

SM Yes. And they were made up of old-guard people, who had been around the business for a while, and that is perhaps why he trusted their judgment.

CEA And how did it work out?

SM It added confusion because their recommendations might be diverse. I told you

earlier that Earl might change his mind from day to day, sometimes even during the day. And so it left everything in a state of flux. You didn't know exactly where you stood. If he thought that you were doing well on Tuesday, on Thursday he might come back in and tell you, "No."

There is one other feature which is a very significant feature of Earl's method of operation. If he found a feature in a studio that he liked, and he thought it might work better in another division, he would simply lift it and take it into the other studio. And he did this any number of times. It could be a hood ventilator or it could be a radiator motif. As a matter of fact, the most profound example of that proliferation was for the 1936 cars, which of course were executed about 1934—late '34 [Fig. 18]. He adopted a feature which we all referred to as the "fencer's mask." It looked just like that, a convex shield. It was a continuation of the hood surface and the surface of the grille, so it was a continuous form, but separated by the fact that it [the shield] was plated and it was composed of a grille. This went through all the corporate cars.

CEA And he picked it up from where?

SM It probably came out of Buick, but I would have to guess at that. They did that a number of times. When we were working at Oldsmobile, we got features that had been generated in other studios and applied them to our car, sometimes for a trial. And sometimes they wound up on the production model.

CEA Finally, what about the role of two-dimensional drawing in Earl's creative process?

SM A very important thing: Designer sketches can be misleading. If drawn in perspective, they can give you some sense of three-dimensional form. Earl would have to vacillate, though, because the sketch would give you a pretty good idea of what the whole thing looked like. But then, if you tried to translate it into a model—either a scale model or a drawing to scale—oftentimes it would not work. And he'd be frustrated by that. So, in one of the later competitions that he ran, everybody had to do a front end. They were all front views, and they had to show the entire car in full scale—no perspective. Well, this was a real problem, because if you have ever looked at an actual front view of a car, especially in those days, the body looms out and dwarfs the whole grille and front end, and really puts it all out of proportion [Fig. 81]. You don't really ever see a car like that.

So there were two ways to cheat it. One is to put in the body—the windshield and all that stuff—very lightly, and then put a lot of emphasis on the rest of the front end with the headlights. And you did this with airbrush illustration on black paper. A drawing was actually done with white pencil, very lightly, and then you'd come in with the airbrush and render it and try to give it a three-dimensional effect, with lighting and polychromatic paint.

Well, they had this competition. Front-end design was it. They were searching for new themes—always looking for the new idea. [George] Snyder and his assistants (it had to be 1937) cheated. He shoved the wheels up under the body shell, put little tiny racing windshields on the car, and won the competition hands down. The fact that his compositions were meticulously done and fresh and very graphic—that is, balancing proportions against focal points—was really why he won. But the manner in which he communicated them was really very dramatic, and it eliminated the other problems all the rest of us suffered from. So our stuff

looked like cattle-ranching trucks, while these things looked like sleek little sports cars. And, of course, Earl just wheeled in that direction, and George won hands down. That was Snyder's perception. He knew what the old man liked, and so he orchestrated it.

CEA Do you think Earl realized that Snyder was cheating?

SM Of course he did. And everybody grumbled about it. But with Earl, one stare bolted you down. You wouldn't dare say anything. But it was indicative of his trend. And he would move back and forth between—"Well, the front-end drawings don't show you what the shape is," so you'd go back to the perspective sketch. Then you'd cheat too much on the perspective sketch, and then you'd go back to the front-end or the scale drawing, where Earl could use his tremendous perception of correct line and balance.

Bill Mitchell

HIS private design office in Detroit is a man's world, where Bill Mitchell interrupts the interview to bark orders at assistants or to speak to old buddies like Bunkie Knudsen on the phone (Figs. 2, 3). When you visit his Florida winter home, he quickly ushers you through the residential building, where (from the look of things) he can't display any car memorabilia. That's his wife's white-shag showplace. To reach the home studio, we go through the garage, pausing long enough to ogle his pin-striped Corvette, gold-plated Jag, and souped-up BMW motorcycle (affectionately dubbed the "Red Baron"). Comfortable in his stag retreat, he surrounds himself with souvenirs from his glory years as Earl's successor at GM, and he paints fantasies of famous car races.

Before joining GM in 1935, Mitchell studied at the Carnegie Institute of Technology and the Art Student's League and illustrated for Barron Collier Advertising. Except for a wartime period of Navy service, he headed the Cadillac studio from 1936 to 1954 and then assumed the directorship of General Motors styling.

As vice-president of styling, Mitchell reigned at the center of the world of commercial design for almost twenty years, from 1958 to 1977, and he created those cherished follies of my adolescence. Now he really wishes to talk only about the elevated social types and race-car drivers he encountered along the way. Mitchell is ungrammatical, repetitive, opinionated, and, at the ripe age of seventy-six, tremendously fast on the uptake. He understands the implications of

every question and responds emotionally to the visual environment. While Frank Hershey is a self-starter, who sensitively recounts his own stories after I press the button, Mitchell offers a real dialogue, with concepts, insights into human and administrative complexities, and a high degree of visual consciousness. But despite his wit, he lacks sensitivity and refinement, and knowing that perhaps makes him a little sad.

To say that this person is powerful and somewhat raw may seem to avoid the issue of his artistic contribution. In fact, it focuses on the values he expresses and on the way he sees himself as a leading car designer. For Mitchell, the overriding principle of car design is the mood or ambience created for the owner. In particular, he believes that others associate your character with the car you drive. Like clothes, cars should express personal differences and have what he calls "identity." Life and design, in his mind, not only intersect, they are one and the same. When reduced to specifics, however, the logic of his theory loses some of its driving force because, by and large, Mitchell thinks you share his taste. He likes to spend his time racing and carousing, and therefore he wants his cars to look powerful, lean, and fast. He assumes you do, too.

It is no wonder, then, that, for Mitchell, to act vice-presidential means making contacts, wielding power, and battling issues rather than subtly discussing them. The image of a designer as fighter is ever present in his interview, even though he censored the most strident statements. Like Hershey, he thinks that a real stylist monomaniacally loves cars, and he should focus on them to the exclusion of the other arts. Like Hershey, Mitchell sees designing as an individual and largely intuitive act. He detests corporate reliance on public-opinion surveys, and he is always ready to defend the creator against committees and know-it-all corporate philistines. But, unlike the practical Hershey, Mitchell is almost a pure stylist, who believes that function and aerodynamics are only acceptable if they help the "look." While Hershey is a reclusive individual, who did what he wanted and left the business as a consequence, Mitchell is an outgoing talker who bided his time and then struck. Mitchell loves the fight, he talks the macho line, and he hopes that his cars show it.

Men like Bill Porter speak of themselves as Young Turks under Mitchell, but to Mitchell's credit, he allowed them a good deal of independence. Although he demoted Porter after his brilliant Firebird design, Mitchell allowed him to achieve the design without interference. Compared with Earl, who could hardly draw, Mitchell was a skilled draftsman, with a hands-on approach, capable of entering directly into the creative process. Yet he allowed more local autonomy in the centralized structure and fostered long-term thinking with advanced-design projects. He placed much greater emphasis upon designing directly from the clay model, and he turned a whole generation of designers away from Earl's soft curves and heavy chrome. While most of these men like and respect Mitchell less than they did Earl, and though they resent his blustery and heavy-handed style, they acknowledge that the forms and methods they prefer were developed

under him. But the blood, as Mitchell says, is weak. For Mitchell, the ideal boss is someone like Walt Disney, whom he portrays as a vulgar, powerful man fighting for his ideas against the odds. In fact, Mitchell comes right out and calls his replacement as vice-president at General Motors Styling an apple-polisher. He believes that Irv Rybicki is no leader and that the present generation of GM cars lacks personality. What is missing is "identity"—that unique look of a car that lets one associate his or her dreams and life-style with owning it. For that design principle, Mitchell lives.

CEA The American car is not really appreciated as an art object in the art world, although it is elsewhere. I am trying to pick examples that show what is creative in American cars.

BM The classics.

CEA Well, yes, the modern classics. To try to explain what makes them great. I have picked the '38 Cadillac Sixty Special [Figs. 29–31] and the postwar GM cars like the '48 Cadillac [Fig 74]. Now, tell me, are these the right cars for you?

BM I think to qualify you have to think of the bad and good, and then you can get in the middle. Take the two worst years that I can think of in my career [1957–58]. We had no advanced rooms; we just did one after another. We did not look forward. We worked relative to the demands of the salespeople: the more chrome, the more money. The chrome was just put on, lards of it. And then, in [our] '59 [cars], Chrysler scared us with the fins [Fig. 87]. They lowered the car and really scared us into a trap. We had been lading [on chrome], and we panicked. Harlow Curtis was in charge, and it just scared him and Earl. So we tried to out-fin. And we had some cars with one headlight in the middle, some crazy things, just because we had no advanced design. When I became in charge, I made sure we had studios that worked years ahead so that you could look at something a while and if it wasn't any good not build it.

CEA Would that, in your mind, be a major difference between you and Earl?

BM Well, Earl, you can't blame him—it was the times, really. He was building this: He built the Tech Center and all of it, and, actually, he was only in the Tech Center five years before he retired. And I inherited all this stuff. So, it [advanced design] was coming in. He built a team that I took over and built better.

CEA But did he plan more than two or three years in advance?

BM That is why he built show cars, yes. Those so-called dream cars had two mean-ings. He wanted to get the corporation off the duff. It was awfully hard to get the board to see ahead. So by putting them in a show, someone would say, "Why don't you build that!" That is how the Corvette was born and the four headlights on the Cadillacs. By putting them in the show, they could say people wanted them. And then you could build them. But he had no advanced-design studios, no. Earl couldn't draw. He didn't want to draw. He came from the coachman days when you had side elevations.

CEA This is something I wanted to ask you. Your background is as an illustrator and a two-dimensional designer. I was wondering whether you think that affected the profile of your cars?

BM Oh yes.

CEA Could you go through that and show me, because I think that is essential for us to understand.

 BM A lot of my show cars you couldn't draw—you had to model them. First of all, I believed in modeling and he [Earl] didn't, because modeling wasn't in its prime then. You'd make sections [cross-section drawings] every ten inches. And then the templates would fit them, and *then* you modeled them. If he came in a studio and saw you modeling, and went over and didn't see it on the board, you'd get hell: "Where is your drawing? How are you doing this without any reference?" Highlights would have to be checked. He would have a bubble meter, and he checked them. Everything was geometric.

 He wasn't interested in modeling. He wanted the drawing: side, front, and rear. Julio Andrade, who was sort of a chief designer for years, had been a sculptor, and he and I got along fine. We did a lot of fast show cars, and then, when the panic hit, the Chrysler thing, some of that stuff we did really fast, without drawings. So I was in sympathy with modeling. You would have to see some of the show cars. Now, for instance, I challenge today Giugiaro [Giorgio Giugiaro of Ital Design] because his stuff all looks like folded paper to me [e.g., Volkswagen Rabbit]. I sent one of my designers, Chuck Jordan, who is second in command now, over to the studio when he was in Italy. And he said, "Bill, you are right. He can't draw a perspective. He draws front, side, and rear." And that is what his stuff is.

CEA When Earl thought about the future, how much ahead was he thinking?

 BM Well, you usually are two years ahead—[to prepare] the tooling and what have you. And, of course, you have to always be in a position, if it doesn't go over, to get off the boat and run. That was where Earl was clever. If he saw something wasn't going, he wasn't a diehard. Now, for instance, right after the war—talk about evolution—it looked like a trend was coming. I was in the Navy for three years, and I came back, and I saw what they were doing. They were covering the wheels, the front wheels. American Motors, Hudson, and quite a few others had a car made with covered fenders. And with Earl, we too were modeling one [Fig. 67].

CEA This was when?

 BM Right after I got out of the Navy. It was '47, and we were working on it. It was sort of an evolutionary trend: "Now we cover the wheels." None of us liked it, but you get mesmerized into that, with everybody working it. All of a sudden, he came in one day, threw it out, and put the fender down—right through. You know, this line [Fig. 74].

CEA The low-line fender?

 BM Yes. We thought he was nuts. He just changed like that.

CEA So it was Earl's idea to lower the fender line?

 BM Yes, sir. He said, "To hell with that big blown-up thing!" Earl just came upon the fact that it would look longer and leaner if you divided it and got that [belt]line.

CEA This was '47?

 BM Yes. The other boys didn't do it, and they looked like bloated pigs. Packards and all of them.

CEA Everyone always talks about Earl taking the group to the Lockheed studio in '41 and showing them the P-38 [Fig. 64], and that that is the origin of the tail fin. But

I have always felt—and this has really confirmed it—that the sleek look only came along at the end of the war.

BM That is right. Once we did one, we did them all like that.

CEA Explain some more about this most important shift at GM after the war.

BM Well, we just took the Cadillac [Fig. 74] and made every one of them the same. At that time, there had to be interchangeability in the doors.

CEA Tell me about that—the concept of interchangeability with this new fender line.

BM You see, the front doors would be the same. But you got back, and then the rear door you made different, and the deck. But the front door usually had to be interchangeable. And, for that reason, if you dragged that [low fender] through, that would go through on all of them [the other GM cars] [Fig. 76].

CEA What about the front fender—was it interchangeable?

BM No, no. The hood and fender were all division sheet metal.

CEA What about the roofs?

BM No. The roofs were separate. See, in those days you could make a roof separate because the quarter [panel] was down below—that line always went through. Then, in later years, when this all went together, it limited you. Then they had to be alike. That tagged them to look more alike.

CEA I think these ['48 Cadillac] are among the most beautiful and creative cars. What do you think?

BM Well, you see, I was brought up with big cars. In New York, as a kid, the Isotta-Fraschinis and Hispano-Suizas, with long hoods, were always my cars. Not long decks—I didn't like the long deck. But on a car like that, it is easy to tailor a long, low look. Now, for instance, the '63 Riviera [Fig. 95]. I put that car in the studio when I did the last Riviera: No way could you make that one look as good as the earlier one, because the earlier hood was that much longer and the deck shorter. You just couldn't do it.

CEA And what was the philosophy behind this ['48 Cadillac]? They say that there were a number of GM rules. And one of them was the curve—the curve of the roof and the curve of the hood.

BM The difference between him [Earl] and me, of course, was that he was a big man, 6'4", and he thought big. In fact, when I took over his office, I had to lower all his seats because he *felt* big. So he liked rounded hoods. I never did. I liked sharper things.

CEA That is a fundamental difference?

BM This will tell you something. Wait a minute. Now, this is interesting. This is a drawing I submitted in 1935 [Fig. 26] when I got my job. That was rendered on dark paper. In '35 that was the way I thought, see: flowing lines. . . . Now, here is a car, one of the last ones I did: a 1967 Eldorado chassis [Fig. 98]. This is a vee'd [V-shaped] windshield, flush glass, and those lines are very similar to the earlier lines.

CEA In these shapes, what would you say is you? What is your creativity?

BM Flowing lines, with a narrow nose. I don't like dumpy, boxy things. Long hoods. And this, the last Cadillac I did, has got the same look. And it showed that I hadn't changed my thinking the whole time I was there. I like knife-edged cars, fleet-looking. I like to have them look like they are going like hell just sitting still.

CEA In which cars would you say that you best got that message across?

BM Oh, the Stingray Corvette.

CEA Any earlier than 1950?

BM I didn't take over till later, so I didn't get a chance to show my hand. I really didn't like Earl's round hoods.

CEA What about these soft—what I would call soft—curves in the body itself? What was GM policy at this time ['48] as far as those section highlights [Fig. 74]?

BM They were to have nice soft lines, and we carried those highlights right straight through. There wasn't any dropping hood. He [Earl] was very much for checking a highlight straight through—a long, straight through-line.

CEA What was the idea behind doing that?

BM Well, he'd get a long, straight through-line, but the roofs looked fat.

CEA Let me see if I understand what you're saying. This was Harley Earl's concept after the war: the low fender line, the continuous highlight line, the large, rounded hood. But it was translated into visuals by a team, by the group of people who were designing it.

BM Yes. Cadillac was always meant to be the stiffest of all of them.

CEA When you say they were meant to be the stiffest, do you mean that they were designed to be more rectangular—a little bit more uptight and upright?

BM The Cadillac, yes. Now, where we came back to the really strong Cadillac was the 1941. [The horizontal egg-crate grille with the central section most prominent remained the Cadillac trademark; Fig. 32.] I'll tell you what happened. Prior to that, Earl was Svengalied by the Lincoln Zephyr. It was flowing and fine grilled, and we were getting sucked into that [Fig. 37]. And, then, we went this way with the Cadillac, and the next year Lincoln turned right around and followed us [Fig. 41].[1]

CEA And what caused you to do that?

BM I don't know; we just made some sketches. And one of my designers, Art Ross, did one of the first ones like that. I would set the drawings up at night, with a light on them. I wanted to sell Earl. He would come round at night when no one was around. And he bought that, and right away things turned around. Then the stiff front became more impressive than the rounded one.

CEA Let me ask you another question along those lines. There is the subtle problem of the meaning or content of the car. After the war, everyone talks about power in advertisements. There is a lot of sexual reference. I was wondering how conscious that was in the design. It is one thing to have it in the ads ("Slip behind the wheel, drive, take over"). But, tell me, did you translate that into visual form?

BM We were conscious of that. We wanted the car to feel like that—powerful and speedy. And we wanted the instrument panel and everything to portray that. No, the designer was very close to the ads.

CEA How did that relationship work, for example, when you did an Olds Rocket?

BM The agencies just hung onto our words. We created the Rocket. All these names—like the Stingray—the names of these cars came out of our place. Until later on, when Gordon [John F. Gordon, president of General Motors] didn't like Monza, didn't like some of these European names.

CEA But what about names like "Futuramic" and "Dynaflow"?

BM Well, the agency did some of that stuff. We worked with them. When I got in there, I found that [things worked best] by comparison. I took one of our

boardrooms, and, to make my point, I put the advertising of Chevrolet, Pontiac, Olds, Buick, and Cadillac all up. And then I invited in the general managers—not the agencies, but the general managers and their chief engineers. And I showed them the good: "Look how much better the Pontiac does than Olds." I said, "We want the agencies to make the cars look better than we do. If I get my picture taken, I don't give a damn if it looks like me, if I look better."

CEA When was this?

BM Late fifties. But we finally got control of it so that all artwork had to be approved by the designers. For example, the chief of design at Olds had to approve. Before, they'd make the highlights different and change it so it looked as if the surface wasn't there. So we had to approve all that.

CEA Now, tell me, when the war ended, and you realized it was no longer a seller's market, you had to meet certain needs of the people. What kind of things were you emphasizing?

BM We had to make the cars look just the opposite of today. There was no diet then, let us put it this way. We wanted to make a car look bigger than it was. Bigger and bigger and bigger. And, as a matter of fact, there was a race on for inter-changeability. Bunkie Knudsen was head of Pontiac, and Ed Cole was head of Chevrolet, and they didn't have a new "A" body to match the "B" body. And my chief engineer came up to where we could put the Chevrolet and Pontiac underguts into the B body. I sold that to Curtis, and overnight the Chevrolet and Pontiacs got to be big cars. They liked that. And now it is wavering. It was where they weren't going to make any bigger Chevrolets and Pontiacs anymore. Now, that is back in again. They are selling the big Oldsmobile so fast that they are outselling everything. The people are fickle. They say one thing and they do another. They say, "Oh, we are going to be good and save gas." And then they say, "To hell with it. We want a good-looking car." Olds and Cadillac sales are up.

 And so what I was going to say was that back in those days you wanted to make a car look as big and as powerful and as glamorous [as possible, and] decorated all to hell.

CEA What meant power?

BM Long hood, strong grille—very powerful grille!

CEA The grille was an expression of what?

BM Power—there was a big engine in there. The instrument panel had a lot of dials to personify that there was a big engine in there. Just the opposite of some of the stuff today, where they have cleaned it all up.

CEA You know, for so long the art world has been disparaging this. They thought this wasn't creative. I am talking about the people in the Museum of Modern Art, the toney, basically East Coast crowd, who did not see this.

BM The reason, you see, is that those cliff dwellers didn't like cars. The inspiration for automobiles never came from New York. I lived in New York. [Ralph] Nader is a cliff dweller. He walks to work. I could give him a ride and give him a stroke. I have got some very powerful cars. . . . In California they love cars.

CEA There is a prejudice among members of the art world against a kind of creativity that is not born within the background that they are familiar with.

BM Well, you see, car designers—there is a great percentage of imposters here. Cars,

you have to love them. You have to feel them, and you have to drive them. Like they'd say, "You have to put the cam into the wheels." You have got to know them all—the histories. And if you are an icebox designer—fine. I know, because I hire a lot of guys here [at his private industrial-design business]. They can do rockets, but an automobile? Humph! Damn few people know how to do a car! You have to get the heritage of an old Duesenberg, an old Mercedes, not just a modern car. It's like an old shoe.

CEA What is the opposite side of that? What do car designers know about icebox design?

BM They don't want to know anything about it. They don't give a damn about it. They are different people entirely. That is why Raymond Loewy was not a car designer. He wanted to be.

CEA Is the '53 Studebaker just a version of European design? Loewy's ideas were minimal chrome, light as possible, and implied motion.

BM Yes, that's right. I wasn't for chrome either. Where we broke the ice there was when we did the first Riviera [Fig. 96]. That set the standard with hardly any chrome. At that time, Pontiac made the Grand Prix [Fig. 93], and by the way, DeLorean was up there then. He couldn't get the tooling changed, but he took the cue and took all the chrome off. Prior to that, if you had an expensive car, it had more chrome. The guy that delivered meat had the one without chrome. So I remember having lunch in Stockholm with [James M.] Roche, who was GM president then, [and he asked questions about] the Riviera and the Grand Prix. He said, "Why?" And I said, "They don't have any chrome because Europe didn't like all that stuff we were putting on." That was the beginning of taking the chrome off ('63 was the Riviera).

I think it is an interesting thing how the Riviera was born. During the Motorama, we had four four-passenger sports cars at the show. And we didn't do anything about it. We knew Ford was looking at our stuff after hours. We'd see them in there, measuring and checking, but they always had done that. And they came out with a four-passenger Thunderbird, and they scooped us, because Corvette was a two-passenger car. Even after Curtis and Earl left, nothing had been done. And the dealers were coming like hell at Curtis. Then they came to Gordon and said, "We've got to have an answer for that Thunderbird." They presumed it to be a Cadillac. So I went with Ned Nickles in a studio back there, and we built this car [Fig. 95]. I wanted to call it La Salle, but Cadillac didn't need it. And at that time, Chevrolet was knocking the hell out of Pontiac, Olds, and Buick. Boy, they were just polishing them off. So, actually, Olds, Buick, and Pontiac competed for it. Olds wanted to put a bore in it and make it smaller and wanted to tinker with it. The Olds guy was a strong-headed guy, but I wouldn't give in. I just held up his mind. I had it all done. The only person who saw it was Gordon. He'd go down and watch me do it, and the only change he came up with was this. One day I went down to do it, and I said, "Jack, what do you think?" I had been doing double-bubble tops and all kinds of things that weren't catching on. "Jack, what do you think it ought to be?" "Oh," he said, "you take architecture," and he went to his office. "See, everything is sheer." That was all I needed. I didn't even put curved glass in it. Curved glass was out. That was the way it was

in 1963. Well, anyway, Buick came along, and [Edward] Rollert was head of Buick, and he said, "I'll take it the way it is." So he got it.[2]

CEA Compare the cars done under you to those before 1950. Take the '48 Cadillac.

BM There were some dumb years with GM. It is difficult, as you see, for me to get excited or to pull anything out. It doesn't take any imagination to do any of those cars. They are pretty dumb, pretty dumb. The engines were dumb. There was no fuel injection. There were no exciting engines. They were not racing. After this, they went racing; they went doing things. So it's a pretty dumb era to talk about. You might tell them that.

CEA I get the feeling from you that you are not so hot on these cars.

BM No, they weren't so hot.

CEA It is important for us to know why you think so.

BM Well, they didn't have any characteristic image of their own. There were no special cars then, see. The postwar Sixty Special [Fig. '74]—now, this is a big, bloated sedan compared to the original Sixty Special [Fig. 31]. And it is later. At the show the other night, my wife and I were at a party, and I was kidding. I said to Roger Smith, "Come here and look at this Chrysler Airflow" [Fig. 15]. That is what Ford is copying now for their new job. It is a one-piece door, and the windows look like portholes. We strived to get thin pillars and give you vision.

CEA Then, you as a person like tight, expressive—what they would call a "personal car"?

BM Oh yes. It's never any fun to work on anything else.

CEA Why is that?

BM Well, we had to be careful. For instance, if you put the Corvette Stingray in the same room where they were working on the regular Chevrolet, all the guys would work on the Corvette. You had to get the mood of it out of there. For instance—this is interesting—when the original Riviera was done, McCann-Erickson took their agency in New York, and they took their writers and photographers and went across to a hotel on Fifth Avenue. They separated them from the agency to give that car its own identity.

CEA Compare your design approach to what is going on at GM.

BM They are all the same: boxes. No, we have to come back to some identity in the cars. You see, in the twenties and thirties, the classic cars, they were great.

CEA There is a question I want to ask you about the thirties. When the turret tops [Fig. 16], the steel tops, came out [1935], that seemed to me to change the way General Motors looked [Fig. 17].

BM When they went to steel bodies, they couldn't get these sharp lines, [and thus] the big radiuses came in. That was the moment the sheer look left the automobile. The dies had big round radiuses, and the fenders curved [Fig. 25]. Before, all that lean look was handmade, see.

CEA What about the structure, the idea itself of a monocoque?

BM Exactly. That's made a fat car out of it. And Ford is going right back to that. They got those doughnut windows in their cars, and, to me, they are losing it. I was out to the club yesterday for lunch. And I said to the guy who parks the cars, "I thought I saw a new Mark IV come in here. Can you find it?" He said, "I can't find it." You know why he couldn't find it? It doesn't look like anything. I finally

found it. You can't tell a Mark IV anymore: There is no more rake; the back's dumpy; the front is dumpy. I got a great saying, "When you take the antlers off a deer, you got a big rabbit." You lose the excitement.

CEA You talked about the steel body. The curves in the thirties [Fig. 17] are asymmetrical, and at the same time, there is a lot of reveal on them, with rounded ends, so it looks as if the body is something thick and rubbery. Did they have to do that, or is it an aesthetic?

BM Oh yes, you had to make that to get the die out. To raise it, you couldn't have a sharp corner; you had to have the radius. Had to have the radius down here and had to have the radius up there.

CEA Did Earl talk about this as an aesthetic?

BM At that time and mood, we probably thought it was a good thing, yes. Then we went back to the sharp, sheer look [Fig. 31].

CEA When the Airflow came out in 1934, GM's reaction to it was timid. Earl didn't go in for a lot of streamlined styling, but he seemed to have wanted to do a little bit of it. Would you say that this fit in with the new dies? You have the process of the rounded die and the turret top, and at the same time there was a push to get into streamlining. Did it all come together?

BM Yes, that's right. Aerodynamics have helped us in a way. You couldn't slant the windshield like you do today. There were too many no-no boys. Now we put on a [slanted] windshield. I like aerodynamics if they make the style look good, but if they screw it up, I don't like it.

CEA Isn't there the problem that everything gets to look the same?

BM Yes, you have to watch it. You don't have to make it [that way], but they do. First the nose drops down on one car, and then they are all going down and the tail is going up. I don't like the thick backs on the car.

CEA I find it interesting that in the early thirties everyone thought that they knew what an aerodynamic car should look like, and all those cars looked pretty much the same [Fig. 14].

BM The Chrysler Airflow type.

CEA And then, around 1934, they realized that there wasn't a single shape that was appropriate—

BM That was *really* aerodynamic.

CEA Do you remember that discovery, and the liberty it gave designers? It seems to me that once they knew that there wasn't one type—

BM We did as we damned pleased. There wasn't anybody saying "that's aerodynamic" and "that isn't." Aerodynamics just came about with the gas economy.

CEA So, when you arrived at GM in '35, they didn't say, "Look, we've got to do a little more aerodynamics."

BM Never heard of the word. No. That was for something to run on the beach, or something like that.

CEA But was it important for Earl, beyond a selling feature?

BM No. We didn't worry about it because some of the [aerodynamic] things right away showed it made the car look like hell. So we didn't like that.

CEA I read in the trade papers of the time that, when they started to make the headlights into torpedo shapes, it actually made the turbulence worse.

BM We didn't know that. We made them look good.

CEA Is there anything we didn't cover that you really want the people to know about?

BM I think it is important that everybody's car—even the sedans—it is important that you give a car some identity. I know *I* like to have a car so that when I park it somebody says, "Who the hell's car is that?" I think what has happened today, as design moves toward Washington, the automobile industry is going to suffer. You have got people who do not understand automobiles telling them what to do. People who walk to work don't like cars.

CEA Did Earl like cars?

BM Oh, he loved them, God yes. He liked to build special ones for himself.

CEA GM is searching for that special identity that you seem to think is so important.

BM Yes. They have got to get more identity into a car. My God! I would not want to buy a suit like another guy. I wouldn't want a hat like somebody else. You don't want your house like the guy's next door. Especially in an expensive car. This Ford thing now: Sure they brought out the [1982] Thunderbird, but to me, they have lost it. . . . The old Thunderbird [Fig. 84], now, *that* is an eye-catcher! Boy, you forget how cute that was. This new Thunderbird is nothing. I say it is a bar of soap. It just looks like nothing. People want something when it goes by: "Jesus! What was that?" With that little grille on the front of it, it reminds me of an old lady who has a fox terrier and she overfeeds him. It is bloated, with a little head coming down the road. . . . I think it is going back to the one-piece door and the thick pillar. Now, when you see the side view in their ads, you get this airflow, but when you see it three-quarters, all this stuff thickens up and it doesn't have that effect.

CEA You take a position. There are so few individuals who have such strong opinions.

BM Well, you can't work on stuff that long [and not have strong opinions]. I have got drawings I am doing right now, and I look over at stuff I did fifty years ago and, "Wooh, geezus!"

CEA But my question is, why did Earl allow you to get the top position that you did, with such strong opinions? Why did General Motors want you if they knew you expressed one point of view?

BM Well, now, when I worked for him, when I was under him, I never crossed him up. I waited until my time. And the boys that followed me are doing things differently than I did.

CEA You mean that you waited to let them know what you stood for?

BM Oh yes. Yes, yes. I got the fins *off*.

CEA How did that go—when things started all of a sudden radically changing?

BM It went very well.

CEA Was it just a fortunate coincidence that you and the late fifties—with all the money that was there to spend on specialized cars—occurred at the same time?

BM Yes, timing had a.lot to do with it. And I had my way.

CEA I am told that you had a theory that causing friction led to creativity. You would come in and purposely cause a hullabaloo.

BM Yes, I would shake them up. I would do it when the studio was quiet. I'd knock over a rack of sweeps. "Holy geezus!" And it would wake everybody up. I'd turn the radio on, anything. "Get going, it's getting like a morgue in here!"

CEA What about the impact of Ford after World War II? All of a sudden they had a very strong new design direction. How did that affect General Motors. Did you care?

BM No. No competition. Really, Earl and I never really cared what they were doing. You never had spies or anything. You just knew where you were going. They were always trying to find out what we were doing, but we—never. We said, "This is what *we* want to do." You had to believe in yourself and go after it that way.

But I'll tell you the big thing. See, nobody had a design studio but Earl. And then Edsel [Ford] was interested. He saw that and started one at Ford. Prior to that, Chrysler was ahead of Ford in the industry, but their chief engineers had contempt for styling. They used to say that you could piss over the top of our cars, we were so low. And, by God, their spite hurt them. They were once known for their engineering. And then, when they got going on their wild stuff, they didn't back it with good engineering. They then got a black eye for engineering.

One other thing. In the organization of General Motors, you always had financial men, sales, and engineering. It was always a good balance. You always had the Coles and the Knudsens and the Estes to balance off the financial guys. You see, after Walter Chrysler, all the people who came in at Chrysler were bookkeepers, right on down the line—Tex [Lester Lum] Colbert, Lynn Townsend, the boys that were there just before the ship went down. They didn't have a balance. And you need a balance to fight this thing out. I was on the Policy Committee for twenty years, and I know. There is always a battle. But when you have a battle, and you win, you know it is pretty well done.

But it is an interesting thing about styling—and probably not just cars. Nobody would criticize an engineer. But I would battle with them. I'd say, "I wouldn't fight you on your transmission and your drive line. But every damn one of you wants to talk about styling." [Jack] Wolfram, who was head of Olds—God, he was an old engineer. He always wanted a red and green car. And I said, "You will never make a good-looking car." And I was at his house once, and he had a parrot, and he said, "Look, he is good-looking." But you know—anyone can be a designer—that was the attitude *they* had. There was never the reverence or respect. I used to say that a designer is the most unappreciated, undervalued man in the team. My dad used to say that a car was a silent salesman. You set it on the floor, and you either like it or you don't like it.

CEA The trouble is that the designer usually is someone who is not verbal. He doesn't explain what he is doing.

BM That is right.

CEA For example, I tried to get out of you how power is designed into the car. And you tell me, but at the same time you don't tell me. It is not exactly a science. Engineering is much more of a science.

BM Well, now, Earl liked them powerful but ponderous. I liked them powerful but sleek, sharp, slick—like a P-38. It is powerful. I wanted to put the crease in the trousers. Now, for instance, the new Corvette is not nearly as good as it could be [Fig. 115]. Instead of looking like a shark, it looks like a grouper. There is room for a little chrome, a little glamour. That is a nothing car. For $26,000, it isn't detailed. You need a little class to a car.

CEA Can you tell me a little about what Earl meant by powerful and ponderous, that combination?

BM He liked round, big rounded surfaces, and rounded roofs. You see, that was new, really, because prior to that, everything was a box. A handmade car was all square corners. Joists and everything else.

CEA Yes, the '35 GM line was no box [Fig. 17]. There was a creative drive there.

BM But he got back to the linear look [Fig. 31] when it got over-bulbous. He was very good at knowing when to get off something. He'd come in, and he'd just see it like that. He taught me to come in alone. If you are in a studio with a lot of designers, they are talking and selling, and you are trying to see it. I'd come in on a Sunday, take a trip around, go to church, come back, and just walk over there. Walk through the room. One day I was driving cross-country with my family, and I saw a Cadillac coming at me. A present Cadillac. And I thought, "The one we are doing, the future one, doesn't have that power—the front." So I took them home, drove out to the Tech Center, and walked down into the shop. The new Cadillac was in the shop, being put together. And by God, I was wrong! I called them down and we stopped it. And we did a new one, because you can't tell the guy in the bar, "You should have seen the one we had." Now, under Curtis, there were some Buicks done that he didn't like, and he came down and changed them. Oh, we got some of those Buicks going in his way. I couldn't stand them [otherwise]. I didn't say "boo," but those big walrus-toothed bumpers and hoods like—Oh my God!—awful-looking stuff.

CEA Why did Earl OK a design like that?

BM Earl liked that stuff. Then he went from that to really fine grilles. He had a liking for heavy-handed things because he was big.

CEA You are saying that Earl really had control. A lot of people say that he was just an administrator who took other people's ideas.

BM No, but he could sell them. See, Sloan hired [the divisional managers], don't forget, and if things didn't go right—in his office Earl had a button, which I inherited. He could push it and talk directly to Sloan. And he'd have a meeting coming up, and he'd press that son of a bitch.

CEA Yes, but the thing is, many people say Earl took other people's ideas. That was the idea behind the closed studios.

BM Yes, but *he knew* what he wanted.

CEA You are telling me really something different: that he had a very strong aesthetic sense.

BM Oh yes. Oh yes. When he wanted something, it would be very difficult to work with him because he knew what he wanted and he couldn't draw it for you. And he would be so impatient with you if you didn't get it. He'd just be furious if you didn't get what the hell it was he was telling you.

CEA So he was more than a synthesizer. He lit a fire under people?

BM Oh yes. He had a chair like a director in a studio in Hollywood. He came from Hollywood. He would sit in that chair, and the way he would do it, he would sit and have all the people around him. "Get that print of the '39 La Salle. And get that. And then get something else! Now, move this back! Now do this!" And he would sit there and everyone would run around like a bunch of monkeys. That was the way cars were done when he was here.

The Art of American Car Design

CEA How do you think Stephen Bayley's book, *Harley Earl and the Dream Machine* [New York, 1983], approaches him?

BM Oh, it's weak. It isn't well founded.

CEA Did it get at the sense of what you are talking about, that he had a driving aesthetic?

BM There are some good things in it, but they didn't get the good facts—what he liked. I remember one night, a Friday night, I went into his office to talk about one of my men. I always called him Mr. Earl. I never said Harley. I would never go in to talk to him much. He was aloof. I was second in command, but I was second! So I said, "You know, you don't realize it, but your size and your voice—you are powerful." And I said, "You just scare the hell out of these guys. They are no good to me. They are scared to do anything. This man, he isn't worth a damn now, and I think you ought to think about it. See, you don't realize." He never worked me over too bad, so I felt maybe I could do something for that man. But Earl came in the next morning, red-faced, and said, "God damn it. You tell that son of a bitch to get off his ass, or throw him out, throw him out into the street!"

CEA He was that cruel?

BM Oh yes. Either go his way or get the hell out!

CEA You told Earl that the guy had a softness, a weakness, and he said, "That's a problem, get rid of him"?

BM Yes, that's right, yep. Old Kaptur [Vincent Kaptur, Sr.], Earl fired him three or four times. He was chief engineer. He said, "I don't know how many times Earl would fire me and then meet me in the hall and say, 'Go get me something.'" Earl was in with the Fisher brothers to begin with. He was powerful. He had the power. Nobody dared cross him. And I had to fight like hell, because they were all waiting to gang up on me. "Hell, we'll knock this guy off." But they didn't.

CEA How were you able to control things? You've got to have stick-to-itiveness?

BM You know, before he died, I was having dinner with Walt Disney at the City Club, and he tried to sell General Motors on Disney [Productions]. Anyway, I said, "How did you ever do *Snow White?*" He said, "I'll tell you. I went to every god-damned bank on the West Coast. Nobody would buy it. They said, 'Krazy Kat, Mickey Mouse, all these black-and-white things. And now you want to do one in color, on human beings? No way.'" He was drinking then. Disney isn't his name; evidently he is Bulgarian or something. "God-damned bastards. Fuck 'em," he said. "I went out and got my own god-damned money. And anytime I want to make a million, I go to Tokyo, Torino, or Toledo." You know, he showed me that customer research is crap. And I told that to young Ford at a dinner one night. I said, "If you have an idea, push it through! . . ." You have to be motivated. That is why the Stingray, the shark, was an animated thing. When it came out, all the cars looked like Ferraris and Maseratis—rounded-looking things—like they were hammered over a blanket, you know. The nose looked like a cheap ranch horse—just no nose. I like sharp, sheer tails. You take an airplane. Now, it would be just a tube without this. You get the cylindrical form, then you put the fin on it, and that is what makes the shark in the water. You go look at sharks. I've been down to Bimini and seen them. Jesus, they are exciting to look at. The others, they look like a grouper.

CEA What do you think is going to go on in car design?

BM Well, part of it is distinction and looks. In a talk in Minneapolis this fall, I showed about thirty cars on the screen, and I said, "I don't know what the hell they are. I am a designer. I've been in the business forty years, and I don't know." I was with a lawyer in Washington, and I came out of his office, and there were five cars sitting out in front. My God, they all looked alike. There was a German car, a French car, an American car, and a Jap car. You can't tell Ford from a GM or Jap. I said to the new chairman of Volkswagen when he was here, "You have to go back and give that car some character. What you have to do is take it away from the box. At least the old Volkswagen, you knew it. You saw it—maybe it was a Beetle—but you could make a new Beetle." But the new Volkswagen is another box, like the Japs'. He just got into the pool with all of them.

CEA I got into a big argument with Jordan about this, and I am not happy about it. I said the same thing: "GM cars today do not have personality." And he answered, "Yes, they have personality. They have *corporate* personality." I said, "No, that's not what I am talking about. To me, 'personality' represents an individual designer." Does that seem a fundamental difference between him and you?

BM Yes. That's why I'd go do these sharks and these special cars when they'd all look alike. Now, this is the way it happens. You come along, and you do an Eldorado. That *is* something. So, right away, they give it to Grand Prix [Pontiac] and Monte Carlo [Chevrolet], and they put the little square window in, and it is the same car all over again. Or you get a grille that looks good—you get the egg-crate grille—and then you put the egg-crate everywhere else.

 No, there are too many designers around. They asked me to give a talk to a class at the art school [Center for Creative Studies] in Detroit, which is getting very good. So these fellows are waiting, and I was in a good mood, and I said, "Well, in the first place, I may be talking to a bunch of imposters. Maybe you guys aren't car designers. You can draw. You can illustrate. But if you don't have gasoline in your blood, you are not a car designer." I looked at some of their stuff, and it looked like a tube of shaving cream with wheels on it. I stuck it to them. I said, "You've got to give identity." It used to be, when I was a kid, I'd walk down Fifty-Seventh Street and look at those big cars. Of course, I was fortunate enough to have lived in that golden era when Duesenberg, Isotta-Fraschini, Hispano-Suiza, even a Renault was a big car, and different looking. My God, all of them looked different! Rolls-Royce! But now, they are all boxes.

CEA But the top designers don't think they are boxes. Jordan says they are exciting. He says, "They've got personality. You're blind."

BM No, no, they are not. They all look alike. I have to read the emblems to know what the hell they are. I tell you that. And do you know what it is? When I was at Rolls-Royce, I stole some of their stuff. As I said, I stole from Rolls, not Mercedes, because you rob a bank, not a grocery store. You've got to have identity. But as a result, I saw a Rolls down here, and it looked like a Buick, and I wouldn't have recognized it if it wasn't for the girl [on the hood ornament]. Have you seen the new Rolls? They got the glass-brick taillight—everybody's got glass-brick taillights. Everybody's got a section on the side. Oh my God! One thing about Earl—now, this is what made him—his cars were different. That's why he loved

Ned Nickles, because Nickles made different cars [Fig. 66]. In his sketches there were all kinds of different, funny-looking cars. They were exciting. Maybe Earl out-finned, but [at least] his cars were different. And that is why Earl had [the building on] 40 Milwaukee: to go out and do something different. Earl used to talk about a baseball. The seams going around, they do something with it. They get you. You throw a billiard ball to a guy, and he puts it down. But a baseball! He'll keep playing with it. The stitches.

CEA And what did he mean by that?

BM Interest. Interest. I said, "Don't be simple like in Simon." Give them something to look at. It's like a watch, you can put anything on it. That's what's wrong with some architecture. Just a column with cement is no good. Have *something*.

Gordon Buehrig

GORDON Buehrig designed for various independent and custom-car manufacturers, including Dietrich, Duesenberg, and Packard, and he worked briefly at General Motors in 1929 and 1933. He was chief designer at Auburn from 1934 until 1936, when he designed the Cord 810 [Figs. 20, 21]. After the war, Buehrig managed Raymond Loewy's Studebaker studio; in 1949 he joined Ford, where he worked until he retired. I interviewed him at his home for a whole day, with a brief interruption for lunch at his Grosse Pointe country club.

Sharing the admiration of so many for Buehrig's Cord 810 design, I was disappointed with the material that came out of the interview, and therefore I include only a small portion of it. Buehrig thinks of himself as a strict functionalist, and he describes his cars almost mechanically, concentrating on the technical process of designing. He seems only vaguely interested in the exterior, and even the relation of shape to function holds little fascination for him. With Buehrig, this refusal to discuss aesthetic problems is not a question of being coy about his designs, as it is with Hershey, who at the same advanced age is bubbling with mischief, intrigue, and power. I believe Buehrig when he says that his designs just pick up where the requirements of packaging, function, and construction leave off. His great design sense flows somehow through his fingers, but not from his head or his heart.

GB I worked for General Motors twice—in 1929 as a designer, and then in 1933, when things were going badly at Duesenberg, I went back to GM for six months. Harley Earl was in charge. He was about 6′6″ and very domineering. All of us designers were afraid of him; at least I was. Years after I retired, I saw him, and he really was a nice guy. But it was different when I worked for him. He, more than anyone else, made design important in the automobile industry, and everyone is grateful to him for that.

CEA He intimidated people?

GB He did me.

CEA But did he intimidate the "coffin" nose on the Cord [Fig. 20] out of you, too? How did he get that shape out of you? You were about to tell me about that shape, and you sort of got onto Harley Earl.

GB Well, what happened was this. At that time, Harley had an office up on the tenth floor of the GM building. He called the designers up there one day in 1933, and he said, "The most important part of the design of an automobile is the grille, the face of it. That is the whole design, right there!" He said, "I want you to all start working on radiator grilles and that's 90 percent of the automobile—the grille." I said, "Mr. Earl, I don't agree with you." A shocker!

CEA When you said that you disagreed with him, did you mean that you felt that his approach to designing was wrong, with his emphasis on the two-dimensional, head-on view?

GB No. I don't know why I was so cocky that I said that, but I did say, "Mr. Earl, I don't agree with you." And he started getting red, and his neck got red, and I thought he was about to throw me out the window. He said, "Well, if you know so much about this, what is the most important part of the design of the car?" I don't know all I said exactly, but I did say, "Look, I've been designing bodies for Duesenberg for five years now, and they all had the same front end on them. And some of them were very beautiful automobiles and sold well, and some of them were very ordinary looking. But they all had the same front end."

 Anyhow, we had this design contest. I don't know how they ever had the time to do this, but they did.

CEA This was the Harley Earl design contest of 1933 we are talking about?

GB Yes. I was the head of one of the teams (four of us), and we came up with this design which had the radiators on the side. I sketched it out [Fig. 22], and we modeled it out and shaped the thing. We were concerned with aerodynamics—I mean, the thing wasn't wind-tunnel tested, but I think aerodynamically it was far better than the Chrysler Airflow. Anyway, when they [Earl and the jurors he selected] had their judging of the models, the official judging, we came in last. But in the other judging, which was put on by the studio itself—where we had all the designers vote on cars—we came in first. [This 1933 model became the basis for the 1936 Cord design.]

CEA Can you remember why, for example, you peaked the outside of the hood on the "coffin nose" Cord [Fig. 20]? This is a unique design.

GB Yes, and it actually leans out a little bit, both on the front and on the side. Looking at the side elevation, the profile line, the center line, actually leans

forward a little bit. It tilts out just a bit. In other words, the whole thing, louvers and all, goes down.

CEA Why did you do that?

GB Why? To make it look great. When doing a sculpture, you shape surfaces to make them look right. If you want to talk about things that are new on this automobile, it has a unit-body frame. Now, this was not the first car with a unit-body frame. That was, I think, a Dodge that was designed and engineered by the Budd company. But we had the unit-body frame up to where the whole front end was detachable. If you notice, the latest-model cars nowadays—the streamlined cars— they don't have a drip molding on them. This one didn't have a drip molding on it. All the other cars had buggy-whip aerials for their radios. Our radio aerial was concealed. It was underneath the car.

CEA I find the back line beautiful.

GB Well, it is.

CEA I don't think there was anything like it at the time or following it. Can you tell me a little bit about that? I notice that it is one of the elements you changed from the Baby Duesenberg [prototype for the Cord 810 designed by Buehrig as a Duesenberg]. Weren't the pontoon fenders much longer in the Duesenberg?

GB Well, actually, we didn't pay any attention to that [Duesenberg] when we did this one [Cord].

CEA Tell me about that.

GB Well, we had it up there, but this was a whole new package. We started with a new package. The old Cord, the L-29, had a straight-eight engine, and forward of the engine was a clutch, transmission, and differential. The back end of the engine was way back, and this gave bad weight distribution because when you are going up a hill your center of gravity moves back and you don't have very good traction on your front wheels. So this layout was much better. We were influenced, I think, by a German Audi, a little four-cylinder car we had with front-wheel drive, which had a similar drive train.

CEA So you had the German Audi there, and you had this Duesenberg model standing around at the same time.

GB We didn't pay any attention to that [Duesenberg model]. It was down in the warehouse.

CEA So you didn't have a direct visual reference to the Duesenberg. You just had it in your head?

GB Yes. We didn't really pay any attention to the Duesenberg, because it [the Cord] was a whole new problem. On this car, the transmission is forward of the differential, and the differential comes in line with the front wheels. The V-eight engine was four cylinders shorter than the straight-eight, so we wound up with a package where the weight was far further forward than on the L-29. And that was a big improvement. It really had a perfect weight distribution.

CEA And that meant what about the design? What visuals could you now create?

GB Well, if you notice, the front end of the small Duesenberg prototype is rather dull. There is nothing going on. On this car [Cord 810], we had the transmission up front, and the radiator sat right over the front axle, right above the differential. It was difficult to figure out how to get a linkage past the radiator forward to the

transmission. Well, at that time, Bendix had invented their Selectric hand-vacuum shift, and that was perfect, because then all we had to do was run some wires from the steering column up past the radiator to the transmission. The engineers wanted an inch clearance between the sheet metal and the transmission—and it was an asymmetrical arrangement. So all we did was provide this clearance and make it symmetrical. That is how we designed the front. It added some interest in this area, which was pretty blah.

CEA Did the transmission change any of the other proportions on the front? Did it alter any of the other shapes?

GB No. The headlights on the original model were hidden inside the fenders. We were trying to visualize how to make the fenders, and it made the fenders a rather easy stamping if you could stamp them from the ridge line inward, and then stamp them from the ridge line outward, and weld them together with a flange and put a chrome strip over the flange. That is the way we had envisioned the original model, and we still had the headlights on the inside. Then engineering decided they wanted to make the fenders a different way, and they found that there was room to put the headlights in the front—which improved the car. So that's how that happened.

CEA Is that why you have a much more humped crown line than on the Baby Duesenberg—because you had to include the lights in the fenders of the Cord, and that in turn changed the profile of the fender line?

GB No. I think it was full jounce and full turn of the front wheels that determined it. Originally, we had designed a different bumper. And then some vender came in with a bumper, and he showed it to us, and we just bought it. It was better than what we had done, and we got it with no expenditure for tooling. That is how that happened. Anyway, the frame side rails of this unit body were out on the side, and you stepped down. The floor was a step-down floor. About five years later, Hudson made a big deal out of it on their car.

 Now, that little rear window. This was before curved safety glass had been invented. Because you have a very rounded, compound surface on the roof, two flat plates of glass [on the rear] gave us the best answer. But there were a lot of things wrong with the car. In a sense, some of the things it needed hadn't been invented yet. It came along at the wrong period, as far as these things were concerned. The front drive, with weight on the front end, gave us very heavy steering. And power steering hadn't been invented yet.

CEA How would that have improved the shape?

GB Oh, it wouldn't have done anything. No, nothing has been invented to improve the shape, except, possibly, that rear window would have been bigger.

CEA You were talking about the complex compound curves in the back, and obviously those are really important to you. Can you remember what you were thinking of? One of the marvelous things about the car is that, not only do you see this beautiful shape from the side, but as you move around to the back it becomes increasingly subtle.

GB Well, let me explain how this was done. We created our own package in our styling group. There were five of us in there. I had two model-builders, a body draftsman, and an airbrush artist. He did a lot of things. He did the catalogue, pictures for the parts book, and things of that sort. And he helped on the interior

design, with some color sketches. Anyway, that was the group. So we were working very closely with engineering on this new chassis, because it was all brand new. And if we wanted to change something, we could. There were a couple of things where we asked for changes. One was the battery location, which was an area we wanted to work in. Another was the muffler location. We needed to get these things out of the way so they would not encroach on interior space.

Well, after we did that, we sketched up on a quarter-scale drawing what it was going to look like. And then we located all of the important points on our body draft. . . . We established the wheel-base. You want it long enough so it comes in just behind the seat in the particular package. You establish points for legroom and points for headroom. And in the plan view [seen from above], you establish shoulder widths, so that, if you take a point at your shoulder, you know how far out that is from center line. And you put in your gas tank. So you get all these points that the envelope has to cover.

CEA Still at quarter-scale for the Cord?

GB Yes. Then we built an armature out of wood, which projected more or less the shape of the car, but with square lines, you know. It allowed, say, in this case, maybe two inches for clay. So you got a wooden armature. Then you take a template, an outside template. And you know roughly about what this [final shape] is going to be. So you build up the shape in clay real rough. Then you measure up (we used a bridge). You already have these points located on a drawing. You know how far each point is back of the front axle, and you know how high it is above the ground level, and you know how far out it is from the center line of the car. Now you add clay to the armature. You know your shape and you put on clay a bit more than you believe you will need for the finished shape. It is all very rough. Then we took a bunch of little dowels, eighth-of-an-inch dowels, and made them up into pieces about an inch long. With a surface gauge and with measurements from the bridge equipment, we would drive these into the clay at each critical point, so that each point was located in clay by a little dowel. When we got through with that, then we could start sculpturing our shape. And as long as we didn't intrude on any of these points, we knew that we had the amount of shape inside that we needed.

CEA You mean that you basically free-sculpted the Cord?

GB Yes, but we did it after we had these points marked. Then we covered them up. As long as we didn't move the points and didn't cheat, we knew we had the required interior shape. Then, when we got through with the clay model, we didn't do a full-size. We went directly from that to die models.

CEA Was it unusual as a working procedure?

GB The only time it was ever done, as far as I know. That is the way we did it.

CEA So, within the limits of the dowels, it was free-sculpture?

GB Yes.

CEA Do you think, because you were working that way, that it affected the shape of the Cord?

GB I don't think so, no. I knew what I wanted it to look like, but I didn't want to cheat on it. I didn't want to have to change it later if I found out I didn't have enough interior room.

CEA Did you have preliminary sketches or drawings?

GB Not much. No, I just worked regularly, with orthographic drawings. I mean, I didn't do freehand sketching.

CEA So, basically, all you had was the Duesenberg model, which was in the warehouse, and your orthographic drawings, but no freehand drawings?

GB That is right.

CEA Do you remember how accurate the orthographic drawings were?

GB Well, when the design model was finished, we made our orthographic drawing like the model. But that was afterwards. Our orthographics were rough first. We just wanted to get an idea of what it was going to look like. But once we got it clayed up, we could shape it. As long as we didn't move any of those pins, we were accurate. It is a very disciplined kind of sculpturing.

CEA At what stage did other people work along with you?

GB After we finished it, we just turned it over to engineering. A fellow by the name of Bart Cotter was our assistant body engineer. He was the fastest body draftsman I ever saw. We gave him the lines by a series of measurements which we took from the quarter-scale, and he put them on a full-size body draft. From that we went directly to die models. It was never proven in full-size. It was just done directly. The process saved time and money.

CEA How about on the creative side—how many assistants were helping you work on this clay model?

GB I had two model-builders who helped me. One had just graduated from high school and the other from college. I was the only one with experience.

CEA How did they work with you? Did you say, "Take some more off here, add some more there"?

GB I did a lot of it. Well, they would help. We had a system where, when we got one side done, we could transfer it to the other side very quickly. And they invented some of the equipment which we used—the equipment was all new.

CEA Were you skilled? You almost describe yourself as a sculptor. Did you really sculpt the model in clay?

GB I'm pretty good in clay. I'm not very good in sketching.

Bob Gregorie

UNINTERESTED in aesthetics, Henry Ford turned over the styling of the company's cars to his son Edsel, who set out to have them designed as art. Between 1932 and 1943, he employed Bob Gregorie (Fig. 36) as his "court" artist, and Gregorie functioned like a vice-president in the family-run business.

Locating Gregorie's home outside St. Augustine takes driving back and forth a couple of times—it certainly is different from finding former GM Vice-President Bill Mitchell's House in Miami. To reach Mitchell's place, you negotiate one of those sentry checkpoints, pass through security walls surrounding the all-new deluxe community, and, less than a quarter mile from the ocean, arrive at his house, sitting on a manicured lawn next to an artificial lake. You get to Gregorie's house by leaving St. Augustine for a scruffy area where grass and sand mingle on the edge of the real ocean. The community reminds me a little of Venice, California, in the fifties. Gregorie's boats and whatnots are scattered about the lawn; even before entering, you feel that he is at ease with himself and with his surroundings.

Gregorie talks about his approach to designing cars as a counterpoint to the system Harley Earl developed at GM. That important issue was discussed in Chapter 2, so by way of an introduction to this interview, let me mention a couple of points about his personality as an artist. First, his mind is complex, and he can talk about his artistic ideas. His thinking is sensitive to implications, and

frequently he answers a question before I finish asking it. Gregorie needs only the hint of a question, quite the opposite of the typical GM designer, who, trained in the nonverbal Earl system, gropes for a response. Bill Porter is the other major car designer whose interview I include who has Gregorie's verbal ability, and he, too, can precisely analyze the aesthetics of his own creation. Both have been blessed with enormous artistic talents, which make their statements all the more important. Gregorie attributes his ability to "dissect a car conversationally" to his training as a boat designer. While he worked briefly as a car designer between 1929 and 1931 at the Brewster body division of Rolls-Royce and for the GM Art and Colour Section, he trained as a naval architect with the firms of Cox and Stevens and the Submarine Boat Company (General Dynamics). It was there, outside the limited world of automotive styling, that he became aware of line sets and proportions and learned the verbal skills to express these relationships. He never much enjoyed the company of other Detroit designers or shared their point of view on styling. He reflects more the aesthetic and cultural concerns of his philanthropic patron, Edsel Ford.

An old-fashioned aesthete, Gregorie is no arty prima donna—his own term for a smock-draped designer. What sets him apart from most of the others I interviewed is his ability to combine art and science, or—to use his words—to make art that is not arty. Gregorie sees himself foremost as a practical and mechanical boat designer who happens to be handy with a pencil. To get to his real priorities, however, you have to ask him how he integrates function with aesthetics. He answers that, although a car designer compromises between the two, he starts with the "pretty effect" and keeps it as his top priority throughout the design process.

Unlike the typical GM designer, who constantly and profoundly compromised to survive, Gregorie never was called upon to make more than delicate adjustments to his artistic integrity. His patron not only encouraged independence and artistic innovation, he expected it. Gregorie lived the life of a conscious maverick who quit the field when his creativity was threatened. His relation to his patron, his professional training, and his artistic outlook set him apart from and above many of his contemporaries.

He shared with Edsel Ford a love for cars with "dignity and cleanliness," although his taste was more expansive than that of the severe Ford. Gregorie imbued his designs with grace, motion, and boldness, preferring the "husky" forms of oceangoing vessels to the delicate outlines of speedboats and racing craft. As far as I know, this is the first time that Gregorie has explained his personal aesthetic at any length, using the example of the 1949 Mercury, a design he places at the top of his achievements (Fig. 50). His preference may come as a surprise to historians, who associate him with the thirties' taste of his Lincoln Continental, the car for which he is best remembered, although he does not want to be. Instead, he believes that the challenge to design the '49 Mercury extended him the most artistically, because for once he could design a car with the freedom

inspired by new sheet metal. Typically, he took a daring chance with the opportunity. Seeing a trend toward slab-sided cars, he undertook a highly refined experiment. The car itself became a "mutant" since the concept was not pursued when Gregorie lost his job; but that should not overshadow his creative effort to bring identity and articulation to the bulky shape of the postwar car.

BG You know, it is interesting, the appreciation people have for some of the older cars. You sometimes wonder why—because there were some horrible-looking cars during the fifties. I am so thankful that I didn't get involved with some of those fin-tailed monsters.

CEA How did those things come about? How were the chief designers picked?

BG Actually, when you stop to think of it, it is probably one of the most unusual professions in the country. There really are only about four or five of us who were directors of design for these various companies. I don't think there is any other profession which is that scant.

CEA And within that, aren't you an exception?

BG Yes, I have been kind of a maverick.

CEA Do others seem to fall into a pattern?

BG Yes, they do. As a matter of fact, I got into it in a different way. I am actually a naval architect, a boat designer. . . .

CEA Do you think there is any overlap between your interest in boat design and your interest in car design?

BG Yes, to a certain extent.

CEA Do you think one affected the other?

BG Designing boats gives you a great feeling of proportion and a sense for a beautiful line. If you design the hull of a seventy-two-foot boat, it is a beautiful set of lines.

CEA Do you think that sense of proportion helped you out?

BG Sure. I can look at a line and tell whether it is fair or should be tucked in here or tucked in there. That is one thing that appealed to Mr. Ford. I could dissect conversationally the design of a car while he stood there and looked at it. That appealed to Mr. Ford greatly. He was a great art connoisseur. He was a patron of the Detroit Institute of Arts and similar interests. And he liked the way I conversationally could design a car or criticize what was wrong with it. For instance, he always liked the way I referred to the aft end of a car—like a boat.

CEA How did you develop those verbal skills?

BG For me it was a manner of expression. You had to have an appreciation for proportion and form. Naval architecture amounts to part engineering and part art. And another thing appealed to Edsel Ford. I knew as much about the mechanical part of the car as I did about the appearance of it. That irked a lot of the engineers in the company. I was on the Engineering and Policy Committee of the company. It was just a happy combination.

CEA What are some of the design and aesthetic points you think about when you design a boat?

BG I love husky boats. I don't care for speedboats or racing boats. I like good, husky boats.

CEA When you mean husky, you mean—

BG Wholesome, seagoing boats—nothing delicate about them. Heavy construction.

CEA I find it interesting that you, as the designer, were making design policy decisions.

BG Yes, but usually with Mr. Ford's general approval.

CEA And that is so different from General Motors.

BG Yes, yes. We worked like a country store. You'd be surprised at the decisions that were made just sitting at the end of a drafting board. Mr. Ford and I would decide on this hood ornament or that hood ornament. There were no committees, nothing of that nature at all. It was only when I left, thirty-eight years ago, that Ernie Breech set out to establish Ford along GM lines. . . .

 It had been such a pleasure to work with Edsel Ford over the years. We managed to arrive at some very, very workable decisions with a minimum of meetings and conferences and a lot of lost motion. I was involved in a subject matter which he personally loved.

CEA Art?

BG That is right. And also, Mr. Ford appreciated that I was qualified to discuss various mechanical phases of the car. . . .

CEA What is your position as to whether something should look good or be functional?

BG Well, it is all a matter of compromise, I guess. You have to compromise. Lots of times you could get a prettier effect one way, but you have to break it off some place and do a few things which might be regulated by other factors.

CEA But you start out with the pretty effect?

BG Yes, you stay as close to a pretty concept as you can. . . .

CEA But so often designers are—

BG Prima donnas, let's face it. I sensed that in the beginning and I beat that feeling down within the department. I said, "There are not going to be any prima donnas here. We are all working boys. Let us not be too arty. Let us do a job. Let us please Mr. Ford. And if there are any problems, let us sit down and talk about it." And, as I said, we fortunately had a direct pipeline to Mr. Ford, which many of the departments in the company didn't have. Mr. Ford would come in there every afternoon and spend an hour or so, so that, if there were any problems, all of us were in an advantageous position. And they appreciated that. I was in charge of all of Ford design: buses, trucks, tractors, everything. Ours was set up in one big room. We didn't have any straw bosses or secondary designers or such. I would do a lot of the pencil work myself.

 And outside the company, I was a mystery. Most of them never heard of me. I never worked for the other companies. I never associated with them [the other designers] particularly. I lived distantly from them. I lived on an island down the Detroit River. I purposely stayed away from them. I didn't belong to the golf clubs they belonged to, and that type of thing.

CEA For the other design vice-presidents, like Earl, Walker, and Mitchell, somehow all that seemed very important—the social business, going to parties, hobnobbing with the muckety-mucks?

BG Oh yes. We stayed away from that.

CEA Why and how did that come about?

BG I am a private person. I just didn't care for that sort of thing. I am a boatman. I am a yachtsman. I didn't care for golf, and I didn't care to get mixed up with them particularly.

CEA Did you design with General Motors cars in mind?

BG We never had any contact. I didn't encourage any contact of our people with the other manufacturers. Absolutely not. I told them, "I don't want to see a line on any of these automobiles that smacks of anything anyone else has ever done." So that is the reason our cars had individuality. There was never a line on any of our cars that was taken from another car.

CEA [Holden] Koto said something very interesting on this subject of individuality. He once tried to get a job with you, and he asked you about his independence. And you said, "My designs are really my designs. I like to do designing myself."

BG Yes. Well, I did. I just had a pride that I was never going to put a line on a car that was obviously taken from any other car. I thought that if I couldn't do something original, something that smacks of Ford Motor Design Department, then I'd better get the hell out of it. And I was pretty handy with the pencil. I mean I can draw automobiles from every angle.

CEA Harley Earl couldn't draw.

BG No. He was a manager. He was like a manager of a ball club. He was a big, burly, cigar-chewing salesman type. I mean, he was a great, big, magnificent-looking guy. He stood in well with the Fisher brothers. They brought him from California to GM.

CEA Do you think different attitudes toward design affected different design departments?

BG Well, let me tell you another thing that happened. Edsel Ford, who set me up there as chief designer, he was an extremely conservative man. He didn't care for flamboyance in his clothes, or life-style, or his automobiles, or anything else. It had to be severely simple, plain, and in good taste—immaculately good taste. That is the way I liked it, too. So that is the reason he and I hit it off right away. And he also liked the idea that I designed yachts. He loved yachts. And we had a very good appreciation for each other's thoughts, as far as automobile design was concerned. He had always handled the design for the company. He was not a designer, but he had a sense of what looked right. And he didn't care for blustering types of people.

CEA Would he make changes in your designs?

BG Oh, he'd make suggestions, yes. If he thought a bumper didn't look right, or if it looked too heavy or something, he'd say, "Can't we lighten that up a little bit?" or something like that. He was a good critic, an excellent critic. There have been stories about Edsel Ford designing cars and bringing designs and drawings in. I have never seen a drawing that he ever made. Now, he might have doodled around at home, but he was an excellent critic, and he had an immediate sense of when something looked right. He sometimes couldn't express why it looked wrong. But if he said it didn't look right, I had enough appreciation of his judgment that I would modify it to a point so that it pleased him.

CEA How did you structure your design department? I have talked with people who worked at GM, and they said that there was a real hierarchy there. If you were a designer at GM, for example, you talked to a chief designer and seldom with anyone higher up.

BG No, we didn't have anything like that. No, no. We just had a small setup compared to General Motors. We had, most of the time, fifty or sixty. They had

hundreds. They had departments—"studios," they called them—a Pontiac studio and a Cadillac studio, and so on. Then they had a head boss man there, and he had his underlings, and so on and so forth.

CEA What do you think is your best car?

BG I think the '49 Mercury [Fig. 50] is one of the nicest cars I have done. We didn't have much to work with prior to that. We just had the old Ford body. That Mercury was the first time we had a chance to start out with fresh sheet-metal work. See, right up to the war, we were practically hamstrung with that old 1935 Ford body. . . . Yet it was a compromise, a switcheroo in midstream. There was a shift of design in midstream with certain compromises because of the decision that was made by the Policy Committee. [The Policy Committee changed its mind twice. First, in 1944, it decided to upgrade the appearance of the standard Ford to distinguish the car from the proposed smaller Ford. Then, in 1945, when the smaller Ford was dropped, the committee asked Gregorie to turn the former larger Ford, almost unchanged, into the standard Mercury.]

CEA Where did the compromise come in the design?

BG Let's go back to Jack Davis, who was Edsel Ford's sales manager of the company. On the same day I went back with Ford in April 1944, Jack Davis came back there. [Gregorie had left in 1943 after Edsel Ford's death.] Number-Two Ford [Henry Ford II] brought him back, just like he brought me back. Same time, same day. And Jack Davis and I worked closely together. He was a really nice gent to work with. He and I could discuss things. He had bought [from Gregorie] and projected this idea of the smaller [Figs. 42, 43] and larger Ford [Fig. 44]—the Ford built in two ranges, which I could foresee as a coming situation.

CEA How was the larger Ford [Fig. 44] changed [Fig. 48]?

BG This car was beefed up to look a bit more important. This car was, as Charles Sorensen [Henry Ford's closest advisor] used the expression, "Let's deluxe-y the hell out of it." After Edsel Ford passed on, my direct contact to management was pretty much with Charlie Sorensen, who was number two in the company, there not being any vice-presidents. When we were getting the face-lifted version of the line of cars ready for presentation [the first postwar cars were essentially prewar designs], old Charlie—he was a big, very earthy, very handsome man—said, "Well, Bob, let's just deluxe-y the hell out of these cars." Old Charlie and I hit it off very well together, because he was a yachtsman.

CEA You mean by "deluxe-ying" that you designed this still as a Ford, and yet you had it looking powerful?

BG That is right. Step the Ford up. You were to have a combination of Fords. Instead of one basic Ford, we were stepping this up to carry the Ford name in a little higher social bracket. That was my thought on it. I originated this concept, and Jack Davis, the sales manager, went along with it.

CEA What about these bombers [Fig. 45] that were in the same room when you prepared the postwar designs?

BG Those were Emerson turrets. We had to work out the interchangeability between the two turrets on the fuselage.

CEA Their bulbous shapes seem like the direction you were going in your postwar cars.

BG You mean the full, round shapes, just like these big Italian gals, there, those opera singers? Well, you know, I'll tell you. Some of these cars, the older cars especially, looked awfully bony. You know, back in the late twenties, they didn't have much meat on them. The fenders were slim, and all the adornments were delicate. Everything had been slab-sided and absolutely flat. The only relief on the surface then was a half-round molding about the size of your finger. I think what we have lost in so many of these newer cars—there is just a trace of it left here in the Ford which became the '49 Mercury [Fig. 50]—is where you had some, what you might call, surface relief in a car. The older cars become attractive to people because they literally have an expression. When you had separation of fenders and headlamps and bumpers, each one was a piece of artwork in itself. It had a graceful flow. It either was a pretty fender or an ugly fender. But it was separated from the hood and the body. In other words, it had an expression and composition. The front of a car had an expression, like a man's face. But today, what you have is just like a loaf of bread. It is just a big gob of stuff that is so wide, and so long, and so high. On the Mercury [Fig. 50], this little effect right here [the dip in the side highlight line] was like a drop sheer on a boat. I have done that on many boat designs.

CEA Weren't you experimenting with that drop already in 1941, as you can see in photographs of your models from the Ford Archives? Is that where the drop comes from?

BG Yes. You take the sheer line of a boat, and you drop the sheer like that, say, in a cabin cruiser. In other words, it was getting this effect: a relief from a continuous, straight-sided look. And for years, they wanted the tail end of the car to be low and look fast, at least in the mind's eye. I've never drawn a car in my life that was higher in the stern than it was in the forward end.

CEA It has definition?

BG It has definition. That is right. That is the word to use. I'll tell you, I think the wheels belong as far fore and aft on a car as practical and as looks appropriate, not only for appearance but for what it does. It gives a car a footing, a stance. See what I mean [Gregorie stands up to demonstrate a knock-kneed stance compared with a bowlegged one]—as little overhang as possible.

 But, I'll tell you, we never approached this thing from an "arty" standpoint. I was a ship designer, so it was all business.

CEA And yet you seem to be very serious about the design of the car. You were not interested in a lot of fluff and ornamentation?

BG No, no, no. I like them nice and trim and clean-looking. In other words, to me, I've never cared for adornment on a car to give it style. The form had to be good.

CEA And yet, that is what I find interesting on the Ford which became the '49 Mercury [Fig. 50]. You talk about this being clean, and yet it is bulbous. It is an interesting combination, no?

BG It is powerful-looking, see? That is what you want, a good thrusting—a thrusting look, a reaching look.

CEA When you talk about "reaching," does that mean low in the back and that projecting front end?

BG Yes, pretty much. Of course, this front end was different in the sense that, instead

of the grille reaching and contacting the sheet metal visibly as a frame, there is no frame around the grille. It was all tucked under to simulate an air scoop or an entrance.

But to get back to the origins of this particular car, we had a small one, just a scaled-down version, with a ninety-inch wheel-base [Figs. 42, 43]. We had been fussing around with the small Ford, the ninety-inch version, and we built a half-a-dozen handmade models, samples. And a power plant hadn't been decided upon. Then we thought highly of that little ninety-inch wheel-base Ford. It was really the basis for the Mercury design. That was a cute little thing for its time. It was very clean. It was neat. And it was to be sold for nine hundred dollars.

CEA This was 1942. And then in 1943 you started doing a larger Ford [Fig. 44], which was very close to it?

BG Well, it was intended to be that way. In other words, we wanted the identity of the big Ford carried down into the small Ford. It was to be a smaller version.

CEA Yet there seems to me to be an important difference between the 1943 large Ford [Fig. 44] and the 1945 models [Figs. 48, 49] two years later. The earlier version seems to be a lot leaner and tighter—almost a European-looking car. I am also thinking of the front, where you don't have as much of a roll [Fig. 42].

BG This is a different concept in a hood. This [earlier version] is more of a conventional frame grille, attached to the sheet metal, that comes right out and doesn't tuck under and doesn't float in the middle of the opening. In the final production model [Fig. 50], you couldn't very well stamp the hood to get that reverse radius on it. When you stamp it, you have to be able to pull the die out. So we split the panels into two on the hood. A separate stamping comes around the grille, here, and lets the grille sort of float in there.

CEA If I understand you, this kind of bulbous front profile stems from the concept of the grille?

BG Yes. In other words, the forms are supposed to be compatible with each other. There is supposed to be a theme there—the *roll of the surface* here and the roll of the surface there. They are all related. Instead of trying to create a clashing contrast or a sharp definition, this flows. See?

CEA Can you remember how you got onto this later "theme" [Figs. 48, 49] in 1945, as opposed to the earlier theme [Fig. 42]?

BG As a matter of fact, I have the original sketch of this, just a rough little doodle that I did at home one night. And I went the next morning with it and got the boys to clay it up this way. That is how this thing came. That is how I used to do. I did a lot of it at home.

CEA I'd like to understand how the design of the '49 Mercury evolved. How did we get to the 1945 stage of this car?

BG We had a chassis and a wheel-base decided upon by the Engineering Department and ourselves. And we would decide on the amount of overhang we wanted forward and aft. This was a chance to do a completely new car. And all during the war, we had fussed around in a small way with models. Many of these models were quarter-sized. . . . In other words, we were trying to bring a new identity into a car.

CEA Am I wrong in thinking that this continuous molding [Fig. 49] on the side—

BG Yes, it is a style line. In other words, here is what we were beginning to be up against with this car. We were losing the benefit of fender identity, fender shapes, which are wonderful. They form wonderful relief on those older cars. You see some of those smart-looking cars in the late twenties and thirties—those beautiful Cadillacs, La Salles, and some of those earlier Lincolns. They had pretty fenders themselves. But when you got into this slab-sided thing, as I refer to it, it is like a loaf of bread. You had to do things to relieve the surface, to give the car an identity, and also to relieve the ponderous bulk of it, you see.

CEA So the Ford which became the '49 Mercury was creative. It was your reaction to the coming slab-side. It was your effort to give these forms—

BG To try to bring back the feeling of a fender and to give it some identity. In other words, this was a pretty line. It tapered gracefully, and it dropped down—a kind of a sparky little drop there. If you stripped this off, like on some of these newer cars, there is nothing. It is just like a balloon.

CEA Let me get you back to the models for just a second. The new interest in these rounded shapes, you say, stemmed from your playing with the grille in 1945 [Figs. 48, 49]. But these earlier models [Figs. 43, 44] were different in other respects. They had smaller lights, for example. It seems to me that you carried the theme of larger forms and more integrated shapes down to the details in the later models. Do you think that is true?

BG Well, you see, the car itself is large. There is a progression of design.

CEA But nothing was being produced during the war. Here we are in '42 and '43, and then we jump to '45. Now, none of these was produced, so this seems to me a progression within your studio?

BG That is right.

CEA Can you remember anything about the progression at all? Perhaps you can re-member something in your mind, like, "I've got to become more powerful in my designs."

BG It was hit or miss, you know. We only had a few boys working on that sort of thing during the war. There was no particular trend. There was no timetable as to when the tooling would start. And about that time—as a matter of fact, in 1943—Mr. Edsel passed away. He was ill for, I guess, six months before that. I had accumulated a great many design concepts up to that time. And I realized that he was never coming back into the office. So we were sort of left hanging fire for about six months after that. Let's see, he died in '43, and in '44 half the war was over. So we had only a year beyond that until we had to think about getting into production. We were primarily interested in getting stuff ready for postwar. You know, rehashing the '42 models.

CEA So the difference that we see here between the '43 and the '45 represented a shift of direction at the time of Edsel's dying?

BG Yes. We were able, actually, to get into a little more bold concepts. . . . Mr. Ford had certain likes and dislikes in colors, and we knew what they were. He loved metallic grays. He liked deep mulberry browns. But we didn't paint cars garish colors in those days, as they do now. He was a stickler for fineness. He liked a trim, delicate effect on a car. He didn't care for this big, bulky, bulbous sort of thing. He wanted delicate bumpers and delicate door handles and things like that

[Figs. 42, 43], which were not quite in keeping with the bulk of these newer cars. So that when he passed on, and we actually got around to seriously going into production with cars of this form and bulk, we were able to step up the size of the lamps and so forth. A lot of these things, like this one you were talking about, with the small tail lamps [Fig. 43], were made when he was still around. We never dared show a bumper as heavy as General Motors would use on a car, or use these great big grotesque hood ornaments—with big stripes on the hood, the Pontiac effect, and all that [Fig. 24]. He'd never go for that at all—no way. . . . The only reason we were able to make that postwar car as big and massive as we did was because of not having his objections. I knew what he would tolerate and what he wouldn't tolerate.

CEA He held you back from what you wanted to do?

BG Well, in a way, yes, and in a way, no. I always appreciated a certain amount of dignity in an automobile. Cleanness, clean lines.

CEA But the fact is, when Edsel wasn't there anymore, you went to these bolder shapes. Is that because you were trying to please someone else?

BG No. The trend was that way. You see the difference between the first Continentals, the '40 and '41 [Figs. 39, 40], and the '42 [Fig. 41]? Right in that period, between '40 and '41, Cadillac had a big, hefty, husky, bold appearance, you know. It had a great big front end, which I referred to as an architectural front end. It looked like the front end of the public library in Washington, with pillars. That is a term I don't think any automobile designers ever used, but a lot of that GM stuff was architectural. I wanted flow lines, motion lines, clean flow, graceful shapes. But we needed a huskier-looking front end. In other words, the Zephyr was getting bony looking [Fig. 37]. That was Edsel Ford's influence, the first two, three, four years of the Zephyr. See, he liked the slender, delicate effect. And I used to refer to it as bony. Well, he and I had some discussions on that. We never got into an argument over it. But, I mean, we tried to impress each other and pull each other's opinion one way or the other. We had to get a huskier front end.

CEA While we are on the subject, can you tell me about your role in the design of the original Zephyr?

BG You see, Briggs used to build a lot of Ford bodies, and Briggs had their own design section. John Tjaarda and Ralph Roberts, they more or less ran that over there. They would suggest ideas to Mr. Ford. They'd have him over there, and they would have a model, and so on and so forth. They had sold the idea of the Lincoln Zephyr to Edsel Ford—the construction of it and the tooling for it and all that. They did the basic body-design work for the Lincoln Zephyr. And, strangely enough, when they got around to the windshield, they couldn't do anything to satisfy Edsel Ford with the front end of the car. He called me up and told me to go over there one morning. This was along in February 1935. So I went over there, and I worked in there for about ten days with the Briggs people.[1] And I worked up a front end—you remember that thing with the fenders and the shelf down here [Fig. 37]. And that satisfied him. So it left Briggs off the hook. It was a little embarrassment to their designers and so on, but it didn't make any difference. They were glad to sell the whole package. That is how that came about.

 While I am on the subject, there is another interesting thing about that. That

front end looked like this [Fig. 37]: The fenders bowed in toward the center, and they were attached to a shelf; but the grille was very narrow at the bottom, and it pitched down at the bumper level. This was the front end on the Zephyr when it first came out in 1936. Now, the radiator core stood up inside. Looking through the grille, it was kind of tall and narrow. And the fan was on the end of the crankshaft in those days, and there was no fan belt or anything. So every time you went through a deep-flooded street, why, it would pull the damn fan into the radiator core. It would suck it in there and tear up the radiator core. Well, that wasn't the worst of it. Anyway, this car never cooled very well. You used to get complaints from out in Arizona and Texas in the summertime. It was hotter than hell out there.

So old Frank Johnson came to me one day. He was the old chief engineer of the Lincoln Division. He was an old boy who started out with Leland. I mean, he was an old granddaddy then, and I was just a kid. He said, "Bob, gee, we're having problems with this car cooling it." Out on the floor we had a chassis out there, and I looked at the thing. Here was the radiator core sticking way up. It was a skinny, tall thing, with a header tank way on the top of it, and the fan was way down near the crankshaft. I measured the depth of the core, and I sketched it and went back to my drafting place. And I said to one of my draftsmen, "Look, draw that damned core this way [horizontally]. Lay the core down like that [on its side]."

Then Mr. Ford came in after lunch, which he customarily did. And I said, "I have an idea, Mr. Ford." He was worried about this thing, too. He had been getting complaints from all over the country about cooling this thing. And I said, "I think we can get some air in here." So he said, "Let's get one fixed up. Just rough one out and put it down in the wind tunnel and see what happens." So we mounted a radiator core like this [horizontally]. And in connection with that, we just roughed out a sheet-metal front end, which went across and down. We just hammered it out—a rough, skinny sheet of tin, beaverboard, Masonite, or whatever we used. And, of course, the thing cooled beautifully.

All right. Then we turned around and modeled a front end based on these air openings. And that became the 1938 Lincoln [Zephyr] grille [Fig. 38], which was carried over into the Continental and so on [Fig. 39]. That caused them all to change. That was the style leader of that year. But no one realized why we did it, see. It was to get air to that damned thing [the radiator]. So after that, Buick and Packard and all the rest of them—all of General Motors—they started these low horizontal grilles [Fig. 32]. That was the beginning of this horizontal grille thing. But they never knew why we had to do this. What it did, it created a whole styling change in the American car.

CEA Can you tell me what was reused from the Zephyr [Fig. 37] and what was added in the Continental [Fig. 39]?

BG Well, what I did, I took a drawing of the Lincoln sedan—just a Zephyr sedan. Like so: The hood was way up here [pointing to a high hood]. It was a blueprint. I took a yellow crayon, and just for the hell of it, I sketched in a profile of an imaginary car. I lengthened the hood and put this little doodad on here [the back] with the idea of dropping the steering column—lengthening the steering

column out. But we needed a new, lower hood. We lowered the hood down about six inches.

This was just a one-off car for Edsel Ford, with no idea for building this for production at all. We frequently built a special car. I built a couple of them every year. But this was to send down to Hobe Sound, Florida, for him [Ford] to use down there. We used the standard grille, the standard front fender—except that the fender was pieced out. The door on the standard Zephyr was way up here [pointing above the Continental's doors].

CEA So you added an extension to it?

BG That is right. We pieced it out. And the idea was this. The floor level was already very low in this car due to the fact that it had chair-height seats. The floor plan was about six inches lower than in an ordinary car, so you had no chassis frame as such. You just had a skinny rail, and that already enabled us to sit lower in there. So then I made a little tenth-sized sketch of it—this blueprint with just a yellow crayon—and showed that to Mr. Ford when he came into the office.

CEA Did you cut down the fenders at all? Someone wrote that you actually cut four inches off the bottom of them.

BG No. That was about the base of the original Zephyr fender. There was a piece put in here [rear of the front fender].

CEA And the rear was a standard fender?

BG Yes. This is a standard fender on the rear. The door panel is new.

CEA Above the rear fender?

BG That is right. The windshield frame was cast like a custom body.

CEA And, of course, the hood?

BG That is right. I had a boy who was working for me, Gene Adams, and we made a little tenth-size scale bridge, a little modeling bridge, with a little scale on it. I had him glue that to a piece of Masonite—a piece of one-eighth-inch presswood—and just punched the profile out and put that on a band saw and sawed that out. So we had a profile right from the drawing that I had made. We set that up on the little scaling bridge and modeled the little car right there. Mr. Ford came in and said, "Let's build one right away." And that was the only drawing and the only model that was ever made of that car. So I turned that over to my head draftsman there, and he just made a rough paper draft of it. We sent it to the Lincoln plant and just built one of them up.

CEA Were there any changes from this mock-up Lincoln Continental to the one that went into production?

BG Practically none. There might have been an inch or two here or there for production. I think we made the trunk a little deeper. There were just a few minor changes, but [it was] practically the same.

CEA What did Edsel say when he saw it?

BG He went for it in a big way. But, strange to say, I never thought much of the Continental. I thought it was kind of weak in the rear end [Fig. 40]. I didn't care too much for the pinched-in rear end. Mr. Ford liked that, you know. He liked that gathered-in rear end. It reminded me a little bit of a dog with his tail between his legs.

CEA What would you have done if you had had your way?

BG Oh, I'd like to have a little firmer effect around the rear end of it there. . . . I never cared much for the Zephyr from the rear end.

CEA For the same reason?

BG Yes. I always said it looked kind of hungry. The bumper was a little too delicate. I liked a little more beef in the bumper. Of course, that [delicate bumper] is what Mr. Ford liked, and after all, I built it for him.

CEA So already this early—in the late thirties—you wanted things more beefy?

BG Yes, for sales, see, [given] our competition. If a man went to look at a Cadillac, for the same money it looked like twice the car as the Zephyr. It was full. You sat back there, and it had a big hood in front of it. It looked like a heavy car, and that is what people wanted. That is what they were paying more money for: the heavier cars.

CEA But Edsel didn't think so much of sales?

BG Well, he finally came around. I finally sold him on the idea of this front end on here [Fig. 41]. . . .

CEA I am interested in another well-known car, the '49 Ford [Figs. 61–63], and in the so-called competition models which you [Figs. 54, 55] and George Walker [Figs. 59, 60] proposed.

BG As you can see from the pictures, they were practically identical. That was a Policy Committee car, a formula car. Dimensionally, mine was practically the same as the one they built.

Anyway, the new Ford was more or less based on the 1946 Studebaker. What they did, they became panicky, and they thought that this car [Fig. 49] was too much car for a Ford, and this car [Fig. 43] was not enough. And so they bought a Studebaker [Fig. 57], one of those little double-ended Studebakers, because they thought that that was the ideal-sized car to have. So they took the headroom, the wheel-base, and established the shoulder room. In other words, we had to design around that. Ernie Breech, Harold Youngren, Bill James, and the Engineering Policy Committee considered that about the size car they wanted. They were afraid of too much weight in the car, overlooking the fact that the larger Ford [Fig. 49] would have reached higher and would have brought a better price. The all-new Ford, as they called it, was based on a Studebaker. They just simply had the Studebaker out there at the test track. They had it all measured up. It was practically a blueprint for the car, except for the skin on the outside. For all intents and purposes, these were basically the same cars.

CEA Any difference between your and Walker's model?

BG The only basic difference was that the other one had that spinner grille—that bull's-eye thing [Fig. 62]. Outside of the trim and the tail lamp and the grille, the car is almost identical: hood length, window height, shoulder width, body depth, and the overall width and the panel surface. The overall package was the same outside of trim. There was a little more shape in my car [Fig. 55], more like the modern cars. It tucks under a little, whereas his has a raw edge. The grille, of course, was subject to change. We had several versions.

CEA And the back [Fig. 55] seems to be projected and rounded off in a way similar to the production version [Fig. 63] and different from the one that Walker proposed [Fig. 60].

BG Yes, but you see the hood section and the fender depth all worked out to about the same on both cars. The formula was the same.

CEA Who helped you with your design?

BG Tom Hibbard and I did this design. The Design Department set up a model plate at the other end of the Engineering Lab, where Walker did the other one. I didn't have anything to do with it. I stayed out of there.

CEA Had you seen Holden Koto's model [Fig. 58] at all?

BG I had never heard of Mr. Koto. No, I hadn't seen it. There was some story about it being made in a basement that I read about.

CEA I am interested to know if there was any overlap between what was going on on your side and what was going on on the other side.

BG No, absolutely not. They borrowed a number of my men and equipment to model their car up.

CEA Why did you decide to have this straight slab?

BG It was a way you could build the car economically. They wanted the cheapest possible.

CEA The cheapest?

BG They wouldn't have put up with any offsets in the panels, or anything like that. It costs more money for dies and metal finishing. What they wanted was a basic bread-and-butter car, which is what resulted. And at that time almost anything would sell.

 What they wanted was a straight slab-sided car like the Studebaker. You can see the similarity between the two of them [Figs. 57, 55]. They are practically identical. It was a Policy Committee car. And, of course, in the Policy Committee, under Breech, they wouldn't have selected our car in the face of Walker's, inasmuch as Breech was sponsoring Walker's car. No way. Breech was running the company then.

CEA How did that transition in the company work?

BG Breech was running the company then, and as a result all design activity was placed under chassis engineering—a ten-year step backward. Due to these conditions, I decided to inform Mr. Ford that I was leaving the company. This was understandable, and my departure was mutually agreeable. After this I decided to retire to Florida, where I have lived for the past forty years and have been able to enjoy a lifelong interest in yachts and the sea.

 In spite of the chaotic Breech era, I have maintained friendly contact with the Ford Company. In fact, a few years ago, I was invited to Dearborn to be honored for the establishment of the company's first design department, where I directed all Ford design activity, working closely with Mr. Edsel Ford.

George Walker

GEORGE Walker is a controversial designer. As an outside design consultant on the first postwar Ford, Walker presented the winning competitive design, causing Bob Gregorie to lose his job; as outside consultant throughout the early fifties, Walker also caused the Ford in-house designers endless grief—at least according to Hershey, who was then director of styling. In 1956 Walker became vice-president of Ford, and Hershey immediately left. Walker held this position until he retired in 1962.

Walker's unusual background for a car designer may explain some of the animosity directed against him by other designers. Unlike the GM stylist, who is expected, in the language of the industry, to have gasoline in his veins, Walker's interests are not monomaniacal. He brings a broad artistic training and years of experience as a salesman to car design. Walker began as a student at the Cleveland School of Art and moved to the West Coast as a fashion illustrator for prestigious department stores. He also designed and sold automobile paraphernalia. He tells the story of arriving at Ford to sell his merchandise. The chief engineer made fun of him when he set up his metal door grabs and window cranks on a beautiful piece of black velvet. The engineer reminded him that Henry Ford detested that kind of glossy presentation, but Walker carried the day as Old Henry, attracted by the display, stopped by his table and bought his wares. From everyone's account, including his own, Walker was an excellent salesman.[1]

Walker stands out in fact and in his own mind as a different kind of car designer. He is an adamant salesman, proud of his "associations" and convinced of the importance of contacts in selling art ideas. He speaks intensely and directly in staccato bursts of words, with few secondary clauses. He is a powerful force, even more primal than Earl, by all accounts. Yet, almost in contradiction, and certainly in distinction to most car designers, he is art-oriented. As he puts it, with the pride of the poor and the blood of an Indian, he was given artistic freedom. Sure of his taste and the rightness of his judgment, Walker refers to himself as a doctor selling artistic advice.

When it comes to the specifics of his visual advice, Walker comes across on three levels. With his independence and jocular approach, he is a good "new directions" man—a confident, well-prepared salesman of novel concepts. Believing that artistic ideas and execution have no beginning and end, he organizes design as a group practice. He thinks of himself as a coordinator of talent, with an eye for style. On the personal level, as a figure drawer he is attracted to finish and detail, and his remarkable memory allows him to recall precisely designs he worked on fifty years ago.

Before assuming the vice-presidency at Ford, Walker directed one of the largest industrial-design firms in the nation, and his clients included Westclox, International Harvester, and Nash. His high-flown and persuasive manner is typical of pioneers like Raymond Loewy, who, along with Walker and a handful of others, founded the profession of industrial design. A former semi-professional football player, Walker at eighty is burly and as personable as you would expect someone with his background to be. He lives in a guarded golf-course compound near Tucson, and almost every day he paints heads of beautiful Indian women.

The interview is excerpted from a lengthy (and rambling) lunch conversation at his home and country club, where he seemed to know everyone, and where everyone seemed to like this jovial and powerful old man. His account of the creation of the 1949 Ford (Figs. 61–63) should be set against those of Bob Gregorie and Frank Hershey and my own reconstruction of events in Chapter 4.

GW I first went to the Otis Institute in Los Angeles in 1916. Then I went to the Cleveland School of Art and back to Los Angeles. I didn't graduate because I took a special course in illustrating and figures. I specialized.

CEA You didn't have three-dimensional model training?

GW Oh sure. Yes, I did. I had the full art training, including sculpturing, jewelry-making, antiques—everything.

CEA Did you know that you wanted to be an industrial designer?

GW I didn't have any idea. But I had done some illustrations.

CEA But that was a strange thing for a person to want to do in those days. How did you get on that track?

GW It was principally because I liked figures. I knew anatomy from one end to another, and that was easy. The path of least resistance, I guess.

CEA Given your background, how do you think you got interested in anatomy and fashion?

GW Well, I'm part Cherokee Indian. They say that the only creative thing for an Indian was art. It may have been from that. I don't know.

CEA Do you remember as a kid, did you doodle?

GW Yes, I went to Paramount School in Cleveland. I remember making a drawing. I wasn't more than ten years old. From then on the kids wanted me to draw for them. I even did the teacher. They must have liked it. And I still have that knack of drawing people. I am charged more tablecloths for drawing on them and ruining them. . . . It is something you can do and the other guy can't do. You are not trying to upstage the other guy. You just do it.

CEA How did an artist-designer like you work his way into the car industry?

GW During that time, just before Harley Earl got there, things were done by hacks. Engineering hack-designers. The engineer would do it, and then turn the idea over to the illustrator, whom he told to "Do this and that." Then the illustrator would get credit for it, and that made the engineer angry. After that the designer became the czar. He got a lot of publicity. If management came in, and the designer was there, the management would talk to him because management thought he designed it. And he was advertised and publicized. The artist was something different. He was a different breed of cat.

CEA Didn't management object to the new power of the designer?

GW Not always. When I went with Ford, that was one of the things Henry [II] said to me: "George, I want you to run this styling like your own business. And don't you let anybody ever tell you what to do, even me!" And I did that. I didn't do it to be smart-alecky. I didn't have to, even though I was dealing with the boss. One time when we were designing Nashes, I assigned a fellow by the name of Ted Ornis, who was a very good boy, to the account. Ted was a meek guy, and he told me, "Mr. Mason," who was then president of Nash, "said this and that." And I said, "Don't let him tell you what to do, even if he is the boss. Tell him to come talk to *me*. He may have more money than you, but you have an art education, and that is why they hired you. You are the doctor. Don't forget that. He can't tell you what kind of medicine to use. You can." So after that, it changed the guy all around. He went out there a different man. And that is what I did all my life. I did it because I knew my profession.

CEA Why hasn't the car designer received the recognition given to other commercial artists?

GW I'll tell you why. Because the average automobile designer did nothing but design automobiles and *he stayed away from the arts*. I fortunately did it the other way. I did everything. . . . But it wasn't easy. The first time I designed for Ford Motor Company, I was designing automobile *hardware*. I took my wares to Ford. Joe Galamb at that time was chief engineer, and he said to me, "Take dat stuff and pud it right ter on the big, long table." And I said, "I won't do that," and he said, "Mr. Ford wants it that way." I said, "He is your boss, but he is not my boss!" Joe said, "You got to put it on this table," and I said, "To hell with that," and I pulled out a big piece of black velvet. I put this black velvet on the table, and I placed my hardware (all the doorknobs and everything) on it. I had it all lined up. And he said, "He won't like it. He won't like it."

Anyway, Mr. Ford came by, and our competitors had their products all lined up on this big table. This was Hardware Day at Ford. Mr. Ford walked right up to my black velvet and said, "That's it. That is what I want." I wasn't right there because I was in the lobby (they didn't like it if you stayed there). Joe Galamb then came over and said, "Mr. Walker, I tell you, it is a funny thing. I never thought he would do it." I said, "Look, he appreciates it [art], but he has been fighting it all through his life. But it is inherent in him. He didn't want that because he is an inventor and an engineer. He didn't believe in art, like most engineers didn't."

I had a similar experience with Henry Ford later on. When Jack Davis was sales manager at Ford, he had a big party, and he said, "George, Edsel Ford is the boss of all styling. You can't break that. But why don't you come out and bring a portfolio. I'll see if the Old Man (they called Henry the Old Man) will look at it." In those days they had offices across from the rotunda, near where the Greenfield Village Car Museum is today. They had all these space partitions, and I sat way down at the end. I made a portfolio, about the size of a small table, of all modern designs—hardware, air-conditioning, panels, and the like. I spent about seven thousand dollars of my own. At that time, it was a lot of money. I made it with a plastic cover. I was so proud of it. I worked a lot of time on those sketches. They were modern. They were fresh.

So I looked down the hall, and I could see the old gentleman coming up. Jack Davis opened the book, and then Mr. Ford opened the book. It fell on the floor! It spread all over! Mr. Ford walked right over my drawings and walked out. Jack Davis said, "You know, Mr. Ford hates anything unfunctional: Your book was unfunctional." I said, "ay-ay-ay." I learned never to make an unfunctional thing and show it to a man like Ford.

CEA How did you eventually get involved with Ford on the '49 model?

GW When we went to the Ford Motor Company, I took the two best men who were automobile men [Joseph Oros and Elwood Engel] from my office, which was an industrial-design office. They had worked with me in the Nash era, when we had the Nash automobile account.

CEA When did your office design the Nash?

GW '37 to '45. Both of them before that had gone to General Motors' Art and Colour Division, so they had a good smattering of design. Engel was from Pratt, and Oros from the Cleveland School of Art. They heard that I was about the only one around Detroit who was doing industrial design, and they wanted to get into that. They were two very, very efficient young men. They gave us a project, Ford did, in 1945, to design a car for them that would be the postwar car, "postwar" meaning Ford didn't have any new design. They had their old design, but it was a very ordinary car. They called me out to Ford Motor Company—to meet with Henry [Ford II] and [Ernest] Breech. Breech was my very close friend. Young Henry I didn't know, except by name. I looked at their car that they had ready to design, or to put out on the market, and I said, "You can't go out with that. You'll go broke." It wasn't a good-looking car.

CEA I went through the Ford Archives and came up with this photograph of a clay model, done in 1945 [Fig. 49]. Is this the one you saw?

GW That was it. That was the one we saw. They finally made it into a Mercury [Fig. 50].

CEA So Breech showed you this. Was he dissatisfied with it, too?

GW Oh yes. He said it was terrible.

CEA Did he say why it was terrible?

GW Well, he asked me what I thought of it because that was my business—styling. I said, "You'll go broke if you ever put it on the market." He said, "Can you do better?" I said, "I could do better than that with my eyes closed." But I said I couldn't do it, "because I already have Nash automobile and I have International Harvester with very good rights." "Well," he said, "we would certainly make it well worth your while if you'd do it." I said, "I would have to get out of my contracts, and I don't know whether I would want to or not." I was very independent. Anyway, I went back to Nash as well as International Harvester over in Chicago and told them what I would like to do—to get out of my contract and design a car for the Ford Motor Company.

CEA And did Mr. Breech set you any kind of objectives—for example, for the car to feel like this or that?

GW No, no. They needed a car badly. They were late in coming out with a car, and timing is all important. Therefore, we got out of our contract. I said, "We will do this job if you and your boys will go down and look at it. Not me going down there, but you coming down to my office (right across from the Fisher Building) to see what we do as it progresses." We progressed to a point. We made a clay model to quarter-size [Fig. 58]; we made it to full-size out at the Ford Motor Company [Figs. 59, 60].

CEA This was when?

GW 1945.

CEA Can you remember what you did, how you designed at Ford?

GW Well, when you design a car and you have your men, you yourself dictate to a certain extent, but give leeway to young designers. I always said, "Go ahead, do whatever you want." Then I would come up and say, "Oh, that has a good front end" or "That is lousy—put that aside" or "The back end is good on this one." And that is what we would do.

CEA Would you, as director, deal directly with these young men, or would you have intermediaries?

GW We had intermediaries, but I was different. I dealt personally with all these men.

CEA One of the things that is so difficult from the point of view of people who are interested in art history is that car design is often a give and take. At times there is not one person who does everything.

GW I always said that. We had nine hundred craftsmen when I was at Ford Motor Company. I helped them. But because I was vice-president during that time I got credit for it.

CEA My purpose is to find out as much as possible where the influences are coming from and who is doing what.

GW "As much as possible" would be the man who is at the head of it.

CEA I know it was forty or fifty years ago, but what I would like you to do is to try to remember those design decisions. Perhaps with a picture of the '49 Ford, you can

say, "This happened there, and then. . ." For example, in one instance, you added an airplane spinner to the grille while the model was in progress. Now, that was a design decision. . . .

GW Do you know what happened with the front end of the car [Figs. 59, 62]? Well, we wanted to sell that job [the spinner grille, which I thought of as] a motor on a plane, with two wings on the side.

CEA Sell it to the board of directors?

GW Yes. And so we had all our sketches, just of the front end, on the board.

CEA To whom were you selling?

GW To what they called the design staff—Mr. Ford, Mr. Breech, the sales manager, and the chief engineer—they were all on that committee. So a couple of hours beforehand, we had these sketches out on the board and were trying to sell the idea. We liked it because it was different. It was different. We wanted this. Breech brought along a great singer, James Melton, who collected old-time cars. And I said to him, "Here is the one we are trying to sell." So during the time we were looking, this guy walks up, just as we started to sell. And he said, "Oh, look at this. This looks like a modern airplane." Mr. Breech said, "We all like that, too." None of them liked it at first. They thought it wasn't like the average car.

CEA So it was basically this old singer who got you in?

GW He got this OK'd. It was just one of those things.

CEA And on the inside, the dash looks a lot like it.

GW Yes, on the interior, we imitated this grille. We just picked up the theme.

CEA Tell me a little bit about the theme. What does a theme mean to you?

GW Well, the theme was that we were intrigued with an airplane from the front end, by seeing the front. We felt that it was something new. On the inside, it was just an ordinary inside, but we thought we would put a motif, from the front end, inside. It was that simple.

CEA Another design decision was the change in the rear taillight from vertical [Fig. 60] to horizontal [Fig. 63] on the model.

GW Those taillights. I didn't like those taillights. One day we started putting them [horizontally] to see how they looked the other way. I said, "Well, let's do it this way. We'll just try it." So when the next model came along, we decided to put the taillight in. And then Breech said, "I thought you wanted them to go along with the front, and that's why you did the taillights that way [vertically]." I said, "Yes, but that is why we had so many differentiations. So let's do it the other way." He OK'd it.

CEA What about the forms that you added to the sides of the horizontal taillights [Fig. 61]? What were you trying to do by flaring the lights out?

GW Well, the highlight line is the top [of the fender] next to the window in the back, and it needed relief [Fig. 60]. It was naked back there. It needed a relief. So as the highlight line came back [around], it had to have a break or something to make it look more important.

CEA Did that extra protrusion on the side relate to the horizontal shape of the new light you chose?

GW No, not particularly.

CEA Because this shape—

GW We had to have that. If it weren't for that on the side, it [the light] would have just been floating in the air. It wouldn't have been good. It had to be important somewhere along the line to fill that in.

CEA So the design decision first was to interrupt the highlight line?

GW Yes, to get the highlight line.

CEA And once you made that decision, then you went to this shape of a taillight?

GW That is right. You had to have something of importance. This was important. The other wasn't important.

CEA All right. One thing I like about the car is where the cut lines or seams come in relation to the design. I sense a wonderful touch when I look at that [Figs. 62, 63]. The cut lines around the doors, trunk, and hood enhance the whole design.

GW When you have a clay model, you study it to see what is going to be the best way for the door to open. You start fooling around, and you start all over again. And you do about twenty of these before you get what you like to have—a good continuity line.

CEA Would the line above the trunk be an example of a good continuity line?

GW Yes, that's right.

CEA The roof is smooth, without any interruption in back, but in the front it has a peak [Fig. 61]. Is that one of the subtleties of this car?

GW The peak dies off.

CEA Exactly. Why was the decision made to do that?

GW To make it look better. If you had the peak running along the back, it would all look the same.

CEA Why did you think it looked better?

GW See, when you started to "die it off," that streak blended into the body. A sense of design. I should add that [in these design decisions] you have to work in strict collaboration with engineering, management, advertising, and all the people who are connected with the automobile business. It isn't just one person. . . . Well, fortunately we liked everybody. We knew everybody in town.

Bill Porter

EVEN if you didn't know that Bill Porter (Fig. 105) created the successful Firebird and the '85 Buick Electra (Fig. 112), you would sense his design interests as soon as he directs you to his home. He describes his suburban Detroit house as the only one on the block with black columns. "Actually, everybody mistakes them for black, but they are really dark green." This thin, delicate, and precise man discovered the original hue of his 1904 house and furnished the interior with turn-of-the-century Craftsman furniture. Also an intense, enthusiastic, and joyful individual, Porter got so carried away with the idea of complementing the house with historic fixtures that today he has no space left, and he stores most furniture, including some of the best Gustav Stickley pieces, in a room over the garage.

Car designers almost always are car crazy, in a positive sense, but very few who reach the top have any awareness of the other arts. Not only is Porter aware of the history of modern design and of the place of cars in it, but he also talks about his designs with the vocabulary usually reserved for painting, sculpture, and architecture. Porter earned a degree in painting from the University of Louisville and teaches the history of modern design at the Center for Creative Studies in Detroit. How he operates as a chief designer at GM, where "artists" are tradition-ally looked down upon, is an interesting question—and such a politically loaded one that I finally felt I could not ask it. But I think that he implies an answer when he says that success is survival at General Motors. Perhaps he has learned to

downplay himself on the job and carefully to mask the arty parts of his personality. His home attire of contemporary Italian casual clothes, for example, is an interesting complement to his working costume of an inconspicuous tweed jacket. It is not a subtle Harris tweed, but the pedantic American kind, and it may afford him some degree of anonymity on the job. A creative talent with a reflective, powerful intelligence, he was rescued from Bill Mitchell's disfavor by Irv Rybicki, who has given him independence. Porter has happily responded by adapting himself to the GM team concept.

As he searches within himself, Porter reveals an unusual combination of self-assurance and openness to question. Certainly, Porter's awareness of his own ability does not detract from his willingness to meet you on your terms. He responds patiently, and if distracted by a follow-up query, he deals with it precisely but never fails to give a thoughtful reply to the original question. Many designers who are not verbally skilled resist the pointed inquiry or answer it with a routine response, but Porter loves a probing question, and maneuvers around it with finesse. Despite his tendency to subtly qualify his responses with an outpouring of learning, he avoids tedium by a combination of intellectual depth, romantic glee, and teutonic rigor.

There is another side to Porter's openness and interest in education. Porter respects others, and he has learned, and is aware of having learned, from the past. He is conscious of the debt he owes to his teachers in the industry, and he singles out two persons in particular: Jack Humbert, the first chief designer under whom he worked, who taught him line refinement; and Norman James, who tutored him in the fusion of art and technology. He even acknowledges the important sources of his own creative contributions. By shuttling designs back and forth between an old-time modeler and an orthographic draftsman, he worked out his own rich vocabulary of forms in the Design Development Studio at GM. There he learned to respect the interaction between precisely conceived ideas on paper and sensitively realized sculptural values in the model.

Porter thinks of himself as an international artist trying to find an original expression within his American heritage. He knowingly takes from Earl's system of precise orthographics, and yet, as a leader of a new generation of Americans, he rejects the "ten-word vocabulary" of Earl's rigid highlight system. He searches for added visual complexity, having discovered during the sixties "a richer vocabulary" based on subtly changing conic sections. Especially important to him are the aesthetics of visual transition, and he researches "evolving" form, correspondence, analogy, discontinuity, and particularly curve life (what he calls "spring") within changing shapes. He also looks for suggestive metaphors and harmonies in these visual intricacies. Porter is a man whose language is dominated by two words: For him, the conscious search for the "exquisite" should produce the hidden satisfaction of the "subliminal." Ask him to explain what he is driving at with a form, and he responds with a metaphor expressing the unconscious "imaging" he hopes to

achieve. As a by-product of his effort to explain his aesthetics fully, Porter reveals many important technical styling secrets.

His interest in aesthetic nuance does not mean that he is without an appreciation of function and construction. Like others who attended Pratt in the fifties, his artistic "struggle" takes place in the mind and has little to do with subjective groping on paper. When he describes his cars, he endeavors to relate their shapes to material, construction, and function. In fact, he calls the "fusion" of technology and art more than a personal interest, a "missionary" compulsion. Porter says he studied for his Pratt M.A. to understand industrial manufacturing processes, not to help him aesthetically as an artist, and he joined GM with a zeal to change technology from its superficial and symbolic role in styling in the fifties to an integral part of design.

But make no mistake: Porter consciously uses and thinks of art as part of his creative process, and he discusses cars in the language of art. He uses Mondrian to explain the matrix of "universal" forms in Firebird III, and he calls on Eames, not Saarinen, to illuminate the spoiler on his Electra. While tipping his hat to the anonymous GM system and acknowledging the many types and levels of influence on him, Porter is drawn instinctively to the design approach that leaves total control in one designer's hands—his own. He believes that by working with multiple media in full scale, he is able to achieve degrees of artistic expression impossible in traditional arts like architecture. I played devil's advocate at one point before the taping, and I asked him why he could not hire someone who was not skilled graphically. I gave the analogy of Philip Johnson, who is not known for his drawing or modeling skills, but who is admired as one of the leading architectural designers. Porter responded by telling me to look at Johnson's buildings: Do they really have the subtlety of form of a good car design?

Following up his question, I suppose that it is fair to ask whether Johnson brings the same abilities as Porter to his craft. Porter and Johnson are both eclectics, and both knowingly seek new richness and complexity in their vocabulary and references. In addition, however, Porter fuses art and technology, adds levels of conscious and unconscious meaning, infinitely adjusts linear and sculptural relationships, and, in the end, makes it all look so uncomplicated. Maybe what he leaves out makes the biggest difference. Despite all he says, Porter speaks through his hands, and he will be remembered for creating deft classics, simple and harmonious in their form.

CEA You were one of the few designers who worked with Norman James [Fig. 100], who did the chassis and the exterior of the Firebird III [Figs. 101–104].

BP Yes, the Firebird III was created by a sort of brain trust, a high-tech group of engineers and designers whom Harley Earl took on at Styling during his last years before retirement. Bob McLean [later identified with the DeLorean automobile], an intensely progressive engineer, had come from the newly formed Industrial

Design Department at Stanford.[1] During this period Earl also hired Dr. Peter Kyropoulis from Cal Tech, whom he made technical director for all of Styling Staff. Stefan Habsburg, a recent graduate of MIT and a protégé of John Arnold, the "creativity" guru, was on the team, and a brilliant young designer from Pratt named Norm James. James actually was the designer. Habsburg had a hand in the conception of the Firebird III, but he and the others were primarily thinkers and technologists who, you might say, both shielded James from the politics of the place and at the same time supported him, fed him information, and brought the most sophisticated technological savvy to his work. In my opinion James had a tremendous talent for expressing the absolute leading edge of technology by means of stunningly beautiful forms—dangerously close to the edge of acceptability. His mind apparently roamed the fields of both aesthetics and technology with equal ease. His was one of those fusing kinds of minds, and I know that he was profoundly absorbed with design methodologies as well as with aesthetic problems such as coherence, balance, and consistency in his designs.

The series of Firebird show cars done under McLean's direction ended after Firebird III and Harley Earl's retirement. At first glance it had the aspect of a jet fighter plane on land, with double-bubble canopies and a brace of fins. There were two engines in it. The primary engine was a regenerative turbine developed by GM research labs. An auxiliary engine powered all the accessories, including a computer-controlled central hydraulic system through which all movements of the vehicle—including throttle, braking, and suspension—took place. The driver's control of the system was through a central stick, pushed forward to make the car accelerate, back for braking, right for right turn, etc. The car was also a showcase for early computer applications and was packed with the bulky "black box" and colorful wiring identified with the state of the art at that time.

CEA You said before in conversation that Earl was very interested in technology and that he thought in the long term about associating himself with intellectuals and thinkers.

BP Someone who knew Earl better than I made the observation that in his last years he was trying to legitimatize Styling Staff, to marry styling with technology by hiring people like Kyropoulis and McLean who could talk the same language as the engineering intellectuals in GM's Research Staff. Significantly, Bob McLean's studio, where the Firebird show cars were created, was named the Styling Staff Research Studio. The name set it apart from the other advanced studios, where most of the other show cars were done. Stefan Habsburg was his assistant, and, of course, Norm James was there.

By the time I actually was transferred into the Research Studio, the Firebird III had been finished for some time. The entire design of both the interior and exterior was done by Norm James, with Stefan's input and support, of course. For one designer, it is a remarkable achievement to be able to work on all those levels—and so brilliantly. One time Norm and I were talking, and on the back of an envelope he explained some of the geometry—almost constructivist geometry—that he worked out to give order to the forms of the car. In spite of the wild fins you sense that there is underlying order. Do you have a pad? [He begins to draw; Fig. 103].

In side view the upper fins actually radiate backward on a series of axes which

splay from a point below the ground at the front of the car. Other elements of the design also conform to these axes. For instance, the axes require that the bubble canopies lean backward [Fig. 101]—the reverse of the familiar teardrop shape. A similar arrangement of splayed axes focusing above the front of the car governs the lower fins.

Looking down on the car reveals a related pattern of splayed axes, like shock waves fanning out and back from a point at the center of the nose. Door and panel cuts [Fig. 100] obey these axes, while the doors hinge on other, hidden axes in elegant opposition. When closed, the door panels reach over and partially down around the seated passengers, and when open they leave vacant a complex volume of space swept by the human figure upon entry and exit. The Research Studio was very much on top of the new field of human engineering (ergonomics), and James was working beyond the accepted static-dimensioning approach into new kinetic solutions.

But the core of James's geometry has to be seen in front view, cross section. He positioned the seated torsos of both driver and passenger inside two squares adjacent to either side of the vehicle center-line [Fig. 104]. Passing diagonals through these squares locates the centers of gravity of the occupants (approximately inside the navels), and extending these diagonals beyond the squares sets up the slant of the upper and lower outboard fins.

Thus the occupants of the vehicle are at the center of an incredible construct of invisible axes or force lines that is the invisible skeleton of the design. In many Frank Lloyd Wright houses, you sense that the house is part of a network of planes that stretches out to infinity, and he has just hardened up a certain portion of this system, made visible as the major lines of the house. Or, in a Mondrian painting, lines and color planes exist as part of a space lattice that extends to infinity beyond the frame. Well, Norm built his space web of force lines into which he molded the forms and surfaces of his Firebird III. If you look, say, at Stan Parker's 1959 Buick, you can see kindred thinking in a production car.

CEA You were saying before that James had a phenomenal influence on the generation of designers who were passing through GM.

BP Well, I think he did. While they may not have had a chance to talk with Norman as I did (I don't think he talked about it very much), there was a sense of that car being there. You could hardly help but be influenced by the force of ideas that were that cogent and distilled: When you see the car, you don't have to have it explained very much. The thoughts that were in the air at that time were jet planes and technology, and Norm was giving other young designers a steel-girder frame to hang these ideas on.

CEA How was it that you were so close to James?

BP I worked with him in the same studio. When I started at GM in 1957, I spent two months as a summer student designer in a studio called Design Development which functioned as a training studio for new designers. Sometime after I returned to Design Development Studio as a full-time employee in 1958, Mr. Earl expanded Bob McLean's empire [from Research Studio] to include Design Development as well as another studio, called Preliminary Design. By 1959 I was working in the Research Studio with Norm and then in Preliminary Design right

next door. Norm and I worked back and forth in both studios together, so although Norm was a very private, introspective person, I got to know his ideas very well.

CEA Was it normal that beginning designers were put in this experimental studio?

BP No. Usually new designers went from Design Development to one of the advanced or, more rarely, production studios. I was fortunate to have the Research Studio experience. McLean came through the Design Development Studio, liked some of my designs, and said, "I'll get you over to Research Studio, kid."

CEA And did you stay in this studio with Norm James until he left?

BP Well, not exactly. It didn't work quite that simply. After I had been in Research Studio a while it began to falter, as did Preliminary Design. There were any number of interesting projects going on, but it seemed that they were getting no recognition. At any rate, near the end Norm was transferred to another advanced studio, outside McLean's area, and I remained in Preliminary Design, which was removed from McLean's jurisdiction. By about 1960, Norm transferred to Santa Barbara to work on a moon-landing-vehicle study out there. It was still General Motors, but it was totally out from under Styling. Some time later I heard that he had left the corporation.

CEA Did you feel that your design was very much affected by him? In our conversation before, you described your teachers at Pratt as pleading with you not to accept a job in the auto industry, which they saw as a corruptor and possibly a destroyer of design talent. You said that you resisted because you saw your role as a missionary who sets out to improve design. Did you get a new kind of religion once you met Norm James?

BP I am not sure whether or not he influenced me. We pretty much had strong ideas—each his own—and while in retrospect they probably were very, very similar, at the time they seemed to us to be quite different.

CEA What were your ideas? Were they straight Pratt ideas?

BP Not at all. They had more to do with the fusion of technology and design. Both of us were intensely interested in that, but it manifested itself in different ways. I was trying to move away from what I perceived were just the superficial symbols of aircraft in automobile designs. In 1959 I was busy in my spare time completing my master's thesis for Pratt, "The Aircraft Image in American Automobile Design, 1933–1959." Aircraft-shaped hood ornaments and the like, as well as the rockets and wings used in automobile body forms, seemed to me to have evolved into a corny symbolism. I was interested in exploring more profound fusions of technology and design, and certainly Norm was dedicated to that and had done so.

One of the problems that the whole era suffered from—certainly, in retrospect, even Norm's approach as well as my own—was that, really, the analogies between the automobile and aircraft only go so far. When you look at the Firebird III in hard, cold terms, you see that this immense vehicle only carries two people. It has tremendous power and even a second engine to power its auxiliary features, and you realize that it has left reality and become essentially a romantic object. But it is a romanticism that is based on the fusion of technology and aesthetics. It is very hard to regain the naiveté of that era.

CEA But what about the romance and you? Did you not accept the romance as much as he did?

BP Well, I probably wasn't quite as taken in with it. I remember making the remark once to Bob McLean that the Firebird was, after all, a ridiculous way to move two people from point A to point B. I remember he got very angry, [and] he just brushed it aside as if I had missed the whole point of the Firebird's *theater*. He didn't want to hear anything negative, and I didn't really want to be negative about it, either. One side of my brain said, "This vehicle is ridiculous and so is the need for its theatricality." On the other side, my brain understood the genius with which this great romantic thing was constructed. The integrity with which it was constructed was, in itself, exquisite and well worth doing. Its fusion of technology and art was thoroughgoing and on the leading edge of the technology.

 The vehicle is still around—or it was a few years ago—and it is awesome, absolutely awesome to behold, even today. It is just gorgeous. I have very mixed feelings about it.

CEA I am interested in a number of things. One is how you see yourself as coming out of an East Coast training, which seems to me was somewhat different from others of your generation, and then how you went on and expressed yourself as a designer, full of your own ideas, after your apprenticeship period at GM.

BP I never really thought of Pratt as a training ground. I already had an undergraduate degree in painting from Louisville, and I had already been in the Army for two years. I went to Pratt because I thought it might help me pick up the veneer or polish that I felt the industry required to hire me. Inwardly, I felt that I was a complete adult designer-artist by the time I went there. I went to Pratt for their engineering courses like Materials and Methods, where you learn about stamping, impact extrusion, and all the technical things you need to know to design a decent product of any kind. I didn't go to Pratt to mature or grow up as an artist or to become trained as a designer, although the New York environment surely had some effect on me in all those ways. But I already kind of knew what I wanted to do, and I already had a little of the missionary bent when I went there.

CEA To what extent were you able to use your missionary bent once you became mainstreamed at GM?

BP Well, I think gradually you find that if you can manage to hang around long enough, and if you survive, the situation that you went in with alters through time and circumstance, and then you become one of the people who are doing the very designs that were being done differently from the way you wanted earlier. And, ultimately, if you happen to land in the right place at the right time, you can influence events in a way that is consistent with your own underlying ideas. And this, of course, is what you really need to do.

CEA What was your next step after the breakup of the Research Studio?

BP I went through a number of lighter time-frame jobs. And, frankly, I was inwardly relieved to dissociate myself from the Research group. Increasingly I had come to feel that, while the philosophy and the methodologies of the Research Studio were great, there was an element of elitism and disdain for production-studio work that was not in the long run parallel to my goals. Perhaps because of my Bible Belt upbringing I felt that it was somehow more important in the overall

scheme of things to make even a small contribution to improving the design of, say, a Chevrolet than to do a remote sports car that would probably have little real impact on the American scene. This although I had long been a member of the *Road & Track* persuasion and a true admirer of many European cars.

As it turned out, I was next involved in a couple of small advanced-studio projects, and then I was transferred to Pontiac Production Studio. I found myself working for Jack Humbert, whom I thought a lot of. Pontiac was my first production-studio experience, and I worked in there for a couple of years, from '60 to '61.

CEA Can I flag you down here? Was it normal in that period to apprentice through a nonproduction studio? Was that how they broke off the rough edges of entering designers without risking production models?

BP Yes. New automobile designers coming in usually worked in a studio called Design Development, which was a training studio. They also had a program where they trained modelers and so-called tech stylists (engineer-draftsmen) at the same time in the studio. Little work projects were set up, and you got a kind of a microcosm of what a real studio was going to be like. It also gave management a chance to observe you and to see where your talents were.

CEA But you were sucked up right away into the Research Studio?

BP No, I was in Design Development Studio for quite a few months before Bob McLean got me over into his Research Studio. I was there a year or so, fortunately with Norm James. Following that I was briefly in a preliminary design and advanced studio, then into Pontiac Production Studio. Then I was sent back to an advanced studio, from which I got promoted and became Bernie Smith's assistant in a totally reorganized preliminary design studio.

By 1963 I was put in charge of Design Development Studio, where I became a teacher of new designers. I loved the work, visiting schools, becoming acquainted with design education programs across the country, and, of course, recruiting and training new designers. I soon came to believe that what the new automobile designers needed most was sharpened abilities to visualize and work with three-dimensional form and space. In charge of training new modelers at this time was Davis P. Rossi, one of the finest modelers the industry has ever had. So I naturally tried to set up design exercise projects to take advantage of this.

It was also during this period that I began to get a handle on some ideas for expanding the vocabulary of automotive forms and surfaces available to the designer. The vocabulary of simplified aircraft shapes was growing stale and seemed too restrictive for the potential richness of expression possible in a product as complex as an automobile. Some of the brighter new designers in the studio caught on to this, and fortunately I occasionally found time to do my own stretching exercises.

Such was the dragster project [Fig. 106]. The engineering layout was done by Dick Lins, an engineer and dragster enthusiast who worked for Kent Kelly, GM's noted aerodynamicist. Kelly himself contributed many key ideas to what was then a very unorthodox—indeed, revolutionary—layout for a dragster. I did the body, and since it incorporated so many unusual forms, I surface developed it first on paper, just for the exercise. Then Dave Rossi modeled it. The body shell repre-

sents a skintight accommodation of human, structural, and mechanical elements expressed as clearly as possible in a form vocabulary that includes parabolic, conical, and subtle bulging ogee forms intersecting in various ways oblique to the long axis of the vehicle. This is a long way from Harley Earl's highlight rules.

Some interesting features of the car: The jacketed front wheels help steer aerodynamically as rudders; the twin parabolas on the nose house the torsion-bar front suspension; the driver is reclined just in front of the roll bar indicated by panel cuts; and the open rear houses the parachute pack. Disappointingly, as the scale model was being rushed to completion, management announced GM's withdrawal from all racing activity. The project was dead, instantly.

Moving on, after about two years in Design Development Studio I became chief designer of Advanced Two Studio and from there moved into the Chevrolet and Pontiac production studios. I became chief designer of the Pontiac Production Studio in 1968.

CEA So 1968 was the first year that you got your hand—

BP —on production cars and was in charge of the design of them. I probably got chosen for Pontiac because I had originated the design theme of the '68 GTO [Fig. 107] while I was in Advanced Two. It had very subtle bulging forms over the wheels, which was kind of a pioneer thing, and they were modeled as if they were being stretched out of the background surface. The background surfaces— the paddlelike sides of the car—are themselves part of an overall monocoque shell surface that includes the roof, connecting through the sail panels. Perhaps I should mention that the '68 GTO body side scheme was a visual relative of the so-called coke-bottle body sides (inspired by area rule jet aircraft fuselages) that I and other designers had been playing with since 1958.

The final design of the front and rear of the GTO was done by Jack Humbert's Pontiac Production Studio. The front end of the GTO was the first production use of the Endura bumper material (tough plastic cast over steel and painted body color), which allowed Humbert to complete the body forms in a perfectly clean way without providing chrome bumpers or the large offsets later required by federal regulations.

It was quite a while after working on the '68 GTO theme—in fact, it was after the '70 GTO theme (also done in Advanced Two) had gone to Humbert—that I was transferred. I went first to the Chevrolet One Studio for three months, just as a kind of quick break-in, under Dave Holls, who was promoted to be in charge of both Chevy studios (Chevrolet Two being run by Henry Haga). Shortly after-wards I was put in charge of Pontiac studio. And it was there that I got the chance to do the 1970½ Firebird [Figs. 108, 109]. Actually, I still worked for Jack Humbert because he was promoted too—put in charge of a couple of production studios, one of which was Pontiac. As I recall, Jack reported to Irv Rybicki, who was Bill Mitchell's assistant in charge of all automotive design. Bill Mitchell was the boss. And he was very much in evidence. But Humbert couldn't tear himself away from his old familiar Pontiac studio, so I felt I worked immediately for him.

CEA What were Jack Humbert's qualities as a designer?

BP Jack was wonderful at executing designs. By that I mean he had an eye for the exquisite registry of lines. Jack had a way of adjusting the lines of a car while it

was being developed that could make even a mediocre theme look thoroughly professional.

CEA When one looks for cars of his that have those qualities, what would be a good one to pick?

BP The '63 Grand Prix [Fig. 93] is crisp, understated, and elegant—a car in which every line is perfectly adjusted. Very Jack Humbert. Jack was a great technician, and anybody who worked closely with Jack over a period could not help but be influenced by his standards of craftsmanship. He was this kind of guy: We would stand back and stare at the model, discussing the exact amount of entasis that we should put into the front end for a given plan view. The exact amount of lift or spring might be as little as a couple of millimeters' rise at the center for the width of the car. And we might discuss the kind of entasis to use, whether it should be two flatter sweeps that would rise to a slight peak at the center line or one single sweep that was balanced all the way across.

There was careful consideration given to the amount of radiation of sweeps, or progressive entasis you might call it, that would be developed up through the entire front. Any production car of that era has a number of horizontal lines in its front-view composition. Using the 1963 Pontiac as an example, Humbert would have determined exactly where dead level would be. Then all horizontal lines above this would bow increasingly upward, through the grille (whose seemingly parallel bars are not really parallel), continuing up to include the leading edge of the hood, and so on. All horizontal lines below dead level would bow downward increasingly as they got further from the level line.

CEA Dead level you would draw where?

BP Somewhere in the bumper zone, most likely just below the top bar. The first horizontal line away from dead level would probably be a half sweep, yielding between a sixteenth and an eighth inch of crown—a very slight amount of entasis. Then the next sweep up, perhaps passing through the headlamps and grille, might have a one sweep—twice the crown of the half sweep. Higher up, we might get to a 1½ sweep, then a 2, 2½, and so on. Most people would never notice these subliminal amounts of entasis, but they do give springiness and life to a horizontal composition that otherwise might appear to be somewhat weak in the center. In recent years, several GM cars have made use of an exaggerated progressive entasis in the center section only of the front end, which Irv Rybicki has termed "proud crown." But its presence is easily recognized, while its effects are intentionally forceful and go well beyond subliminal form adjustment. Incidentally, "proud crown" in the center section of a front end usually requires more than normal entasis in the flanking elements to keep them from appearing to sag by comparison.

Another phenomenon that Jack monitored closely (although its goes back much further than Humbert, I'm sure) is called "lead-in." For instance, if you look at the outline of a television screen, you can think of it as four small radii on the corners with four other, larger radii forming the sides of the screen. Although this is approximately correct, a designer would probably not draw the screen this way. Instead, he would move each corner radius slightly inward, toward the center of the screen, so that the other, larger radii, if continued, would pass

outside of them, just missing the corner radii. Then, using a progressive curve (or "letter" sweep as they are called in the studio, because sweeps having progressive curves are designated by letters of the alphabet, while radius sweeps are numbered), the designer would smoothly reconnect the corner radius with each side radius to make the transition between them less abrupt. This progressive curve is called the "lead-in."

CEA And visually what are its advantages?

BP If you connect the radii mechanically (and it's possible you might want to do that to convey a particularly harsh quality), you get an optical jerk where the radius abruptly changes direction and rate. Your eye picks up the shape as a knuckle and the larger radius goes hollow, or visually concave, right next to it. If you want the overall form to be smooth, as in a lozenge shape, you must have adequate lead-in. People who are sensitive to these optical effects can monkey with the exact amount and rate of lead-in (and, of course, the basic radii of the surfaces and corners themselves) to achieve an enormous range of "flavors"—plump sleekness, gaunt harshness, anonymous neutrality, etc. It is common practice, too, by using different rates of lead-in on either side of a corner or peak, to cause it to "pull" in different directions. And careful attention to lead-ins in different areas of the car can help give it consistency, a subtle, subliminal continuity among its parts. But you don't have to know about these things to appreciate them. You don't even want to know. It's just that, when you look at a really beautifully done car, you know that somehow or other it's better. Well, I may sound very chauvinistic to say this, but over the years, when you look at the best GM cars, they do look better in this quality of execution than cars from some other makers. You sense a certain intangible "correctness" about them.

CEA This touches on a question I was going to ask you. Was Humbert unusual in that sense at GM? Was his studio known for that kind of refinement?

BP Even in a place where standards were high all over, Jack was outstanding. He had the respect of other designers.

CEA Let's get back to the Firebird. You said that Humbert's skill was actually refining a given shape. What about the Firebird? To what degree were you responsible for the whole, rather than for refining the car?

BP That is a tough question because in a team effort people build on each other's contributions and everything kind of fuses. But I was the studio chief.

The overall package size and the proportions of the car were in place in a general way when I went into Pontiac studio in 1968. Chevrolet Engineering and Henry Haga's studio had evidently been working on the project for a while at least. A clay model of a Pontiac version that had been put together in a very short time by Jack Humbert and a modeler named Jerry [Gerald F.] Snyder was sitting in the far corner. It had a heavy, simple sort of torpedo-ish body theme to it that I immediately liked and saw potential in—maybe because it seemed to look back a little to the Harley Earl days, or maybe because its midsection bore more than a casual resemblance to a car I had worked on a couple of years earlier in an advanced studio, or maybe because it was not like the latest planar stuff out of Europe. All it needed was a lot of life breathed into it. So as soon as other projects in the studio allowed, I asked my designers to work on new front and rear themes

while we got down to the business of putting new snap in the axes of the forms and rethinking and rebuilding the surfaces. In the short span of a few weeks, the car began to take on its new and—by and large—final personality.

CEA Were there certain aspects of it that you can go over that you thought out yourself?

BP Oh, I am sure. You got a month? But seriously, the Firebird was a labor of love that I took an intense personal interest in. And, since I was in charge, I naturally thought out every design change in order to keep on top of it. Believe me, it got its share of the usual considerations, like entasis. I wouldn't think of doing a car without it.

CEA You use the word "spring." Why is it a desirable quality?

BP For the most part, automotive forms, lines, and shapes are convex. And since they are, they should probably be springy in character rather than doughy or bloblike—a couple of other possible traits of convexities. But I don't know exactly. I think that a designer's mind draws on a host of analogies as sources for automobile body forms and shapes, and springiness in curves and surfaces describes only a portion of many undead characters he might achieve.

Obviously there are times and places where a designer would want a languid curve, or a stiff curve, or a muscular curve, or some other curve or surface that no word describes. And we all know that sometimes a certain awkwardness or a technical "error" is the secret of life in a design. But while metal or plastic can be made to take on just about any character of curvature, there do seem to be certain broad classes of curves and surfaces having to do with materials being stressed that are somehow especially appropriate (Ruskin's word) for the shell, skin, surface of an automobile. Usually, the stressing of materials is involved in the manufacture of automobiles, and it seems reasonable that that should be expressed in the design in a general way. For lack of a better term I referred to one of these [classes of curves] as springiness. As an example, bend a coat hanger and its curve will just be lumpy. But if you take a thin copper wire and stretch it— yank it until its molecules work harder—then bend it, its curves will have a lovely clean spring to them.

Somehow in commenting on your question about spring, I got hung up on surfaces. But this property can be present in the axes of forms, giving a sort of inner life to the whole car. Until the advent of oddly shaped supersonic aircraft like the B-70 bomber, forms with curved axes probably tended to be identified (in the car designer's mind) with the motion of carriages and ships, not to mention animals and fish, while straight-line axes spoke of the motion of aircraft, missiles, and trains. Both kinds of axes had, and still do have, their adherents. But regardless of the axis of the form, its surface can be energized. When an elementary compound surface has lively or springy curves in both directions, it can take on a kind of vigor, a lenslike quality.

CEA Like the laminated Eames chair in your living room?

BP Yes, although the laminated wood limited the amount of compound forms Eames could achieve. His fiberglass shell chair has a very fine compound form, and when you compare it with the shell of a Saarinen pedestal chair, which I don't find as well modeled, you can see how excellence in the surface curvature makes a

difference. Eames chairs of the forties and fifties have a very satisfying quality for me. I have always loved them.

[moving to Porter's garage housing his 1973 Trans Am]

BP This Firebird first appeared in the 1970½ model year as the so-called second-generation Firebird body. It ran more or less unchanged through 1973. Then in 1974 it got a new front and rear, which were not done by me. The Firebird was developed at the same time as the Camaro [Fig. 110], which was done in Chevrolet Two Studio run by Hank Haga, right down the hall. Naturally, there was a kind of friendly rivalry because we had to share certain body parts, most notably the upper, including roof panel, windshield, side glass, backlight, and deck lid. The door outer skins, while similar, are not alike on these cars. There was a little suspense over who would master the upper because in many ways the character of the upper is the key to the character of the car. In any case, the upper was developed as part of the Firebird on our full-size model in Pontiac studio. Hank had to take my upper and make his Camaro lower work with it. I guess this could be considered a disadvantage, but we took great pains to make sure that the upper was compatible with both themes.

 One idea in the Firebird that was very important to me was worked out fairly early in the game. I envisioned the central cabin area where the upper and lower were totally fused from top to bottom in a smooth, pure monocoque form [Fig. 109], the curve of the side glass in cross section extending cleanly right down into the door surface without a big glass offset or a shoulder of any kind. Then the ends of the car would be, in effect, pulled out of this main central form in both directions [Fig. 108], appearing to emerge from it and yet be fused with it. I was intrigued with that idea. Humbert felt that it wouldn't work. He was my boss.

CEA Why did he feel it wouldn't work?

BP I don't know for sure, although he may have thought that the pure monocoque would make the body seem too thick in the middle. To make a long story short, I tried modeling it my way and I began to realize that, even though I loved it as an idea, it just didn't work visually, try as I might. So on my own I began to come around to Humbert's point of view, which he had held rigidly all the time. Ultimately the car was modeled very close to being a pure monocoque. But there is a subtle shoulder right here all along under the side window. Behind the door you can feel it more easily. As the sail panel pulls in, it starts to become more pronounced [Fig. 109] and soon becomes the pronounced shoulder over the wheel opening. In certain lights there is the phantom fuselage continuing through the door.

 It is not so much a departure from the pure monocoque, I like to think, as just a return of a little force to the elongated lozenge of the lower that the pure monocoque somehow absorbed. And yet it doesn't retain so much of its independence that the top-to-bottom unity of the cabin area is destroyed. In this respect I put away a purist mentality and worked on achieving a melt, a marriage, a balance between force and unity.

CEA How did you coordinate that with the center line running through the door?

BP The center line through the door is a manifestation of the main axis of the car. It

is expressed as a "bone," or radiused peak line—as if the metal were bent over a pipe rather than a sharp edge—but always with lead-in on either side of the "pipe." In the early cars, the '70½ model, this bone is somewhat more rounded than in later models, where the bone is a little too sharp. As time went on the dies probably wore a little and were refurbished or replaced, and this feature was inadvertently altered slightly.

CEA Did you fade the swelling from above the bone?

BP Yes. As we noted earlier, the shoulder is most subtle under the side glass in the area in front of the door handle. Then it gets stronger as it passes out in front of the door. As it goes forward this shoulder is not parallel but is running slightly uphill relative to the bone line. Gradually it emerges from the door as the form of the front fender spine. Once clear of the cowl it takes on a little interior wave, so that it actually stands as a spine, a fender paddle. Yet the top of it is a long arching cone rather than a peak, growing sharper toward the front, and as it reattaches to the body it appears as a sharp crease in the plastic bumper. This cone is an important device in conveying the feeling that the whole front end of the car emerges, or is pulled, from the monocoque cabin. An important technical detail is that this cone, as it emerges from the cowl area, is perfectly tangent to the top of the subtle shoulder through the upper door surface. That same shoulder behind the door emerges full strength over the rear wheel. Although the overall effect of all this is relatively simple and clean, care in the orchestration of some interesting topography was necessary to make it really work in a convincing way.

In 1963 and 1964, when I was working with the new designers in the studio called Design Development, some of us began developing designs with these ever-changing forms as opposed to the older, more constant section forms. The Harley Earl formula called for a highlight that marches down to the end of the car [Fig. 74]. And this rule was completely consistent with his compelling and pervasive philosophy of longer, lower, wider. Yet a lot of the next generation of designers were feeling that this was like having a ten-word vocabulary. I mean, what can you say with a ten-word vocabulary? We just had to expand our range of acceptable shapes to express other kinds of things. James had broken through with the Firebird III. The Firebird III had shattered Harley Earl's highlight rules, but it was almost as if no one noticed because the car looked so much like an airplane. Nevertheless, it was a foot in the door.

CEA So your production Firebird worked out of the experiments that you had begun in the Design Development Studio?

BP Well, yes, some portion of the form treatment and surfacing did. But nothing like that happens in a straight line. In a design organization as big and active as GM Styling, with the number of talented designers, ideas bounce around and feed off each other. Nobody has a monopoly on originality. Some ideas float in the air like pollen, some go underground only to emerge years later, and so on. But on the most obvious conscious level I knew that the forms I was interested in in the mid-sixties were not in the Harley Earl tradition and were on the edge of acceptability. However, there was growing excitement, and other young designers were aware of them too.

CEA How were you unique? When you describe Humbert, it seems to me that you are

emphasizing more of an interest in linear subtlety. You detail a series of radial outlines rather than a large-scale, sculptured complexity. Is that perhaps you more than anyone else in particular?

BP It is not all that clear-cut. Perhaps it is more a question of emphasis. Perhaps he did get into lines and angulations more, while I probably tend to go after forms and surfaces more. But I can't imagine neglecting a line either, and Jack wouldn't have put up with a bad form. Of course, we had somewhat different definitions of what was good and bad in each area—the differences between any two personalities. I do know that the 1968 GTO [Fig. 107], where the theme of the car was those subtle bulging forms over the wheels, was my idea. And I have a feeling that form had long been a special preoccupation of mine at the time (and still is), as evidenced by my early fascination with Harley Earl's so-called highlight rules.

In the summer of 1958, when I returned to GM as a permanent employee in the Design Development Studio, the person in charge of training new modelers was a man named Jim McCormick. Jim was a sort of designing sculptor, who eventually became chief designer of an advanced interior studio. With his encouragement I worked back and forth between my drawings and the model. First I would work out my initial perspective sketches into careful four-view orthographic drawings laced with sections in all views. (This form of drafting—dating back to the carriage industry—is called "surface development.") Then Jim would have the modelers in training fit my section templates into the clay model, usually one-fifth scale. Once the surface between the templates was smoothed we could see what I had done wrong, analyze it, and I would go back to the drawing board and replot my sections. New templates would be cut, put back on the model, and so on. Jim McCormick, from his orientation as a sculptor, brought a very great understanding of more complex forms to our discussions, and he was a sympathetic counsel as I tried to grapple for my own answers with more expressive forms outside the range then acceptable to management.

The previous summer there had also been an older draftsman, Carl Pebbles, still around from the Harley Earl days, who gave me advice: "Now, Mr. Earl would say, 'You've got to put the forty-five-degree highlight line right there,' " meaning that Mr. Earl would have insisted on stretching the highlight the length of the car. The forty-five-degree highlight concept (as well as those at thirty and sixty degrees) was a useful [surface development plotting] device for trueing up forms, but as I learned more about forms by learning how to control them, it became clear that the old rules dictating where the highlights should go were at best only a general guide and, at worst, stifling to the imagination.

Frankly, I am not sure that Mr. Earl's enforcement of his "rules" was as rigid or as thoroughgoing as his underlings pictured it to be. But there was ample evidence that he did make an effort in that direction. He had a Scottish modeler named Jack Wylie who made the rounds of the studios, including occasional visits to the training studio, to keep an eye on the way forms highlighted. All modelers in those days had "highlight gauges" (a protractor device with a leveling bubble) in their tool kits, and they used them frequently. Mr. Earl was undoubtedly trying, by means of imposing his own taste in a codified way, to bring order to the job of designing new cars each year for five divisions. And he was surely

aware that his generalized control of form vocabulary was the basis for his strong GM image.

Trying to think back to what were my personal sources of inspiration—the art that really had a grip on me—I can remember that I harbored a deep love for the work of de Kooning, Seymour Lipton, Reuben Nakian, and Brancusi, among others from the fine-arts world; certain examples of the work of Pininfarina, Touring, Scaglietti, Frank Costin (Lotus), and Bugatti from the automotive world; and Frederick Kiesler's endless-house model from MOMA and Eames's shell chairs from the architecture/design world. Coming into the automobile industry with my missionary bent, it was all-important to me that I strive to reach a state of personal mastery as an artist that would enable me to forge powerful, workable design solutions using forms *I* loved, regardless of whether or not they were acceptable to anybody else. I was compelled to reach for these goals clandestinely, if necessary, because I was afraid that if I were to be revealed as a doubter of the prevailing religion I would be fired, and to be fired would have ruined any hope of attaining my goal.

My youthful notion was that if I could just attain this exalted, inwardly secure stage I would then somehow be able to find some synthesis, or at least some satisfactory balance between my new "style" and the existing mainstream, which appeared to be the taste of Harley Earl metamorphosing into that of Bill Mitchell. Remembering back, the hope of achieving something like this was my ongoing mindset. But, of course, I was unable to achieve this stellar program in anything like an orderly way. If an outside observer had chronicled my daily performance on the sheets of my sketch pads, he would have seen a weird juggling act, with my aesthetic gyro apparently gone berserk—its needle swinging wildly between heart-felt attempts at profound design statements, an occasional tongue-in-cheek pot-boiler, [interspersed] with an unchartable landscape of flavors and hybrids.

For a while I harbored sporadic notions that I would set up a studio and model-making facilities at home so that I could explore intensely felt personal design directions while maintaining a more standard, acceptable output at work. But I never did, maybe because I somehow realized that this would be escapist and that a more challenging answer lay in finding solutions that would expand or move the mainstream, fusing with it and altering its quality from the center.

Once in a while over the years I have returned to this current of highly personal expression in a sketch or two. [I kept] hoping maybe the time was ripe for acceptance, but only traces of it have proved to be injectable, so to speak—never a whole design. The center of gravity of the real design problem for me lies in the mainstream, with GM, I suppose, as the central current. The object is to broaden it, to enrich it from within—or applaud when it comes from without. Objectively speaking, I have invested the greatest part of my own career in a sense addressing this problem: working out designs that dealt with moving the mainstream from within via the form-vocabulary-expansion route. My work on the dragster and with the new designers in Design Development Studio certainly appears to me to be building on this effort. But the vocabulary-expanding character of these earlier projects was a bit academic because I had not as yet done anything significant that had made it through to production.

It became an intense experience, then, when the new form theme I did in the advanced studio in 1965 and 1966 became the real 1968/69 Pontiac Tempest/GTO [Fig. 107]. Jack Humbert did the final production version, and little if anything of the new form was lost between my advanced-studio model and his finished-production model.

Jack's front-end design, certainly in its GTO mode, was vastly better than the one on my model. On the down side, he had to add a shoulder in the upper portion of the door just below the beltline to clear a hinge limit, and this somewhat compromised the purity of the overall shell-paddle monocoque scheme mentioned earlier. In my opinion, the advanced-studio rear-end theme was a little better, and Humbert himself changed this and went to the advanced-studio version for his '69 rear-end face-lift. All in all, the GTO was a milestone for me. It did bring new forms into the mainstream.

CEA In your analysis you interweave your career and the historical design situation with a precise physical description of the cars. Let's return to the 1970½ Firebird and the historical context where you found yourself slightly later.

BP At that particular moment, in the late sixties, Italian automotive design was beginning to have a new influence here in the form of clean, uncluttered designs using smooth planes intersecting along crease lines. The Maserati Ghibli, for example, was a strikingly handsome car whose great size could easily be related to the Firebird/Camaro. Its elongated proportions were expressed in terms of bowed planar surfaces folded along carefully controlled crease lines.

Many younger designers in the building, including Henry Haga and I, were very tuned into these new developments. But, unlike Hank, I guess I felt some inner compulsion to do a different kind of car. Perhaps some chauvinistic ideas about wanting this to be a more American statement, or maybe some deep love of Jaguars and Lotuses buried in the psyche (there's a contradiction: both are English cars!). Who knows? It was probably all these things and more. But I knew *I* didn't want this particular car to be done in the Italianate style.[2]

As it turned out, the car [Fig. 108] has more than a little Italian blood in it—but from the preceding period of Italian design. The basic fuselage of the Firebird pays distant homage to the Disco Volante, and certainly the front is not unrelated to some Ferraris. But when it was designed, I was acutely conscious of resisting the Italian planar style and wanting very much for the car to have the benefit of the vocabulary of forms we had been staking out for the previous few years. I felt so strongly about that that I just had to do it. I wanted the upper to be based on these meniscus curves in cross section rather than those arced planes with the creased edges. Obviously this lower wouldn't have been even thinkable (with its conic and fused forms) if I had had, as a given, an upper that was based on creased planes.

CEA And yet there seems to be little of the complicated conical play that you have on the lower. Is that theme from below not picked up?

BP Well, the conical motif is present in the roof in a quieter but more pervasive way. But there are some other things in the roof that have a relationship to the lower. For instance, the curvature of the very leading edge of the roof just above the windshield, if continued forward, would *not* flow down to become the wind-

shield surface but would arc out over it, forming an imaginary bubble that would reconnect with the cowl surface along this edge at the rear of the hood.

What you have going on here is another order of events involved in the unity-yet-difference between the upper and the lower. When you slice these windows out of this virtual roof bubble, that portion of the real roof that is left seems thinner on the edge—even more shell-like. And the real windshield and side glass [Fig. 109] become partly tensional membranes stretched across the openings of that shell. I just think there's something exciting as hell about that! The windshield surface is furthest inside the virtual bubble, the sideglass somewhat less, and the backlight lies in the plane of the roof surface flowing down to the deck. Actually, there are some conic surfaces in the roof, too, as I said, but they are subordinated to this shell game.

CEA Where would these conic surfaces be then?

BP Oh, there is a curved cone, beginning just above the number-one pillar, that gets wider and wider as it goes back, until it curves down and passes alongside the rear window, where it flattens way out just in time to fuse with the lower. Think of it sort of as a thin shell that, while structural, is like a cape that is unfurling. It is as if the cape were held by the front edge and unfurls toward the rear, imparting a subliminal sense of something having been affected by motion.

CEA With these ideas, how did you deal with Bill Mitchell when he came around to okay the design?

BP Well, Bill does not think in these terms. He was more concerned with whether or not he liked the overall style impact of a design and tended to focus on certain immediately recognizable features. As vice-president he had a lot of territory to cover every day. So as the surfaces were worked out, I just hoped he would like them.

CEA You didn't bother explaining to him any of these subtleties?

BP No, he would have been insulted if I had tried. Insulted and angry, probably. You know, I'm not sure that art in progress needs to be or even should be explained that much to another designer. I am giving you as careful an explanation as I can because you are an historian, coming at it from outside the process. But among designers there normally is much more rapid and intuitive communication, especially among designers attacking the same project. They may think everything I've just been talking about—and beyond—but their thoughts are more in a visual code. Images are traded, but not so much in sentences. Many designers, Bill Mitchell included, are interested in what things are up front but not so much how they get that way.

CEA So how was the process OK'd?

BP He just came in and either liked it or didn't like it. The car has a mood that he either liked or didn't.

CEA Did he ever request any changes?

BP Oh yes. I didn't mean to sound as if he didn't take part in the design process. However, of any production car I worked on under Mitchell, this car made it through the gauntlet to production in a form closest to my ideal of it.

CEA It doesn't have any of the sharp edges that Mitchell insisted on in almost all of his cars.

BP Quite true. During the initial stages of the theme development, Mitchell seemed to accept the idea that this would be a more rounded car, although he never actually discussed it. To play up this character, at one point I tried a round mouth on the front. "Like an Osca," Mitchell said, recognizing what I had in mind by making reference to a small Italian sports car of the early fifties with a perfectly round radiator grille.

Throughout the entire project, however, Bill Mitchell spent far more time with the Camaro down the hall than with the Firebird. Except for one or two isolated instances, he made very few changes. He simply did not take the hands-on interest in this car that he did with the Camaro in Hank Haga's studio. Although I remember being a little apprehensive about this at the time, I was also relieved because I interpreted it as a sign of approval. It meant that the ideas we were developing he either liked or felt comfortable with. Mitchell was not shy about telling you what he didn't like.

CEA How about the people working under you? Did you talk about the aesthetics and the philosophy of design with them?

BP Of course. Routinely with the designers. They must be aware of how the problem is being defined in order to participate and key themselves to help generate inspired design solutions. In the formative stages of the Firebird design, two designers, Bud Chandler and Vince Disessa, made significant contributions. Dialogue with the engineers and the modelers is vitally important too. The job of executing a design in three dimensions involves continuous opportunities for interpretation, so the skill and precision of the modeler can be very significant.

CEA In your conversations, you are constantly referring to the modelers and the respect that you have for them.

BP Good modelers, yes. I love to work with good modelers. Going back to your composer/musician analogy: If designers are the composers, then modelers are the musicians. They can make you sound great or lousy.

CEA But when you compose, do you do it in the old GM way, of working first on paper all the way through the orthographic stage, before you see it in clay? How do you as a designer work?

BP The "old GM way," as you refer to it, has always appealed to me personally as the ultimate way to work because it puts the designer, given that he has adequate powers of visualization, in total and absolute control. The designer himself creates the entire surface in his mind and on paper, in the form of a network of lines, then gives templates to the modelers, who, theoretically, could just as well be machines. If the network is perfect enough, there is no room for interpretation. The designer is composer *and* musician. In those early exercises of mine with Jim McCormick, and later with Dave Rossi on the dragster model, this was exactly how I proceeded to work.

In practice, however, some interpretive matters do creep into the model-making activity anyway. Some types of shapes are very tedious to surface develop and simply easier to "find" in the clay. Also, with very subtly curved shiny surfaces, even a very minute change of curvature can dramatically alter the exact way they reflect light. Later, as I moved into the advanced-studio situation, with a full-size model waiting to be worked on, it was hardly practical to have a crew of

modelers sitting around for a month while I worked out an elaborate full-size surface-development drawing.

But in spite of the pressure to keep things moving, I did tend to work as much in this manner as I could for as long as I could—sectioning some, although no longer all, areas of the car myself and, with my tech stylists' help, giving the modelers templates.

CEA Even in the early seventies?

BP Experienced modelers tend to think more in terms of building major sections of surface right on the model from, say, a key cross-section template or two and a plan-view sweep—all referenced to engineering limitations as shown on the orthographic drawings. The surfaces thus produced [this elementary modeling operation is called a "drag"; Fig. 11] are very true and mechanically correct. But surfaces with ever-changing sections cannot be produced this way, and these include the ellipsoids, cones, warps, parabolas, and others that comprise the vast areas of shapes with the richest sculptural possibilities. All of the latter must be carefully built by hand, though at times they can be roughed in or approximated by mechanical means. So with the passage of time, I have moved toward working closely with the modelers, trying to bring their arsenal of craft methods to bear as much as possible on the construction of the more complex forms I wanted.

Today I tend to work out the forms in my head and on the model right in front of me, and I have drifted away from working out the forms in my head and on paper, except for contouring basic control sections, of course. If there is really a loss of control in forgoing the grid-line network as a working medium, it is probably offset by the enrichment that the artistry of the modeler, another set of eyes and hands, can bring to the process.

But regardless of the shift in my personal working style over the years, automobile designers never really get very far from the orthographic projection. Running drawings of the clay model are kept by the studio engineering staff, and once the clay model is finished it is recorded (today, electronically) by means of thousands of points on its surface. This data is then used to construct a mathematical surface in the computer from which, ultimately, the production steel dies are cut. The acres of drafting tables that used to be so characteristic of this process have given way today to darkened rooms with rows of green, glowing cathode-ray-tube screens. But the content of the process is virtually the same: the precise definition of forms in space.

Of course, the technology that brought that computer to the drafting room has brought it to the design studio as well. But while it might seem that the computer would afford the designer the means to go back, in effect, to the "old GM method" of Harley Earl, the method of working things out orthographically (now in the tube instead of on paper), there has been only isolated interest in doing this so far. Not many designers have the interest, let alone the patience, to learn the unfamiliar language necessary to communicate with GM's ultrasophisticated surface-generating program. While work is being done on simplified, or "user-friendly," systems, it is by no means clear if or when they will alter our present studio working methods. So far, all of the user-friendly systems that I have seen involve simplified methods of form generation. I am therefore some-

what apprehensive that any such system may covertly limit the designer's form vocabulary without his being fully aware of it.

At GM Design Staff today, it is generally true that the most advanced three-dimensional computer capabilities are used in the service of refining and precisely defining forms that are created by other means—by means of sketches, full-size tape drawings, and, as always, clay models. Meanwhile, the idealized vision of the automobile designer seated before his console, generating full-size, three-dimensional (holographic), full-color images on a great computer screen before him, exists in the minds of many as the ultimate design studio of the future. [See the Irv Rybicki interview.]

CEA Is the computer as a potential working tool better suited to other commercial arts than car design? Does this difference say something about the nature of car design as an art?

BP In a broader context, the image of the future designer at the computer is especially appealing to many non-automotive designers and design educators who have not themselves needed or been motivated to develop the ability to visualize complex sculptural forms in space in their mind's eye with any real clarity. [For example] the everyday practice of architecture and industrial design seldom calls for the manipulation of really complex sculptural forms in space. Indeed, the vocabulary that has dominated architecture and design through most of this century constrains the designer to use simple geometric forms, albeit often in compound arrangements. Designing with geometric forms, no matter how intricate their arrangement, does not call for the same kind, perhaps even order, of visualization skill as does designing with complex sculptural forms. This is not to suggest, of course, that difficulty of visualization has any correlation with aesthetic merit.

Since these visualization skills are not part of the internal dialogue of their own creative processes, designers and educators of this persuasion tend to refer to these skills as "communication skills"—that is, as a means for communicating one's ideas to others. It follows that such noncreative work is appropriately done by means of the logical, mechanical processes of the computer. The dazzling brilliance and clarity of the best computer-generated images lend considerable credence to this point of view and tend to mask the question of the computer's potential role in the conceptualization process.

Automobile designers, on the other hand, in order to maintain control over the complex sculptural forms used in their work, usually strive to picture their forms in space in their mind's eye while they are conceiving them. This simulation or visualization of real space in the mind is the arena in which the conceptual struggle, if there is one, takes place. The actual thought process slips in and out of this space "fix" as the designer struggles to capture the gesture, mood, presence, or whatever it is that he is after. And during the process the mind-space itself is subject to distortion, blurring, etc., as ideas play across it. Perhaps the presence of these vagaries, captured in the initial sketch, may be an ingredient of its appeal. In any case, many automobile designers, myself included, think that for the time being the designer's free-perspective sketch, with pencil and paper, is still the all-around most spontaneous, least inhibiting or limiting conceptual-visualization

tool that he has, primarily because it allows him to automatically communicate with himself during the conceptualization process. Later, of course, the same sketch or a refinement of it may serve to communicate to others.

Nearly every automobile designer, at some time during the long design process, goes back to his original theme sketch for inspiration, for reference, to ensure that the presence or gesture captured in that first image of the design is somehow kept alive throughout the grinding realities of the development process. If inspiration does not survive perspiration (to elaborate on Edison's adage), the game is lost. There are those who would argue that notions like spontaneity and inspiration have no place in contemporary design, but few would seriously agree, I think. Rightly or wrongly, automobile design, more than any other major area of industrial design, has been the resident home of the romantic, even expressionist, point of view, aesthetically speaking.

CEA This discussion of working methods was touched off by the special characteristics of your Firebird design.

BP One thing I forgot to mention about this car is that the main body forms sit on top of a sort of vestigial chassis or implied platform shape [Fig. 108] that is about six inches tall all around the bottom of the car. I confess to having had some qualms about using such an obvious reference to a chassis on this car, when its actual structure is frame/integral with a front subframe. But by the time the Firebird was being designed, this platform idea had become such an entrenched convention at GM that there was no getting away from it. To the degree that the car was monocoque, the frame/integral construction was eloquently expressed, I thought. Therefore, in the final design, the platform shape remains as a generalized abstraction of the concept of structure (and attendant mechanicals) rather than a direct expression of it. Hence its main purpose is aesthetic, not unlike the triglyphs on a Doric temple.

In front this shape carries the parking lamps and some lower grille slots, while along the side and rear of the car it exists as a low, somewhat stiffer surface, distinct from the main-body form above it. If you sight down the side of it you'll notice that it curves upward ahead of the front wheels and even more so behind the rear wheels, in a sense "supporting" the ends of the car [Fig. 109]. Some variant of this implied chassis idea has been commonplace at least since the mid-sixties on GM cars and serves visually to thin up and lift the mass of the car in all views.

CEA We've talked about the articulation on the bottom and side, and the continuity and relationship with the top. What about the terminations on the front and the end? How were those conceived?

BP Glad you asked. There is an interesting story here. This double opening was the Pontiac theme [Fig. 108]. And the particular treatment of it here on the Firebird received a lot of attention with respect to the character of the spring in the curves and their "lead-ins." The outer curves of the apertures are in general more rounded than the inner curves, and the overall effect is an ever-so-slight smile—or perhaps it's a grimace. It is one of those ambiguities, but it does have an expression. I was working alongside a designer named John Shettler, who was in charge of the Pontiac Interior studio. We took sections and contours off of the nose of the car and actually used some of them on the interior (for instance: the section of

the padding around the instrument cluster, the contour of the cowl, as well as the welt of the seatback padding).

CEA It became the leitmotif?

BP Yes, really. Even the shell of the seatback has it. Bud Chandler did some wonderful full-size sepia-tone sketches that nailed the front-end motif, which was perfect for Endura. In manufacture, this urethane-plastic material was cast directly around the steel understructure, creating literally a one-piece reinforced plastic front end. Because the entire front was, in effect, one gigantic bumper, all the forms could be completed with sculptural integrity. My preoccupation with the Firebird involved the idea of infusing this new technology into an American vocabulary of forms. I felt it was important to do that.

CEA What is it that makes this typically American rather than unique?

BP I don't know exactly. And yet anyone with an eye for automobile design would immediately recognize the Firebird as American. Perhaps it is its hybridness, like a Delicious apple. There is a particular relaxed muscularity that manifests itself in such diverse American designs as our World War II army helmets (versus the British, German, and Japanese helmets that were so nationalistically distinct from ours) and the plywood Eames chair you pointed to. And certainly the Firebird has some of that. And yet I am not sure that it isn't just chauvinism talking when I say the Firebird is American, because in a sense I don't even know what "American" is. I think of ourselves as just designers. International. I don't know, I guess I felt that to not go the Italian, edgy style—even though that sounds very negative, as if you are backing into the future, doing something for negative reasons— I just felt it was important to explore the (what I considered) new, richer vocabulary of forms that I had had a hand in developing during the preceding few years. I thought that could be a real contribution rather than just echoing or doing an interpretation of the latest Italian stuff.

CEA Do you feel it then became a contribution, or was it more of a dead end?

BP It probably was a dead end, at least for a very long time. I think you are right about that. I assume that is what you are implying.

CEA I mean, you were fighting city hall, with Bill Mitchell's "London-tailored look" on the one hand and all the Italianate people on the other.

BP Well, that may be an oversimplification. While Bill Mitchell was undoubtedly pushing the neo-razor-edge style and favoring its superficially similar nonrelative, the planar Italianate, he was still capable of tolerating individuality (and even fighting for it), if it happened to be his particular brand. In the case of the Firebird, while it wasn't really his brand, he at least let it live.

But you are quite right in that this car did not really lead any place in the mainstream. It stands as a curious anomaly, although it was enormously successful in that the basic body ran for ten or twelve years, surviving innumerable face-lifts. Some would say because of the face-lifts. In any case, the body turned out to be one of the most durable designs of the seventies, during an era notable for plywoodlike surfacing. Today it is clear that rounded forms are returning to the mainstream, enriched (we can hope) by what happened upstream.

CEA What do you think this did for your career and for you as an artist? I mean, you really tried something unique, and it worked.

BP It was very satisfying to have a design on the road that I genuinely liked myself.

But at the time, it was not thought of as anything particularly outstanding, either by the public or within the industry, and it had little or no effect on my career. A couple of years after its introduction, the large production studios were split into two smaller studios, and in the wake of these realignments I was transferred to an advanced studio.

I was in an advanced studio for approximately seven years, and for much of that period the advanced studios were under Chuck Jordan's direction. My involvement with the Firebird did not end with Pontiac studio, because the present-generation "F" body, the one introduced in 1982, was developed by Roger Hughet (my assistant) and me in Advanced One studio. Jerry Palmer did the Camaro version in Chevrolet Two studio. Once the basic body forms were resolved, my full-size model was sent up to Pontiac Two studio, where John Schinella's group did the final front and rear as they appeared in production.

In early 1980 Bill Mitchell had [been] retired a couple of years, and Irv Rybicki, who succeeded him as vice-president of Design Staff, saw fit to move me back into a production studio. It was here in Buick One that I had the opportunity to work on the 1985 Electra [Fig. 112], which has been a wonderful car for me. It was the first really satisfying production car I had been involved with from beginning to end since the 1970½ Firebird.

CEA A very subtle car.

 BP Thank you. It was satisfying for me because I felt that the Electra was such a difficult car. In the old days, the Electra exemplified all the things that many younger designers didn't care for. Oversimplifying, Electras were essentially large, ostentatious cars with a lot of ornamentation. The last bastion of the porthole. And so it was a revelation for me to find myself working on a car whose very image exactly corresponded with something that I felt it was time to change. And here was the opportunity to address that, to step right up and take a swing.

This car has some intentional subtleties in it, too, that you might be interested in hearing about. First of all, the Electra has a lot of plan-view curvature in the body side—a little of the boatlike quality which Gregorie probably would have enjoyed. Then, the lower body section is "loaded" through the doors: About three or four inches above the side rub strip, there is a very subtle bulge or crown in the section [Fig. 113]. The kind of bulge you see right under the windows on the Firebird is down in the midsection of the door on the Electra. The side glass and upper door surfaces lie more or less in one plane, sloping down and outward until it reaches its widest point at this bulge, so that the car has a slightly pear-shaped quality.

Down below the side rub strip there is another stiffer, more well-defined horizontal "bone" belonging to the lower body tub which is inset somewhat from the upper body form just under the rub strip. This harsher bone in the tub stiffens it visually and relates this out to the bumpers on the ends of the car. But it is the subtler, fuller bulge above the rub strip that lines up horizontally with the tops of the wheels and carries that sense of power in the car. Ted Schroeder, my assistant, can be credited with first sketching this body section, and as the car developed I decided that the subtle bulge should be manifest all around the car—through the front and rear end as well.

CEA If you had to verbalize what that continuous bulge does, what would you say?

BP It gives the form a special density, like muscle. It is like something just visible in the skin of the car that was created by the inner pressure of a dense, horizontal force plane. It's also a little like a torpedo, a loaded depth charge—right through the body, right across the tops of the wheels—lending its force to the wheels. The bulge is subtle, but it is meant to be the kind of bulge that only power or force could produce in a form.

CEA And yet, if I understand what you are saying, it doesn't really change in the same way it does in the Firebird. It doesn't move and have a dynamism. Is that because you wanted to give this a more staid image?

BP Yes, I think so. The overall lower body-profile shape of the Electra is a pronounced wedge, while the upper settles back into that wedge. So the dynamism of the car, if you will, resides in the interaction of those main forms, and the surfaces can afford to be more taut overall and more muted than those of the Firebird.

CEA Is it also that you wanted to give it the sense of larger size, as if it is moving out on the bottom?

BP Actually, not so much size as density. See, the "A" car (1983 Buick Century) doesn't work like that. Its section through the door is folded above and below the center so that it neither lifts nor settles. The overall verticality of the mid-door section reinforces the plane of the wheels to provide a neutral background for the subtle wedging of the crease lines in side view. By contrast, the Electra section is "loaded" midway down in the door, while the surfaces from the bulge up-slope inward like a pyramid. Pyramidal massing is a time-honored device Harley Earl used on all his cars to give a sense of weight and stability. Although it is in a different context on the Electra, it has somewhat the same effect.

CEA And yet it is not dead because it has an extra bulge below it?

BP Yes. In the tub area, the surface from the bone downslopes inward, forming, in effect, a good-sized chamfer that gives a little lift to the bottom of the car, countering to some extent the downward force of the pyramid.

CEA The one question, though, that I have about this car is why you chose to crease it in the roof and around the rear window [Fig. 114]. How was that decision made?

BP Well, that was one of the few lines on the car that I didn't really have full control of. That was mastered in Oldsmobile.

CEA Ah, because from my point of view, it is the only thing that doesn't work.

BP Well, had it been my upper to master, I probably would have put some form of radius there. Nevertheless, I do think it turned out quite interestingly. Since the sail panel itself is not shared with Oldsmobile, we were able to bring the crease line downward just past the rear deck shoulder, which fuses into it from the rear.[3] This solution relates the side plane of the entire upper very nicely to the side plane of the lower body, creating the large pyramidal surface I was speaking about a moment ago. Given the roof crease, there was one thing that kind of interested me, that I tried to play off against it. In side view, the shape outlined by the roof crease and the drip molding along the top of the side windows arcs up and forward, making a sort of forward-thrusting cantilever shape. Meanwhile, at the very tail end of the car I fiddled with this little crease line so that it curves up and

away laterally, crossing the car in what I thought was an interesting countermovement. [The crease] worked out well in that it both emphasizes and controls the corner where some pretty complicated planes meet.

The rear deck is somewhat unusual, too. Normally, the sweep of a deck surface decelerates (grows increasingly curved) toward the rear. On this car I reversed this situation because I felt it was more elegant to have the deck grow flatter as it approached the little kickup on the end. The kickup is beneficial aerodynamically, and I think it gives the car a certain panache. Important technically is the way it emphasizes and terminates the shoulder where the deck rolls over into the side plane of the car. This shoulder can be thought of as a continuation of the hood shoulder, interrupted by the transparent plane of the side glass. But the aft shoulder, to give it a little action, is tapered as if it were wrapped over a baseball bat, blunt end forward, handle end at the rear flare. Since the rear shoulder form on the Electra works out so well at the base of the sail, I cannot really say I am unhappy about the roof crease.

CEA Would you point out some design details on the Electra?

BP There's a little slice of techno-mod hiding just under the rear edge of the hood. When you raise the hood, you can see that this zone right at the base of the windshield is an area where all kinds of stuff with totally disparate functions (wipers, nozzles, vents, intakes, etc.) come together in a crowded little space. We traversed this functional no-man's-land with a terraced, slotted, curved panel of flat black plastic held in place with the mandatory flat black screws. Perfectly appropriate, I think, and it was fun to play it in a high-style Italian-product-design idiom.

I was extremely happy with the way the overall front-end design turned out, too [Figs. 112, 113]. In the last few years before this car, the Electra traded heavily on the nostalgia of a stand-up radiator shell and other neoclassical symbolism which I felt, as an idiom, was really shredded and worn out. I felt that we were making a real breakthrough in developing a car whose front was, graphically, just one simple horizontal ribbon, and yet, by the device of the power bulge, giving it a sense of force sufficient to make it credible as an Electra.

But I think the specific area I am most proud of on the whole car is the form of the air intake under the front bumper and the swept-back surfaces on either side of it. Each flanking surface is, in a sense, the anchor for one big fillet, stretching from the scoop backward on a diagonal toward the front wheel. In the computer screen, the section lines of this surface are exquisite—like the topographical diagrams you've seen of hyperbolic paraboloids and such. I think if Eames and Bertoia were still alive they would enjoy these shapes. They're modeled with the same kind of care as some of their chairs. Dave Schelosky, the modeler who spent many weeks under the front of the car, said it's a pity only the garage mechanics get to see it.

CEA What is it that is you in the car and what is it that is original? How about those questions?

BP That is too profound.

CEA It isn't all that profound, is it?

BP Yes, I think so. You kind of are what you eat. You are the sum total of the things that you have seen and the other designs that you have admired.

CEA And are you conscious of any of those things when you work?

BP Oh sure, I think so. Insofar as you can be, I am.

CEA When you talked about the Firebird, you had large objectives in mind: an American Look, a reaction to Earl's limited vocabulary, and so forth. Yet, when you talk about the Electra, you seem to speak of more limited aesthetic objectives, objectives perhaps more to do with beauty than with a kind of large creative statement. Is that fair to say?

BP Well, perhaps in time I may be able to think about the Electra in larger terms. I have a certain perspective about the Firebird because, after all, there is a distance of nearly twenty years between it and me, while this one was just finished four years ago. There has been more time to reflect on the Firebird. Also, I am working on the successor for the Electra right now, and that colors my perception of it considerably.

　　　I believe that most automobile designers are well aware of the mainstreams and currents in their own field. Of course, many of us tend to be so in love with cars that we neglect other areas of design, just as some painters don't have a clue about what's going on in architecture, and vice versa. Designers know intuitively which styles are high, which are low, which are coming in and which are going out, both here and abroad. And like most artists, they feel belittled and trapped to be categorized themselves, although they tend to identify with styles, or to think of themselves as locating a little into this or a little into that, or maybe anti-this or anti-that. While they may not be focused on this every minute of the working process, they certainly know the Japanese Look, or the German Look, or the Italian Look, and are conversant with the subspecies. I always think very strongly in terms of American design directions because, I guess, I always identify GM with America.

CEA So what's American about this Electra? Can you tell me that?

BP Oh yes, at least in part. I think this kind of loaded bulge is American. That would never occur in any kind of car but an American car. It would not occur in a Japanese car nor in a German car. Not in that way at all.

CEA You really see your own creative contribution in large part as an American art form then?

BP It would be very egotistical of me to think that. But although it bothers me, too, to be categorized, I recognize my work—certainly some of its essentials—as being in an American idiom.

CEA Perhaps one could think of it as just the opposite of egotistical. In a way, I thought that you were describing yours as a uniquely creative view, but in reality you think of it as part of a larger American style.

BP Well, yes. I usually think of my work, my life, as taking place in the overall world of art and design, but now and then I am conscious of my American vantage point. Speaking of that aspect, it has an underside—the fact that American automobile design has been so out of style in recent times. One of the noteworthy aspects of America's continuing love affair with the automobile is intellectual America's continuing love affair with the foreign automobile. For decades now, an important segment of the American automotive press has made the foreign car the object of intense veneration. All of us who grew up with *Road & Track* magazine have been caught up in this lore, and we are all influenced by it. God

knows, at GM, just as anyplace else in America, Ferrari is the ultimate designer's car! And, even back in the sixties, we all knew where a Californian was coming from, so to speak, when he turned up his nose at "Detroit iron." Fortunately, today these older attitudes are changing, and some American cars are gaining respect even among foreign-car enthusiasts.

CEA And yet there is very little press for the subtleties and complexities of the kind that you described.

BP That's true, not much. Automobile enthusiasts' magazines are naturally more interested in engineering, road testing, etc., than in aesthetics. Industrial-design magazines have a different problem. Due to the old rift between automobile designers and the rest of the industrial-design profession, most industrial-design writers are somewhat traumatized by the automobile. They either find it very distasteful or it is incomprehensible to them as a subject. Of course, other art-world publications—magazines on art, architecture, and the decorative arts—do not really consider the automobile to be within their province. Good critical writing on the subject of automobile aesthetics is not unknown, but it is rare.

CEA What do you think the future is? Do you see that America is going through a renaissance, that we are about to turn the corner to a great period?

BP Well, I think that could happen. The potential is there because we do have excellent designers. And, in spite of the apparent confusion in the field, we almost certainly have the best design education. At least the rest of the world thinks so. Many, many Japanese automobile designers and some top Europeans are U.S.-educated. The world's automobile companies recruit regularly each year from our major design schools, to the extent that the transportation students in my class at the Center for Creative Studies in Detroit may wind up working almost any-where in the world, if they choose. If the U.S. industry can successfully utilize its own talent, it is truly possible for American automobile design to regain the world leadership it so clearly enjoyed in the thirties and forties. I don't know that we can expect to regain it quite as decisively, but I think the potential is there. We have the talent, the education; we have the wind tunnels, the technology. We have the stuff. It is above all a question of courage and commitment to design.

CEA I can hardly wait till your next one comes out.

BP We do have some beautiful cars coming out in the late eighties and early nineties. One in particular comes to mind that I'm involved in now. We are pouring our hearts and souls into it, which, I guess, is all you can do.

Irv Rybicki

CHUCK Jordan, director of design at GM, gave by far the shortest interview—after fifteen minutes he declared it a waste of time and denied permission to publish. After my experience with Chuck Jordan, I thought that the doors of the GM Tech Center would be closed to me forever, and with them the chance to talk with Irv Rybicki. In fifty years, Rybicki is only the third vice-president of design GM has had, and his insights into creativity would be necessary to understand car design today as well as to round out the historical picture. I was surprised indeed when my letter suggesting that perhaps the brief exchange with Jordan may not have reflected Rybicki's views was greeted with an immediate telephone reply. Rybicki's administrative assistant extended an invitation for a two-hour interview for any day of the week I requested. So, well over a year since I interviewed Chuck Jordan, I found myself again walking through the doors of the Tech Center.

A GM P.R. man greeted me, asked some questions, and then stuck around for the entire taping session with Rybicki. During the taping I was struck by how many times Rybicki addressed issues raised in my conversation with Jordan, in particular the unresolved question of excitement and personality in GM products. At times, he seemed even to quote Jordan, as when, for example, he asserted that "people are moved by what they see: 'Damn, I've got to have that [a GM car].' " There is little doubt in my mind that Rybicki was briefed about the earlier

interview and tried to answer any lingering questions. Which is simply to say, as the P.R. man explained, that Rybicki gives few interviews with historians, and he probably was concerned to set the record straight.

Certainly, his attempt to smooth the waters is in keeping with his image as a good company man. After experiencing more than forty years at the hands of two headstrong vice-presidents like Earl and Mitchell, the company probably decided that a self-effacing, kindhearted gentleman was what they needed. He is known throughout the industry as a good manager, skilled in human relations. He is not only available to his employees and willing to listen to their ideas, he goes out of his way to ask their opinions. "Democratic" is a word frequently used to describe him. Rybicki could not have been more gracious to me or more intelligent and straightforward about his position. Quick on his feet, he is complex in his thoughts. He sees himself caught between his own belief in functional and "clean and simple" design, the overriding need for design "excitement" based on the desires of the buying public, and the pressures from foreign competition and federal regulations to meet standards of safety, fuel economy, quality, and packaging, among others. I don't mean to give the impression that he is not sensitive to creative individual artists. In fact, he encourages young designers, but only insofar as their innovations lead to distinctive divisional identities. He is totally unconcerned with individual artistic expression, particularly his own, and as a result of his clearly defined point of view, Rybicki is unwilling to market unique and daring new cars. Unlike Mitchell, who fundamentally believes that supply creates demand and that the role of the great designer is to stimulate new demand, Rybicki is a conservative player. He sees individual expression only in terms of divisional or corporate personality, and he believes that risk should not go beyond satisfying the feelings of the public as previously expressed in polls and opinion surveys.

Rybicki is convinced that he is following GM President Roger Smith's policy of "the three R's: risk, responsibility, and reward." Yet, while more responsibility has been turned over to each designer, Rybicki offers him little artistic acclaim. And as for risk, Rybicki declines to put his artistic neck on the line. Feeling besieged by foreign competitors and government regulators, he does not see characteristically American innovative and individualistic design as an essential weapon in his fighting arsenal.

CEA Outsiders have drawn many impressions about the design profession. In this book, I would like to have the designers speak for themselves. Would you talk about what you are up to? Maybe you would distinguish yourself from former vice-presidents. I had hoped that we would have cars in front of us, so that you could show me your thoughts.

IR I don't think I need properties to tell you what we face here and where we are going. You have talked to some of the old-timers like Frank Hershey and Bill Mitchell. I was a kid designer during their time, and I can tell you that the

business then was very simplistic, simply because we had a domestic market that was all our own. The people here at General Motors Design Staff (back then, it was called GM Styling) concerned themselves only with Ford, Chrysler, and Hudson Motor Car Company, or what finally all evolved into AMC. But nobody talked about the Japanese or the Germans or the Italians. Now what have we got? We've got everybody here in America. In the focus of this staff, we very seldom talk about Ford. We talk about Japan; we talk about BMWs and Audis; we talk about what is coming out of Italy. We have got an international market in the United States, and we have to cover all those bases with our products.

And, of course, we have partners in this business, located in Washington, D.C. They have complicated the scene tremendously with CAFE [corporate average fuel economy] standards and all the other standards within the vehicle on lighting and side-door beams. There are now many more dots on the blank page before the designer starts. They didn't face that in the thirties, forties, fifties, and sixties. I lived through that era. I know what I am talking about.

So, what are we doing? We are doing many things. Apart from the product, we are bringing in as much technology as we can to speed up the creative process. We are working on designer workstations, where we can look at creative thought with computers. A problem I always had when I was a designer up on the boards was that I had more ideas swimming through my head than my hand could possibly put on the page. It takes several hours to lay out an automobile, render it, and get it up on the wall. If we could speed up that process, we'd have a better selection. We are very close to putting that in place right now. I see the day when a designer will sit at a computer terminal and create in just a matter of minutes an image that flashes through his mind, put it in the computer bank, and create another one. Perhaps he would decide that the face on the first one was great, but that the body shape and the upper and tail end on the second one are very good. So he can bring the face out of the memory bank and put it all together in a new car. Now he has an image he really has some confidence in. Then he'll project that image right out into space in holographic form and in full scale, and he'll be ten feet away from a full-scale model. He can walk around the image and look at the face, look at the tail, and get a feel. It may be one day that we won't build three-dimensional models. We'll scale and section that image in the computer.

CEA How do these technical improvements and the new complications arising from Washington's legislation and overseas competition affect new design shapes?

IR Certainly federal-mandated standards had a great effect on the shape of the automobile. Bumpers back in the fifties, sixties, and early seventies were flush with the face and the back of the vehicle. They were cosmetic bumpers. Then Uncle Sam came up with two-and-one-half- and five-miles-per-hour bumpers. That [legislation caused us to] project the bumpers out in front of the car and out the back of the car, and give them more length and more weight. The change initially left them looking rather awkward and cumbersome relative to the shape of the vehicle. Then we got into soft materials, and we started integrating the bumpers right into the body shape, à la Corvette [Fig. 115]. You are going to be seeing a lot more of that in the future. So the car became a total form that doesn't have add-on shapes at the front and the rear. Yes, bumper regulations affected us.

Side-guard beams also affect the cross section of the car. You have to clear the beam. The glass has to clear the beam as it drops. The beam changed the body shape of the vehicle drastically. CAFE regulations certainly had a pronounced effect. We were doing automobiles 230 inches long for a great many years, and then, suddenly, someone rings the bell and says, "You are going to do them two feet shorter." This team had been doing long cars for thirty years. We had to reeducate ourselves. Because the price of fuel was higher elsewhere, the other design houses around the world were doing small cars for a long time. They had a step or two on us at that point in time. But I think we are learning fast. I think we are coming to understand the elements that are necessary for doing shorter vehicles, for making them attractive to the eye as exciting packages.

With all the vehicles we have at General Motors, yes, we make a mistake occasionally. But that is something in today's world you have to work hard to avoid because a new car program can cost this corporation three billion dollars or more. If you make a mistake, it is a very costly mistake. So, yes, standards, fuel efficiency, all of these things have had an effect on form.

And, of course, today designers all over the world are chasing aerodynamics, trying to improve fuel efficiency that way. You are going to change the body shape anyway, and aerodynamics is probably the cheapest way to gain a mile or two per gallon rather than retooling engines, transmissions, and all the other components. But I don't believe for a moment that aerodynamics is a total answer by any means, because there are many factors that make an automobile: quality, government-mandated standards, packaging, aerodynamics, costs, manufacturability—all of these ingredients have to be taken into account when you are creating a car.

CEA If I understand you, you are saying that a basic difference between you and, let's say, Bill Mitchell is that you are more of a functionalist, but a complex functionalist, in that you take into consideration a whole range of functional determinants.

IR I'd say that's the basic difference, not because Bill believed one thing and I believed something else. I think times have changed what I believe. If Bill were sitting in this chair today, he probably would be looking at the problem very much as I do. You don't have much of a choice. The competition is tough out there. The Japanese do thirty miles per gallon. They've got price. They've got quality. It is not an easy ball game.

CEA You talked about excitement. That was an interesting word for you to use. What did you mean by it, exactly?

IR Well. What do I mean by excitement? I am sure you have walked through a shopping center on a Saturday afternoon, and there were hundreds of people walking by. But this one young lady walks by, and she has a gorgeous face like Brooke Shields and a lovely figure. She strolls like a female, and that catches your eye. There is a little tingling sensation that goes along with it.

It is that way about a beautiful piece of architecture. Our eyes move us emotionally when we see. We try to create vehicles that will do the same thing for the consumer out there. The Corvette created a lot of excitement, and the Fiero: We can't build enough of those devils. That is what I mean by excitement. People are moved by what they see: "Damn, I've got to have that."

CEA Can you put that excitement into visual terms or distinguish your aesthetic from Mitchell's? Mitchell talks about exciting cars as looking sheer and lean. He calls his "the London-tailored look." Earl preferred a powerful image expressed in large, massive, and rounded shapes. Is there any visual terminology that you would associate with excitement?

IR I think the path we are trying to travel takes us somewhere between those two men. We are not entirely sold on the sheer look [Fig. 99], nor are we sold on the totally round look [Fig. 75]. I don't know whether you will grasp what I am going to say, but I hope you do. Look at some of the offerings coming out of Dearborn [Ford]. They talk about being the leader in aerodynamics. With their shapes, they have vehicles somewhere around .35. We've got a Firebird out there that is .298. It isn't round or fat. It is a slippery-looking car. It is more of a racehorse than a hippopotamus. It looks like it is going to move. To do a round car is very easy. You can do it so that it looks heavy and sluggish, as if it won't move away from the curbstone and it will take 500 horsepower to get it running. That is not what we are about to do. This thing standing there has got to look like it's doing a hundred miles an hour.

CEA More in the taste of those Italian sports cars after the war. I am trying to associate an aesthetic with your designs. Is it like the Cisitalia or those Fiats that came out after the war?

IR Are you saying, "Are we going back there, borrowing from that?"

CEA Well, you speak about functionality, and there was a great move toward functionality at that time. I wonder whether that affected you.

IR I think the game has changed because of the desire to build world-class, quality vehicles at General Motors. We want to lead in quality, not follow. We've had some problems in the past. If we are going to build quality vehicles, we are going to have to deal closely with the engineering and manufacturing groups and to understand what they can run through their systems. That is going to affect how we tackle the appearance job here. In the past—in the thirties, forties, fifties, and sixties—the designer did what he wanted. If he wanted a taillight that was wide on the back of the car, even if the light was all chrome and die-cast (and those castings weighed thirty pounds apiece, per side, sixty pounds per car), no one ever gave it a second thought. Why, you wouldn't put sixty pounds of castings on a car today. That means burning more fuel. You just don't do those things.

 So I think functionality is a requisite today. You have no choice but to move in that direction. The customer is taking a harder look at the product. They are quality conscious out there. They want to be sure they are getting a ten- or eleven-thousand-dollar value when they lay down their hard-earned dollars. That is what we are trying to give them.

 I might add this. I don't think we are in the fad business here. We are trying to do vehicles, as in the second-generation Camaro [Fig. 110] that lived for eleven years. We'd like to be able to do that with everything from a Cadillac right down to a Fiero. We don't want to create designs that, when you look at them ten years from today, you say, "My, why in the hell did they ever do that?" We'd rather have you say, "Well, that damn car still looks good today." That is the goal here.

CEA You seem to believe in certain eternal aesthetic values. You want your cars to be

classics. In one of the few quotations I could find, you talked about frills and doodads.

IR I have never been for that. Not even in the days when we were doing it. I questioned why we had to put nonfunctional chrome moldings on the side of a vehicle or to cut slots that had no function in a fender. What was the purpose in that? I'm from the Clean and Simple School. But not simple like Simon. You know there has to be some entertainment, but you can do it with form rather than doodads. Look at the back glass on the Camaro and Firebird. It is an S shape. Nobody had ever done that before. After they had seen the clay model, our glass suppliers left here thinking, "My God, they have gone mad. How are we going to do this?" They got it done. I've never been a big-car man, either. Building 230-inch cars—that shocked me. I could not understand why it took five or six thousand pounds to move a 150-pound man down the street. I think we are now getting car sizes that are correct.

CEA Why are you now working five years ahead on these cars? Instead of the lag time being, as it was in the past, two or three years, you now [summer 1985] more or less have your 1990's completed.

IR Not totally, but close. They have extended the lead times to ensure that the prototype and the pilot will lead us to build a quality car that comes first off the line.

From our point of view, from the point of view of the people who create the look five or six years down the road, [the lag time is too long]. You consider that [in addition to lag time] the vehicle has to run [and look good] five or six years, so that [the interval] is twelve years from the time we started the idea sketches. There is a lot of risk involved in the delay. We would like to be two or three years away from the market.

The goal is to get there with the new organization in the corporation [the decentralization of GM into separate Chevrolet-Pontiac and Oldsmobile-Buick-Cadillac divisions]. We had a system that wasn't front-loaded. Design Staff could finish and the other groups were out there trying to put the other programs together, and our work just sat around. Now they are building other teams to front-load these programs while they get the old system out of the way. I am encouraged that, within the next program or two, we will be doing it in three to three-and-one-half years. I do believe that.

CEA Is it more in keeping with your working method that you like to brainstorm? Designers who were working with you in the late fifties say that you were one of the people who introduced a more rational approach to the design process. Rather than doing it intuitively, you discussed problems a great deal. Is that true?

IR I would say that might be essentially true. In the studios I ran, such as Olds and Chevrolet, we never really jumped into theme sketches until we discussed the car and verbally tried to build what we would chase. I found that, rather than isolating a designer at his desk, with his own thoughts trying to find the solution, if you could get the creative team to communicate with each other we got down the road a hell of a lot faster. When we worked overtime hours—and we were working ten to twelve hours a day, and we still do a lot of that today—I discovered that after a dinner meal the whole team was sluggish. Their productivity

dropped all to hell. Rather than have them at the clay model and drawing board, I would hold a meeting in my office. I found that it was far more productive. I got more out of them for eight hours the next day than to have them push clay around or do sketches.

CEA Can you think of any other systematic or structural changes that you made to the creative process as vice-president?

IR We made a lot of changes. When Bill [Mitchell] left, the divisional studios were controlled by two people. Chevrolet-Pontiac was controlled by Chuck Jordan, and I had Olds-Buick-Cadillac. I had a piece of the advanced work, and he had a piece of the advanced work. Another chap, Dave Holls, and still another guy, Clare MacKichan, also had pieces of the advanced-design work in the building. I lived through that for a great many years and discovered that it was a system that I didn't think worked at all.

I told Bill about it on many occasions, but he didn't agree with me. It didn't work because, if a group like mine (Olds-Buick-Cadillac) got into trouble with a program because we were falling behind and we needed extra help to get the job done, I couldn't go to Jordan or MacKichan and get help from them. They had their own problems, and they were not about to give Irv their talent. It slowed the process, and we were always late. When you are late in this system, it costs the corporation a hell of a lot of money. You are buying premium time in all of the tool shops and engineering shops. You can't live that way.

So one of the first things I did was to reorganize the design team. I put all the design under Charlie [Chuck Jordan, design director]. Then we took the divisional studios and put them under one man. Then we took all of advanced design and put it under one fella. So we had complete control of the entire team. If the guy running North American car-design operations had a problem with Cadillac—let's say he needed more hands—all he had to do was go through Pontiac, Olds, and Buick and select the people he needed. He could get them there, and we'd get the job done.

CEA How about the working process of designing? What you have been talking about is more of an organizational change.

IR It hasn't changed, other than what I described to you earlier—that is, the changes we are planning on making with computers. Today, we are using computers in the studios as a proving device after we have found the theme and are working on it. We are working with the computer to be sure that the body sections are clearing the door-guard beam, that the glass will drop past the beam, that our bumpers are meeting federal specifications, that the doors will swing out, that the hinging is proper, etc. That is what we are doing with the computer.

The computer at the moment here is not a tool that the designer, the creative mind, is using. He is still on a sketch pad out of his head. He is still putting it up on paper. When we find one we like, it is taped full-size, as quickly as we can do it. We may do five, six, or seven tapes before we commit our resources to a full-sized clay piece because then you are spending money at a rapid rate. Generally, the selection process is made here at Design Staff, by us. Then we show what we believe to be correct to our clients, the five motor-car divisions and the corporation.

CEA Can I get you to talk a bit more about what you mean by "slippery"?

IR Slippery? Yeah. A racehorse is slippery looking, but a hippopotamus isn't. A

racehorse can run pretty fast, but a hippopotamus can't. That is what I mean by slippery. A Camaro, a Firebird, a Fiero, are slippery-looking cars. They look like they'll get through the wind with no resistance at all. I see some other efforts on the part of our competitors. While they claim that they have aerodynamic automobiles, I can assure you that a General Motors product will never look like that. We'll have drag coefficient numbers as low or lower than theirs.

CEA What is there in the Firebird design, for example, that means slippery to you?

IR It is all in the silhouette and the forms. How best to put this? I can do a full-sized tape of a Firebird and put it in five different design houses. All I'll give them is the silhouette of the car, the outline of the glass, the wheel openings, and so forth. I give that drawing to five different design houses, and you will have five different looking automobiles because they will each section that car in an entirely different way. If I sent it to Dearborn, it would come out very round. If I sent it to the Italians, it would come out very harsh. If I sent it to the Germans, it would come out very muscular. And if you go to France, it might come out a little bizarre looking.

You take it to Japan, and I suspect they'd take all the sting out of it. There wouldn't be all that much left. I don't know their cars, other than the Honda Accord. That is the only one I can recognize on the street. For the others, I have to read the name plates. "Is that a Toyota or a Nissan? That's a Toyota. Yeah, OK." The Japanese like harsh cars.

CEA If that is true about each company having its own look, how—

IR Its own philosophy.

CEA How does that philosophy come about? Does it come down from the top, or is it something that occurs decade after decade?

IR I think it occurs over time. It is a tradition here. I like to think of it in this way. You can take a .200 hitter and put a Yankee pin-striped uniform on him, and suddenly he becomes a .280 or a .290 hitter. It is the House That Ruth Built. It is the atmosphere. General Motors has been recognized for a great many years as a leader in appearance.

CEA Is there something you want the people to know about your design philosophy that we haven't covered?

IR Yes. Make them clean and simple. And make a statement that the consumer can recognize, guys. I'll go into a room, and we will have spent weeks on a project. The project is nothing but a collection of knowns, assembled in an entirely different way. Well, we sit down and talk about it. The project is put aside, and we go back to the drawing board until we find that shape that makes a statement. I think you'd admit, when a Fiero comes down the street, you'd know it was a Fiero. It isn't anything else in your mind's eye. It isn't a Toyota MR-2, is it? It isn't a Fiat X-19? You know it's a Fiero, don't you?

CEA Why do you know it's a Fiero? You see, that is what I am trying to get you to verbalize.

IR What do you think it is?

CEA I am an historian. You are the designer.

IR Its form telegraphs "Fiero." It is entirely different than a Fiat X-19. Now, the press was saying, before the car was introduced, that it was going to be another Fiat. It is not a Fiat at all.

CEA Let's try the question this way: What is the difference, then, between it and the Fiat?

IR The form. It is an entirely different form.

CEA What about the form? You are like Frank Hershey. I can't get Frank to articulate the visual specifics of his creations, either. He quotes Mr. Cord: "If the car doesn't sell itself, you'll not be asked to buy." That is his way of saying that you can't verbalize about form. I find that, with even some of the great designers, whether they can verbalize about form has nothing to do with the quality of the design.

IR It is an emotional experience, so it is very difficult to verbalize about what sets our cars apart from others. I can't tell you from A to Z why I like a Fiero, other than to say that its form is exciting. I couldn't say why, out of the five girls walking down here, that one appeals to me. There is some magic there that triggers some sort of chemistry, so that my eye is drawn to that particular one. I think that it is the same thing in this business. It is an emotional experience. We are totally and completely involved with these things emotionally out there. That is what we are trying to do: reach the consumer's emotions.

CEA Interestingly, when you talked about design before, you talked about it quite functionally. Are you saying something different?

IR An automobile is two things. True, it is a functional object. It has to serve the consumer one hundred thousand miles, trouble free. When we take on a project, function is the first thing. You can't just toss all of this to the winds. The car has an engine. It's got a transmission. It's got to seat six people. It has all of these government-mandated standards. You want eighteen cubic feet in the deck. "Now deal with this. Put it together in some exciting way, in a new and fresh way." Sure, it is functional, but it also has to be emotional. A Checker cab will do everything I described. It can carry six people, and it has all kinds of deck room. But it is a horrid-looking thing.

CEA Let me ask you one last question. I talked to Jordan about the personality of a car, and he said that GM cars basically reflect a corporate personality rather than the personality of an individual designer. You were just saying that each corporation has its own design personality. By contrast, Bill Mitchell believes that the cars produced under him were a statement of *his* personality.

IR Yes. He believed that all the years he was here.

CEA Is that a difference between your and Mitchell's leadership? I speak of yours collectively, meaning also Jordan, Holls, etc.

IR Hmm. I think I can best answer your question this way. If General Motors said, "Irv, here is x number of dollars. Take a studio before you retire. We are going to let you build a car for yourself. Make a running machine. We will spend the money." When I got through, nobody would like it but Irv. Period.

So, what we are doing out there in those studios is slanted totally at the consumer, not at me. We are trying to understand what he is buying and what he may buy down the road, and we aim the vehicle at that market, in that direction. If I went through those rooms and had them do exactly what I wanted, in each and every room, for Olds, Buick, Chevrolet, Pontiac, and Cadillac, hell, the whole thing might come to a halt. Our market share might slip to 20 percent. I can't do that.

I am looking for variety. I am looking for individual divisional personality—with a blanket GM kind of a look. You are going to ask me to describe it, and I can't. In other words, if we do a Chevrolet at one end of the scale and we do a Cadillac at the other end of the scale, you are going to know that both cars came from one design house. You are going to know immediately that the Chevrolet did not come from Japan or Germany, that it is obviously a General Motors product. Yet, if you set the two side by side, they are entirely different cars.

CEA A complicated answer. One of the aspects of it I find intriguing is that, as you see it, the personality of the car in part expresses the personality of the consumer. Could you expand on that? How do you know what the personal desires of the consumer are?

IR We have a marketing group that is out there working with the consumer. We get feedback from its clinics and studies, and we use that information when we start a new program. That is how we know. I don't go out and directly talk to 220 million Americans, and neither does any of our designers. We have systems within the corporation that keep us abreast of what's going on in the marketplace. When you ask us to project ourselves out there five years from now, hell, you could have another oil crunch or some outside force that changes the whole ball game. Then we'd get caught short. I haven't got a crystal ball. No one has. You pay your money and take your chances. Roger [Smith] always said there were the three R's: risk, responsibility, and reward. What else have you got?

CEA What can you tell me about the future?

IR I will tell you what I can, which isn't a hell of a lot. Cars will be cleaner, simpler, slicker, and far more fluid. And what General Motors produces will not look like anything from Dearborn, Highland Park, Japan, Germany, or anywhere else.

We have a lot of it in the system today. We do things such as this, for example. We'll see something in one of the rooms, and we'll decide among the management group that it doesn't apply to any of the programs. It is just a sketch on the wall, [but we are excited about it]: "Damn, that is an exciting machine. Let's get off into the corner and model it full-scale." And it still stands up very well. We'll then invest the money and build a fiberglass model that does nothing but sit around here for years. We are testing to see how it lives among the team. Two years from now, if you set it out in the hall, do people just walk by it like there was nothing there, or are they still stopping and looking at it? I mean, like our shop people. The people in all of our shops—wood, metal, plaster, paint—represent, I suspect, the average consumer. In two years, when you see them stopping and looking at it and making positive comments, you know that you are on to something lasting.

The next-generation Camaro-Firebird happened that way. We hadn't even launched the cars that are now on the street when we saw this sketch. We built it. The fiberglass model is now about four years old. It became the theme piece for the fourth-generation Camaro-Firebird, which will be introduced somewhere in the 1990s.

CEA So then, "evolutionary" means something a bit different to you than it did to Earl. Evolution for him was a yearly progression, whereas for you it seems more

of a leap forward, which then you let rest. If it goes, then you go for it. Is that fair to say?

IR That is fair to say. Back in Earl's time, we could tool cars faster. We did a new car, introduced it, and three years later we did a major face-lift. If you made a mistake, you could easily correct it with that face-lift.

Today we put a car out there and we hardly touch it for a six-year period. You may change grilles and a few things like that—paint the trim to keep it fresh—but not much beyond that. You are living with the basic theme for five to six years. Make a mistake today, and you're going to lose your shirt. We did in 1978 with two automobiles for Olds and Buick, called aerobacks. People always say that with the power of General Motors we can sell anything. Well, that is not true. You can advertise the hell out of a loser, and you're not going to sell it. We run a lot of programs through this building. Every now and then you might stub your toe.

CEA I talked with some of the people from the late fifties, and they say that when you were chief designer for a studio you would enter the competitions Earl and Mitchell would run. Usually the chief designers would not enter, but you wanted to compete. Is that right?

IR Yes, I did. They kept me out of it a few times. Yeah, I loved it. Hell, that is the heart and soul of this business: competition.

CEA Do you ever bring in something from one studio to another studio?

IR Never.

CEA You still keep that locked-studio system?

IR Absolutely. All I'll take to them is a word picture. I'll tell them that I think they are marching down the wrong road. I'll tell them where I think this thing ought to go. You'd be surprised how effective that is, because it is not mine. They listen to my words. Each designer interprets those words differently, and then they go back. Based on what I've said, they start creating new themes. If you have five designers in a room, the variety [of what they produce] based on our conversation is wide. I like that approach. I am not going to hold anybody's hand out there. I am not taking any sketches into those rooms. No, sir. That is not how you build young creative people. You put the responsibility on them by saying, "Do it, young man."

CEA You believe in the locked-studio system as a creative stimulus? Let them do it on their own?

IR Absolutely. Irv has designed one hell of a lot of cars in forty years: There is no point in my going out and doing it. I'd rather the young people express themselves. That's a youth market out there. Sixty-year-old guys are driving around in Corvettes. They don't want some old stodgy automobile. We've got to have the young people create the cars. Hell, I've done a lot of them out there over the years, friend. A lot of them.

CEA Which is the one that you are most proud of?

IR The one we are going to do next.

CEA But the one that *you* did?

IR The one that I did? I don't think I ever did a car in total for General Motors. It is very rare that we have had a designer put up a sketch, and then that we have used

that total sketch. But I have influenced the appearance of General Motors products over the years. I moved them in different directions as a result of what I did. I can remember Harley Earl taking a lot of my sketches off of the wall. Bill was running the Cadillac studio at the time, and he would say, "Bill, let's do that."

CEA Can you remember a car that you influenced a great deal and with which you were very satisfied?

IR There were many, many. It is difficult to answer. There are a lot of reasons for not nailing it down. . . .

CEA Aren't you worried about posterity?

IR I never worry about things such as that. They have to judge me on what I've done. If they choose to forget after I leave, so be it.

CEA How are they going to know?

IR I guess I won't [be remembered]. That is not going to destroy me. I've made my contribution. The corporation was running between 50 and 60 percent [of the market] all the time I held major jobs out there. And the vehicles I was associated with never failed. I can't pinpoint an automobile for you that I'd say Irv had a lot of influence on, and I can't say that this car was one of my best efforts or that it did well in the marketplace.

CEA Maybe we are coming to an important difference between you and Earl. Earl could not draw, but you are known as a visual artist. His lack of technical ability in a way forced him to use a system of communal design. Perhaps it shows a lack of arrogance on your part that you maintain his collective approach even when it masks your important artistic contribution.

IR Sitting in this office, I have the power to go out there and do anything I want. I could stop a program in Pontiac this afternoon. "Say, fellows, get rid of that face. Here is what I want you to do with it." I am not about to do that because I might walk into Buick and spread that philosophy in there. In the end, they are all going to start looking alike. They will start looking like Irv cars.

 That is the wrong thing to do. If I let the chiefs and their teams run, we have a better chance for diversification, for creating divisional personalities that are sound, so that one [division's cars] don't look like another's. You are going to see some of this in the eighties, as we use more specifics among our divisions and less interchangeability than in the past. You will see some different-looking cars from Pontiac, Olds, Buick, and Cadillac. There is a very diversified market out there today. No one thing sells. You have to have two-place cars and four-place cars and high sedans and sports sedans. All of it.

CEA That is an interesting concept of individuality: individuality to meet the needs of consumers rather than to project the personality of the man at the top. Fair to say?

IR Are you saying that is where I am coming from?

CEA Yes.

IR Absolutely. That is where I am coming from. That is where I have always come from.

Notes

INTRODUCTION

1. See the interview with Gene Garfinkle.

2. A handful of *temporary* exhibitions of American cars were held at art museums, including the Museum of Modern Art in 1951; the Harbor Art Museum, in conjunction with the Junior League of Newport Harbor, California, in 1975; and the Detroit Institute of Arts in 1985. See Museum of Modern Art, *Eight Automobiles,* New York, 1951; Strother MacMinn, "The Auto as an Art Form," *Road & Track,* August 1975, 54–58; and Detroit Institute of Arts, *Detroit Style: Automotive Form 1925–1950,* Detroit, 1985.

3. I am deeply grateful to the designers who permitted me to tape their conversations. Unless cited, quotations are taken from the following interviews conducted by the author: David K. Holls, December 14, 1983, Detroit, Mich.; Gordon M. Buehrig, December 15, 1983, Grosse Pointe, Mich.; Charles Jordan, December 16, 1983, Detroit, Mich.; Strother MacMinn, January 18, 1984, Pasadena, Calif.; Gene Garfinkle, January 18, 1984, Pasadena, Calif.; George Walker, January 19, 1984, Tucson, Ariz.; Frank Hershey, January 20, 1984, and May 2, 1985, Bullhead, Ariz.; William L. Mitchell, December 16, 1983, Detroit, Mich., and January 18, 1984, Palm Beach, Fla.; Bob Gregorie, January 19, 1984, St. Augustine Beach, Fla.; Holden Koto, January 20, 1984, Boynton Beach, Fla.; Vincent Kaptur, Jr., April 19, 1984, Pinehurst, N.C.; Richard Teague, April 26, 1984, Detroit, Mich.; Bill Porter, June 16, 1985, Detroit, Mich.; Irvin Rybicki, July 23, 1985, Detroit, Mich.; Stanley F. Parker, May 20, 1986, telephone interview; Ron Hill, May 29, 1986, telephone interview; Don Roper, June 1, 1986, telephone interview; Homer La Gassey, Jr., June 1, 1986, and September 25, 1986, telephone interviews.

4. See Donald MacDonald, *Detroit 1985,* New York, 1985, 116.

5. For a discussion of styling at Briggs, see ed. Michael Lamm, "Body by Briggs," *Special-Interest Autos,* November-December 1973, 24–29.

6. Strother MacMinn and Michael Lamm, "The History of American Automobile Design, 1930–1950," in *Detroit Style: Automotive Form 1925–1950,* The Detroit Institute of Arts, 1985.

7. Arthur J. Kuhn, *GM Passes Ford, 1918–1938: Designing the General Motors Performance-Control System,* University Park, 1986, 83.

8. Alfred P. Sloan, Jr., *My Years with General Motors,* Garden City, 1964, 269.

9. Giles Blunden, "Automobile Color," unpublished seminar report completed for a graduate colloquium in modern design at the University of North Carolina at Chapel Hill, 1986; Kuhn, *GM Passes Ford,* 123–25.

10. Sloan, *My Years,* 269.

11. See Bill Porter interview in Part 2 and Del Coates, "The Computer-Aided Designer: Are Car Designers Slow on the Draw?", *Industrial Design* 30 no. 2, March-April 1983, 44–45.

12. Detroit Institute of Arts, *Detroit Style.*

CHAPTER 1

1. Homer La Gassey explained (September 25, 1986) that in 1986 European firms hired more than a quarter of the graduating majors in transportation from the Center for Creative Studies. See "School for Stylists," *Motor Trend* 15 no. 12, 1963, 76; Ellen Ruppel Shell, "Tomorrow's Car Is Taking Shape Now in Pasadena," *Smithsonian* 14 no. 11, February 1984, 78–85; Dan McCosh, "Design Schools: Seminaries for a Chosen Few," *Automotive News,* January 21, 1985, 2, 4; Masahiko Kaneko, "Art Center College of Design '86," *Car Styling* 55, Summer 1986, 74–78. For the impact of GM design methods on the curriculum of the Art Center, see former Cadillac Chief Designer George Jergenson, "Styling Is an Art," *Motor Trend* 1 no. 10, 1949, 10–11.

CHAPTER 2

1. Sloan, *My Years,* xxiii, 433–34.

2. Kenneth E. Coppock, in Ken Gross, "1941 Chevrolet Special Deluxe," *Special-Interest Autos,* May-June 1978, 15.

3. See also the observations of Vincent Kaptur, Jr.: "He was a poor communicator to begin with, and then not being able to draw, the communication problems were utterly fantastic."

4. Harley Earl, "Preface," General Motors Public Relations Staff, *Styling—The Look of Things,* 1955 (revised 1958). This is one of the rare publications produced with the cooperation and technical assistance of the GM Styling Staff. Ford followed with a publication by its Public Relations Staff, *The Ford Book of Styling—A History and Interpretation of Automotive Design,* Dearborn, 1963.

5. "Production Evolution," *Twenty-Ninth Annual Report of General Motors Corporation for the Year Ended December 31, 1937,* 37.

6. This was an approach shared with Raymond Loewy, who coined the term "Maya"—most advanced yet acceptable—for it. *Never Leave Well Enough Alone,* New York, 1951, 277.

7. Alfred P. Sloan, Jr., *Adventures of a White-Collar Man,* New York 1941, 185.

8. See, e.g., Stephen Bayley, *Harley Earl and the Dream Machine,* New York, 1983, 73.

9. Just as Mitchell links Earl's dependence on orthographic drawing to his lack of ability to render, Kaptur, Jr., relates Mitchell's reliance on clay to his inability to read a drawing.

10. Bob Thomas, *Confessions of an Automotive Stylist,* New York, 1984, 27: "Harley . . . was a master at line drawing and I soon learned how a thirty-second of an inch could change the whole character of a design."

11. The specific process of laying the selected sketch on the board was done by a select group of men, like Bill Block, as a vice-president of a major American automobile company explains: "[In this system] you got to have the Bill Blocks—who was the famous guy who worked for Harley Earl. He was the body-layout guy. He worked with the designers on doing the finessing of the lines. He was very, very good at that. Kaptur was another one. . . . Harley Earl, he had the director's chair—this chair that was a little taller than other chairs. He was so damned big he needed a higher chair. It was like a director's—with a canvas back. He would sit down, and there would be this huge blackboard in front of him. Bill Block was the robot who did the work for Harley when he wanted it done. And he was very good. He knew Harley like the back of his hand.

They worked together for years. . . . Well, Harley would like a sketch; he'd yank a sketch off of the wall and take it over and say: 'Bill, now we are going to do this one. I kind of like the lines on this thing.' So he put this thing up in the corner and Bill would be there with his sweeps and his jumping around—as if he were suspended from the roof with a bungee cord. And Harley was on him like a tiger."

12. For an explanation of the Earl "rules" for highlighting, see Jane Fiske Mitarachi, "Harley Earl and His Product: The Styling Section," *Industrial Design* 2 no. 5, October 1955, 54–60; for a specific application, see Strother MacMinn, "Inside the Prewar Olds Studio," *Special-Interest Autos,* May-June 1977, 41.

13. Thomas L. Hibbard, "Early Days in GM Art and Color," *Special-Interest Autos,* July-August 1974, 41.

14. In a roundabout way, Earl admitted his principal role as a receiver of ideas when he underscored his position as a prompter: "For my part, I often act merely as a prompter. . . . I sometimes wander into their quarters, make some irrelevant or even zany observation and then leave. It is surprising what effect a bit of peculiar behavior will have. First-class minds will seize on anything out of the ordinary and race off looking for explanations or hidden meanings. That's all I want them to do—start exercising their imaginations. The ideas will soon pop up." Harley Earl, as told to Arthur W. Baum, "I Dream Automobiles," *Saturday Evening Post,* August 7, 1954, 82.

15. Hibbard, "Early Days," 54.

16. Al Fleming, "The Earl of Design," *Automotive News,* September 16, 1983, 228.

17. Mitarachi, "Harley Earl," 60.

18. Hibbard, "Early Days," 43.

19. For Earl's presentation techniques and his power over general managers, see Fleming, "The Earl of Design," 227.

20. Mitarachi, "Harley Earl," 23.

21. Sloan, *My Years,* 277.

22. Earl, "I Dream," 17.

23. Bob Gregorie, "Fantastic Ford Finds," *Special-Interest Autos,* December 1970, 9.

24. H. P. Gillette, "Ford's Business Philosophy," *Engineering and Contracting* 67, 1928, 138; Kuhn, *GM Passes Ford,* 289.

25. Ibid.

26. Bob Gregorie, in Michael Lamm and David Lewis, "The First Mercury and How It Came to Be," *Special-Interest Autos,* July-August 1974, 17. See Lorin D. Sorensen's comments on Gregorie's predecessor, Walter Fishleigh, in "The Fishleigh Fords," *Special-Interest Autos,* March-April 1977, 54–56: "Walt found he could stretch his imagination before the young company president without fear of losing his job. In fact, Edsel was sympathetic to Fishleigh's pent-up creativity." See Robert Lacey, "Patron of Art," *Ford, The Men and the Machine,* New York, 1987, 329–42.

27. Bill Williams, "Cosmo," *Special-Interest Autos,* April-May 1973, 38.

28. Paul Leinert, "Former GM Design Boss Now Runs Consulting Service: Mitchell Is Active in Retirement," *Automotive News,* October 16, 1978, 32.

29. Bill Mitchell, in Gary Witzenburg, "A Designer's Designer—William L. Mitchell," *Motor Trend* 29 no. 7, 1977, 76; in "Designing the New Chevrolets," *Motor Trend* 29 no. 2, 1977, 90; and in Julian Pettifer and Nigel Turner, *Automania,* Boston, 1984, 145. See also Leo Levine, "Bill Mitchell Brings Style to GM with a Capital 'S,' " *Motor Trend* 21 no. 2, 1965, 63–67; and Keith A. Gave, "Stylists Recall Past, View Future; Looking at Cars with Teague, Mitchell, Bordinat," *Automotive News,* July 23, 1984, 30.

30. Gordon Buehrig interview with Marcus Whiffen, "The Master of the Cord: Gordon Buehrig at Eighty," *Triglyph* 3, Winter 1985, 8.

CHAPTER 3

1. *Interiors* 107 no. 5, December 1947, 92; Elizabeth McCausland, "Gallery of Everyday Art," *Arts and Architecture,* March 1946, 38.

2. *Interiors* 103 no. 4, November 1943, 49.

3. For a discussion of the growth in size and power of postwar cars, see Laurence J. White, *The Automobile Industry Since 1945,* Cambridge, 1971, 216–20.

4. Ibid., 203; Ed Cray, *Chrome Colossus: General Motors and Its Times,* New York, 1980, 363.

5. Joseph C. Ingraham, "Detroit's Billion-Dollar Gamble," *New York Times Magazine,* June 29, 1958, 16–17.

6. Lowell Kintigh, in *Automobile Quarterly* 15 no. 4, 1977, 370.

7. Advertisements for Oldsmobile appearing in *Vogue,* August 15, 1948, 57, and October 15, 1948, 41.

8. Julian Robinson, *Fashion in the Forties,* New York, 1976; R. Riley and Sally Kirkland, *American Fashion,* New York, 1975.

9. *Life,* September 30, 1946, 29; *Life,* October 14, 1946, 81.

10. *Life,* January 13, 1947, 71.

11. Robinson, *Fashion,* 53. Just as the European-oriented art and industrial-design critics demeaned the bulbous, egg-shaped American car, the established fashion critics for *Harpers* and *Vogue,* raised on Parisian design, barely covered Adrian's clothes or condescendingly mentioned them in a department called "The California Market." They focused on the Old World designs of Americans like Norell and Mainbocher, or on the sportswear collection of Claire McCardell. In this category, McCardell's "American look" was widely praised, and prestigious stores like Lord and Taylor encouraged the casual look. In keeping with the overall undefined shapes of the predominant World War II car form, McCardell's mass-produced clothes were padless, braless, and worn without heels, and her most popular dress (the 1938 "Monastic") had no waistline or bust darts, and the back looked just like the front.

12. "Shaped in Paris," *Vogue,* October 1, 1948, 191. On September 1 of the same year, *Vogue,* 168, described the clothes on that ideal figure as deserving the "classification: new classic." This fashion highlighted the built-up figure by cinching in the waist, shaping the bosom, and padding the hips; and these tight lines were set off by full skirts and petticoats draped with soft fabrics. See Ernestine Carter, *The Changing World of Fashion,* London, 1977, 32–40; and Prudence Glynn, *In Fashion,* London, 1978, 23–30.

13. "A Star with the Stars, Mabs of Hollywood," *Holiday,* January 1947, 12.

14. "V-Ette Whirlpool Bra," *Vogue,* October 1, 1948, 126; "Yours for a Glorified Lifeline," *Holiday,* June 1, 1947, 64.

15. A commercially successful architect like Durrell Stone distanced himself from the International School even before the war by introducing local materials, bold shapes, and especially ostentatious materials and ornaments like gold leaf and gold mesh. Even European-oriented designers like R. M. Schindler took extensive trips throughout the United States in the years before the war in hopes of merging regional materials and construction techniques with European principles of architecture. For their ideas on pre- and postwar design in America, I would like to thank Stephen Callcott, Jessica Cobb, Genie Pridgen, and Melanie Young, members of a seminar given at the University of North Carolina at Chapel Hill during the spring of 1985.

16. Francis de N. Schroeder, "The Growth of American Taste, 1888–1945," *Interiors* 105 no. 4, November 1945, 134. For the best treatment of the visual interrelation of the arts after the war, see Robert Goldwater with René d'Harnoncourt, "Modern Art in Your Life," *The Museum of Modern Art Bulletin* 17, 1949, 5–37. In 1947 Russel Wright consciously relaxed the torpedo outline of his prewar American Modern dinnerware in his postwar Casual china. Similarly, in his postwar line of Bauer pottery, Wright tried to capture the feeling of irregularity and unpredictability and to express a one-of-a-kind look through textured glazes and natural or organic shapes. In "Good Glazes en Masse," *Interiors* 105 no. 10, May 1946, 104–6, 120, Wright described his goal as "the exploration of natural impurities and characteristics, not in their refinement; the natural variations helped rather than hindered." An object with an extended irregular shape, like the cream-colored 1948 Schick razor, typified the change in the immediate postwar years and contrasted with the black, more purely torpedo shape of the 1930 model ("Redesign: Schick's New Shape in a Little Shaver," *Industrial Design* 1 no. 3, June 1954, 88). In 1947 *Graphis* magazine declared that the field of two-dimensional commercial arts also "finds itself at a similar turning point," where "the pre-existing recognition of the need for a change has been converted into a reality" (W. H. Allner, "Mathew Leibowitz," *Graphis* 17, 1947, 16). The new postwar direction can be seen in graphic artists

as different as Paul Rand, Mathew Leibowitz, and Ben Rose, who emphasized irregular curves and biomorphic shapes in products ranging from magazine ads to textile curtains.

17. David Holls says that this expression was an entrenched part of GM design philosophy.

18. Norman Bel Geddes, *Horizons,* Boston, 1932, set the standard for industrial designers' biographies and philosophical statements, such as Walter D. Teague, *Design This Day,* New York, 1940; Raymond Loewy, *Never Leave Well Enough Alone,* New York, 1951; and Henry Dreyfuss, *Designing for People,* New York, 1955. See Jennifer D. Roberts, *Norman Bel Geddes,* Austin, 1979, 16.

19. Dreyfuss believed that his role as an American was to liberate the population from domination by decorative "lions' claws and creeping scrolls" (*Designing,* 74). This goal was to be accomplished by mass-producing designs based on the new European principles. Although Geddes insisted on the originality of the inspired creator and the importance of eliciting emotional response from the viewer, he insisted that surface qualities must directly express the structure and functional requirements of any problem.

20. Raymond Loewy, *Industrial Design,* Woodstock, 1979, 13, and *Well Enough,* 220.

21. Philip Johnson, "History of Machine Art," in *Machine Art,* Museum of Modern Art, New York, 1934, 8–9; Alfred H. Barr, Jr., "Forward," in *Machine Art,* 1–4. Peter Blake, *Mies Van der Rohe, Architecture and Structure,* Baltimore, 1960, 22.

22. Alice M. Carson, "All Change Is Not Progress," *Museum of Modern Art Bulletin,* December 1942, 8–9.

23. Edgar Kaufmann, Jr., "The Department of Industrial Design," *Museum of Modern Art Bulletin* 14 no. 1, Fall 1946, 2, and *What Is Modern Design,* Museum of Modern Art, New York, 1950, 6–9. See also Kaufmann, "Detroit Institute of Arts," *Arts and Architecture* 66, November 1949, 29: We "must finally recommend either the intrinsic or the superficial." A similar moral imperative and formal determinism accompanied the opening on January 1, 1946, of the second most important industrial-design museum in the country, the Gallery of Everyday Art at the Walker Art Center in Minneapolis. Inscribed in one- and two-foot-high letters across the wall of the introductory exhibit was the message: "The FORM of everyday things is determined by USE . . . MATERIALS . . . TECHNIQUES," a theme reiterated in the small print below: "use or function is the main source of form." See McCausland, "Gallery of Everyday Art," 38.

24. Harold Van Doren, "Streamlining: Fad or Function?", *Design* 1 no. 10, 1949, 2. For isolated examples of the contrary position—that is, that the monocoque was a moral and functional shape—see L. Moholy-Nagy, "New Trends in Design," *Interiors* 102 no. 9, April 1943, 66–67; and "A New Era of Design," *Interiors* 103 no. 9, April 1944, 55–57.

25. "Styles Change, Modern Trend Is Toward Richer Design," *Interiors* 105 no. 3, October 1945, 88.

26. Sergio Pininfarina and Renzo Carli, *Pininfarina Cinquantanni,* Torino, 1980, 25, 35–42. Expanding on his design theory, Pininfarina explained that a car is like a woman. As the design of a woman's dress must be chosen according to her carriage, so the exterior design of an automobile must fit its interior chassis. If a woman has a nice face and figure, she will look good with or without ornamental gadgets, but if she is ugly no amount of surface detailing can make her look pretty; see Rodolfo Mailander with Jim Earp, "Pinin Farina Called the Leading Designer of Today by the New York Arts Museum," *Motor Trend,* January 1953, 17–19, 45–47.

27. John Wheelock Freeman, "The Studebaker Story," *Industrial Design* 1, 1954, 38–45.

28. Museum of Modern Art, *Eight Automobiles,* 2. European aesthetics and design philosophy did not go uncontested after the Second World War, when the impact of East Coast design was balanced by influences from other regions and other arts. Well-reasoned arguments based on the functional qualities of new materials were mounted in favor of bulbous and streamlined shapes. Reiterating the European position, spokesmen for the Museum of Modern Art offered only a black-or-white alternative between "intrinsic" and "superficial" design (see note 23), whereas the latest self-supporting materials posed no distinction between surface form and interior structure. This new line of argument was espoused even by a hard-line advocate of the Bauhaus position like L. Moholy-Nagy, who had become exposed to the reality of Midwest commercial-design practices in his new position as director of the School of Design in Chicago. In 1943 he openly declared that streamlining—that is, skin-deep design based on rounded surfaces—related directly to the new, self-supporting structural system and therefore could be considered an intrinsic and honest visual

expression (*Interiors* 102 no. 9, April 1943, 67): "Through manipulation of flat sheets, for example, we can achieve self-supporting structural elements. Curving a flat sheet is a customary strengthening procedure, and curving it, like the eggshell, in all directions, is the most substantial structural manipulation that we know. It achieves the advantages of a skeleton structure with the skin only."

Not only did Moholy-Nagy acknowledge that the car industry largely originated this new structurally related design ("this type of design was mainly developed by the motor car industry"), in the Bauhaus tradition he observed that streamlining fulfilled other functional requirements of production and labor in the automobile industry. "The smoothly 'streamlined' body of a car is stamped today by one action from flat sheets of steel. Though 'streamlining' was originally introduced for a more economical organization of speed of moving objects, its new form principle radiated also into the production of every other type of static goods. . . . This new principle of design, using one-piece objects, mass produced by automatic action of the machine, will one day eliminate the assembly line and with it change the present working conditions in which fatigue of the worker plays an important role." Although sharing the functionalist position of Museum of Modern Art loyalists, Moholy-Nagy directly contradicted their conclusions by proposing that fully rounded, superficial shapes of streamlined forms satisfied the needs of structure, process, materials, and labor.

While many other designers considered the shapes of the World War II "future car" a serious possibility for postwar production, they also thought that this design offered a serious philosophical alternative. Still bowing to the tenets of Bauhaus determinism, these designers predicted a new style era based on the appropriateness of streamlining to monocoque structure and the new molded materials. In "A New Era of Design," perhaps the most explicit article of this kind (*Interiors* 103 no. 9, April 1944, 55–57), the editors observed that "we are only just now entering a brand new phase of design, that phase which utilizes stressed-skin, or monocoque, or even streamlined design." Significantly for the relation of the monocoque shape to car design, they claimed that the closest analogy in nature to this new form of design was the egg. They then followed with a series of comparisons explaining the difference "between monocoque and conventional architectonic" forms in the plane, boat, appliances, and the car. A comparison between the most current egg-shaped vehicle and the Model-A Ford contrasted the intrinsic skeletal structure of the past, made from a "handcrafted assembly of many parts," with "the modern car with all welded body construction," which, despite its independent chassis, was "approaching a monocoque design." Other articles in *Interiors* stressed the appropriateness of streamlined forms to modern materials, such as plastics, which in the process of molding "likened themselves functionally to modern design—the streamlined form." The functional superiority of the rounded shape was even extended beyond structure, material, and process to use: "an electric shaver housing is more comfortable to hold, far stronger and better looking, if it has a streamlined contour rather than a rectilinear form. Happily, it is easier to mold a form with rounded corners than a rectilinear form" (Donald R. Dohner, "Industrial Design Material— Plastics," *Interiors* 103 no. 4, November 1943, 45).

Clearly, the postwar synthesis of American and European forms in American car design tapped the philosophical and visual countercurrents within the mainstream of industrial design. While the shape of the monocoque car could be justified in terms of European functionalism, it corresponded to the seemingly contradictory desire of postwar Americans for excess, novelty, and ornament.

29. Gary L. Witzenburg, *Firebird: America's Premier Performance Car*, Princeton, 1982, 92.

30. "Rybicki Picks His Favorites," *Automotive News*, October 20, 1983, 20; see also "Irvin W. Rybicki—Interview with the Man in Motion at GM Design Staff," *Automotive News*, November 7, 1983, 8. Don De La Rossa, Chrysler's vice-president of design, expresses a similar functionalist philosophy; see Andrew Nahume, "Custom Built Dreams," *Studio International* 196 no. 1004, 1984, 57.

31. Commenting on this problem, Frank Lloyd Wright said that "Elimination may be just as meaningless as elaboration. . . . to eliminate [the] expressive . . . is not simplicity. . . . It may be, and usually is, stupidity." Frank Lloyd Wright, *An Autobiography*, New York, 1977, 169.

CHAPTER 4

1. Sir Dennistoun Burney, "Deep Conflicts Stir Engineers at Detroit with Visitors Scoring," *Automotive Industries* 66 no. 6, February 6, 1932, 1.

2. Michael Lamm, "The Automobiles of Norman Bel Geddes," *Special Interest Autos,* May-July 1977, 24–25.

3. Henry Dreyfuss, in Joseph Geschelin, "Automobile Body Lines Tailored by an Industrial Artist," *Automotive Industries,* October 1, 1932, 414.

4. Joseph Geschelin, "Fall Auto Show (1932)," *Automotive Industries,* January 28, 1933, 99.

5. Athel F. Denham, "Elimination of Cowl Probable, Says Ralph Roberts, Briggs Designer," *Automotive Industries,* February 13, 1932, 224.

6. Karl Ludvigsen, "Automotive Aerodynamics—Form and Fashion," *Automobile Quarterly* 51 no. 2, 1967, 147–54; Jerry Sloniger, "Aerodynamics and the Attainable Automobile: Wunibald Kamm," *Automobile Quarterly* 21, 1983, 182.

7. "Do Streamlined Car Bodies Cut Air Resistance? Not Much Says French Engineer," *Automotive Industries,* July 21, 1934, 74–77; Jean Andreau, "How Side Winds Affect Car Stability," *Automotive Industries,* August 11, 1934, 172–75.

8. George L. McCain, "Dynamics of Automobile Design," in "How the Airflows Were Designed," *Automotive Industries,* June 23, 1934, 766–67. See also Michael Lamm, "Magnificent Turkey," *Special-Interest Autos,* April-May 1973, 14; and "Airflow Prototypes," *Special-Interest Autos,* April-May 1973, 18–20.

9. "Skillful Basic Design Simplifies Production of Airflow Bodies," *Automotive Industries,* May 5, 1934, 550–51.

10. Joseph Geschelin, "Production of Airflow Bodies Demands Utmost of Welding Art," *Automotive Industries,* August 11, 1934, 166.

11. By 1933 most American cars had a slanted, V-shaped or curved grille, with only a trace of a seam separating it from the hood; the bumpers on some cars were curved and the grille was moved well ahead of the front wheel, increasing the appearance of length. Also by that year the fenders began to receive valances or skirts, integrating their appearance with the molded form of the body. Previously, isolated steps toward streamlining had been made, as described by E. S. Sutton, June 11, 1932, in *Automotive Industries,* 856: "The first move in this process of evolution has already been made. It consisted of the slanting of the radiator and windshield, the omission of the air-catching visor, and the rounding of the roof and side posts in front." By 1935 this process of streamlining the separate parts set the stage for the stylistic integration of the whole.

12. At this time, an outspoken industrial engineer and a true apostle of streamlining, Egmont Arens, followed a design direction similar to Earl's, maintaining "that good automobile design is something more than copying the lines of an aeroplane. . . . The word 'streamlining' got everybody a little confused, I am afraid, and off the track . . . [the] goal must always be a line that pleases the eye." "Next Year's Cars; 1937 Automobiles Offer a Still Greater Opportunity to the Artist-Designer," *American Magazine of Art* 29, 1936, 730–31.

13. Earl, "I Dream," 18.

14. Sloan, *My Years,* 276.

15. Joseph Geschelin, "One Basic Pattern in 1935 Car Styling," *Automotive Industries,* February 2, 1935, 143. For the dependence of less popular GM makes on the body stampings of Chevrolet, see Vincent Kaptur, Sr., in Ken Gross, "Chevrolet Special Deluxe," *Special-Interest Autos,* May-June 1978, 16. Typically in the years of the mid-thirties, lower production cars like the 1936 Buick shared the central body with Chevrolet, which was the production leader, but the rest of the car—including the fenders, lights, hood, and trunk—was produced solely by the Buick design studio. Under pressure from Buick chief "Red" Curtis for bigger, bulkier cars with chrome-plated radiators, Buick's designers extended these rounded shapes into a lengthy and drawn-out series of smooth curves, capped in the front by a "fencer's mask" grille (Fig. 18). Hershey, who was chief designer at Pontiac in 1934, when this feature was conceived, describes its origins in the Buick studio as "the most profound example" of Earl's tendency to "simply lift" from one studio and "proliferate" to others. "He adopted a feature which we all referred to as the 'fencer's mask.' It looked just like that—it was a convex shield." The feature enhanced the aesthetic quality of continuous rounded surfaces, as Hershey explains: "It was a continuation of the hood surfaces and the top surface, but separated by the fact that it was plated and it was a component of a grille. This went through all the corporate cars."

16. Blunden, "Automobile Color," 4.

17. The direct effect of large metal dies on streamlined design was widely taken for granted in

other areas of industrial design. See Harold Van Doren, "Streamlining: Fad or Function?", *Design* 1, 1949, 2–5; and "Form-Function and Flight," *Interiors* 103 no. 5, December 1943, 46–47.

18. Vincent Kaptur, Sr., in David K. Holls and Michael Lamm, "The Revolutionary 1934 La Salle," *Special-Interest Autos,* May-July 1977, 15; Kaptur recollects the effect of steel bodies on interchangeability in Fleming, "The Earl of Design," 226. See also Walter Gotschke, "Is Your Car an Egg or a Potato?", *Automobile Quarterly* 6 no. 4, 1968, 397.

19. Roger Huntington, "Did the Cord Really Contribute?", *Car Classics,* August 1975, 19–24; Strother MacMinn, "Chief Pontiac and the Silver Streak," *Special-Interest Autos,* January-February 1978, 19; Gordon M. Buehrig with William S. Jackson, *Rolling Sculpture,* Newfoundland, 1975, 61–65.

20. MacMinn, "Chief Pontiac," 21.

21. Sloan, *My Years,* 276.

22. Mitchell admired Earl for his love of cars, especially racing and special cars, as did Hershey: "Harley had one thing I always loved him for. He loved automobiles more than anything in the world. Automobiles were his whole life."

23. Quite at odds with the corporate standard at the time, a highly placed GM designer recounts that "there were very few top executives in General Motors that I knew who actually loved automobiles. They liked the stock-market report, they liked the production figures, they liked the volumes and sales, but they never appreciated the aesthetics of a beautiful car. You couldn't paint one special for them—they didn't give a damn about it. They would rather go fishing. . . . Curtis was the only one we ever built special cars for. They had no love for a car, no soul."

24. Enhancing the dynamic effect in rendering, George Lawson pioneered the technique of using Prismacolor pencil on black cover stock (Fig. 26). See Michael Lamm, "George Lawson Designer," *Special-Interest Autos,* March-April 1978, 23.

25. L. Scott Bailey, "The Phantom," *Automobile Quarterly* 21 no. 3, 1983, colophon.

26. William L. Mitchell, "1940 La Salle," *Special-Interest Autos,* August-October 1973, 30.

27. Mitchell says that for the Sixty Special he invented "wings" on the sides of the grille (Fig. 30); "otherwise the fender line would [have] come through the grille and make it look like a jockstrap."

28. For good descriptions of the car, see Paul Carroll Wilson, *Chrome Dreams: Automotive Styling since 1893,* Radnor, 1976, 37; "Bill Mitchell's Early Years" and "Watershed: The Sixty Special," *Car Classics,* 1976, 436–38, 439–41; Mitchell, "1940 La Salle," 30; and Sloan, *My Years,* 276.

29. Michael Lamm, "Twenty-One Years of Chrysler Idea Cars," *Special-Interest Autos,* October-November 1972, 16–20; David H. Ross, "Le Baron, Style Setter of Custom Coachbuilders," *Car Classics,* April 1978, 38–45; Alex Tremulis, "Created by the Measured Mile," *Special-Interest Autos,* May-June 1975, 42, 53–54; Michael Lamm, "What Chrysler Corp. Cars Could Have Looked Like If There Had Been No WW II," *Special-Interest Autos,* May-June 1971, 10–15. For some of the choicest "bathtub" epithets, see Loewy, *Well Enough,* 212, 312.

30. B. R. Kimes, ed., *Packard: A History of the Motor and Company,* Princeton, 1978, 528–29; Bill Williams, "1948 Packard Station Wagon," *Special-Interest Autos,* June-July 1973, 45–51.

31. Kimes, *Packard,* 530. Under the direction of Edward Macauley, Al Prance, the styling chief at Briggs, directed the exterior body-work changes. In the end, he kept only the roof and deck lid from the Darrin-inspired design. For the debate on the design responsibility for the earlier Clipper, see Richard M. Langworth, "The Right Car at the Wrong Time," *Special-Interest Autos,* October 1980, 12–19.

32. Ed. Michael Lamm, "Edsel Ford's Hot Rods," *Special-Interest Autos,* December 1970, 36–38; Michael Lamm and David L. Lewis, "The First Mercury and How It Came to Be," *Special-Interest Autos,* July-August 1974, 16; J. Erle Graham, "Edsel Ford's Classic Sports Car Discovered," *Car Classics,* December 1975, 26.

33. Hibbard, "Early Days in GM Art and Color," 40. For the European orientation of Howard "Dutch" Darrin and his association with Hibbard, later Gregorie's right-hand man at Ford, see Darrin, "Disaster Is My Business," *Automobile Quarterly* 7 no. 1, 1968, 57–60.

34. Kimes, *Packard,* 449–90.

35. See Thomas L. Hibbard, "Some Not-Quite Continentals," *Special-Interest Autos,* April-May 1973, 42: "About September 1943 . . . Joe Galamb, the body engineer and a good friend of Sorensen, also forced Bob Gregorie to go. . . . Several months later—around March 1944—Henry

Ford II, knowing that Gregorie had gotten a raw deal as the result of a personality clash, rehired Bob."

36. The "deluxe-y" stage is played down in or missing from most chronicles of Ford styling history. See, e.g., Michael Lamm, "On the Way to the 1949 Mercury," *Special-Interest Autos,* August-September 1972, 16–17. A large mock-up of the Flying Fortress in the Ford car-styling studios, created in connection with studies for Emerson gun turrets (Fig. 45), may have directly affected the massive new car shapes after 1944.

37. Small clay models show that earlier experiments of this kind were conducted within the Ford studios. The models were never pursued, probably due to Edsel Ford's objection. See Ford Archives photograph no. 177754, from 1942.

38. Bob Gregorie's sensitivity to sculptural detail is described by Thomas, *Confessions,* 18, who portrays him as "a master with the knife."

39. Gregorie had modeled a continuous "sheer" line of this kind as early as August 19, 1941, as seen in Ford Archives photograph no. 16355-386.

40. One can trace Gregorie's search for a grille with its final rolled-and-tucked shape. In the earliest 1945 prototypes, Gregorie designed a fully rolled hood, but as he puts it, he still was tied to a flat "conventional frame grille. . .that comes right out. . .and doesn't float in the middle of the opening" (Fig. 42). Other designs from 1945 (Fig. 49) began to approach the final free-floating rolled grille of the '49 Mercury (Fig. 50): "This front end was different in the sense that, instead of the grille reaching and contacting the sheet metal visibly as a frame, there is no frame around the grille. It was all tucked under to simulate an airscoop or an entrance." The major difference between the final design and this clay mock-up was that he had to create a separate stamping and a seam line around the opening in the production car (Fig. 50) in order to achieve the separation and tuck-under he describes. "You couldn't very well stamp the hood to get that reverse radius on it. When you stamp it, you have to be able to pull the die out." The final grille is similar to one Gregorie experimented with on small models as early as September 19, 1941 (see Ford Archives photograph no. 16355).

41. Gregorie believes that the introduction of the 1941 Cadillac further explained the appearance of the bulbous new shape at Ford (see Gregorie interview).

42. For a premonition of this decision, see "Fantasy or 1942 Fact?", *Interiors* 103 no. 5, December 1942, 48. For statistics on the built-up wartime demand, see Motor Vehicle Manufacturers Association of the United States, Inc., *Automobiles of America,* Detroit, 1974, 112.

43. For a discussion of the smaller Chevrolet, see Karl Ludvigsen, "The Truth About Chevy's Cashiered Cadet," *Special-Interest Autos,* January-February 1974, 18–19; and Cray, *Colossus,* 359–60. For a discussion of the dates of Ford policy changes, see David L. Lewis, "Ford's Postwar Light Car," *Special-Interest Autos,* October-November 1972, 22–23; Lewis, "Lincoln Cosmopolitan: The Gleam in Edsel Ford's Eye," *Car Classics,* April 1973, 57; David Lewis, Mike McCarville, and Lorin Sorensen, *Ford 1903 to 1984,* New York, 1983, 132.

44. The direction of GM design in 1946 followed Gregorie's revisions of the Ford line in 1944–45 and paralleled a widespread interest in the World War II standard type during these years. John Tjaarda, for example, designed many monocoque cars during the war, and George Walker, in the April 1945 issue of *Mechanics Illustrated,* prepared an insider's view of "the cars of tomorrow," showing a single large bulbous shape concealing the wheels and a combined bumper and grille spanning the front end of the car.

45. William L. Mitchell, in Richard M. Langworth, "Of Fins and V-8's," *Automobile Quarterly* 13 no. 3, 1975, 311. For photographs of these small models, see Maurice D. Hendry, *Cadillac, Standard of the World,* Princeton, 1973, 284–85.

46. Earl, "I Dream," 82; Mitchell, in Langworth, "Of Fins," 311, recalls that during that year "all production design was stopped and H. Earl reorganized his styling section into two groups with Frank Hershey in charge of Chevrolet and Pontiac and myself in charge of Olds, Buick and Cadillac."

47. Frank Hershey, in Langworth, "Of Fins," 312.

48. Langworth, "Of Fins," 312.

49. Ned Nickles, in Ludvigsen, "Cadet," 18.

50. Even well after Mitchell's return in 1946, changes continued to be made, as can be seen from

the dimensional records of the Body Development Department kept by Vincent Kaptur, Sr., and preserved by his son. On the sheet of the "1948—6069 5 Pass. Sedan 4 Door," notes show that the back light was "revised" May 16, 1947, and that trim dimensions were "brought up to date" on October 31, 1947, and then "revised" March 16, 1948.

51. Another possible source for Earl's decision was the through-line fender produced on the 1942 Buick. According to Mitchell, he developed this fender line in his Cadillac studio on models like the one he gave to Earl in 1940, and which sat on his desk throughout the war.

52. "Lockheed P-80A Shooting Star," *Aviation,* February 1946, 128. Other postwar airplanes with a more sculpted appearance were the Northrop H-35 Flying Wing and the Douglas Skystreak, with an elongated tail shape.

53. The Lockheed Constellation had been in circulation since 1943, when it first served as a troop transport. In 1946 it was commissioned as the world's fastest commercial airplane. As an advertisement in May of 1946 observed, it "suddenly reduced the earth's surface approximately fifty percent."

54. Earl, "I Dream," 82. In an incident from 1953, Earl acknowledged the direct impact of jet aircraft on the design of a specific car: "I picked up a magazine and noticed a picture of a jet plane, the Douglas Skyray. It was a striking ship, and I liked it so well that I tore out the picture and put it into my inside coat pocket. . . . The result, as you may have seen, is that the Firebird [1954] is an earth-bound replica of the Skyray airplane."

55. "1947 Champ, Coming or Going?", *Special-Interest Autos,* November-December 1973, 35.

56. Ibid., 30.

57. The international recognition began in September 1946, when the Cisitalia was awarded first prize at the Villa d'Este Gold Cup Show. See Stanley Nowak, "Cisitalia," *Automobile Quarterly* 8 no. 2, 1969, 132.

58. Freeman, "The Studebaker Story," 43.

59. By 1949 the leaner Italian taste was not just limited to cars but swept across Italy's major industrial exports, such as the Olivetti typewriter and Vespa motor scooter, which are marked by small and tightly undulating volumes (rather than by large bulbous shapes) and by thin-edged reveals and small chrome accents. See F. H. K. Henrion, "Italian Journey," *Design* 1, 1949, 10; and Jean Gallotti, "Olivetti," *Domus* 233, 1949, 32–33.

60. William L. Mitchell, *Corvette: A Piece of the Action,* Toronto, 1977, 11. "I stayed home and devoured every issue of *Autocar,* drooling over the racing paintings of Gordon Crosley and reading every other foreign journal I could get my hands on—and suffering the strange looks of everyone around Detroit who really didn't know what I was about. Except Harley Earl. He had a feeling for cars."

61. Earl, "I Dream," 82.

62. Michael Frostick, "The Cisitalia Breakthrough," in *Pinin Farina: Master Coachbuilder,* London, 1977, 80, 86–91; Richard Straub, "Following the Fender Line," *Automobile Quarterly* 3 no. 3, 1964, 327.

63. This is not to say that Earl did not envisage a subtle transition from the delicate chromed grille of 1948 to the massive forms of the early fifties. Indeed, compared with the more horizontal and heavily chromed grille of 1949, the 1948 front end carried over the egg-crate formula from the Ross-inspired 1941 model and reflected its more vertical shape. Hershey describes the delicate 1948 model this way: "Harley kept wanting us to make a Tiffany front end. You know, the '48 had a very simple front end, with no guts to it."

64. Lewis, *Ford,* 87.

65. Raymond Loewy, in *The Dream Machine: The Golden Age of American Automobiles,* ed. Jerry Flint, New York, 1976, 12.

66. Holden Koto, as told to Michael Lamm, "Living With Style," *Special-Interest Autos,* January-February 1976, 40–45.

67. Raymond Loewy, "Modern Living: Up from the Egg," *Time,* October 31, 1949, 71. Loewy commended the European point of view by deriding the "bulk" (weight) and "flash" (ornamentation) of the American car as a "jukebox," "an orgiastic chrome-plated brawl." Raymond Loewy, "1955 Model: Jukebox on Wheels," *The Atlantic* 195, April 1955, 36–38.

68. Studebaker tried out some of these ideas in an aborted compact-car project. See "Before the New Wore Off," *Special-Interest Autos,* July-August 1971, 12–17; and Koto, "Style," 44.

69. Buehrig, *Sculpture,* 117–19; "1947 Champ," 31; Koto, "Style," 44.

70. Robert E. Bourke, "Some Reflections," *Automobile Quarterly* 10 no. 3, 1972, 267; see also Lewis, *Ford,* 139.

71. Ernest Breech, in Flint, *Dream Machine,* 48.

72. George Walker: "Breech was my very close friend."

73. Koto, "Style," 45; Lewis, *Ford,* 38.

74. George Walker, in Flint, *Dream Machine,* 48–49.

75. See the interview with Bob Gregorie.

76. While claiming that Gregorie's project wasn't anything like his own, Walker believes that Gregorie got wind of his design by Machiavellianism. According to Walker, Gregorie's assistants confided that while Walker was working on his model, Youngren, the chief engineer with a key, would take Gregorie into the locked room. Gregorie's response: "I didn't have anything to do with it. I stayed out of there." He realized that his project was doomed from the start. "They wouldn't have selected our car in the face of Walker's inasmuch as Breech was sponsoring Walker's car. No way. Breech was running the company then."

77. Breech, who certainly was in a position to know, shed some interesting light on the sources of the 1949 Ford. When Koto was thinking of leaving Ford in 1955, he had an interview with Breech to explain his role in the development of the 1949 Ford. "Well of course he knew all that. He said, 'Well, I'll tell you how the whole thing happened. Your model came in there and there were three other models and the outcome was a combination of the three.' " Michael Lamm, "1950 Mercury," *Special-Interest Autos,* August-September 1972, 17, with little evidence says that the roof and doors of Gregorie's model were adopted on the 1949 production Ford.

78. George Walker thought of the grille motif itself as an aircraft with "a motor on a plane and two wings on the side."

79. In 1951 Dupont's breakthrough in white pigment, a nonchalking rutile titanium dioxide pigment, opened the way for lighter, brighter colors and became the base for many of the pastel shades of the fifties. Blunden, "Automobile Color," 5.

80. Virgil Exner, "Colorful Cars," *Automotive Industries,* December 15, 1953, 52.

81. The changes between the first project (Fig. 78) and final model (Figs. 80, 81) of the Wildcat III show car are outlined in *Styling—The Look of Things,* 48–65. Changes include details like the hood indent, bumpers, headlights, fender cut-aways, and air scoops, as well as larger alterations to the shape of the trunk and rear overhang.

82. As recalled by Carl Renner, who was one of the senior designers working under Chevrolet Studio Chief Clare Mackichan. For a discussion of the clay prototypes for the 1958 Chevrolet, see Wick Humble, "1958 Chevrolet Impala Sports Coupe," *Special-Interest Autos,* August 1980, 17–19. The '58 Chevy rear-end theme began as a quick sketch in GM Advanced Body Design Studio Two, according to Bob Cumberford and Stan Mott, "How and Why the '58 Chevrolet Was Designed; The True Story, Told by Two Stylists Who Helped in Its Development," *Motor Trend,* December 1957, 43–50.

83. See especially Bill Mitchell's comments on the panic, in his interview in Part 2.

84. Ingraham, "Detroit's Billion-Dollar Gamble," 16–17.

85. Already in the fall of 1956, it was clear that the redesigned '57 Buick was going to be a financial disaster. Buick Division alone lost more than 160,000 sales units between the model years 1956 and 1957. See Terry B. Dunham and Lawrence R. Gustin, *The Buick—A Complete History,* Princeton, 1980, 271.

86. *Styling—The Look of Things,* 2.

87. Loewy, "1955 Model," 37.

88. Bob Cumberford, "Chrysler's Theory of Success: Coming from Behind to Lead the Way in Styling," *Motor Trend* 9 no. 10, 1957, 40–43; "The Man Behind the Valiant: A Study of Virgil Exner's Styling Philosophy," *Motor Trend* 11 no. 10, 1959, 30–31; Richard M. Langworth, "SIA Profile Virgil M. Exner," *Special-Interest Autos,* December 1982, 20–25.

89. H. R. Neal, "Are Auto Tail Fins Functional? Chrysler Offers Proof That They Are," *Iron Age* 180 no. 2, 1957, 116–18.

90. For the current state of spying in car design, see MacDonald, *Detroit 1985,* 123ff.

91. Carl Renner, in Humble, "1958 Chevrolet," 19.

92. For a look behind the scenes of Jack Humbert's styling at Pontiac, see "Pontiac Bodies Bold and Beautiful," *Motor Trend* 17 no. 2, 1965, 63–67.

93. For photographs of the evolving models for the 1967 Eldorado, see Hendry, *Cadillac,* 314–15; for the background development, see his "1967 Cadillac Eldorado," *Special-Interest Autos,* February 1982, 38–45.

94. For the most complete account of the stylistic development of the Toronado, see Michael Lamm, "Toro and Cord," *Special-Interest Autos,* July-August 1976, 14–19. He chronicles the origin of the design based on Oldsmobile Assistant Chief Designer David North's "Red Rendering," a dream car developed in the Oldsmobile production studio in 1962 under Stan Wilen. For detailed color photographs of this rendering, see Anthony Young, "Looking at Toronado," *Automobile Quarterly* 18 no. 3, 1980, 318–23. The 1961 Lincoln Continental derived from a Thunderbird design proposed by Elwood Engel in 1958. See Michael Lamm, "1961 Lincoln Continental," *Special-Interest Autos,* May-June 1976, 14–56.

95. See note 104.

96. The publication of Ralph Nader's book *Unsafe at Any Speed* in November 1965 and the holding of hearings by Senator Abraham Ribicoff of the Senate Subcommittee on Executive Reorganization resulted in Congress passing the Highway Safety Act and the National Traffic and Motor Vehicle Safety Act (signed into law September 1966), establishing the National Highway Traffic Administration. The NHTA drew up the Federal Motor Safety Standards, including more than fifty standards over the next decade (36 Federal Regulation 97218, Standard 215, and 41 Federal Regulation 9346, Standard 581, in particular cover bumper impact and height specifications). See John B. Rae, *The American Automobile Industry,* Boston, 1984, 131–39; MacDonald, *Detroit 1985,* 84ff.; Brock Yates, *The Decline and Fall of the American Automobile Industry,* New York, 1983, 252ff.; Douglas H. Ginsburg and William J. Abernathy, eds., *Government, Technology, and the Future of the Automobile,* New York, 1980; Sam Peltzman, *Regulation of Automobile Safety,* Washington, D.C., 1975. My thanks to Charles Madison for his graduate-seminar report, "Federal Regulation and the Design of the Automobile," delivered at the University of North Carolina at Chapel Hill in the fall of 1986.

97. See Rae, *Automobile Industry,* 140–42; Yates, *Decline and Fall,* 138.

98. Madison, "Federal Regulations," 10.

99. Jay McCormick, "Ford Lets Stylists Style Cars Again," *Automotive News,* October 1982, 26; see also Phil Patton, "The Shape of Ford's Success," *The New York Times Magazine,* May 24, 1987, 18–24. For the design development of the Ford Taurus, see Jim Hall, "Design File: Ford's Taurus," *Motor Trend* 37 no. 3, 1985, 42–48; Ron Daniels, "1986 Taurus/Sable: Ford Redefines the American Passenger Car," *Car Design,* Summer 1985, 30–35; and John Holusha, "Ford Puts Its Future on the Line," *New York Times Magazine,* December 1985, 94–100.

100. "The New Generation of Luxury Cars from GM," *Car Styling,* Spring 1986, 10.

101. Richard Rescigno, "What's Ahead for GM: Interview with Roger Smith," *Barron's* 64 no. 11, March 12, 1984, 11, 24, 28, 30, 32, 34; Bryan H. Berry, "Interview with GM's Mr. Smith," *Iron Age* 226 no. 7, March 7, 1983, 19–22; Anne B. Fisher, "GM's Unlikely Revolutionist," *Fortune* 109 no. 6, March 19, 1984, 106; Alexander L. Taylor, "Mr. Smith Shakes Up Detroit," *Time* 123 no. 3, January 16, 1984, 59.

102. "Rybicki—The Man in Motion," 18; Matt De Lorenzo, "GM Opens California Design Center," *Automotive News,* October 17, 1983, 30; Michael Cieply and Kathleen K. Wiegner, "California Dreaming," *Forbes* 133 no. 9, April 23, 1984, 91–93; Matt De Lorenzo, "California Bids for Leadership in Auto Design," *Automotive News,* December 31, 1984, 1–2; John McElroy, "Toward Design: West Coast Style," *Chilton's Automotive Industries* 164 no. 10, October 19, 1984, 33–34.

103. Dan McCosh, "The Reshaping of Design at General Motors," *Automotive News,* January 21, 1985, 1–2.

104. Lindsay Brooke and John McElroy, "Pssst . . . The Windswept Look Is In," *Chilton's Automotive Industries* 165 no. 3, March 1985, 47–50.

105. Raymond Serafin, "Awaiting Allanté: Cadillac Rides with Pininfarina in Ultraluxury," *Advertising Age,* March 13, 1986, 4–5.

106. See Yates, "Detroit Styling: A Lost Hollywood Dream," *The Decline and Fall,* 175–98.

FRANK HERSHEY

1. For a discussion of the GM aerodynamic car, see Michael Lamm, "Albanita," *Special-Interest Autos,* February-March 1973, 50–53.

2. For the conflicting histories of who designed the original Thunderbird, see Richard M. Langworth, *The Thunderbird Story,* Osceola, 1980, 15, and "Little Bird Meets Big Bird," *Special-Interest Autos,* June-July 1972, 30–37, 54.

STROTHER MACMINN

1. "Strother MacMinn, A Man of Wit and Genius," *Car Styling,* Autumn 1986, 69–78.

BILL MITCHELL

1. Bill Mitchell reminisces on the origin of the "tombstone" horizontal egg-crate grille introduced on the 1941 Cadillac in Michael Lamm, "1941 Cadillac 60-Special," *Motor Trend* 29 no. 6, 1977, 122.

2. For the behind-the-scenes account of the styling of the 1963 Riviera, see Michael Lamm, "1963 Buick Riviera," *Special-Interest Autos,* March-April 1976, 28–32; and Jeffrey I. Godshall, "Riviera Reborn—The Story Since 1963," *Automobile Quarterly* 19 no. 2, 1981, 203–11.

BOB GREGORIE

1. For John Tjaarda's account of the Zephyr's development at Briggs, see Richard M. Langworth, "In the Track of the Zephyr," *Automobile Quarterly* 14 no. 2, 1976, 194–201.

GEORGE WALKER

1. "George Walker—The Cellini of Chrome," *Time,* November 4, 1957, 99–105; "End of an Era: Ford's Colorful George Walker Steps Down," *Motor Trend,* August 1961, 38–39.

BILL PORTER

1. See Joseph B. Bidwell and Robert F. McLean, "Firebird III," *Automobile Quarterly* 1 no. 3, 1962, 272–79.

2. Gary L. Witzenburg, *Firebird: America's Premier Performance Car,* chapter 5, where Porter describes how Pontiac General Manager John DeLorean intended the new Firebird to be a three-thousand-dollar Maserati Ghibli. Wayne Vieira, Porter's assistant in the Firebird studio, was predisposed, as a "California hot-rodder type," toward the look of "performance" rather than the taste of the Italian school of design. See also Michael Lamm, *The Fabulous Firebird,* Stockton, 1979, 53. William T. Collins, assistant chief engineer in charge of the Body Engineering Group at Pontiac, explains Porter's role in marketing the Firebird at different trim levels, in Jan P. Norbye and Jim Dunne, *Pontiac: The Postwar Years,* Osceola, 1979, 138–39.

3. For the design development of the GM "C" cars, see Jim Hall, "Shaping the C-Cars," *Motor Trend* 36 no. 4, 1984, 41–43.

Index

Numbers printed in boldface type indicate the principal discussion of a subject; boldface italic type indicates illustrations.